THE ART OF

EDITED BY DANIEL WADE

/ BALLISTIC /

134 Gilbert St | Adelaide SA 5000 | Australia
correspondence: info@ballisticpublishing.com

www.ballisticpublishing.com

First Edition published in Australia 2010
by Ballistic Publishing

Softcover Edition ISBN 978-1-921002-71-7
Hardback Special Edition ISBN 978-1-921002-75-5
Limited Folio Edition ISBN 978-1-921002-70-0

PUBLISHER
Daniel Wade

MANAGING EDITOR
Daniel Wade

JUNIOR EDITOR
Gemma White

ART DIRECTOR
Lauren Stevens

DESIGN & IMAGE PROCESSING
Lauren Stevens, Daniel Cox

INTERVIEWS
Renee Dunlop

PRINTING AND BINDING
Everbest Printing (China): www.everbest.com

PARTNERS
The CGSociety (Computer Graphics Society):
www.CGSociety.org

ALSO AVAILABLE FROM BALLISTIC PUBLISHING
EXPOSÉ 8 ISBN 978-1-921002-84-7
The Art of God of War III ISBN 978-1-921002-72-4
EXOTIQUE 6 ISBN 978-1-921002-81-6
d'artiste Character Modeling 3 ISBN 978-1-921002-67-0
d'artiste Matte Painting 2 ISBN 978-1-921002-41-0
Creative ESSENCE: The Face ISBN 978-1-921002-36-6

Visit www.BallisticPublishing.com
for our complete range of titles.

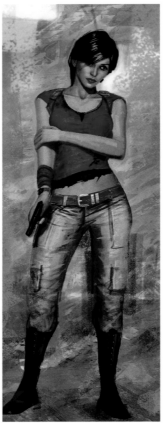
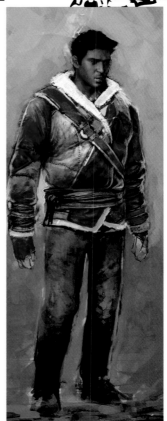

CONTENTS

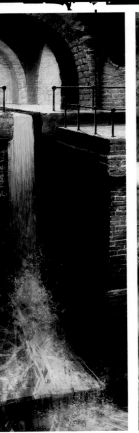
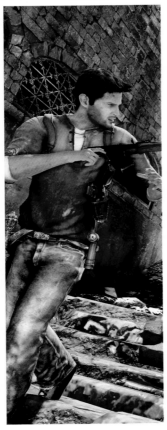
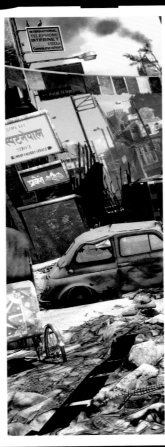
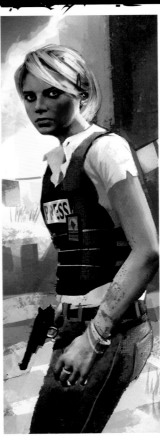

DANIEL WADE

Publisher, Ballistic Publishing

/ B A L L I S T I C /

I'm passionate about games. Since my father brought home a Commodore 64 in 1983, I've watched an industry grow from one- and two-person developers to today's game developers that have casts of hundreds or thousands if you count the publisher, localization, and sales and marketing teams. There's a vast chasm between the production quality of today's games to those of previous decades as they push hardware like the PlayStation 3 towards its full potential. Though the visual and sound design of a game can immerse you in the same way a great movie can, it's only when a coherent narrative, and empathetic characters are included that you really lose yourself in a game. Naughty Dog's Uncharted 2: Among Thieves sets the standard for game production quality, and looking at the art that went into the game gives you another level of appreciation of the talent required to turn that artistry into a believable and beautifully realized world.

'The Art of Uncharted 2: Among Thieves' is the first in Ballistic Publishing's 'Art of the Game' series. The series will include the year's biggest game releases, and each title will offer a unique glimpse into the creative world of game development by the people who create the games. In the pages of this book, you'll see some of the remarkable work that breathed life into the characters and environments of Uncharted 2: Among Thieves. From concept art, through to 3D modeling, and production environments, cinematics, and effects, we give you an unprecedented view of the creation of a gaming classic.

A book like this is only possible through the hard work of many immensely talented people, and it has been enormously satisfying to work with everybody at Naughty Dog. We would love to have spoken to everybody on the team, and included more art, but then you wouldn't have the book in your hands now, and you probably wouldn't be able to lift it. It's easy to see the influence of the Naughty Dog philosophy in the professionalism and good humor of everyone who helped to bring together the art and words for this book. In particular, I'd like to thank Shaddy Safadi (Concept Artist) and Evan Wells (Co-President) for their help to get this project off the ground. For their unwavering help throughout the production I'd like to thank Creative Director Amy Hennig, and Art Director Robh Ruppel. At every stage, they were extremely generous with their time and support. Thanks also to Arne Meyer who was a huge help on the organizational side, along with Sam Thompson at Sony Computer Entertainment America. I'd also like to especially thank Ben Rinaldi at Sony Computer Entertainment America who showed the patience of a saint to get us to the starting block. Thanks go to Renee Dunlop for conducting interviews at Naughty Dog, and to interviewees Erick Pangilinan (Art Director), Rich Diamant (Character Lead), Josh Scherr (Cinematic Animation Lead), Richard Lemarchand (Co-Lead Game Designer), and Mike Hatfield (Lead Technical Artist).

We hope you enjoy this book as much as we enjoyed creating it, and watch the Ballistic Publishing website for new titles in the series.

ROBH RUPPEL

Art Director, Naughty Dog

FOREWORD

Uncharted. What an experience. I'm not talking about playing the game by the way. I'm talking about making it. It broadened my horizons, that's for sure. It made me a better artist by making me so aware of believable and appropriate detail. I was never a fan of detail for detail's sake but having to invent a "forgotten" culture and have it integrated with existing ones is not for the faint of heart. The amount of research and understanding that went into this game was something I had not experienced before, and I've worked a variety of assignments from publishing to feature film design. In the democracy that is Naughty Dog you're held accountable by the group mind, and it's pretty unflinching. Art is the beginning. Through drawing, painting and sculpture the world is slowly defined, stair by stair, handrail by handrail, and pile of rubble by pile of rubble.

There's an old saying in the film business that films aren't finished they're just released. It's a process. This game was definitely a process. Nothing is static. Nothing is ever "done". It's always, constantly tested, evaluated, redesigned, redefined and redone. All to the betterment of the final product I want to add. In this book lies a sampling of the hundreds of drawings, paintings and sculpts that begin this process of making Nathan Drake's world real. From the early ice cave and train levels to the lost city of Shambhala it was all drawn and redrawn.

What is ice like? How do large hanging icicles differ from fallen snow? How does fallen snow differ from compacted and fissured snow? How do you get a sub-surface scatter effect without the real rendering cost? How can you design piles of rubble that can be reused but not look like they are? How do you build an entire city from atop a hotel AND still have it render at 30 frames a second? All these problems and scores more have to be thought about, addressed, figured out, redone, readdressed and somehow still look beyond fantastic.

It's a process that while you're in the middle of seems never ending. You know the game is looking pretty good, and it's heading in the right direction, but you're still in the trenches with bullets flying overhead. You peek up to see the progress and then back down. It's not until the game ships, and you rest a bit that you're able to see the ground covered. And then, the public responds, and they love it. So, all that work paid off. All the effort was justified. All the long hours contributed to a great experience that people "got" and enjoyed. We made a difference. That's all any "art" wants to do. To communicate. To find its audience and have them say: "yeah, awesome, thanks."

EVAN WELLS

Co-President, Naughty Dog

Our most basic philosophy at Naughty Dog is to support the creativity of the amazingly talented people that we've gathered here. Over the years we've done a good job of attracting the best in the industry so we're confident in giving them the freedom to do what they do best. What we try to do as managers is to create a culture that fosters creativity and collaboration. We want to take all of the BS out of the way that stands between somebody's inner burning desire to create and actually seeing it on the screen and getting it into the hands of gamers. We cut out the bureaucracy, and we don't have any unnecessary hierarchy. We want to have the creatives talking directly to one another without having to go through a series of leads and producers which will only end up diluting the message. If somebody's got an idea, they just go straight to the person that's going to help them accomplish that idea, and then it's up to the rest of us who are managing the company to keep up. It means that we've got to run around a lot to make sure that we're on top of things. We don't send a lot of emails, and we don't document things. It can become a little chaotic sometimes, but we thrive in that chaos and I think that's what offers us the flexibility to tackle the really challenging and daunting tasks that other people might avoid. As we began work on Uncharted 2, it was clear our ambitions would require that the team grow considerably from the size we were at the completion of Uncharted: Drake's Fortune. However, we made sure to stay true to our core philosophy in order to retain the close-knit team feeling and never lose that small developer culture and agility.

Our over-arching goal of Uncharted 2 was to create the feeling of playing through an interactive summer blockbuster movie. We wanted all of the excitement and spectacle that you get from the best set-piece moments from a good action-adventure film, but wanted the player to be in control the whole time. But we didn't want to stop there. We also wanted to delve into our characters and infuse the action with more meaning by tapping into human emotion. So we had to put as much emphasis on storytelling and narrative as we did the gameplay. Neither one was more important than the other, as both contribute to the overall experience the player has. What this meant was that not only did our cutscenes have to be top notch, with excellent writing and performances, but we also had to continue weaving the narrative throughout the gameplay. So it was a deliberate decision to pair Drake up with an ally for the majority of the game. This gave him a partner to converse with and allowed us to further the plot even during our most action packed moments. And the visual quality of the game had to perfectly match the cutscenes and vice-versa, so in the end, the player doesn't feel any disruption in the flow of the experience. We also went to great lengths to make sure there was a smooth audio transition between the cutscenes and the gameplay which is a detail that's too often overlooked. And of course the pace of the game would be completely destroyed, and the cinematic feel totally lost if we didn't present the game completely devoid of load screens so the player never has an excuse to put the controller down and walk away.

We set out to make a game that was better than the first one, and we thought that we had done a good job, but we had no idea we'd get the reception that we did. It's been extraordinarily flattering to see the reviews and the awards that we've won, but nothing is more gratifying for us as creators than to hear the words of praise from the fans. Everybody at Naughty Dog is a perfectionist, sometimes to a fault. And it was this pursuit of perfection that led us to bite off quite a bit to chew, and turned Uncharted 2 into an enormous game. It was over 90 minutes of cutscenes; the equivalent of a feature length film. We made the single player campaign half again as long as the first game. We added in competitive and co-operative multiplayer and a cinema mode. The game was so massive that any lesser team would have crumbled under the weight of it and wouldn't have been able to pull it off. But everybody here was so passionate about what they were doing, and was so proactive about just pitching in and doing what was necessary, that the work got done. And it got done to a level of polish that shouldn't have been possible. I've never seen a group of people fire on more cylinders and work in a more collaborative fashion. It was truly the definition of a team effort. I couldn't be prouder to have been part of it.

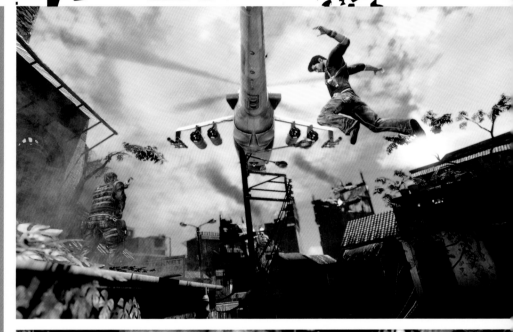

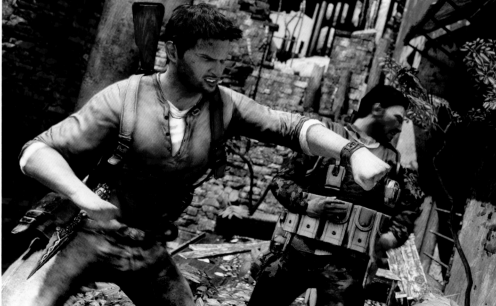

AMY HENNIG

Creative Director,
Naughty Dog

Like everything else in the project, the creation of the story, the writing of the dialogue, and bringing the characters to life (both in-game and in the cinematics), are all very much a collaborative process. From the beginning, we design the game as a narrative experience—which means that the story, gameplay, and character development have to be planned out together, inextricably intertwined. Gameplay events are driven by story beats and vice-versa, and the entire experience is carefully paced and plotted to keep the player immersed—both emotionally and viscerally—from beginning to end. When we get all the ingredients right, we're able to deliver the kind of Saturday-matinee, summer blockbuster experience that inspired us to create Uncharted in the first place.

This collaborative philosophy extends beyond Naughty Dog to our working relationship with our actors and mocap director, as well. Uncharted is very unusual in that we have a long-term creative collaboration with our cast—when they sign on, they're signing up to work with us for a year or more, so it's almost more like working on a TV series than it is a video game. Once we've cast the actors, they really come to inhabit those characters—and we work with them so regularly that their idiosyncrasies and the cadences of their speech all become ingrained in the characters' personalities. Like a television production, we have rehearsal days where we table-read, rework and block the scenes together, giving us an opportunity to

discover all the little ad-libs and improvisations that bring the scenes to life. And we're fortunate to have Gordon Hunt on board as our director, with his decades of experience in stage, television, and animation/voice direction. I've worked alongside Gordon for the last thirteen years, and I always say that he's forgotten more about directing than I'll ever learn. I'm a firm believer that if you can hire a director you can trust, someone who really knows how to work with actors, you'll be doing yourself—and your cast—a huge favor. A good director has both the empathy and the specificity of language to give an actor precisely the adjustment they need, when they need it. Having someone like this on your team is an invaluable asset.

The best part about collaboration is that all of our work becomes stronger through interpretation. Whether it's a writer, game designer, artist, programmer or sound designer; whether it's your composer or your director or the actors in your cast—each time the creative baton is passed, the idea evolves and gets better. This of course requires collective humility and mutual respect among the team—to know that we're all the keepers of the vision, and that the job of the leads and directors on the team is to shepherd the vision, not to own it. At the end of the day, the real reward of our work is to see the germ of an idea grow and evolve into something exciting and unforeseen—which is only possible through iteration, collaboration and teamwork.

RICHARD LEMARCHAND

Co-Lead Game Designer,
Naughty Dog

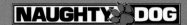

When we start any project at Naughty Dog we always make sure that we have a very clear, concise design goal to work from. It gives us something to refer back to throughout the course of development so that we know that we're staying on track with the design. Our main goal for Uncharted 2 was to create a playable version of the pulpy summer blockbuster movies that we all grew up with and love. We wanted to top what we had done in Uncharted: Drake's Fortune, and there were a few specific things that we wanted to expand on. One of these was to magnify the scale of our set-piece moments where a dramatic event unfolds like a scene from an action movie, but where we manage to keep the player in control throughout the whole of the sequence. The player's moment-to-moment control of the game's hero is part of the magic of our form—the interactive game form—and I think for many of us we've been chasing that goal for all of our working lives. How can we create moments that have the intensity of linear story and all of the craft of linear story but are embodied in gameplay, in a continuity of moment-to-moment gameplay?

There were a few sequences like this in Uncharted 1 that kind of stuck in our minds, and we decided to see what would happen if we pushed the techniques they employed far beyond anything that we'd done before. Anyone who has played Uncharted 2 probably knows what I'm talking about. One good example is the collapsing hotel sequence that we showed at E3 in 2009, when we unveiled our game with a demo on an enormous screen at SCEA's press conference. Drake and Chloe are exploring this hotel that comes under rocket attack by a helicopter, and it begins to collapse around them. It's the kind of thing that in days past we might have been tempted to do in a linear, pre-rendered cut-scene. But we were able to allow to the player to keep playing all the way through this sequence as the hotel came down around them, and I think it made a lot of people's jaws drop. It certainly had a big effect on us at the studio, in terms of firing our imaginations about possible play experiences. So there's more of that kind of stuff in Uncharted 2 than certainly any of us have been able to realize before. From the beginning, that was a major part of our goal of achieving this level of playable cinema.

Another thing we did to expand the player's moment-to-moment choice was to concentrate much more on verticality when we were working on the level layouts. Drake has all of these climbing abilities, which we'd expanded quite considerably for Uncharted 2, and so we focused on making the levels more climbable and sometimes put in more than one way to get to a certain spot. This paid off in combat as well as exploration because as well as increasing his focus on climbing, we also made it so that he could use all of his combat moves, all of his gun combat moves in whatever traversal state he was in. Whether he was climbing halfway up a rocky wall or balancing on a beam, he could always pull his gun out and return incoming fire. That let us put fun gunfire combat exchanges anywhere in the whole game, which was tremendous for expanding our game's play possibilities.

CONCEPT ART
CHARACTERS

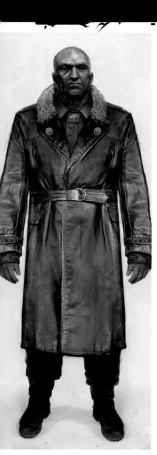
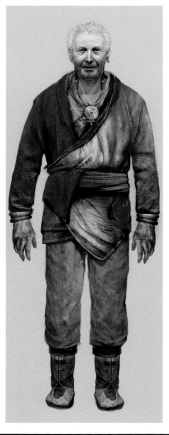
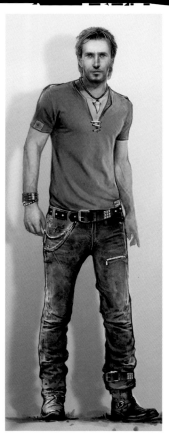
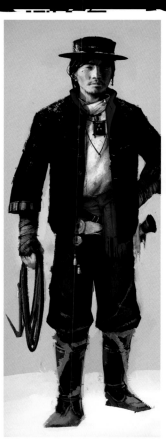
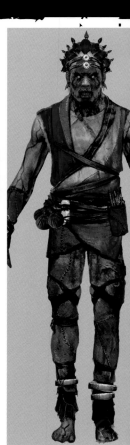

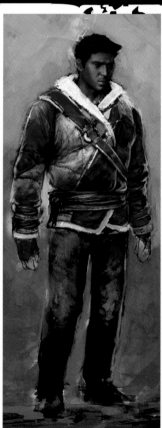
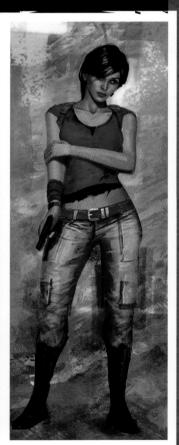

Robh Ruppel
Art Director

CHARACTERS

Designing characters for Uncharted is very atypical of most design assignments. The world of Uncharted is meant to be grounded, real, believable, not calling attention to itself for the sake of design. In that regard, it is actually much harder to come up with design solutions that are distinct enough that we can easily tell characters apart, but still be considered "real-world". For Uncharted 2, we introduced several new characters along with returning characters Elena Fisher and Victor Sullivan. For the two returning characters we retained a similar appearance to the first game, with some costume updates for the different climates. Elena is now an investigative journalist, so she has a somewhat more professional look in this game. Drake's new love-interest, Chloe Frazer, appears alongside an old cohort, Harry Flynn. Together they entice Drake into a shady scheme, which pits them against a rival relic-hunter and fugitive war-criminal named Zoran Lazarević. Over the course of his journey, Drake befriends and is aided by Tenzin, a Tibetan villager, and a mysterious explorer from another era, Karl Schäfer.

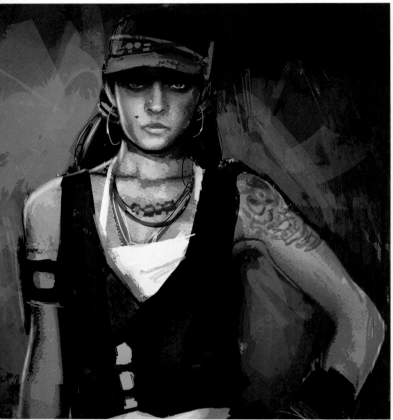
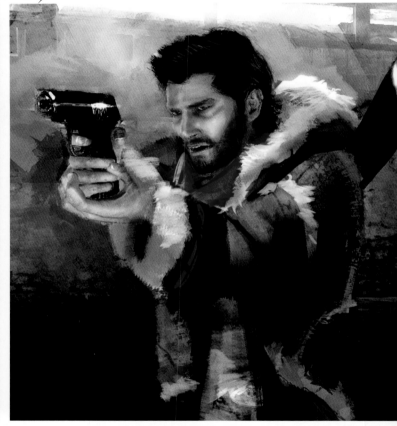

CHARACTERS

One of our main goals with Uncharted 2: Among Thieves was to approach the design as a union of narrative and gameplay, and to tell a character-driven story. In the first Uncharted, we pretty quickly thrust Nathan Drake into circumstances where he had to assume the role of the hero, and help those around him to survive. It was a good introduction to Drake as a character, but we had subtly suggested that there were more layers to him, that in his "real life" as a modern-day treasure

hunter, he probably associated with some dodgy characters, and might be a little shady himself. So while we intended Drake to be essentially a decent guy—charismatic, charming, with a good moral compass when the chips were down—we always wanted to portray him as a bit more complicated than that. He operates within a questionable fraternity of international fortune hunters—really just a euphemism for smugglers, con-men and thieves—so from the beginning of

development, this seemed like a compelling aspect of his character to explore: the tension between his "light and dark sides," and how the various people in his life would pull him in different moral directions. We introduced Chloe Frazer as a new love-interest for Uncharted 2. Like Drake, she's a fortune hunter for hire, but she's a little more self-interested and unpredictable than he is. Her reckless and impulsive nature allowed us to draw out those sides of his character more.

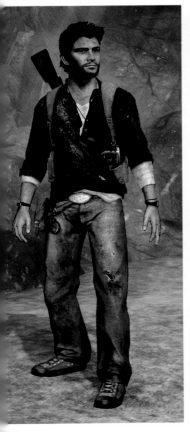

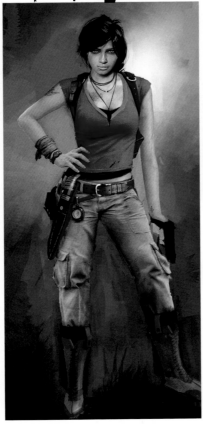

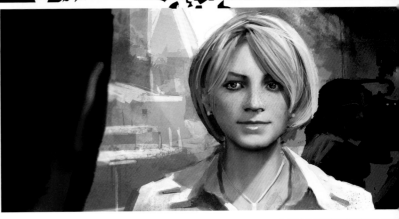

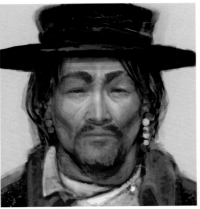

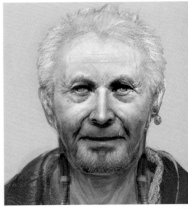

We deliberately developed the supporting characters as kind of emotional satellites for Drake—mirrors that we could hold up to show these other sides of him. So we've put a lot of emphasis on telling a character-driven story, rather than just pushing the story forward with visceral action, plot devices and set-pieces. We wanted to paint Drake and the supporting players as characters who are richer and more complex, as authentic people, and to develop some more serious conflict in the story without getting too angsty about it (which is an easy trap to fall into). We're very conscious of our roots in pulp fiction, where you have a more colorful, romantic-adventure, light-hearted tone. So we want to straddle that line—not taking ourselves too seriously, but also not being too jokey or cheesy. We want the player to join these characters in this thrilling, enjoyable, summer-blockbuster experience. We always saw that as a way in which we could stand out—by being colorful, both figuratively and literally.

Chloe ideation [Shaddy Safadi] *opposite left*
Drake ideation [Shaddy Safadi] *opposite right*
Drake [Shaddy Safadi] *above far left*
Chloe [Shaddy Safadi] *above center*
Elena [Shaddy Safadi] *top*
Tenzin [Hong Ly] *above left*
Schäfer [Hong Ly] *above*

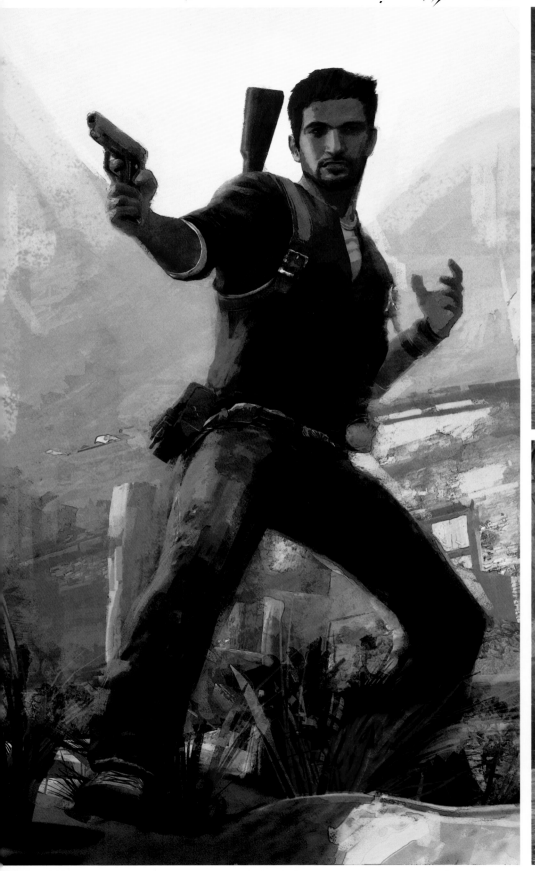
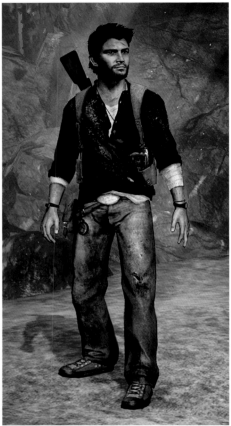
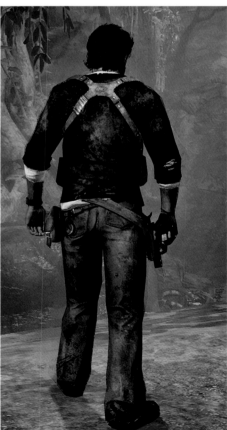

Robh Ruppel
Art Director

NATHAN DRAKE

In this game we wanted to explore Drake's seedier side, his slightly shadier side, and we thought we'd mirror that with the visuals. So we gave him a darker shirt to wear, and scruffed him up a little bit more—that was the big change for him. We wanted the visuals to express what he was going through emotionally, and to reinforce the somewhat darker nature of his journey in this story. Model-wise Drake didn't change very much from the first game—he's still essentially Drake. We had two main looks for Drake that we needed to establish: his new, slightly edgier "dark gray t-shirt" look, and his cold-weather outfit for the snowier locations. When he reaches Tibet, we wanted Drake to be dressed more like the locals, so we gave him a traditional sheepskin coat.

Drake pose [Robh Ruppel] *opposite left*
Drake front final [Shaddy Safadi] *above left*
Drake back final [Shaddy Safadi] *left*
Drake parka [Hong Ly] *this page*

Drake injured [Hong Ly] *opposite top*
Drake parka [Hong Ly] *opposite center*
Drake ideation [Shaddy Safadi] *opposite bottom*
Drake ideation [Shaddy Safadi] *this page*

DRAKE IDEATION

To give Drake a more local (Tibetan) look, we started with very traditional coats made of sheepskin. The authentic coats often look a little shapeless, so we took it in at the waist and widened the shoulders to make sure he still had a heroic look.

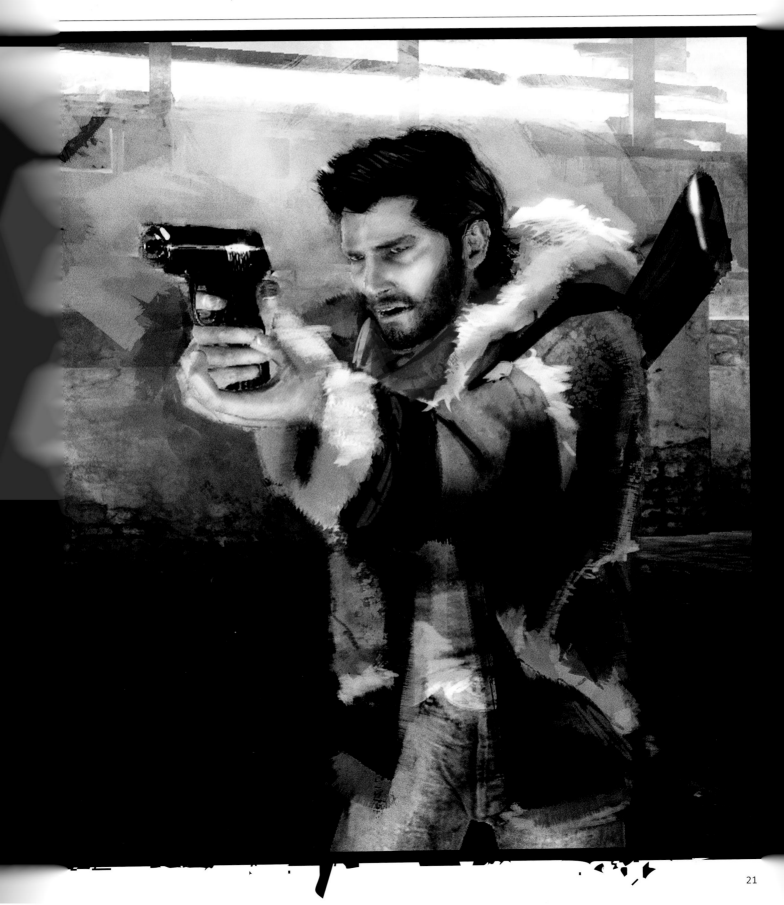

CHLOE FRAZER

Chloe Frazer is an exotic ex-girlfriend of Drake's, though I don't know if "girlfriend" is the right term. Let's just say they were romantically involved. She's meant to be sort of dark and mysterious, so we wanted her to be somewhat exotic-looking, of mixed ethnicity. She's definitely the opposite of Elena, who's more the cute, perky, blonde, all-American-girl type. As a contrast, we wanted Chloe to be dark and smouldering. These were all considerations when it came to designing her. Visually, she's a bit more dangerous. Elena seems very "safe" in contrast, and when you see Chloe it's like "This looks like fun but it could be bad—this could end badly."

We experimented with a lot of different looks for Chloe. We tried out a number of ethnicities, styles, hair shapes, costumes and cultures trying to define the character. We ultimately went with very dark straight hair, which had a lot to do with contrasting with Elena. You know, dark hair, exotic, dresses a little bit more provocatively than Elena does. Casting Claudia Black also helped us define Chloe as a character, because she has such a great voice and physical signature. People may know Claudia from the 'Farscape' and 'Stargate SG-1' series, as well as 'Pitch Black', and countless game voices.

Chloe final sketch [Robh Ruppel] *this page*
Chloe ideations [Shaddy Safadi] *opposite page*

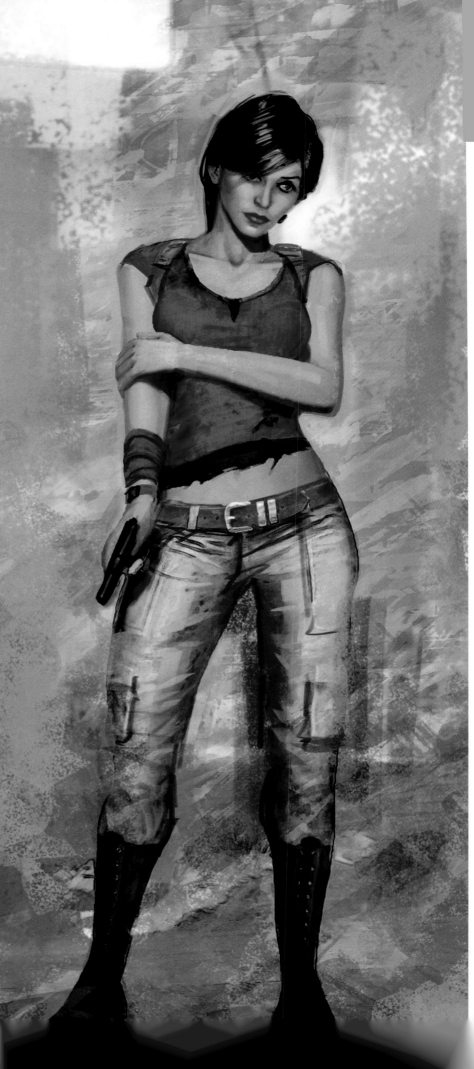

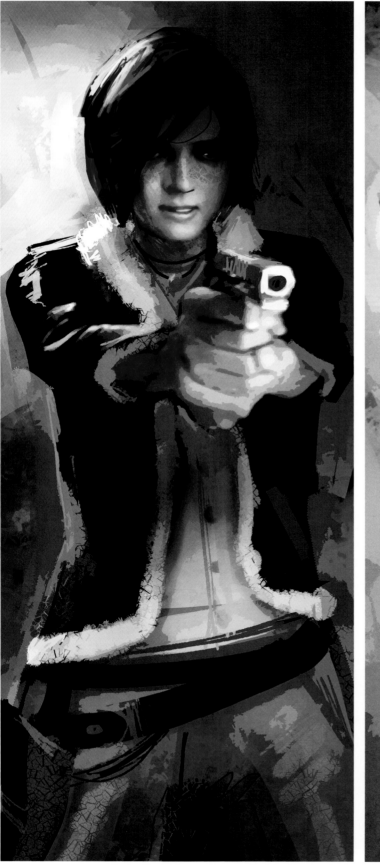
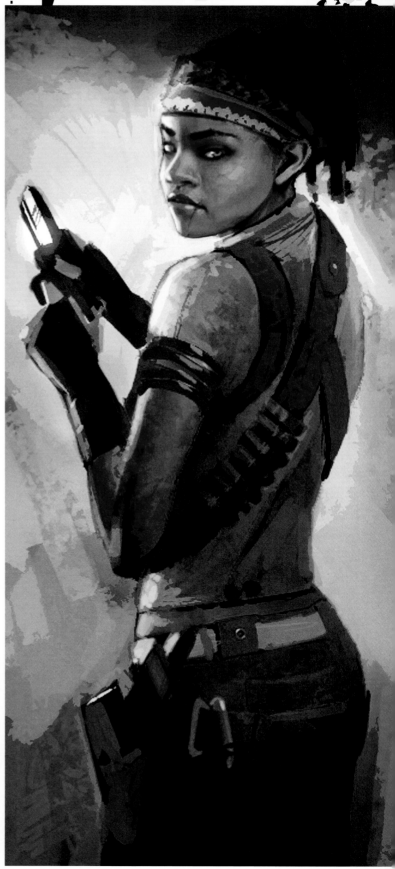

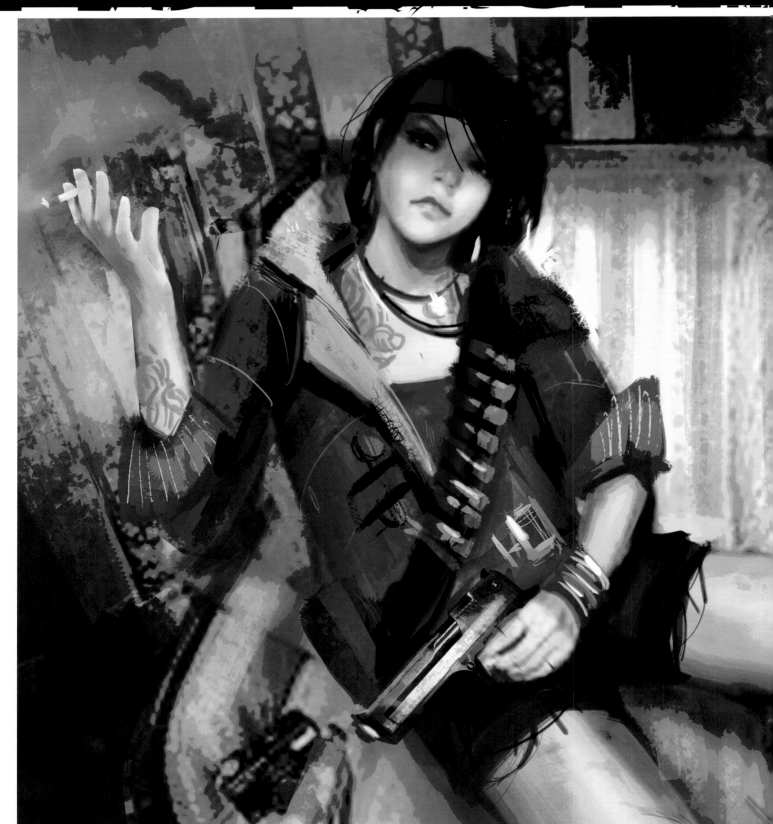

CHLOE IDEATION

We tried out a number of ethnic variations for Chloe, including Indonesian, European/French, African and Indian. Something a little exotic, with a hint of danger. We wanted Drake to be attracted to her, but with a definite undercurrent of unpredictability.

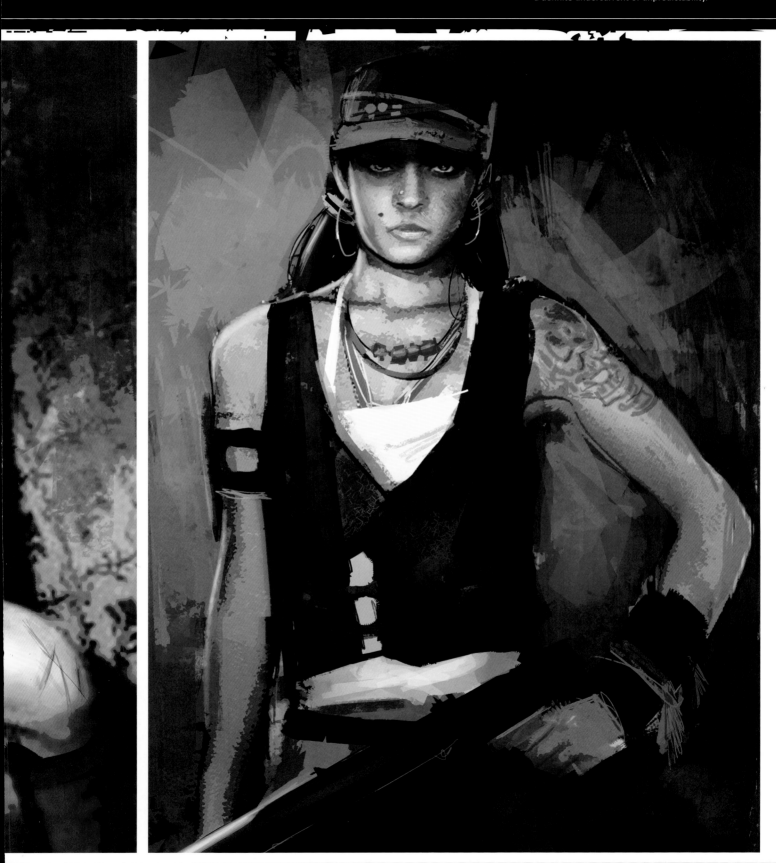

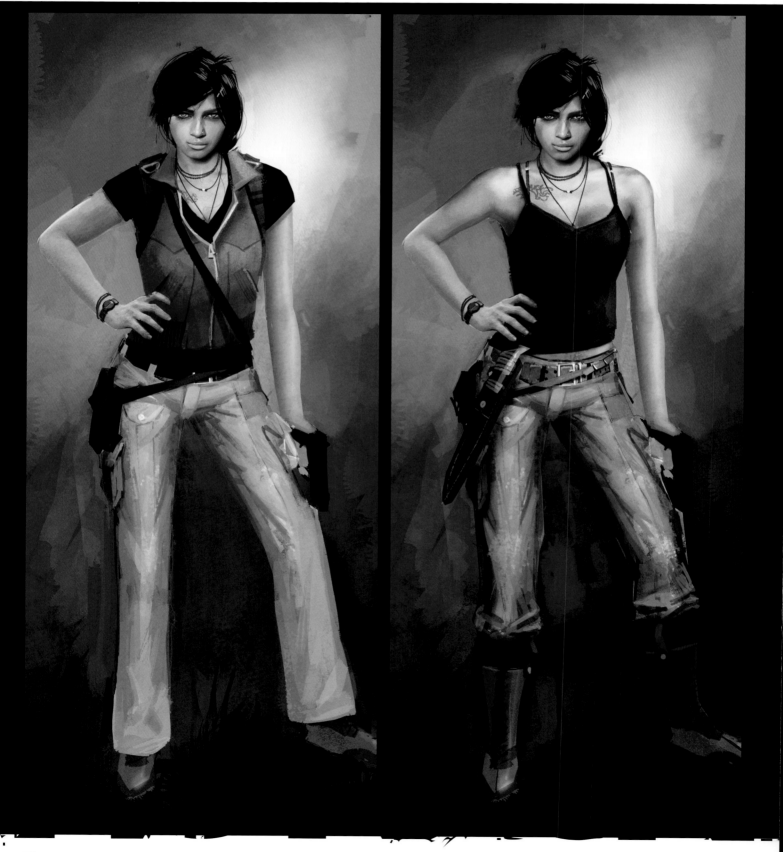

Chloe outfit concepts [Shaddy Safadi] *this spread*

CHLOE OUTFIT CONCEPTS
We tested out all sorts of color combinations, and different types of clothing for Chloe. What says: "female adventurer?" How much skin do we show? How little? That sort of thing. We were trying to define all of that.

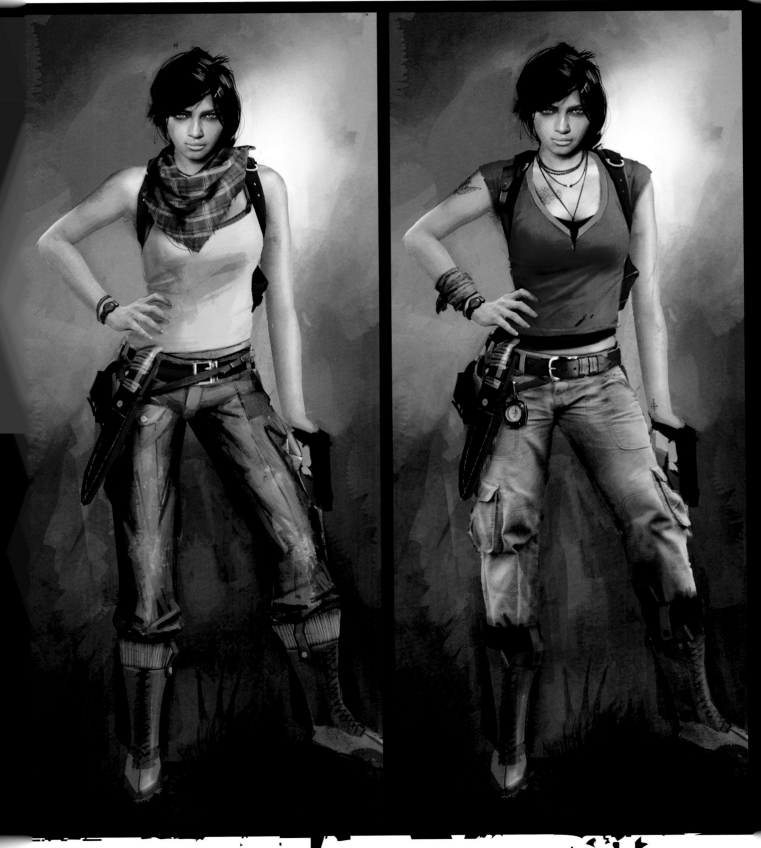

TENZIN

Tenzin is a leader in this remote Tibetan village that Drake ends up in after the train wreck, so we wanted to design a look for him that was appropriate to the region, but was also clearly his own style, so that he stood out from the rest of the villagers. We were trying to find an interesting look for him, so we pored through all these different books on Tibet and the Himalayas and found a picture of this one guy that had a really unique feel to him. He almost looked like someone out of a spaghetti western, because in the picture he had this sort of poncho on, and this short Lee Van Cleef type hat with a wide brim. So this guy was our initial inspiration, but then we probably did 50-100 designs for Tenzin, trying to work out his final look. The photograph was a great launching point, but then you start designing him and have to ask: 'What does he look like from the front? What does he look like from the side? How would this outfit really work?' Then you realize we can't have too much flowing cloth because then it would have to be rigged, and we'd have to have follow-through in the animation, so tight-fitting clothing works better (and is easier) in that regard. So we went through a lot of iterations trying to maintain that same feel, but also make him work within our game pipeline, which, unlike film, still imposes quite a few restrictions on how we costume the characters.

Tenzin final [Hong Ly] *this page*
Tenzin model sheet back [Hong Ly] *opposite left*
Tenzin model sheet front [Hong Ly] *opposite right*

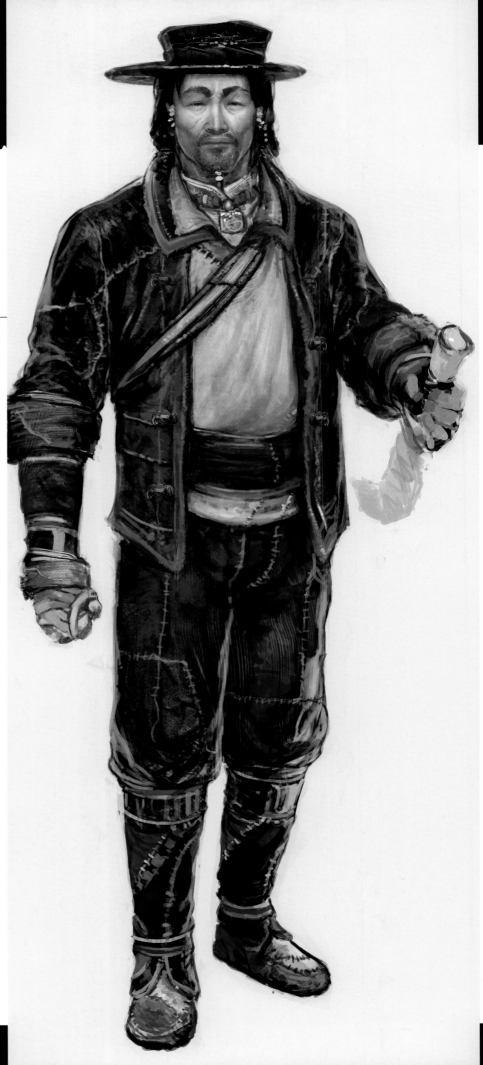

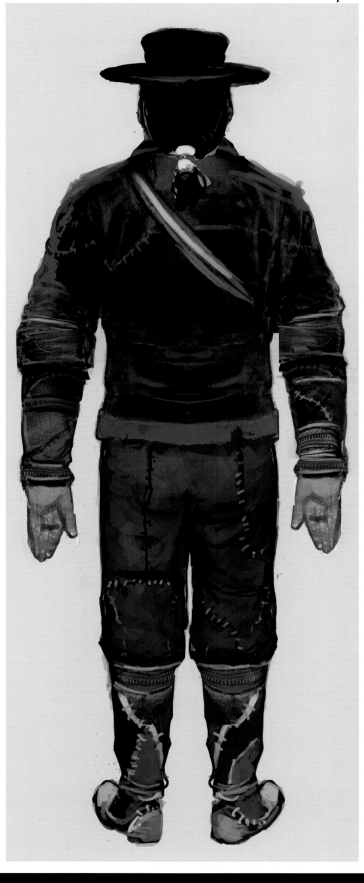
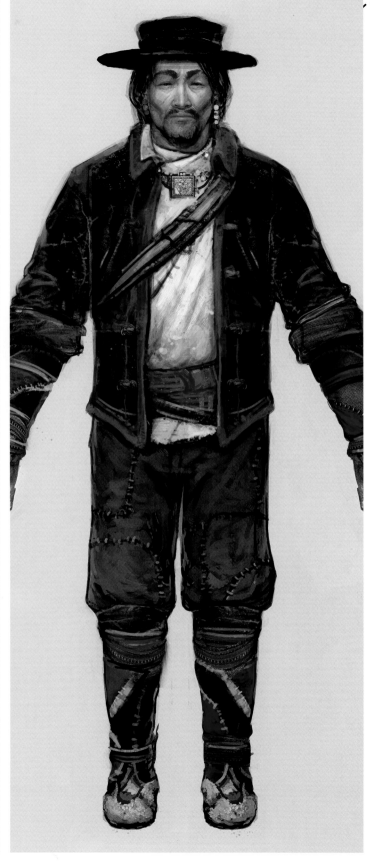

TENZIN IDEATION

His clothing is meant to be more realistic than symbolic. We looked at what people wore in Nepal and Tibet, and the color schemes that are common in their clothing. We needed Tenzin to look like he really lived there, so we used lots of tans and browns and just a few hints of red, to make it feel authentic. We added some red accents to his jacket and waistband, just to visually break up the tan look, but Tenzin essentially dresses like a villager, which makes him more 'of the people'.

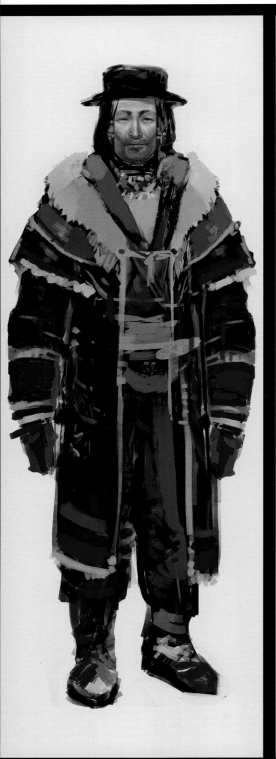 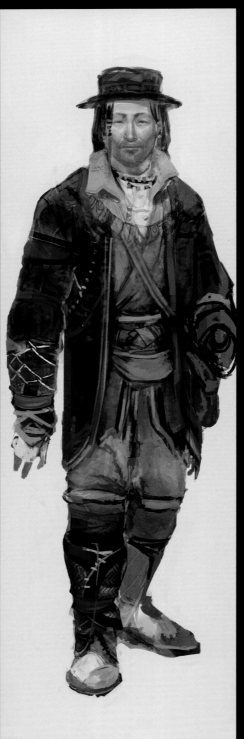 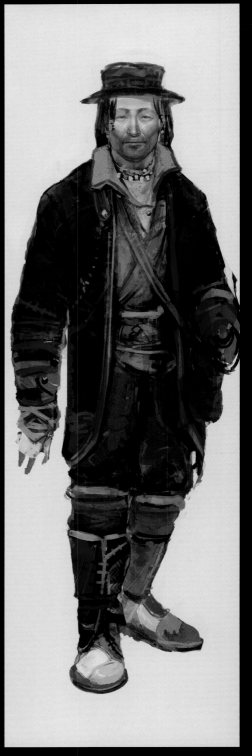

Tenzin ideations [Hong Ly] *this page*
Tenzin pose [Shaddy Safadi] *opposite page*

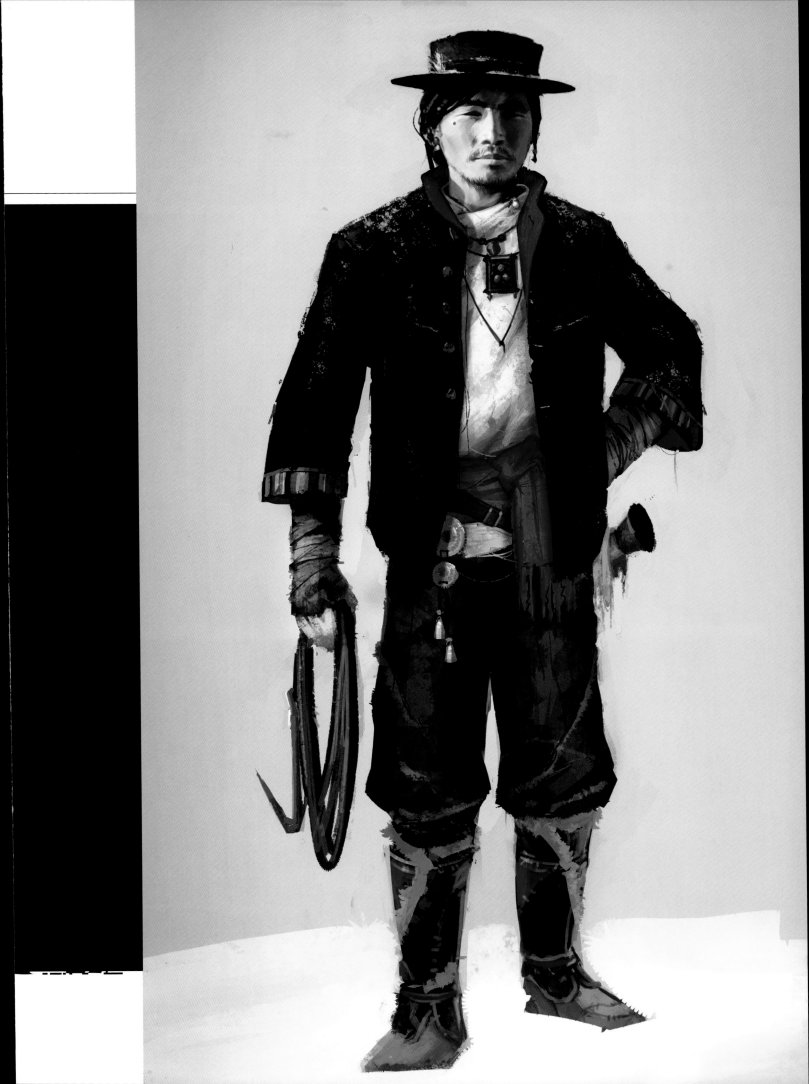

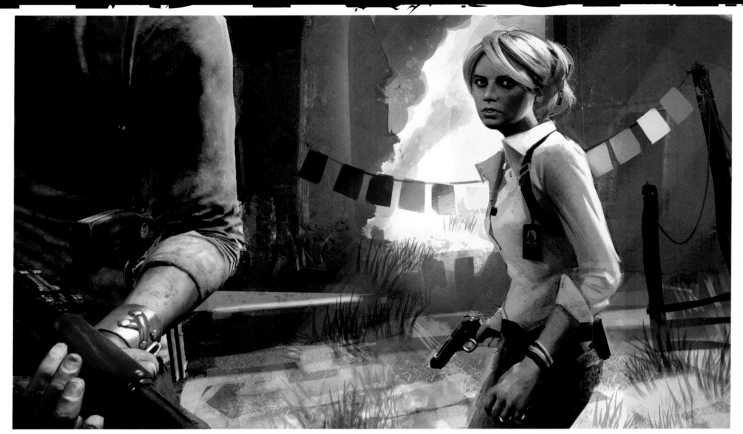

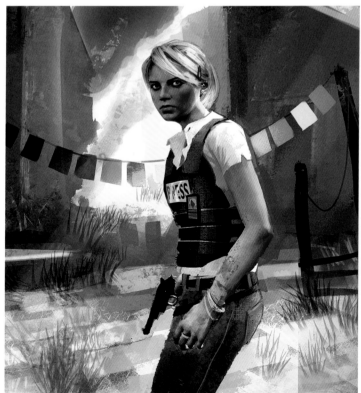

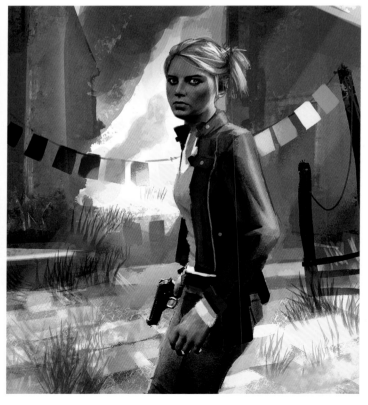

Elena final [Shaddy Safadi] *opposite top*
Elena ideation [Shaddy Safadi] *opposite bottom*
Elena meeting Drake [Shaddy Safadi] *this page*

ELENA FISHER

Elena's look is fairly similar to the first game, but she's an investigative journalist now, so we needed to give her a more mature look, an outfit appropriate for a reporter in the field. You'd be surprised how many sketches it takes to really find the right look and get a consensus on the design. So after trying dozens of sketches, we settled on a nice simple white shirt that felt semi-professional, something practical but appropriate for in front of the camera. She's out in the field, so she needs to look functional but also just a little bit dressy.

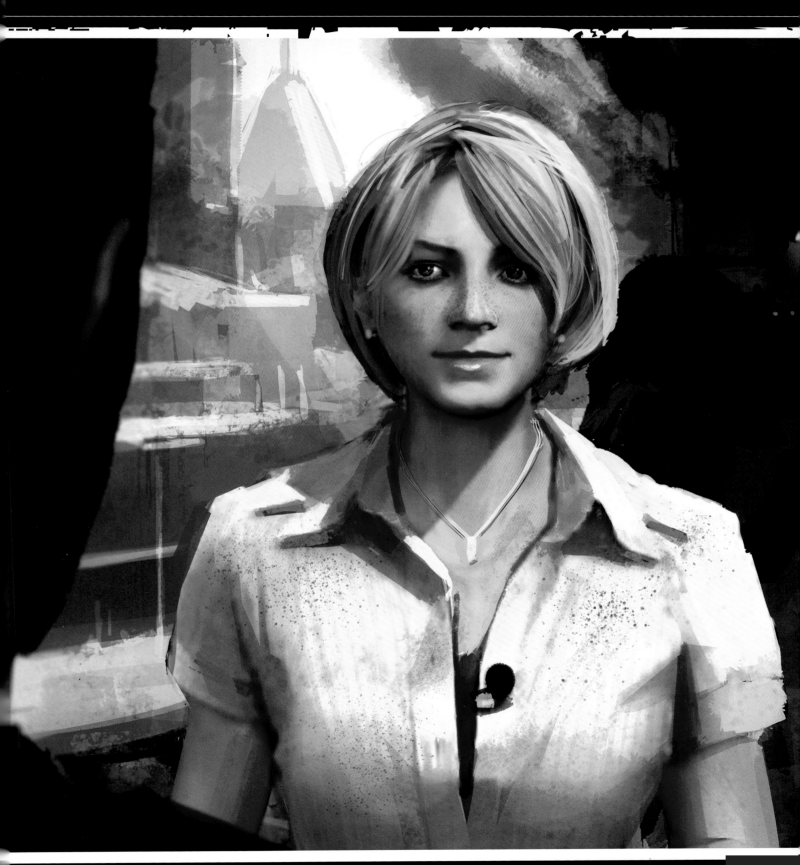

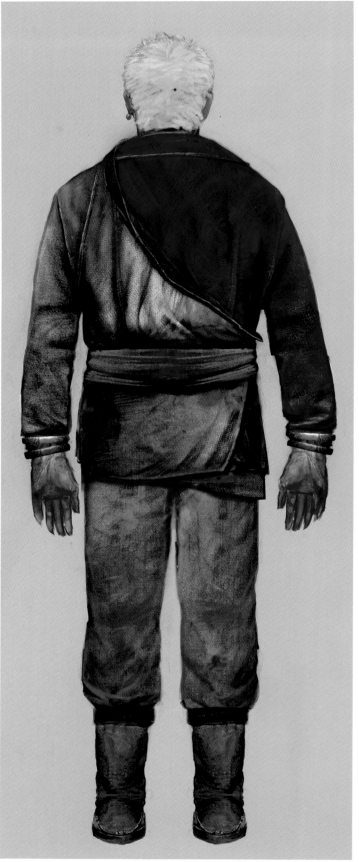
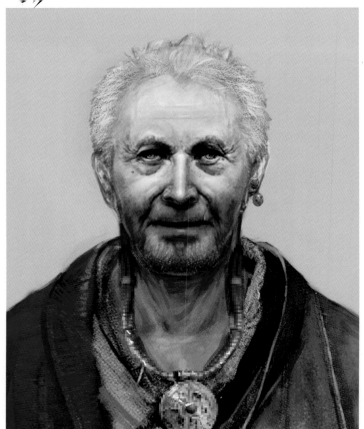
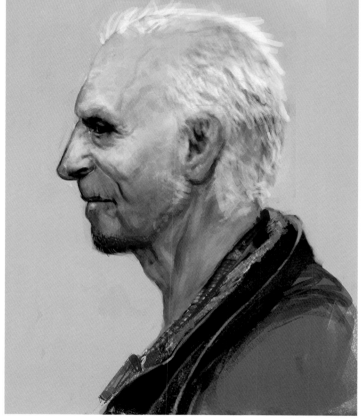

KARL SCHÄFER

Schäfer is a throwback to the explorers and mountaineers of the 1930s, a guy who's in his nineties now but was part of a German expedition to find Shambhala seventy years ago. Like Drake, he almost died in the attempt but was rescued by the locals and has lived in this remote Tibetan village ever since. He has learned their language and adopted their clothing and customs. He wears a Tibetan-style robe, trousers and boots, but his look otherwise is unmistakably European. All his jewelry and his prayer-box necklace are based on authentic Tibetan ornaments. We did a lot of research to develop his look, referencing real-life explorers from the '30s as well as elderly Tibetans and their style of dress. It's all a matter of research, and trying out different iterations to see what works with the character. Painting is still the fastest way to explore these types of designs.

Schäfer back final [Hong Ly] *opposite left*
Schäfer head concepts [Hong Ly] *opposite right*
Schäfer final front [Hong Ly] *right*

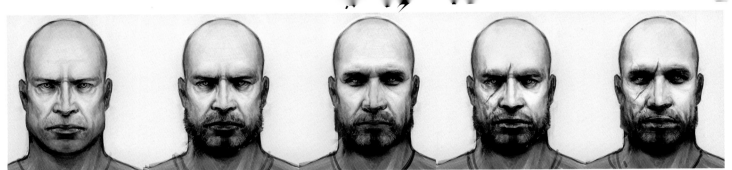

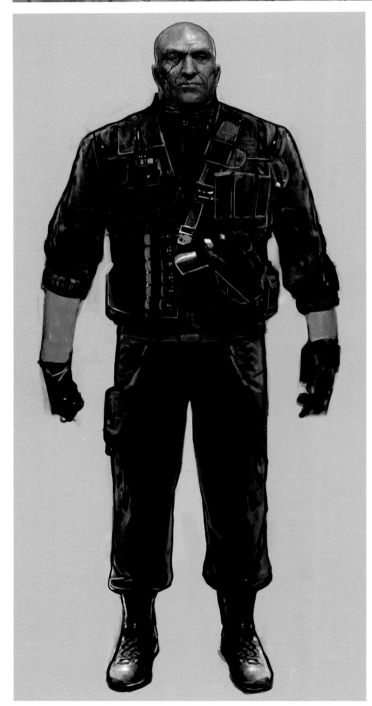

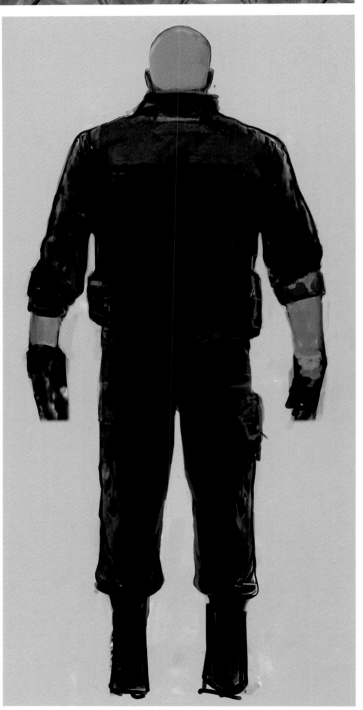

ZORAN LAZAREVIĆ

Lazarević is our main villain, so he needed to have a more imposing and intimidating presence than the rest of his men, while still clearly being a formidable soldier himself. He's meant to be the charismatic leader of a rogue paramilitary army, a fugitive war criminal who's notorious for committing unspeakable massacres and atrocities. So we did a bunch of research into real-life mercenary leaders and what they wear, but we also needed to make him a larger-than-life figure. We gave him a powerful build and some extra height, so he would physically dominate the scenes, and dressed him in all-black military gear, bristling with weapons. We needed to exaggerate some of his features, but we also wanted to keep him grounded in reality, so every little detail on his outfit is accurate and functional. His most prominent features are his shaved head and the angry-looking burn scars along the right side of his face and body—wounds inflicted in a NATO bombing raid that he survived. All of these details had to contribute to the overall impression— when he enters a scene, you immediately know he's in charge; he fills the room with his presence. You get that from his stature and ice-cold demeanor, and of course a lot of that intensity and dark magnetism comes from the actor's performance, too.

Lazarević face concepts [Hong Ly] *opposite top*
Lazarević model sheet front [Hong Ly] *opposite left*
Lazarević model sheet back [Hong Ly] *opposite right*
Lazarević ideation [Hong Ly] *right*

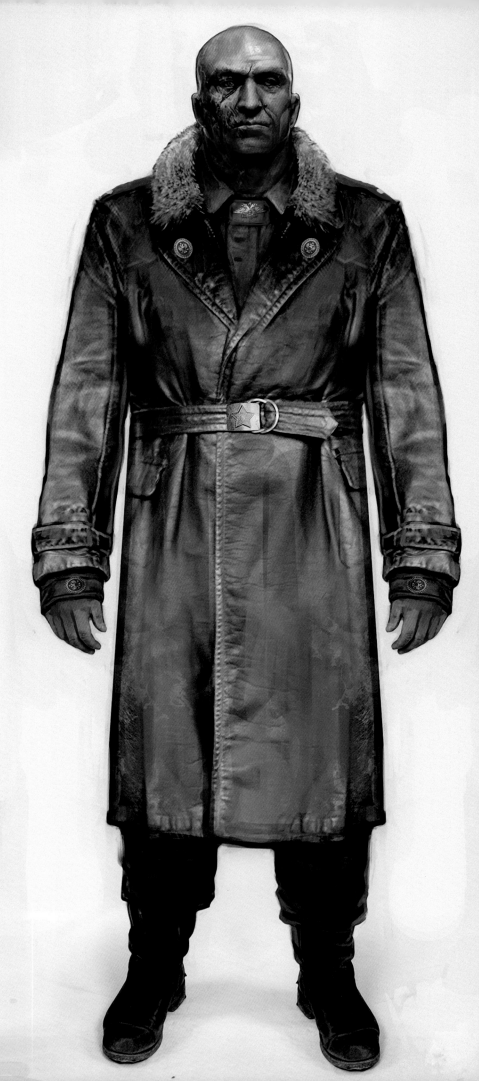

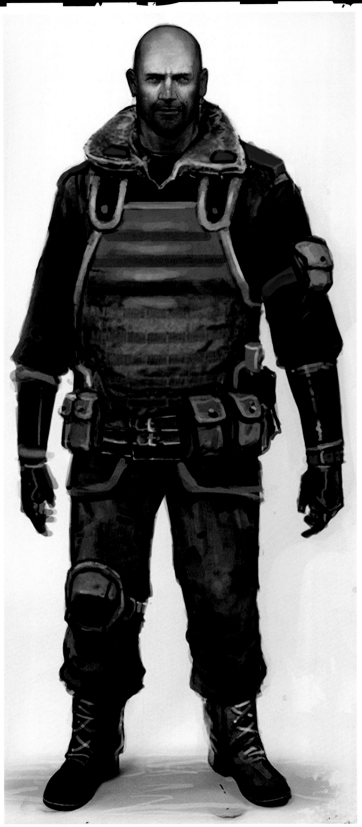
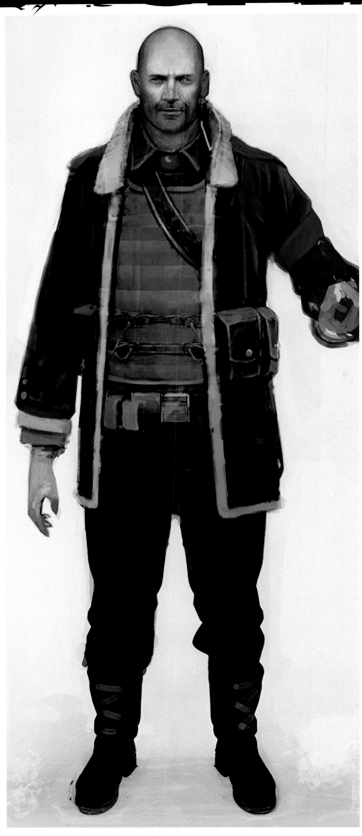

Lazarević ideations [Hong Ly] *opposite page*
Lazarević head [Hong Ly] *below*
Lazarević face concepts [Hong Ly] *bottom*

LAZAREVIĆ IDEATION

Lazarević's look was based on real-life mercenaries and paramilitary leaders and what they actually wear. It was all painstakingly researched. In designing his head and face, we studied photos of men from the Balkans and Eastern Europe to establish a look that would be accurate yet distinct.

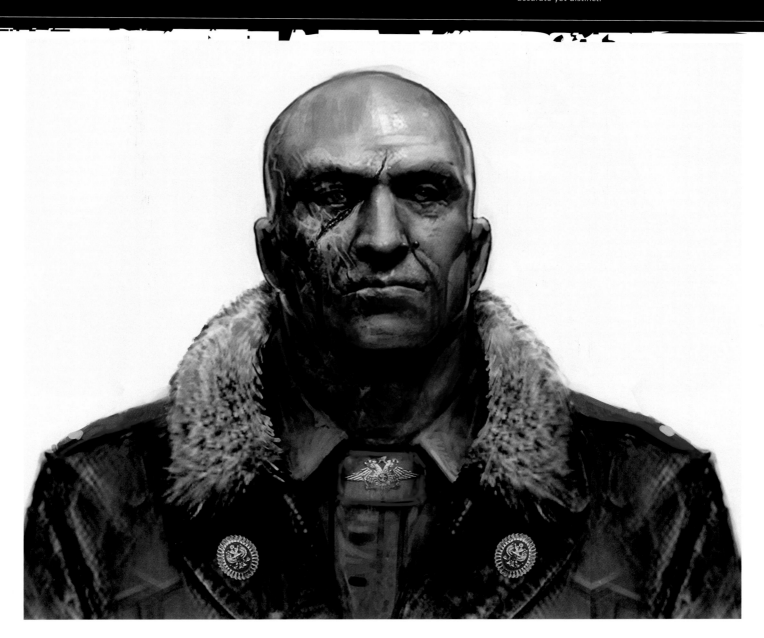

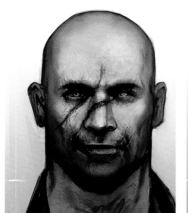 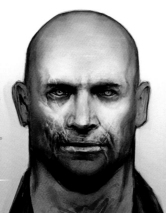 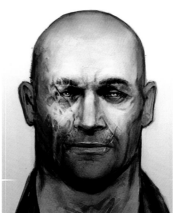 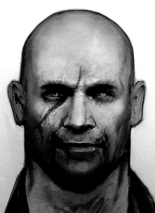

ENEMY SOLDIERS

In Uncharted 2, it was extremely important to come up with distinctly different enemy classes—the lighter armored class being easier to kill, while the heavy armored class are more difficult. We try to reinforce these gameplay distinctions with the visuals. The guys who are easier to kill don't have as much padding, they don't have helmets on, and we tried to keep them lighter in value so they're easier to see and pick off. At the opposite end of the spectrum were the big heavy guys, with lots of padding, pockets and gun belts, darker uniforms, and lots of covering on their helmets so that you know in an instant when these guys show up that you're in trouble. If you see a guy who looks like a giant, tough beetle, you know this guy is going to take a lot of bullets to kill. So the player thinks, "Maybe I'll go around him, maybe there's a way to flank this guy so that I don't have to confront him head-on." Or the player may sneak up on an enemy camp and think, "Oh look, there's three low-level guys here. I can easily take these guys out." Again, we wanted the visuals to give the player an idea of what they were up against, to convey information that would allow the player to strategize.

Light soldier [Hong Ly] *right*
Soldier classes [Robh Ruppel] *opposite page*

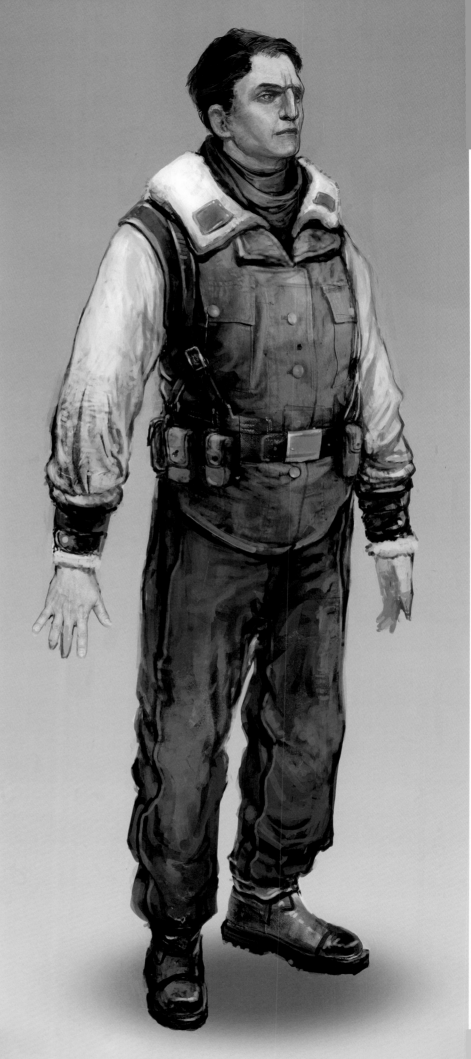

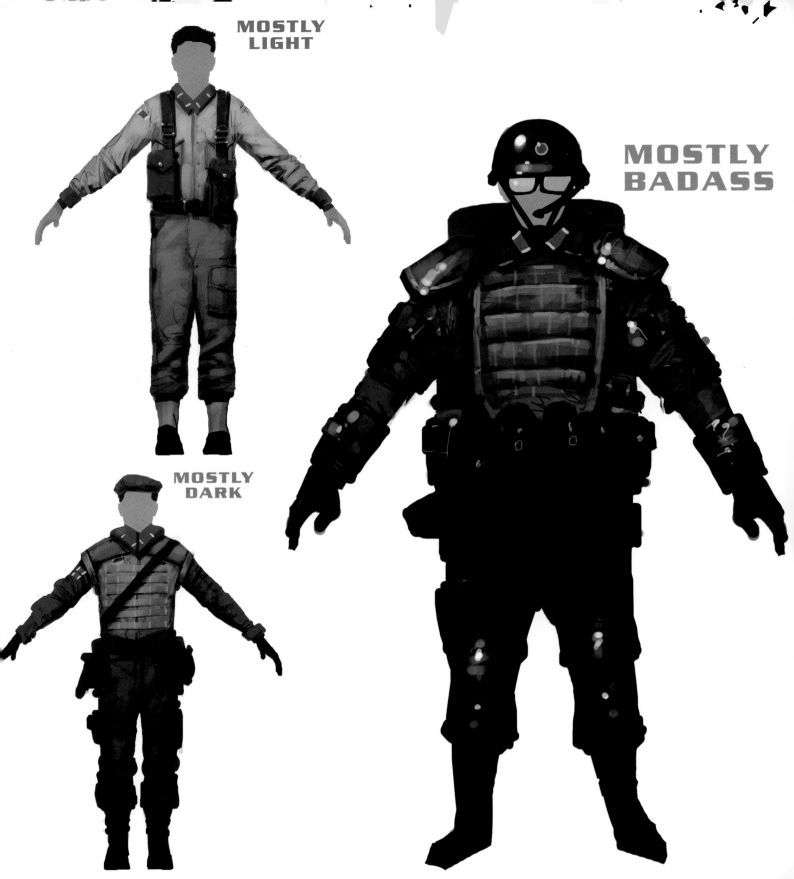

MOSTLY LIGHT

MOSTLY BADASS

MOSTLY DARK

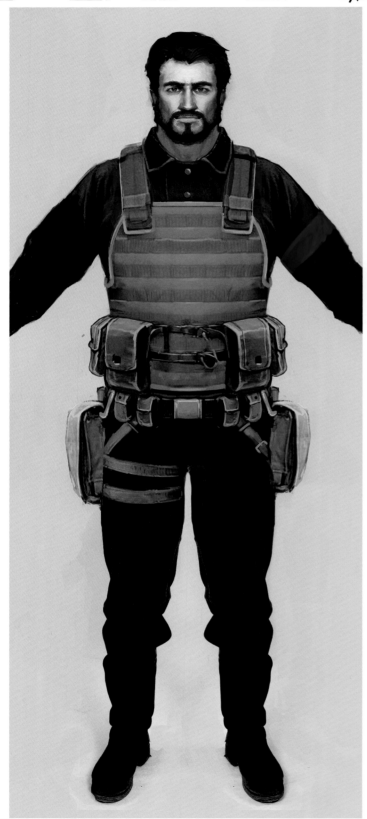
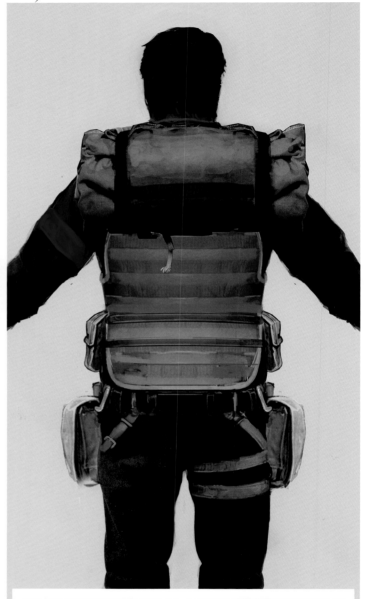
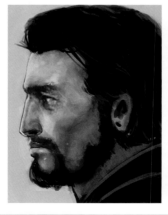
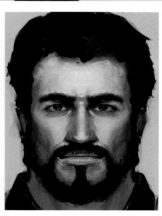

Medium soldier [Hong Ly] *opposite page*
Light soldier [Hong Ly] *top left*
Heavy soldier [Hong Ly] *top right*
Heavy soldier [Hong Ly] *bottom right*

SOLDIERS

The hardest part about designing the soldiers was finding real-world packs and attachments that would work with our three classes. The easy part is inventing the abstract—easy, medium, and hard. It's another matter to find believable accoutrements to fill it out.

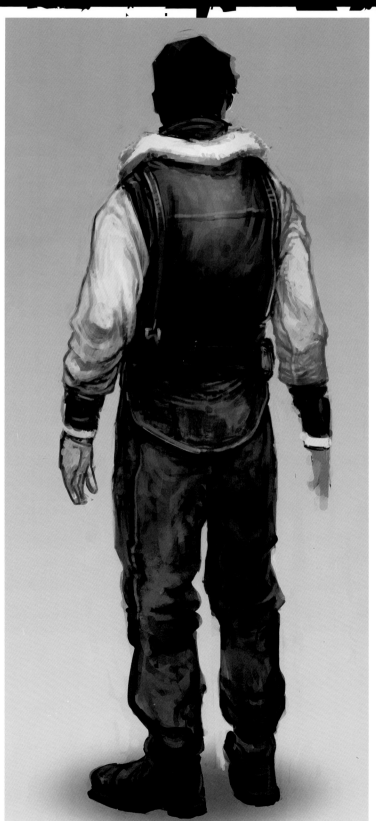

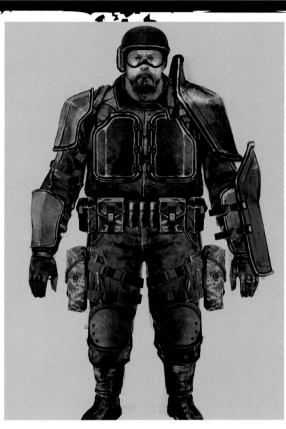

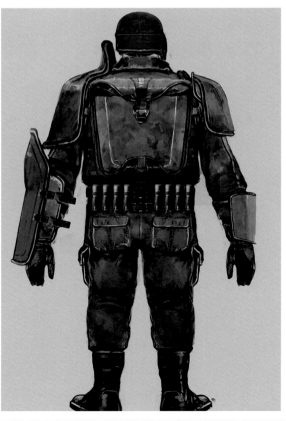

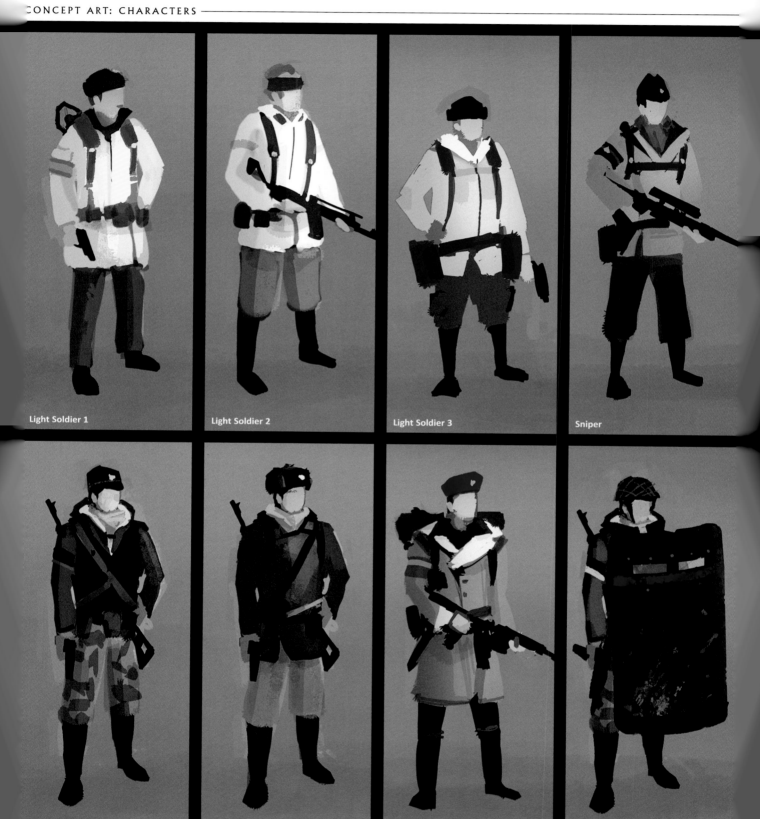

Light Soldier 1

Light Soldier 2

Light Soldier 3

Sniper

Medium Soldier 1

Medium Soldier 2

Medium Soldier 3

Shield Guy

Soldier variations [Shaddy Safadi] *this spread*

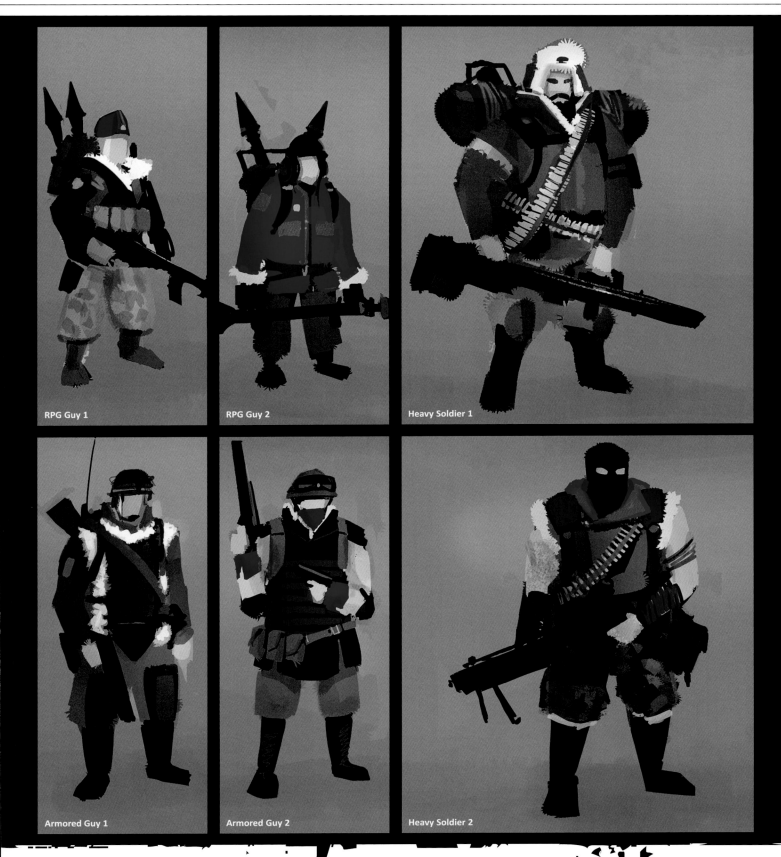

RPG Guy 1

RPG Guy 2

Heavy Soldier 1

Armored Guy 1

Armored Guy 2

Heavy Soldier 2

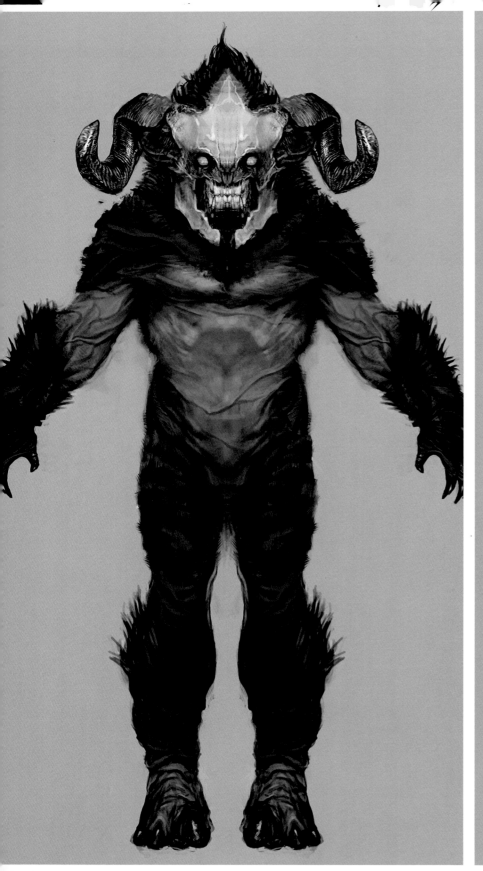
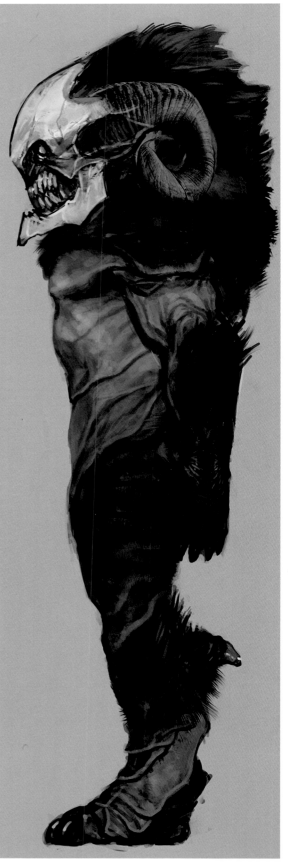

GUARDIANS

When Drake first runs into the Costumed Guardians, we want the player to believe that the Ice Temple (and later the Monastery) is guarded by these monstrous creatures, so at first glance they need to look like some kind of animals. Much later, after one of them is killed and unmasked, you realize that these are just elaborate costumes—they're not actually animals, they're warriors dressed up as creatures. They're masquerading as monsters to frighten explorers away from discovering Shambhala—the idea being that intruders will think twice about entering a forbidden area if they think it's guarded by mythical creatures. So the silhouette of these Guardians needed to look fierce—we didn't want it to look like a person in a suit. First, we came up with what we wanted them to look like—massive ape-like creatures with long horns—and then we realized we had to believably fit a guy inside there. We started off with the creature design, creating hundreds of sketches with a huge number of variations. At one point we were thinking they might have arm and leg extensions to make them even bigger, or to give them a distinctly strange, non-human look. Once we settled on a design, we reverse-engineered how the monster suit would realistically work—here's a piece of leather that's wrapped around, this part's made from an old animal hide, and the face-mask is a yak skull with ram horns attached. We designed all the elements of the outfit to look as though it was constructed out of local objects, like wolf-pelts, sheepskin, yak hair and skeletal remains.

Costumed Guardian final [Hong Ly] *opposite*
Guardian early concepts [Hong Ly] *this page*

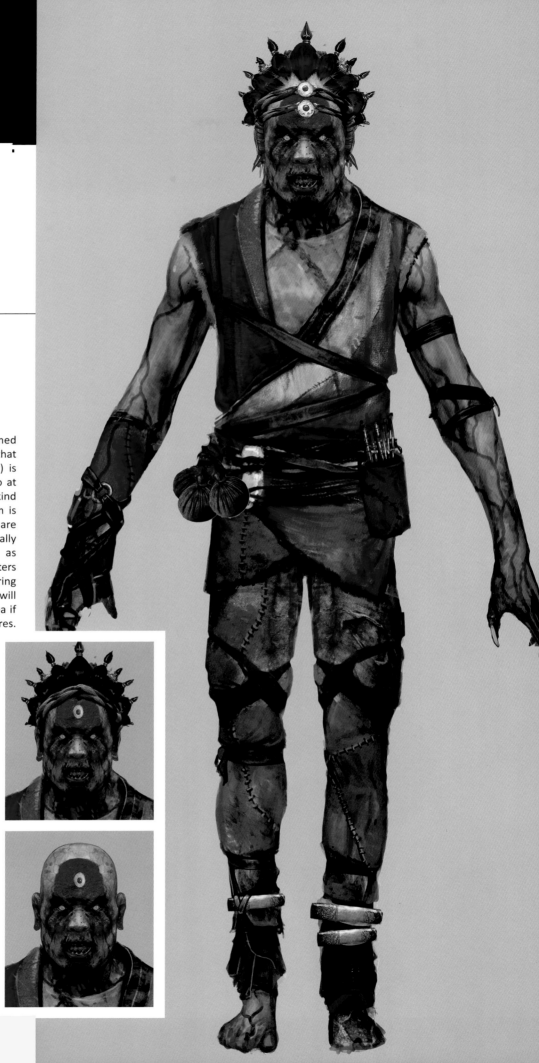

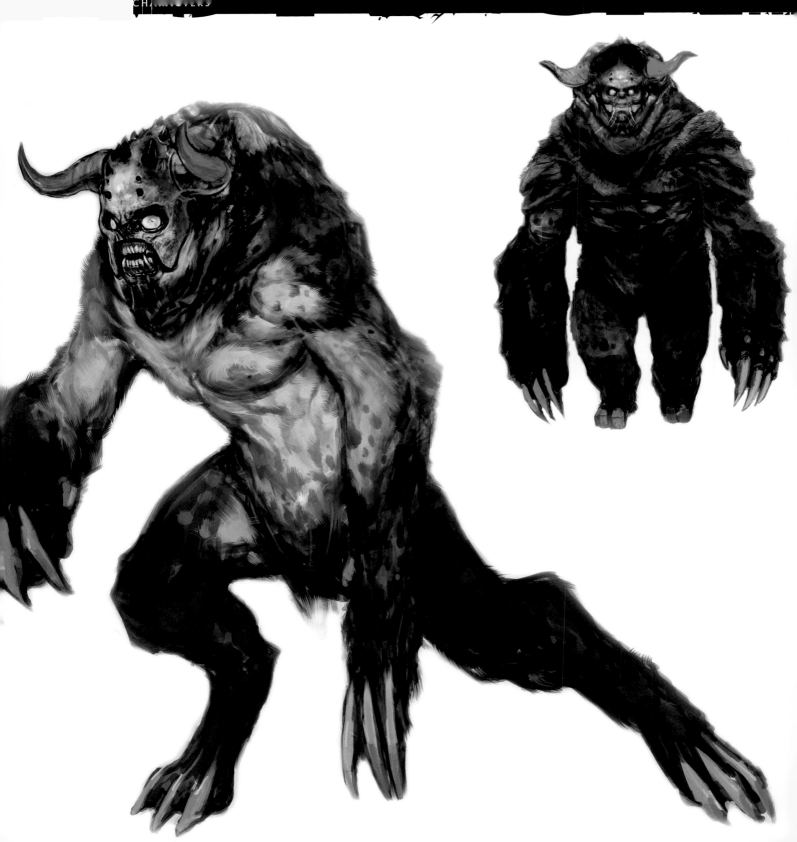

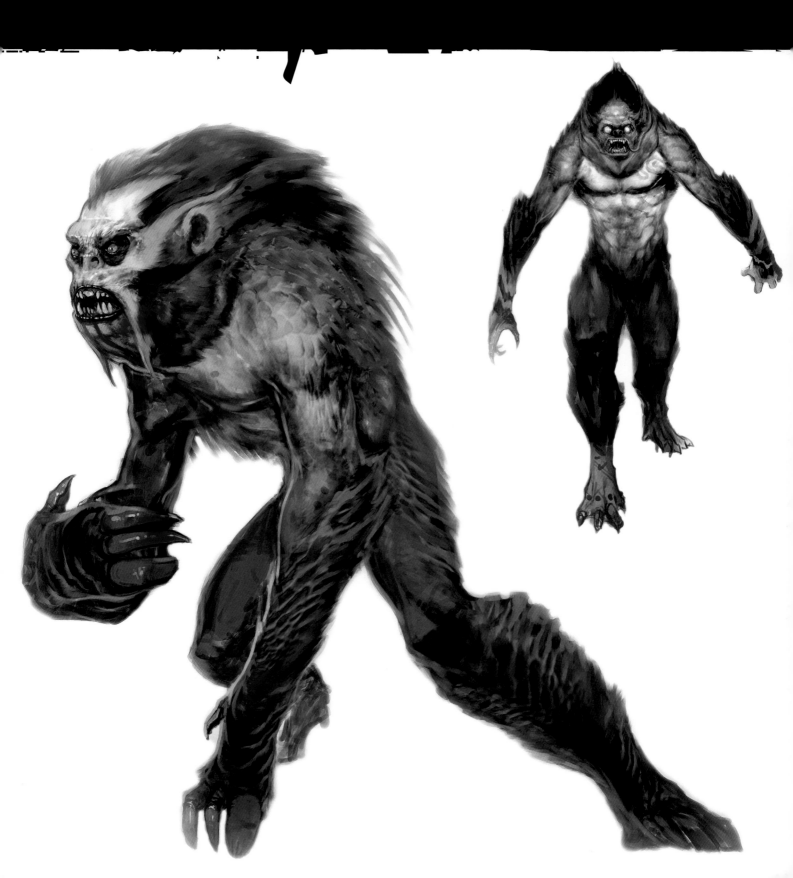

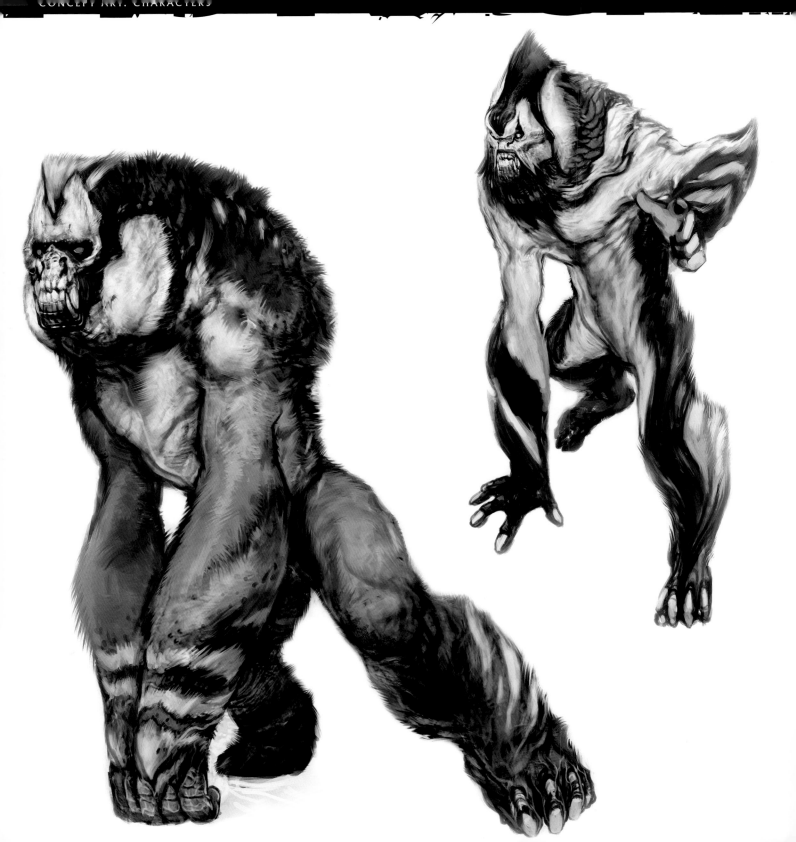

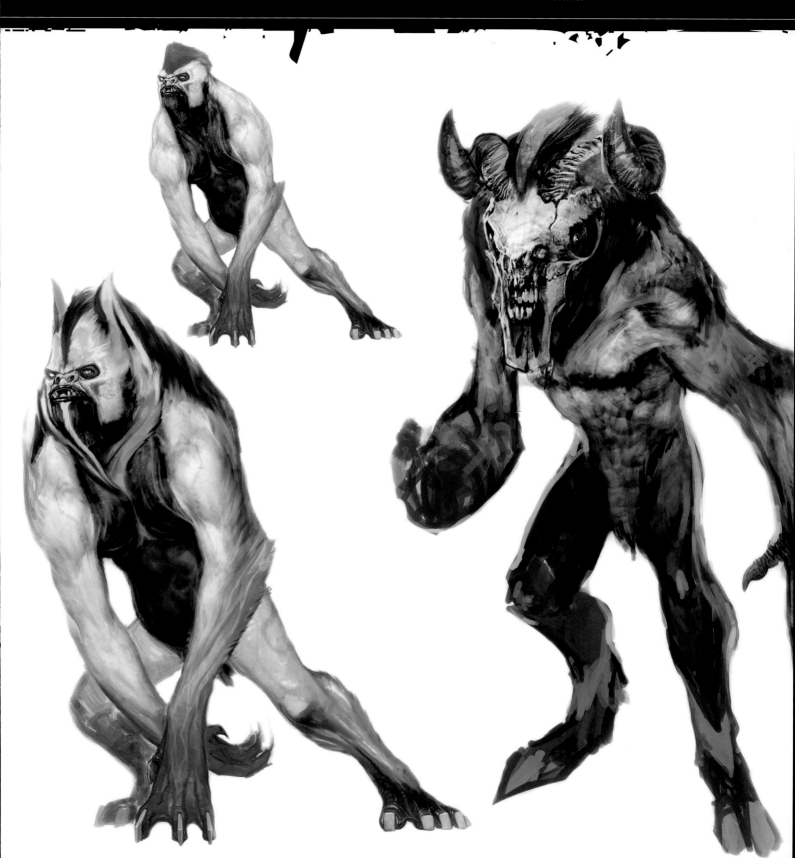

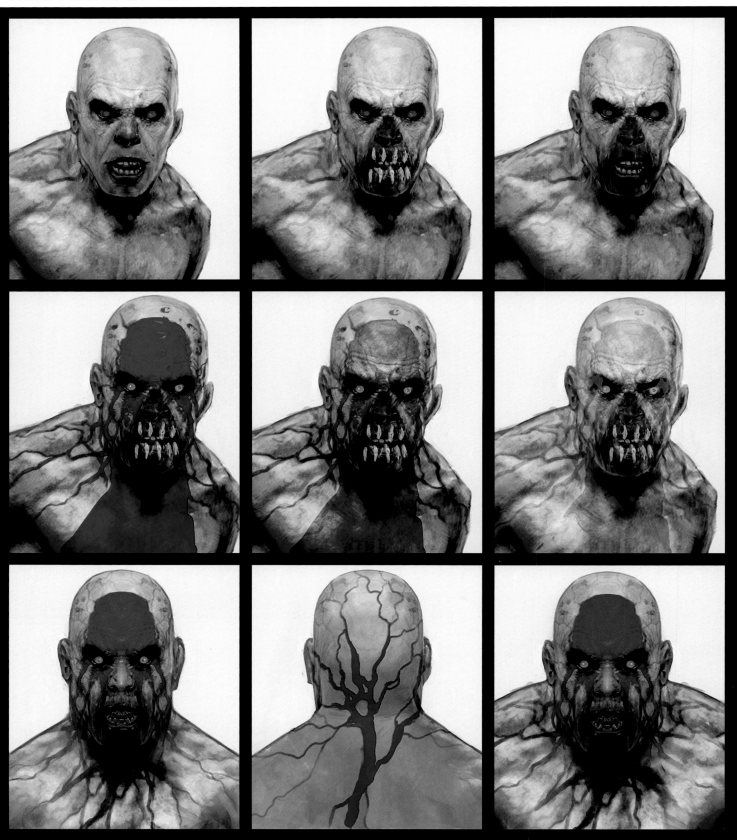

GUARDIAN FINAL SKETCHES

The Guardians are ancient warriors who have lived in Shambhala for centuries—virtually forever, since eating the sap from the Tree of Life within Shambhala has made them essentially immortal. But the sap has also mutated them—making them larger, more muscular, able to shrug off damage and rapidly heal. Their skin has developed a blue-ish hue, and their teeth are stained black from eating the sap. It also affects the minds of those who ingest it, filling them with homicidal rage and afflicting them with an obsessive addiction for the sap. So while it preserves the life of the Guardians, it also effectively imprisons them there as the eternal gatekeepers of Shambhala. We went through a lot of iterations trying to find the look for the Guardians, especially since we didn't want them to look like the cursed inhabitants of the island in Uncharted: Drake's Fortune. The mutated Spaniards were very wiry and animalistic, so we wanted the Shambhala Guardians to be more imposing and warrior-like.

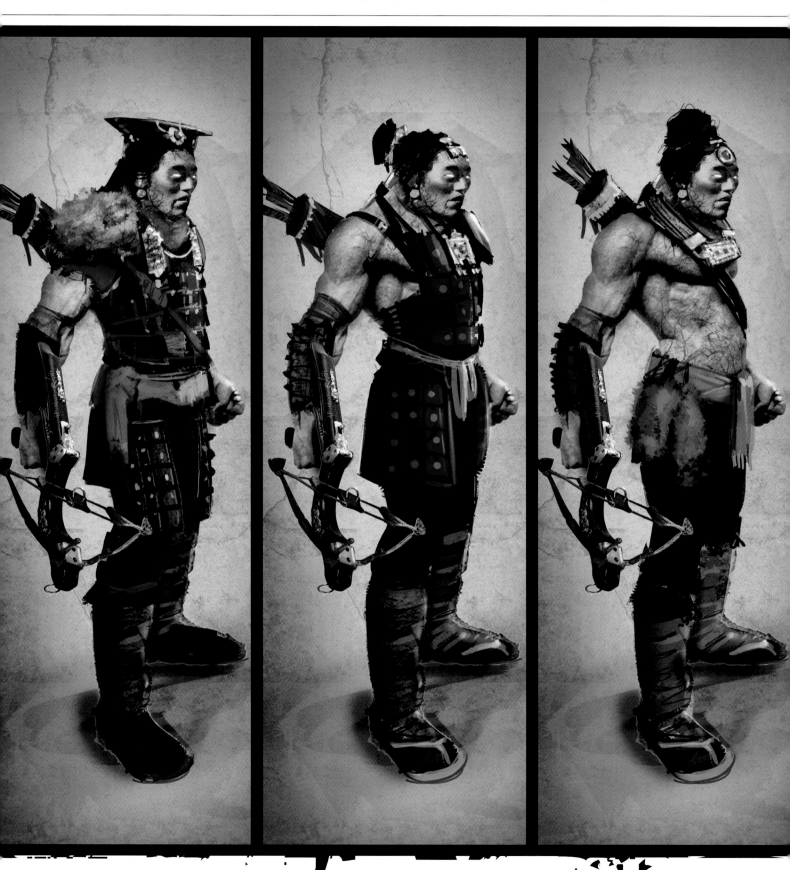

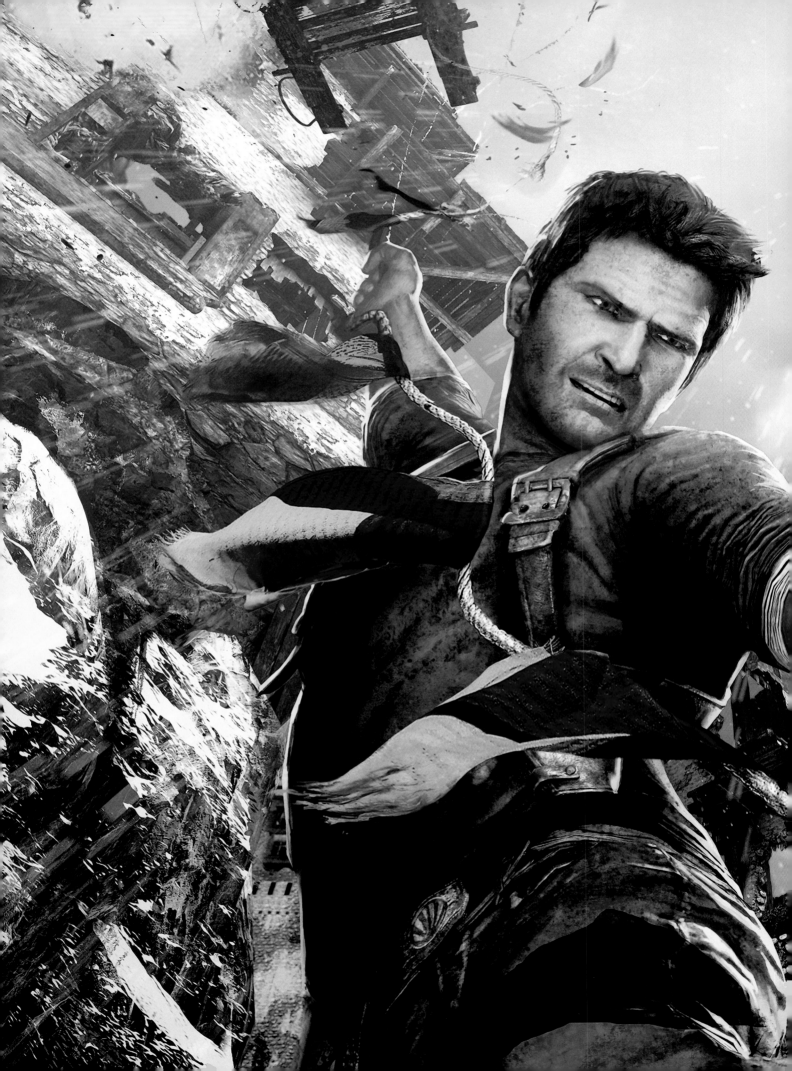

3D MODELING CHARACTERS

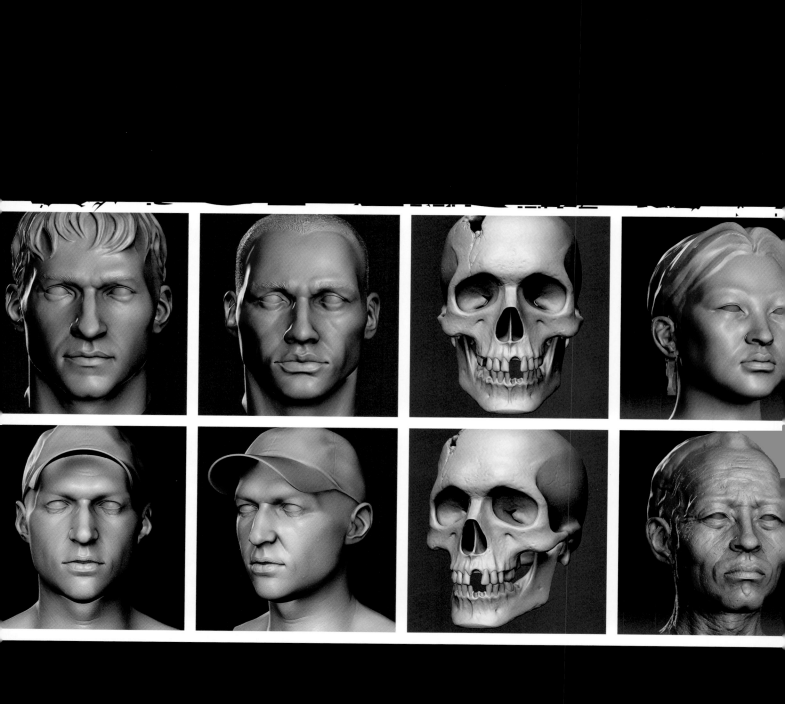

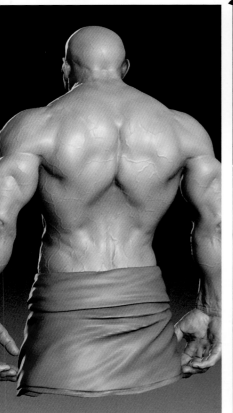

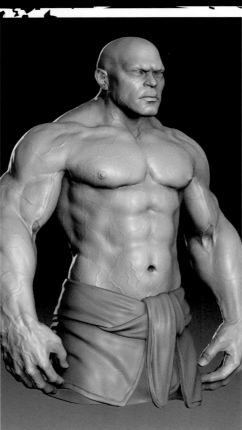

Rich Diamant
Lead Character Artist

3D CHARACTER MODELS

Modeling characters generally begins with a concept, sketch, or a series of reference photos to establish the look of a character. We normally begin by getting a folder of images with different actors in it to establish the feel for the model. Sometimes we get rough outfit sketches, and a reference folder with coordinating shirts and pants, for example. On the modeling end, we do a lot of really quick models to get them into the engine quickly to give a rough example of what it could look like in-game. It can be hard when you look at something on paper, because you'll ask: "Is it going to work? Will it be suitable for the environment? Is it too colorful? Is it not colorful enough?" The quickest way to find the answers to these questions was to get the model into the game engine as soon as possible. We were able to do that step within a couple of days by building a fairly basic block-mesh and projecting the reference images as textures onto the models. We'd rig them in about ten minutes, throw them in-game, and decide whether or not it fit our vision. Once we got the initial "OK", we would sculpt up to about 80% of the model and place it in game to test it. The advantage of this type of iterative approach is that if it doesn't work, you didn't waste valuable time and you can go back and fix it. I don't think the characters were 100% complete until the day we shipped the game, so it always had that kind of openness that things could change, and things did change, a lot. Drake alone changed many times throughout the production, including his clothes and hairstyle to name a few examples. I spent almost four years on Drake, and the majority of the time on Uncharted 2 was spent on doing different outfit changes and small tweaks on his model.

Soldier head ZBrush models [Model: Bryan Wynia] *opposite page top*
Jeff head ZBrush models [Model: Bryan Wynia] *Opposite page bottom*
Skull model [Model: Bryan Wynia] *Opposite page center*
Villagers head ZBrush models [Model: Rich Diamant] *Opposite page right*
Shambhala warrior ZBrush model [Model: Rich Diamant] *this page*

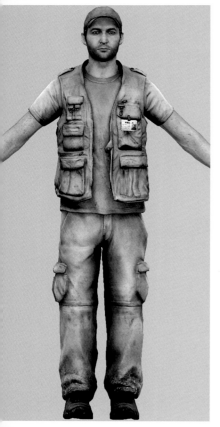
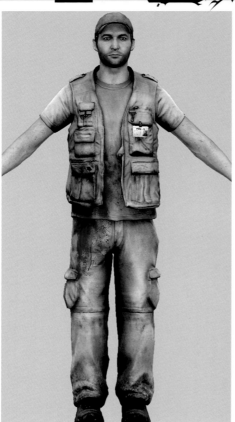
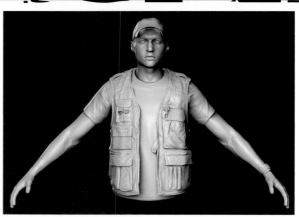

3D CHARACTER MODELS

Moving from Uncharted: Drake's Fortune to Uncharted 2: Among Thieves, the level of character detail jumped both in terms of their look, and their facial expressions, due to an upgraded facial animation system. In Uncharted 1, each character was built from an average of 22,000 polygons which jumped to an average of 27,000 polygons for Uncharted 2, with some characters at 30,000 polygons, and the highest character weighing in at around 42,000 polygons. There was a mandate up front that we had to keep Drake at the highest level of detail throughout the game, so a lot of memory and processing was focused solely on him.

The only thing that was upsized for the cinematics were the textures because there's a little more memory available for cinematics compared to in-game. A major goal of Uncharted 2 was to create characters who could realistically emote, and there weren't enough polygons in the original character models to animate subtle facial movements like puffing cheeks or more complex expressions. The original Uncharted character's faces were around the 2,700-4,000 triangle mark. For Uncharted 2 we raised the average count to more than 8,000 triangles for the faces. In modeling terms, that was the biggest change

from the first game. We wanted more fidelity, and to allow subtle facial expressions while still keeping things smooth. Another pipeline change that we made with the face was to open the characters' mouths. We'd previously modeled characters with closed mouths, which made it easy to model a face and retain a neutral expression. With this new change, you can actually see a big difference between the first and second game in the corners of characters' mouths. Another change we made was to add more edge loops so that when the characters made pucker-like expressions, you didn't get breaks in the geometry.

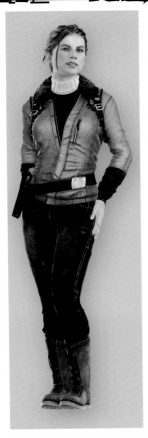 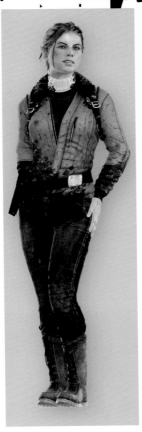 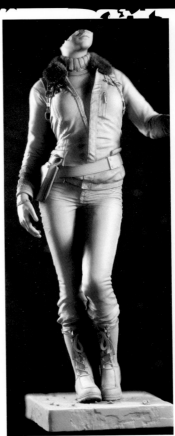 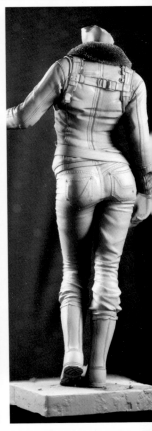

At Naughty Dog, we use either ZBrush or Mudbox depending on each artist's preference. We build a high-polygon model and then make an arbitrary game mesh. From that, we would texture either the game mesh or the high-polygon model and sample all the textures. There are many different ways that artists like to work, and we are able to visualize 90-95% of the final result in Maya in terms of what it's going to look like in game. We can build all of our shaders in Maya. We have an external shader database, which consists of proprietary shaders that we can connect to inside Maya. The final tweaking takes place once it goes into the game engine. There are subtle differences in the lighting between Maya and the game engine. Most tweaks come at this stage, because we'd look at a character in Maya thinking it looks right, but then you would bring it into a level and it could be too dark or have too much occlusion. So there is some back and forth between what we see on our PCs and what we get in the actual game.

Jeff in-game and ZBrush models *opposite page*
[Model: Bryan Wynia]
[Textures: Corey Johnson]

Elena winter outfit and sculpts *this page*
[Head model/Textures: Rich Diamant]
[Body model/Textures: Hanno Hagedorn]

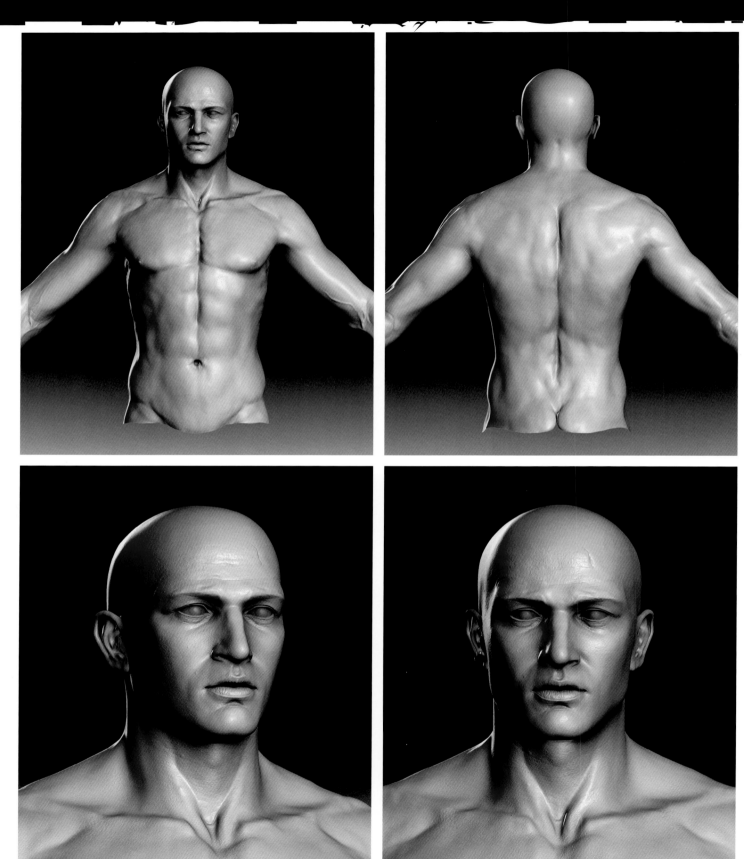

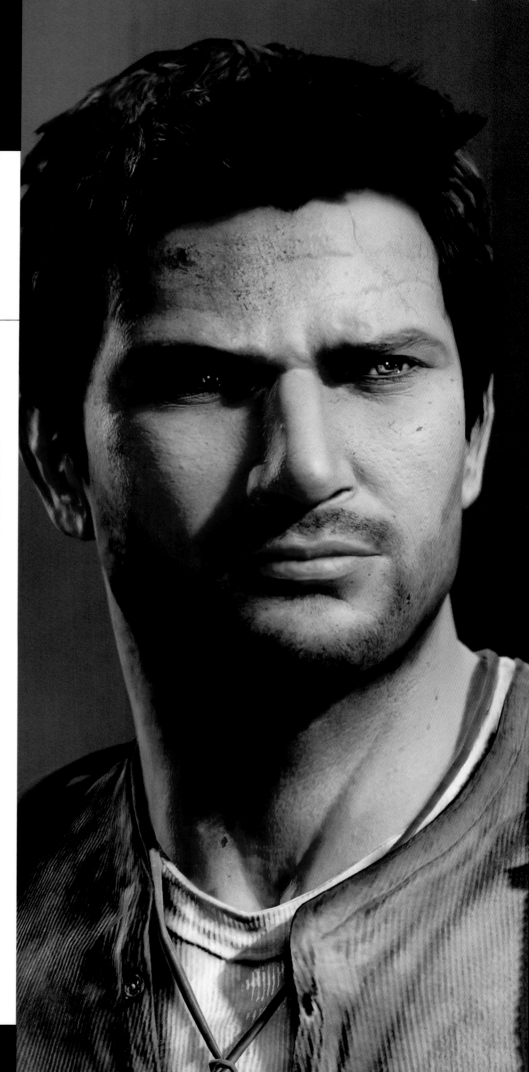

Rich Diamant
Lead Character Artist

NATHAN DRAKE

Nathan Drake, as the central character in Uncharted 2: Among Thieves, received the most attention throughout the modeling development phase. He's the face of the game, so there was a lot of scrutiny for every change that was made to his model. Drake's face got a complete overhaul, so it was rebuilt from scratch. The overhaul of the face more than doubled the number of joints, which allowed the animators to control the facial expressions at a much finer level. If you compare Drake from the first game to the second game, you'll see that his brow and cheekbones are a little more defined as well as being a little more buff since the first game. They're subtle details, but they helped to make him seem a little older and rougher. The changes had to be subtle enough that nobody would look at him and say, "That's not Drake!", which did happen a couple of times during the production. Almost everything about Drake was revised, including a whole new outfit and a new hair setup. After looking at the new Drake we decided it was necessary to bring every character up to the same fidelity as him. In terms of the animation rigs, we didn't modify anything besides the faces. The reason being is that so much animation was dependent on the rigs that if we made major changes, they would have to redo thousands upon thousands of animations for all the characters' movements. We have a very smooth character pipeline in terms of the rigging, so not much changed for Uncharted 2 in terms of how the characters worked and the way the animators worked with them. The biggest change was definitely the faces and that was everyone's predominant focus. When you look at the cinematics, that's the thing that jumps out at you and makes the characters believable, so they needed to be the best we possibly could make them.

Drake ZBrush models [Model: Rich Diamant] *top, opposite top*
Drake parka [Model/Textures: Rich Diamant] *center, bottom*
Drake in-game model [Model/Textures: Rich Diamant] *opposite bottom*

3D MODELING: CHARACTERS

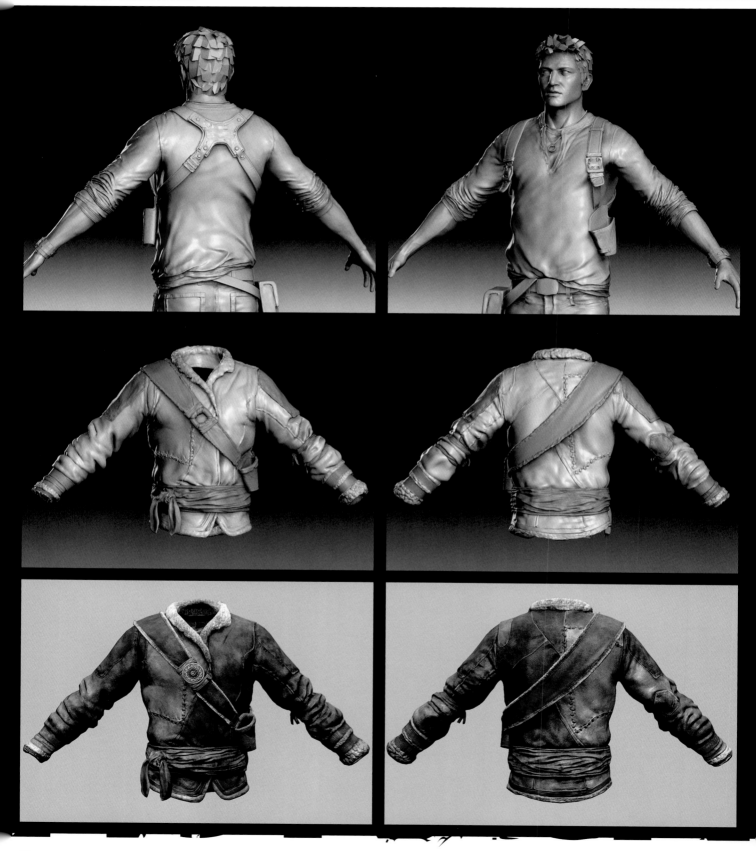

DRAKE

Once we build the game meshes, we pass them on to the TDs and riggers. If there are any issues it will then come back to us for tweaking. There's a really nice relationship between the modelers and the technical department. If there are a lot of issues, we can go into the rigs and utilize their great tools, which help to make sure we don't break anything. It's a nice way of working where, if there are issues, it's very easy to solve and we don't have to backtrack. It's a really good pipeline fo getting the characters quickly and efficiently in-game.

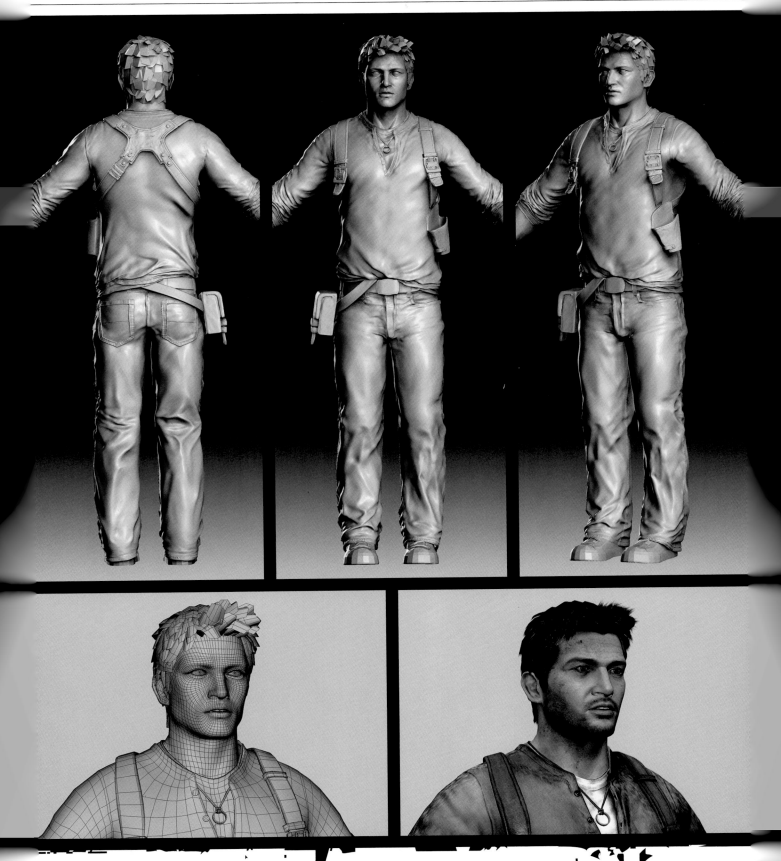

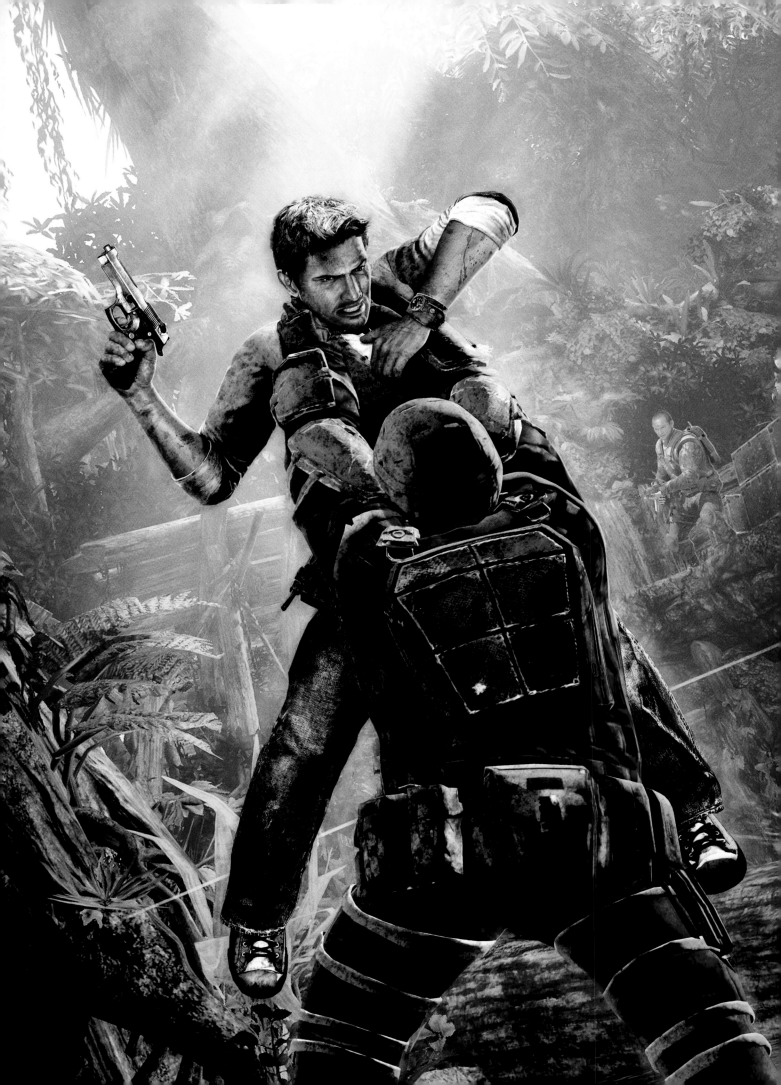

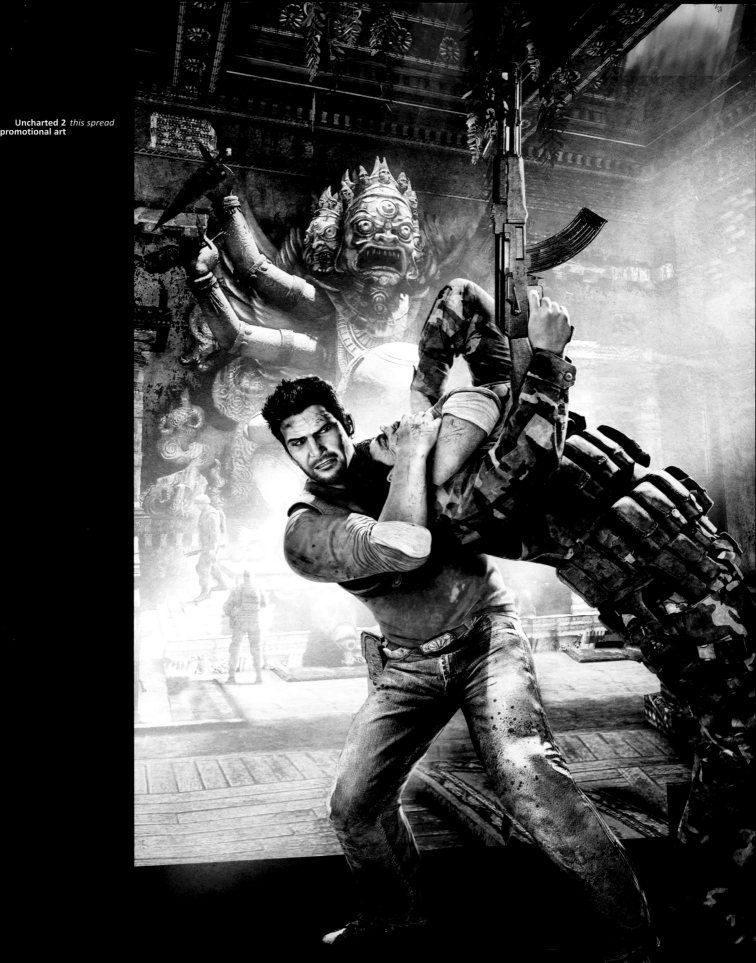

Chloe model and head sculpts *this page*
[Head model/Textures: Rich Diamant]
[Body model/Textures: Hanno Hagedorn]

Chloe portrait [Model/Textures: Rich Diamant] *opposite page*

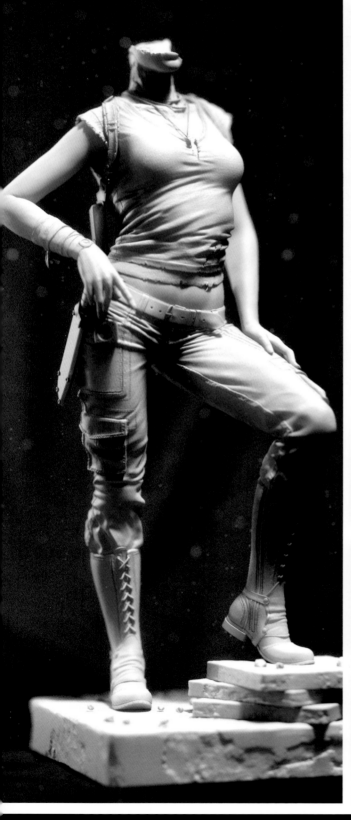

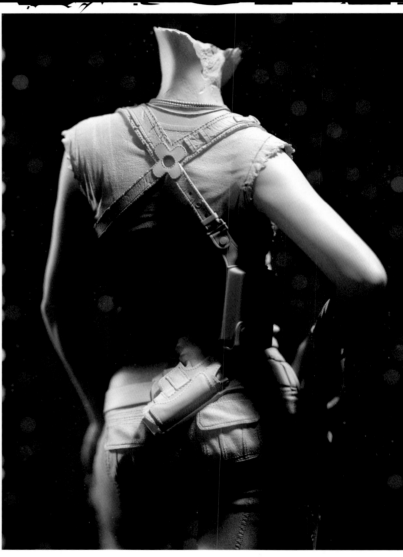

CHLOE FRAZER

Chloe was conceived as an exotic-looking character, with an underlying toughness. The consensus was to make somebody who was grounded, and not a typical video game chick with big boobs and a big arse, that everybody would ogle over. When you start iconifying the features of a girl that make her more beautiful, you tend to choose similar things like a smaller chin, a more triangular face, and bigger eyes. With Chloe, I tried to push things towards the iconic features of a beautiful woman while trying to keep things real. Female characters are always the most scrutinized, the most challenged, and the most commented upon. One example of things that we considered while building the female characters was to omit the wrinkle maps for them. We have wrinkle maps for faces so when the character emotes you can bring in, for example, the forehead wrinkles, which adds more realness and believability to the characters. Even though it happens with real women, when we tried it with Chloe and Elena, they looked a little creepy. So you always have to walk the tightrope with female characters.

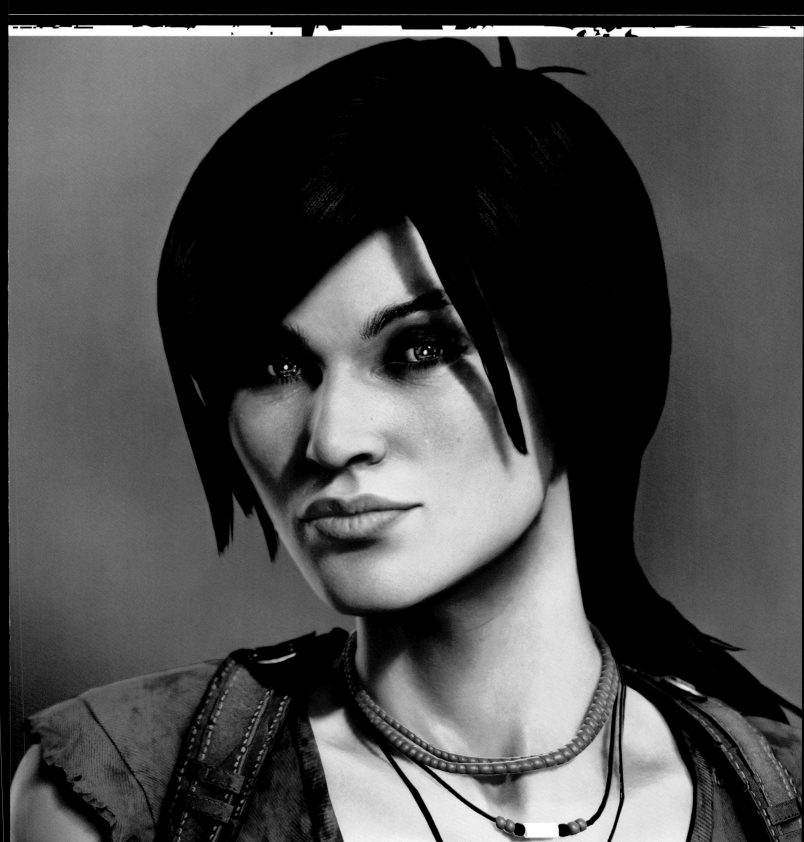

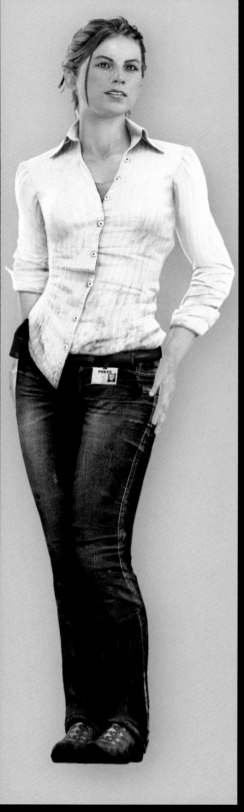
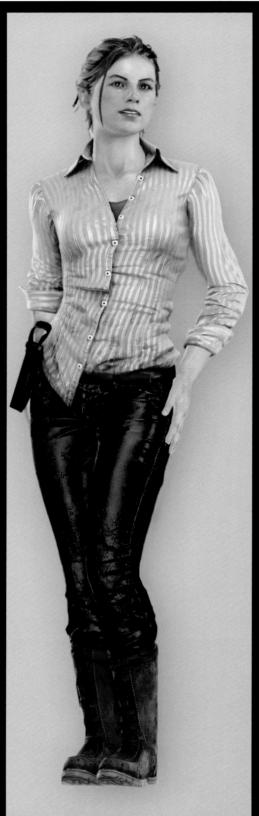

ELENA FISHER

Elena was established already from the first Uncharted, so we didn't need to change too much for her besides adding the new topology and opening her mouth, which was pretty basic. The initial design was already there. She does go through some outfit changes throughout the game, though. When Drake is reunited with her in Nepal, she's wearing jeans and a half-tucked-in blouse. In Tibet, she wears a winter jacket and boots. Each outfit has to have clean and dirty or beat-up versions, and must be able to dynamically accumulate snow, or get wet. Events toward the end of the game also required that we create a severely injured version of Elena.

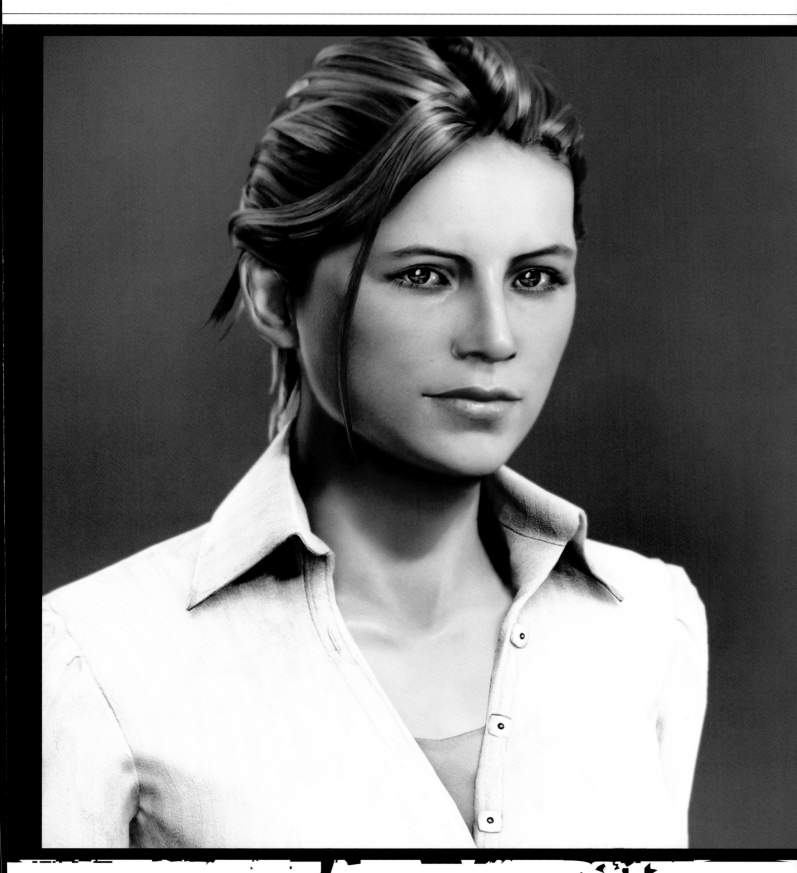

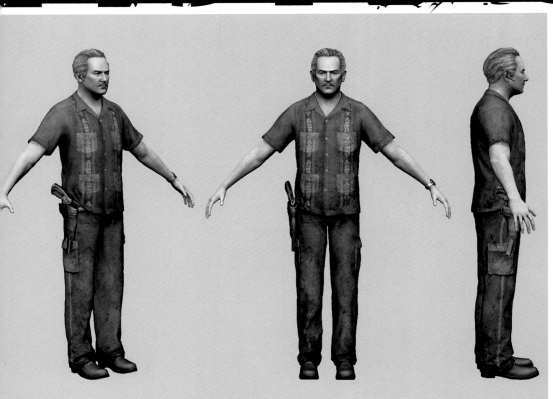

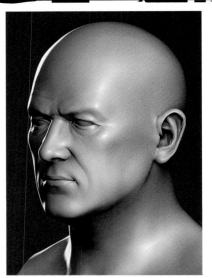

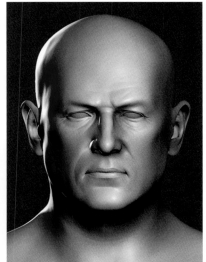

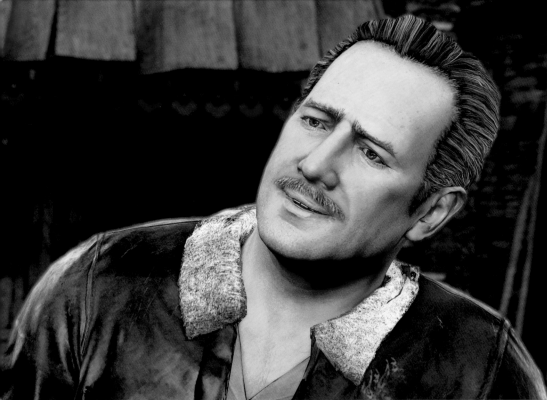

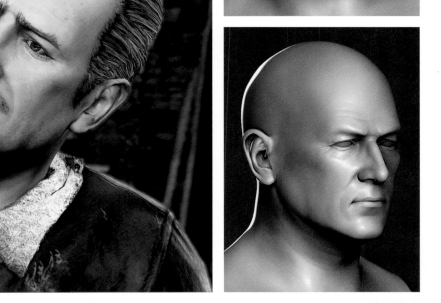

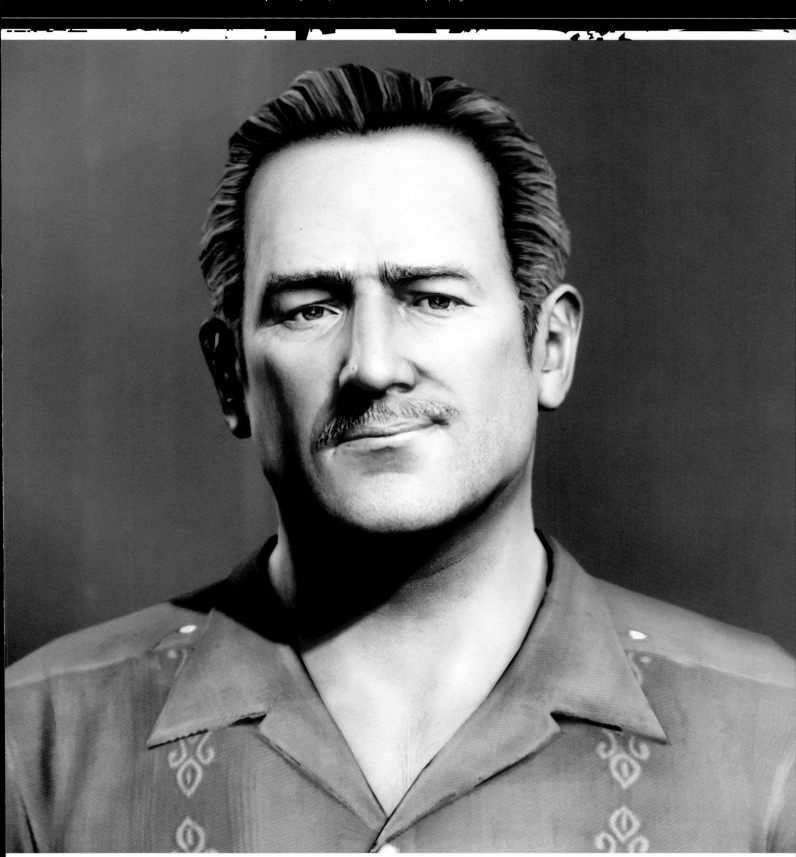

Sullivan model and ZBrush head sculpts [Model/Textures: Ricardo Ariza] *opposite page*
Sullivan in-game model [Model/Textures: Ricardo Ariza] *opposite bottom left*
[Jacket model/Textures: Darcy Korch]
Sullivan portrait [Model/Textures: Ricardo Ariza] *this page*

VICTOR SULLIVAN

Victor Sullivan is a veteran adventurer who's been in the treasure hunting business for years and has both the enemies and debts to show for it. We updated Sullivan's model to a similar standard as the new characters.

Tenzin model [Model/Textures: Darcy Korch] *this page*
Tenzin portrait [Model/Textures: Darcy Korch] *opposite page*

3D MODELING: CHARACTERS

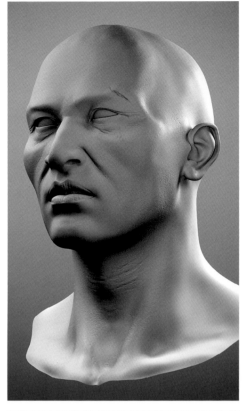
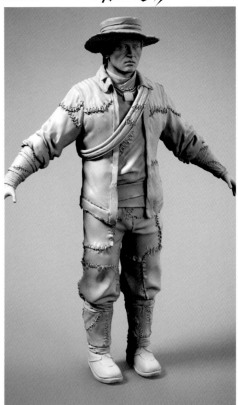
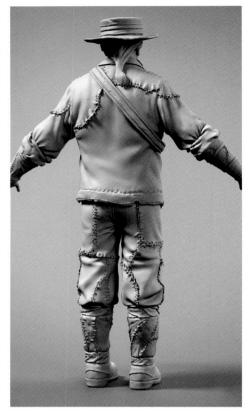
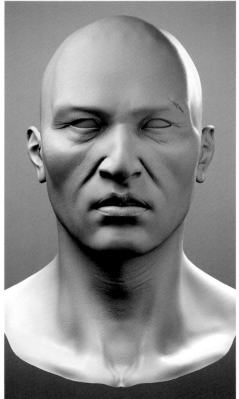
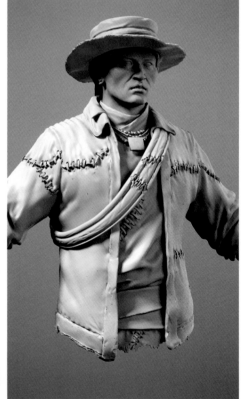
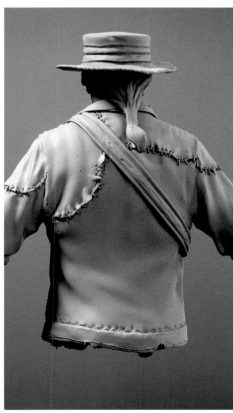

TENZIN

Tenzin is a leader in the remote Tibetan village where Drake comes-to after his near-fatal train wreck. We went back and forth a lot over Tenzin's design, mostly regarding technical issues. He started with a long jacket, which became a problem because it would require another level of cloth dynamics. If you have something that's fairly long, then it's going to look weird when the character is moving around. We took some design liberties and instead gave him a smaller jacket that fit tighter. He went through a couple of iterations, but once we settled on his outfit he was a pretty straightforward character to model. The most important thing in Tenzin's design was for him to have an authentic Tibetan look. Once we got that locked down, based on a lot of reference from people in that region, it wasn't too difficult to get his model done.

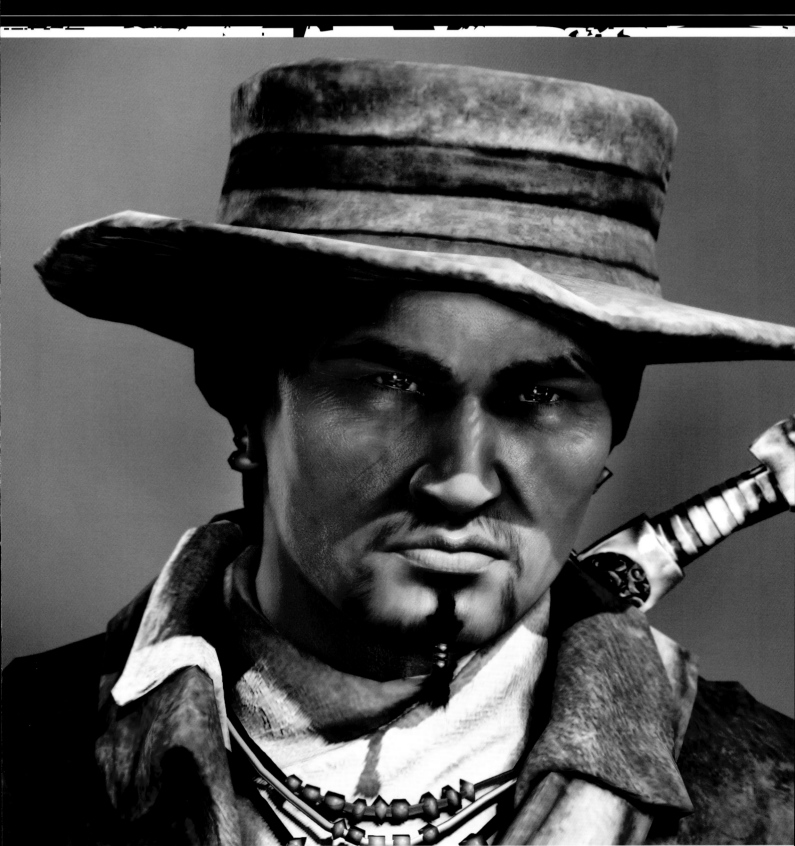

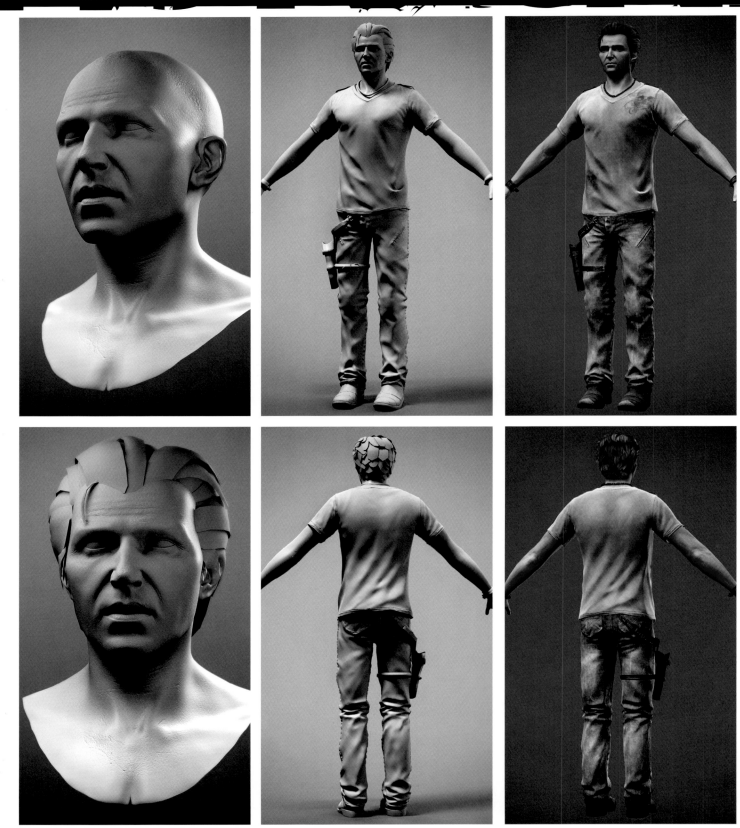

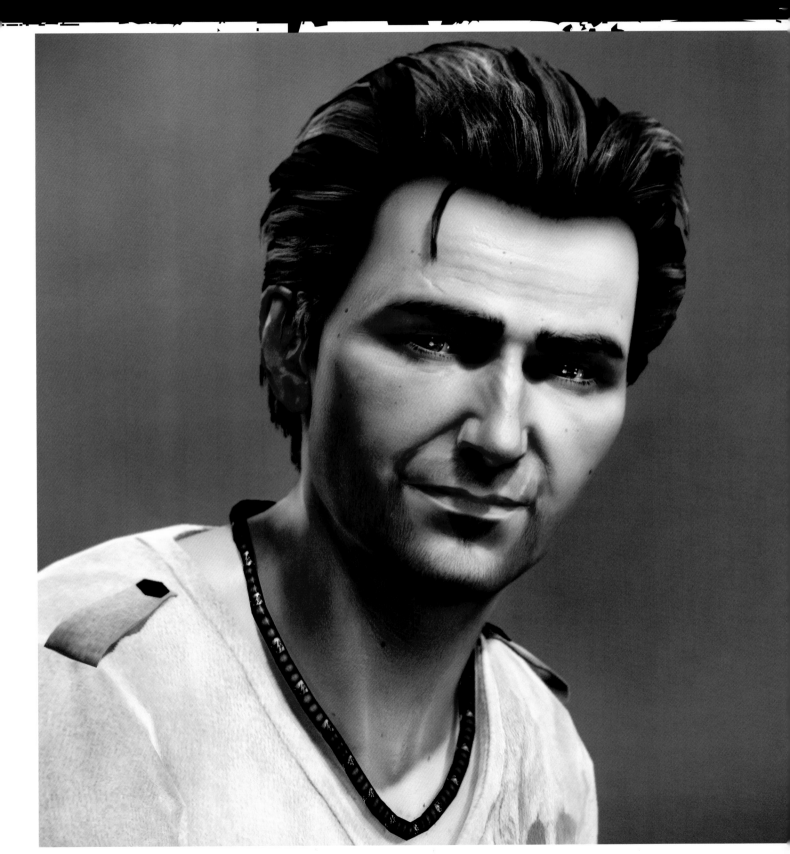

KARL SCHÄFER

Schäfer model [Model/Textures: Hanno Hagedorn] *this page*
Schäfer portrait [Model/Textures: Hanno Hagedorn] *opposite page*

Schäfer was loosely inspired by Austrian and German mountaineers that visited Tibet during World War 2. He's an elderly and gentle character who abandoned his past and adopted the Tibetan way of life, which is reflected in his wardrobe and jewelry. Schäfer was a particularly fun character to work on. His age allowed us to play with skin details and use some fancy wrinkle maps. Because he's only seen in cinematics we didn't have to be too concerned about performance—his hair alone is made up of about 6000 polygons. At 43,000 polygons, he's definitely the most expensive character in the game.

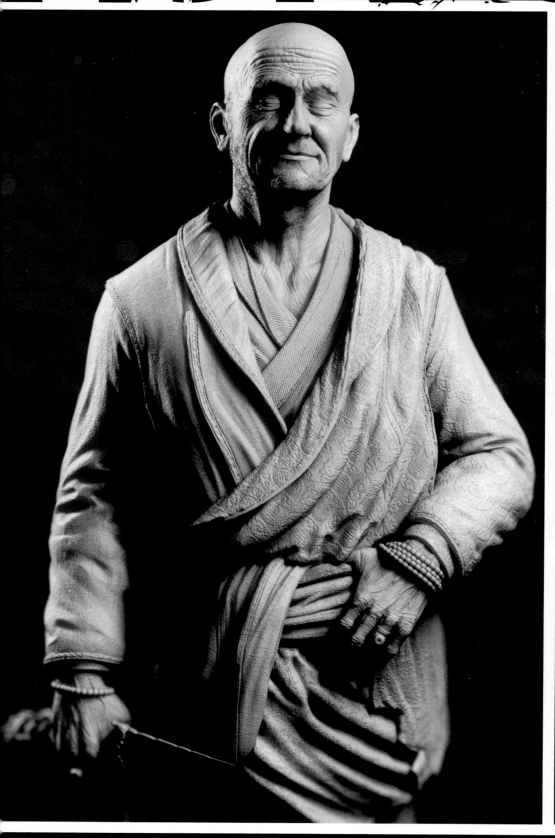

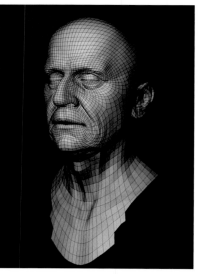

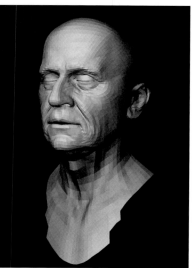

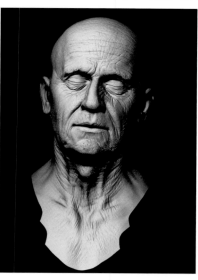

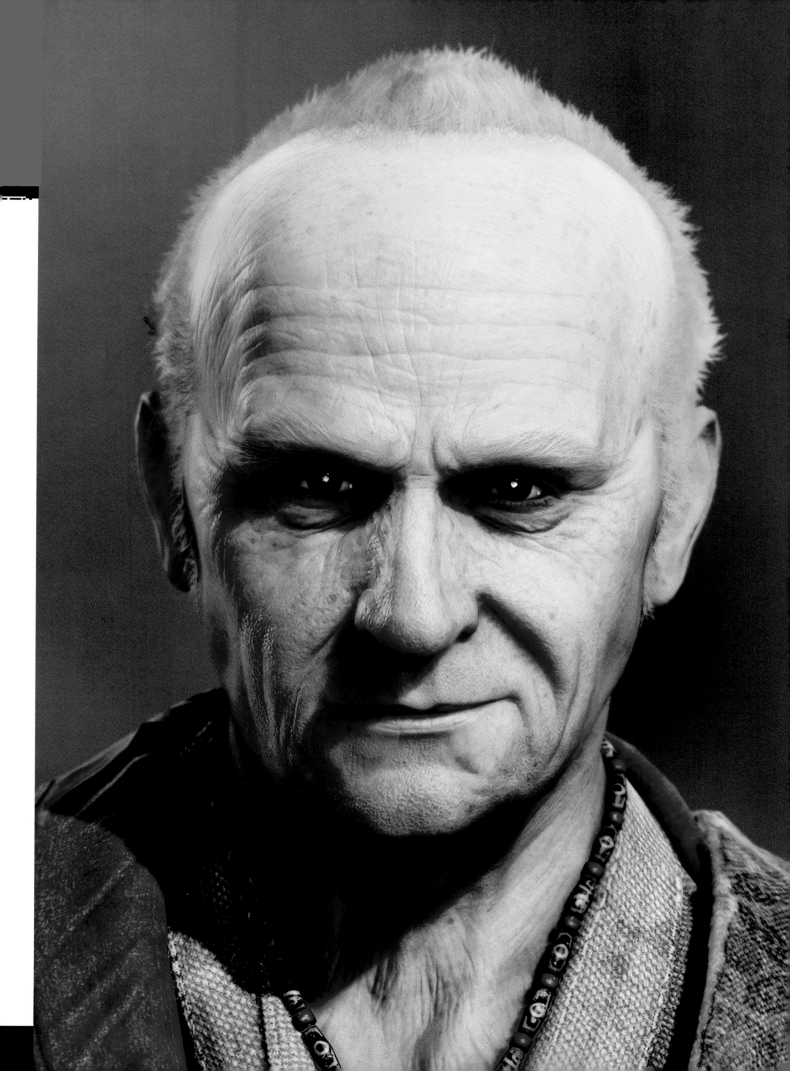

LAZAREVIĆ

Characters don't come much more sinister than Zoran Lazarević. As a fugitive war-criminal and battle-hardened soldier, Lazarević is not afraid to get his hands dirty. This needed to be reflected in his outfit. The design needed to be pragmatic, functional and grounded in reality. So everything on his uniform has a specific purpose. We even thought about what would be in his pouches to give them the right shape. His design is a classic case of form following function. The final model gently blends the initial concept with the actor's (Graham McTavish) physique and features. It is necessary to build from the physiology of the actor to a certain degree, to create a more harmonious performance.

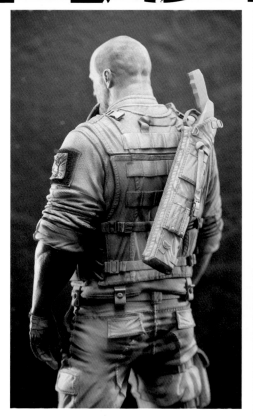

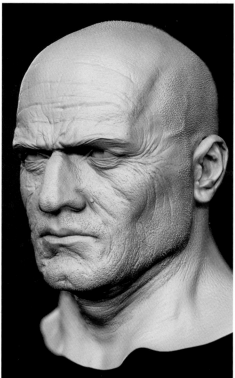

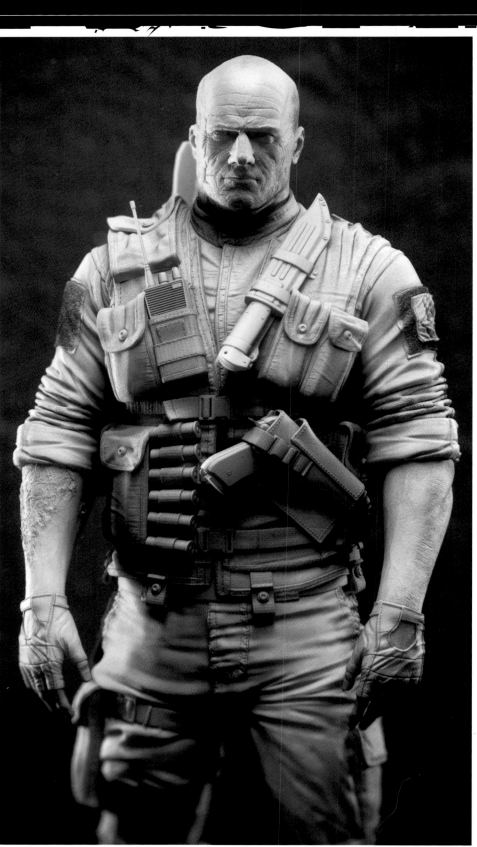

We created multiple versions of his head. First, there is the default scarred version. After he drinks from the sap, his scars heal and he rejuvenates. To convey this, his facial features become a little softer in their forms and his skin looks less weathered. Both versions were created as separate multimillion polygon models with full details. For the final battle, there are three more stages of damage displayed with texture swaps, ranging from slight scratches, to blemishes and light bleeding, to his most "wounded" state where he's bleeding heavily with sweat running down his face. At 37,000 polygons, he is one of the more elaborate characters in the game. His head alone consists of about 13,000 polygons.

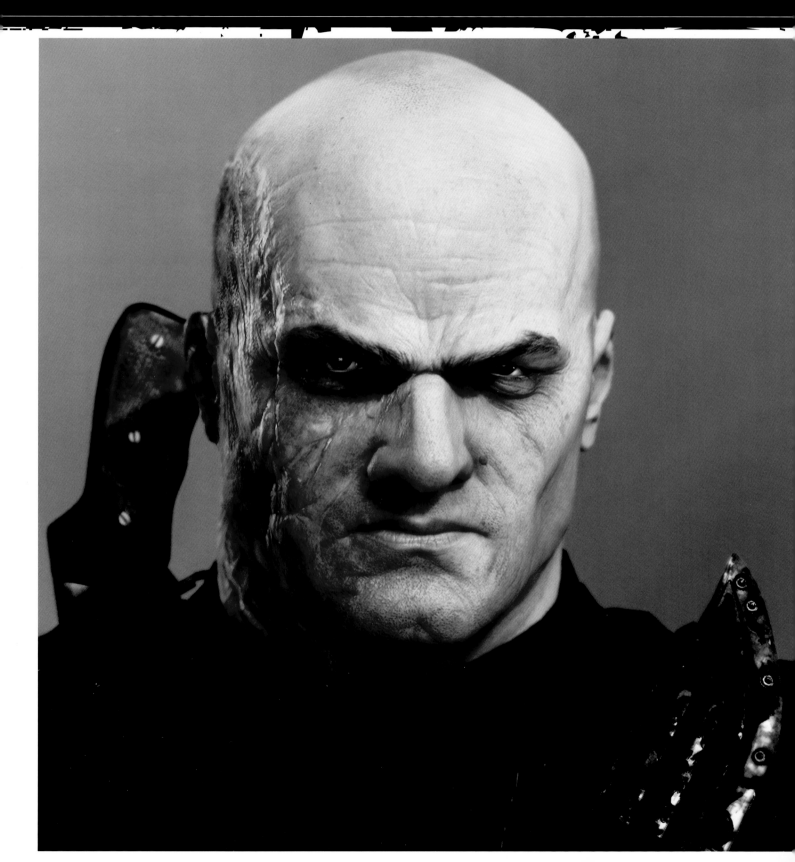

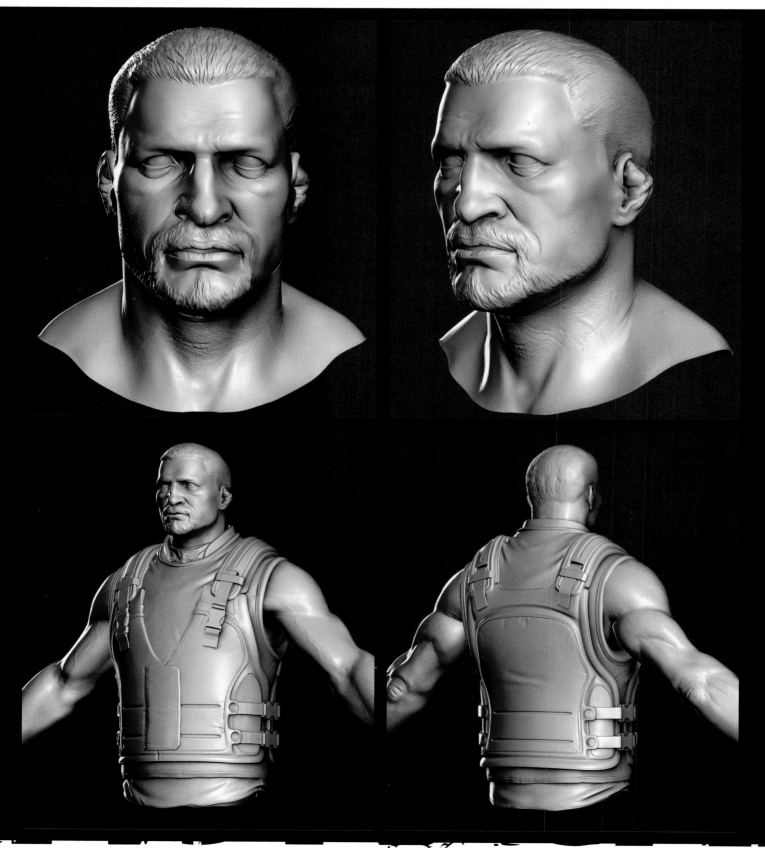

Lieutenant Draza ZBrush models *this page*
[Model: Bryan Wynia]
[Textures: Corey Johnson]

Standard Soldier model *opposite page*
[Model/Textures: Darcy Korch]

LIEUTENANT DRAZA

When creating Lt. Draza, one thing we really wanted to make sure that came across in his design was that he was this hardened ex-military fighter and brawler. We gave him a broken nose, cauliflower ears, and even removed a portion of his left ear. We also gave his fatigues a classic olive drab military color to clearly set him apart from Lazarević.

STANDARD SOLDIER

Modeling the soldiers in the game presented a logistical challenge due to their numbers and memory footprint. We started with individually-modeled soldiers with their own texture maps. But by doing that, you had the same memory footprint for each soldier, and we'd be limited by the number of soldiers we could use on screen at once. We eventually settled on a parts system, so most soldiers used the exact same bodies, and we varied them with different equipment packs and different heads. This allowed us to load, for example, one body, five heads, and five packs, and mix and match character parts, which saved a huge amount of memory. We had two different types of bodies for the light soldiers, ten different packs, and four different types of heads, but we could make twenty different types of soldiers based on those elements. So instead of loading twenty individual characters, we'd effectively be loading only five characters. For the medium soldier we did the same, and depending on where you were in a level the game designers would decide whether to use light medium or heavy soldiers. The modeling team set these characters up in Maya scenes, so a shotgun-wielding soldier would get the shotgun pack, and a sniper would get the sniper pack, etc.

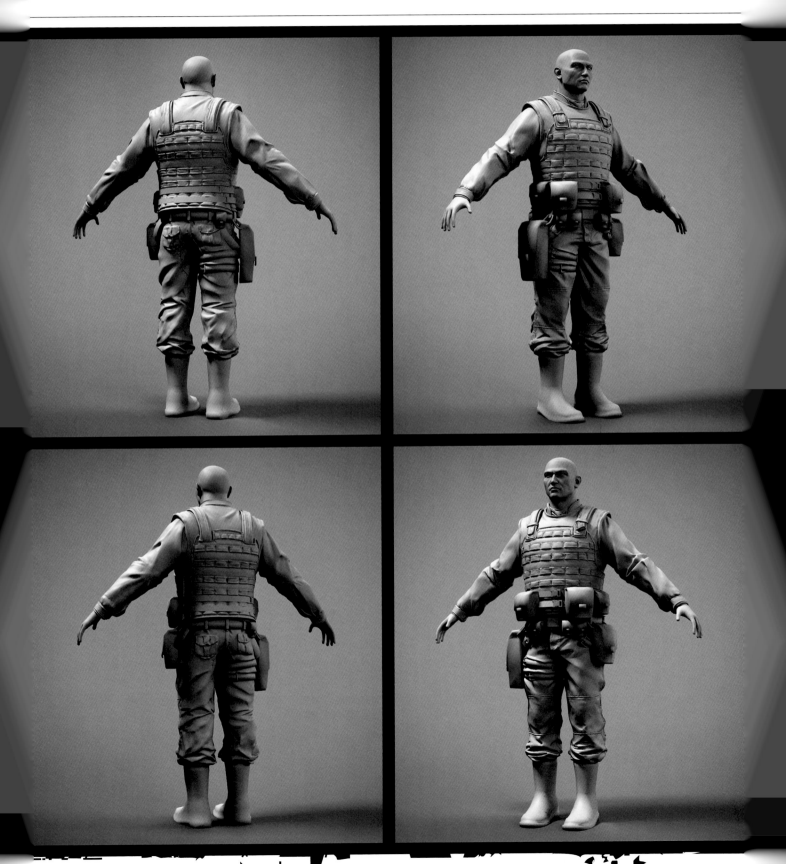

Villagers head models *this page*
[Model/Textures: Darcy Korch]

VILLAGERS

Originally, the villagers were to be background characters that you didn't see up-close or interact with, so they weren't modeled to the same level of fidelity as other game characters. Towards the end of the production, it was decided that the player could walk up to the villagers and interact with them. We had to look at the assets and decide what we could do with them in the time frame. Within a week we modeled all new heads, created all new texture maps for them, and updated as much as we could so they'd hold up a little better. They also didn't share the same facial topology as other characters because they weren't made to talk. To address this, we modified the enemies' faces and stuck them on the villagers so they could have the same types of emotions. The modeling of the villagers was challenging purely due to the design changes.

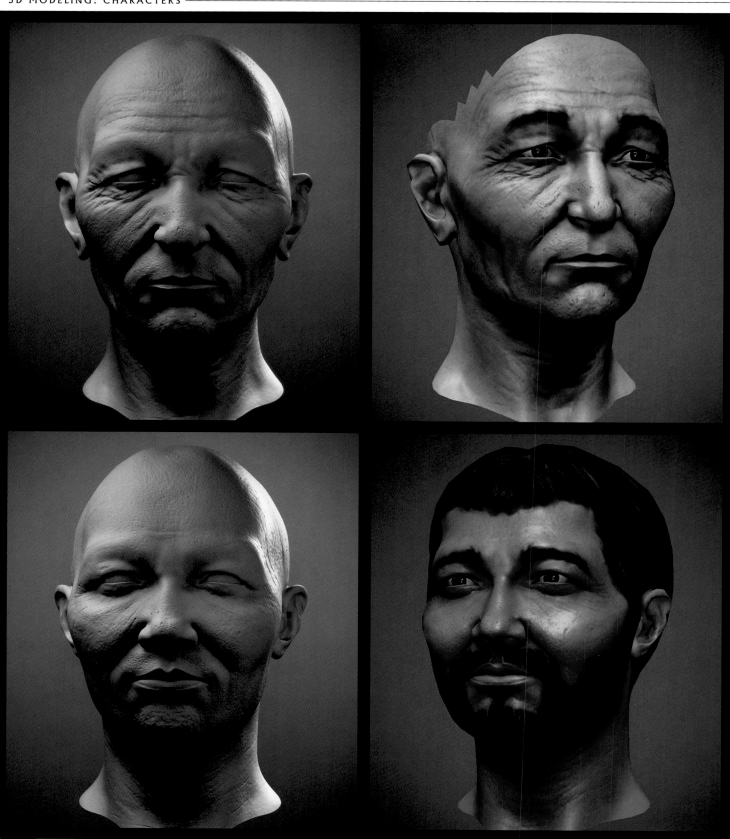

DEAD EXPLORER

Dead explorer models *this page*
[Model/Textures: Darcy Korch]

Members of Schäfer's ill-fated expedition, these Nazi explorers were shot by Schäfer to stop them from retrieving the Cintamani Stone. The expedition party was initially outsourced. We touched them up, got them into the game and improved them. In the game they were just posed as they were dead, but we also built them as playable characters for the multiplayer game. Multiplayer was a challenge because we had to make sure that every character (including the females) could use Drake's skeleton for animation. The multiplayer also had less of a texture budget than the main in-game characters so we had to create different texture set specific to multiplayer. Once we'd created a character we would make sure it worked for single-player, for cinematics, and for multiplayer. We had a great pipeline to make sure that everything could work.

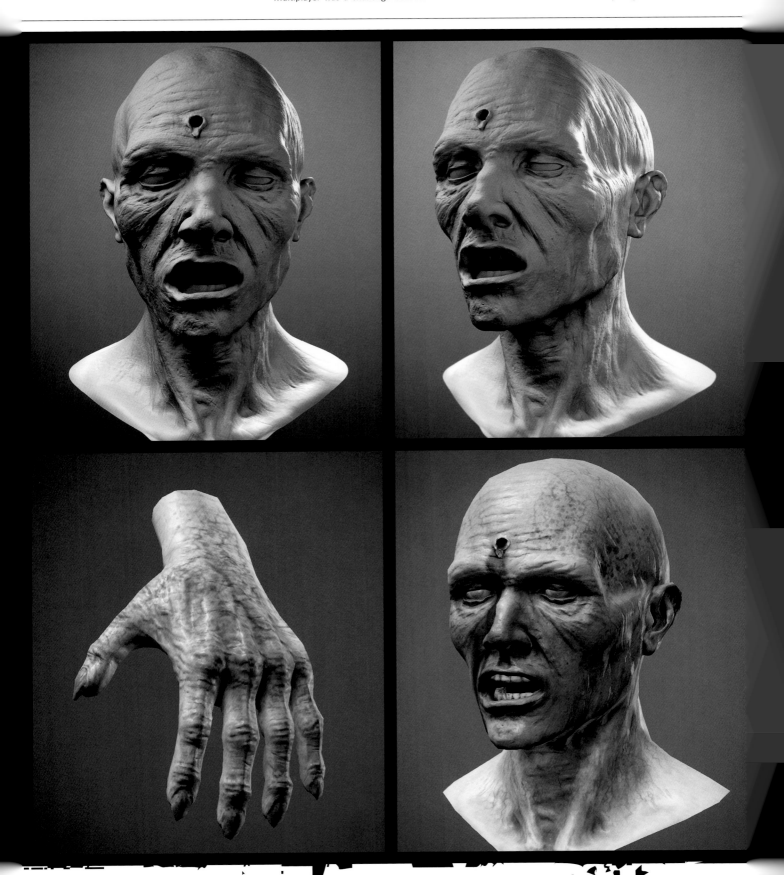

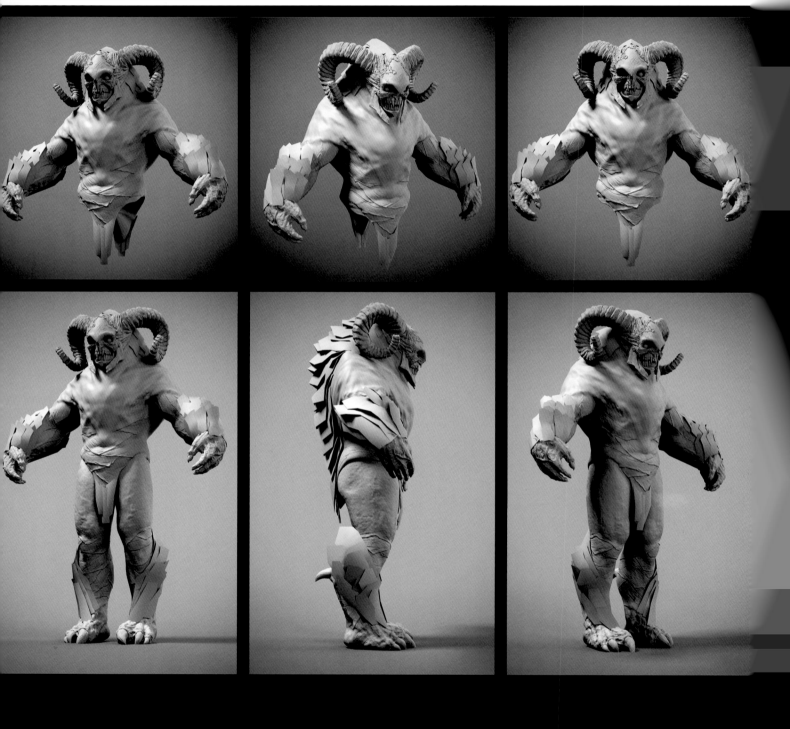

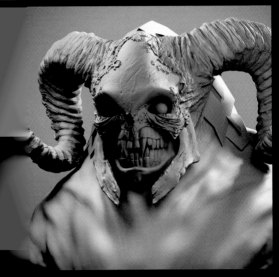
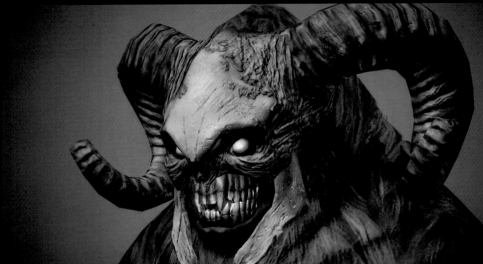

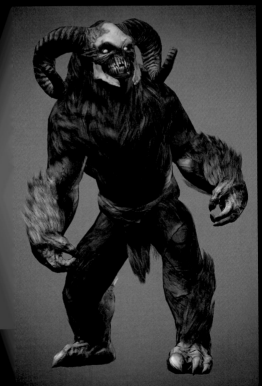
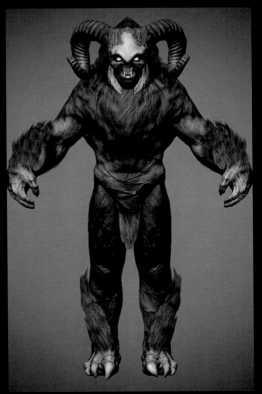
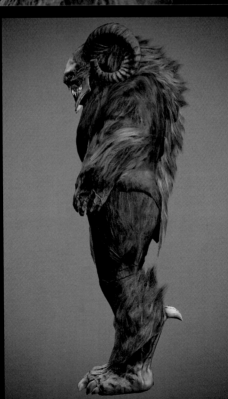

COSTUMED GUARDIANS

Modeling creatures is nothing new for the Naughty Dog team, but the technical hurdles to cover a creature in fully-animated fur are substantial, using current technologies. We have a fur shader in the game engine, and initially the idea was to put the fur shader across the Guardian's entire body so he would be covered in fur. Because the Guardian appeared in both cinematics and in-game, we had to find a solution that looked good both ways. The main challenge was that we were constrained by the draw performance of the game engine and the number of polygons it takes to fill an entire character with fur. We did a bunch of redesigns of the character and removed fur from a lot of areas, but kept it in key areas that would work in-game. We went through a lot of iterations before we settled on having enough fur that it gave the right feeling while still being doable. In terms of the modeling, the Guardian was pretty similar to the other characters. Modeling the fur was the same basic idea as hair. It was just a question of how much we could put on him.

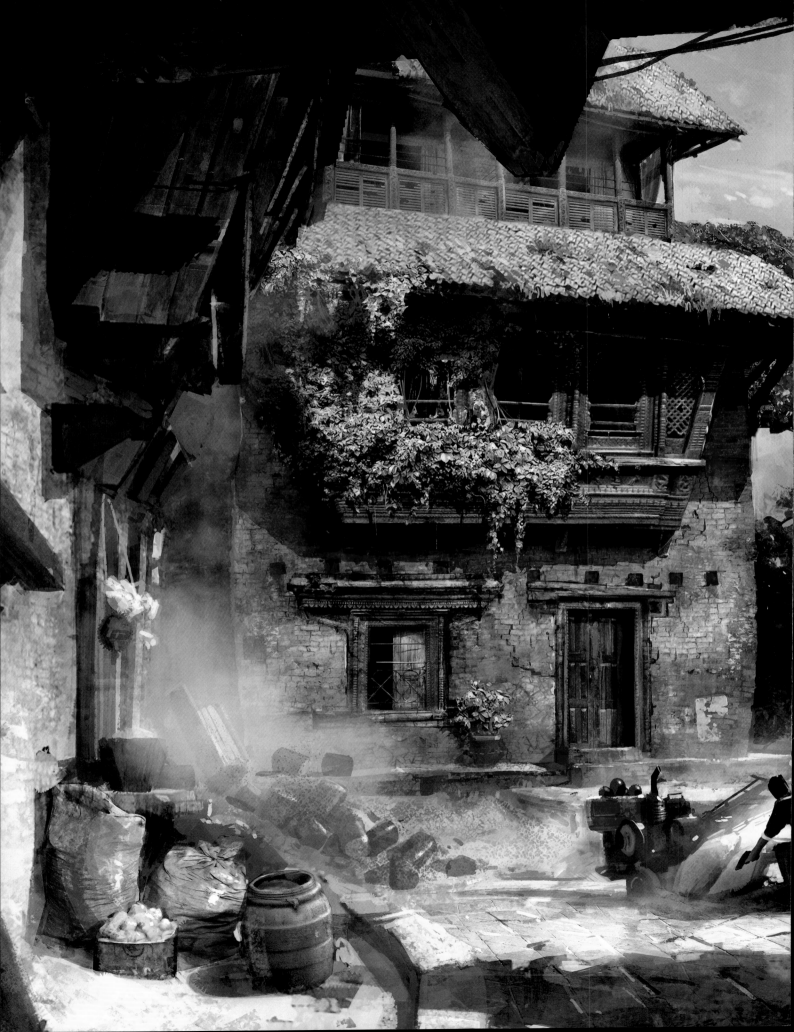

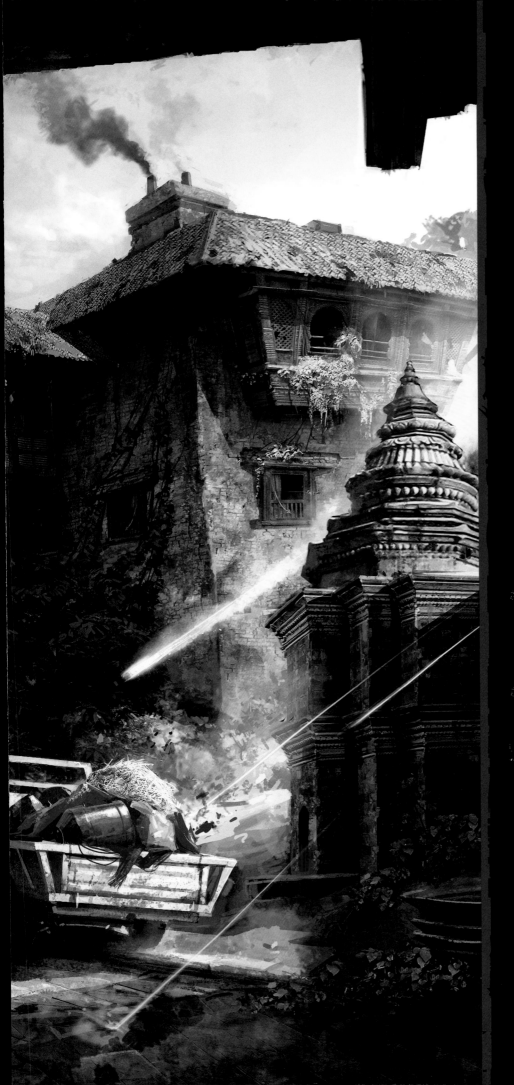

CONCEPT ART
ENVIRONMENTS

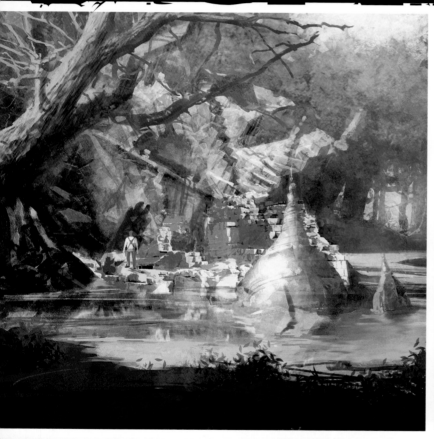

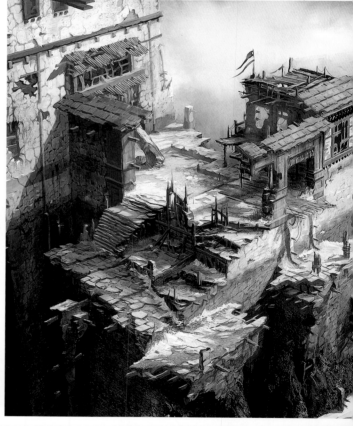

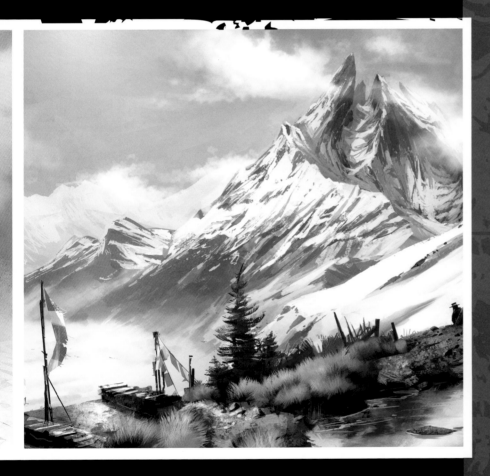

Nepal warzone: rural [Shaddy Safadi] *previous spread*
Borneo sunken temple [Robh Ruppel] *left*
Monastery outcropping [James Paick] *center*
Ice cave vista [Shaddy Safadi] *right*

Robh Ruppel
Art Director

ENVIRONMENTS

The environments all need to have a "real-world" feel. Which means we had to be hyper-aware of all the details that go into making something feel lived-in. What's the history of the place? Who lived there before? What did they leave behind? How many times was it repainted? Where do people hang their coats? All of these types of questions need to be addressed in order to make the settings come alive. We also set out to make Uncharted 2 a more visually rich and varied game so we made conscious choices not to repeat similar areas. We wanted constant visual momentum. The overall process for creating environment concepts for a game varies because every level is different. The first levels that went into production on Uncharted 2 were the Train level and the Tibetan Monastery. We knew that we wanted to figure out the tech for an extended train sequence—where you're actually moving through the environment on a fully-realized and articulated train, not just on a straight track with the background scrolling past. That was a huge technical challenge.

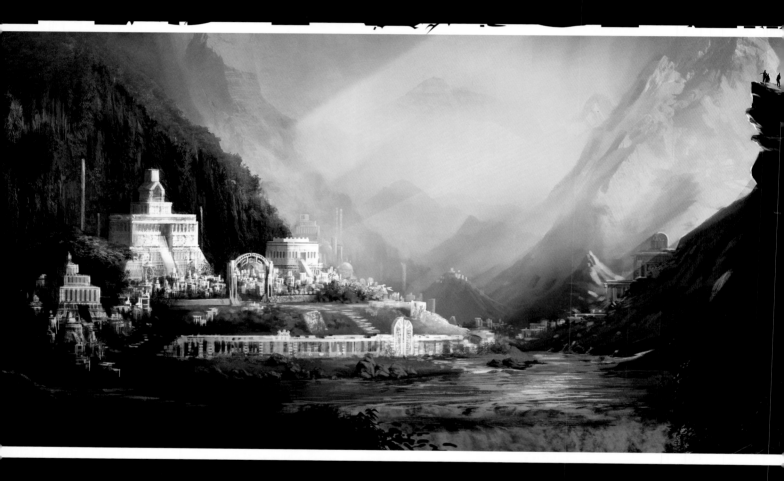

ENVIRONMENTS

The design of environments is a collaboration between game designers, concept artists and environmental artists. For example, in the early development of the Monastery level, one of the designers had laid out a block mesh for a combat area. In the block mesh phase, the designer is just getting a feel for the space using simple geometric solids like cubes and planes—it's a super-simple way of working out the level design in 3D and getting a feel for the space. At the same time, we were looking at reference for the Monastery and were inspired by this amazing real-world monastery called the Tiger's Nest, in Bhutan. It's perched on

the cliff-side, on these little slivers of rock outcroppings; the monastery is almost as sheer as the cliff itself. So we took that as inspiration, to influence the design of our Monastery level— the idea was to move the gameplay away from being flat and horizontal, and make it much more vertical. For instance, you may start from a skirmish in a small staging area, then run up a cliff or climb the architecture into another area, so you're now moving through a space that's more accurate to the indigenous location and the actual monasteries there. This is one way in which the concept artists contribute to the game development, by suggesting how

things would truly be built in the real world, and how we can leverage that. We're always trying to get the perfect combination of great gameplay and visual design that makes you feel like you've been transported somewhere else. If everything was just laid out on a flat plane, you wouldn't feel like you were exploring a new space. For another example, on the train we knew we were going to need a transition to carry us from the lush lowlands with the bamboo forests to the higher elevations, where it becomes more rocky and craggy, with more snow—a bleaker landscape. As the train progresses we're leaving civilisation behind,

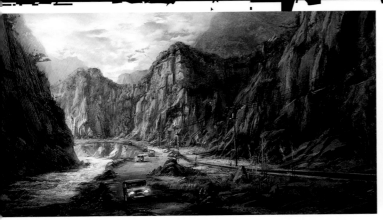
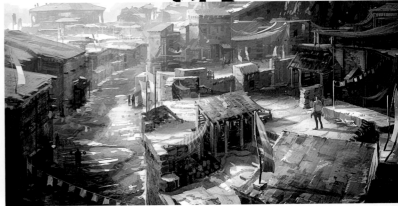
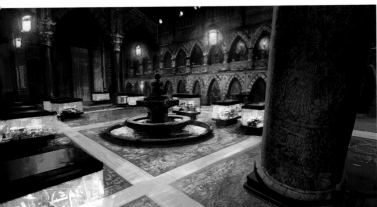
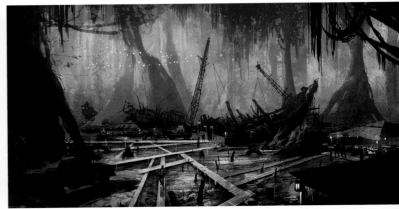

so we're going to see less indication of little villages. It's going to get stonier, with sheer cliffs, more ice and snow, and more danger. At this point, before the level is locked down, we can do a lot of blue-sky brainstorming to establish the artistic look. This phase is always the most fun in terms of having the most creative freedom. A lot of times there may only be a simple block mesh we have to go by, so we can take that and say, "Okay, we have a room with a hallway, that leads into another room. How can we make this interesting?" That's when we start doing the research and gathering reference. We'll do a few thumbnails, a few color sketches, talk it over with the designers and game director, and establish an emphasis for what needs to be conveyed. What do we want the player to feel here? What's going on here emotionally? Where are we in the story? Then we'll really start to flesh it out with tons of research and drawings, and more finished artwork. As the levels go through development, there are inevitably changes—we just always want the visuals to enhance what's going on with the emotional beats of the story and gameplay. So if the design or goals change in a particular level, I have to make sure that the visuals are also in sync and doing their job.

Shambhala [Andrew Kim] *opposite page*
Convoy ideation [James Paick] *top left*
Musuem artifacts [Robh Ruppel] *above left*
Village houses [James Paick] *top right*
Borneo dig site [Robh Ruppel] *above right*

Train Wreck	Museum	Borneo Dig	Nepal Warzone	Temple	Jeff Rescue	Train	Train Wre

Environments color script [Robh Ruppel] *this spread*

Village	Ice Cave	Village Battle	Convoy	Monastery	Monastery Tunnel	Shambhala	Ending

COLOR SCRIPT

The color script is an overview where you can see the entire mood of the game in one glance. It allows us to make sure we're contrasting color and mood so the player not only feels like he's moving into different areas, but we're also enhancing the emotion of the scene. We start with the levels we know are in the game—that may be just three to five levels in the beginning, then we keep adding and updating as we go. We do a color script just like you would for a film, making sure that each area is very distinct from the last. We just come at it from ideas like, "This is mostly greens and reds, let's make sure that where we're going to isn't exactly the same, so that there's a transition." There's a

change every time we go to a new level or a new section. We definitely tried to steer away from the color palettes you commonly see in a lot of games these days. That common look comes about from a film process called the bleach bypass. Originally, some filmmakers wanted more contrasty darks in film stocks, so they bypassed the bleach process so the blacks clog more, so you get this super high-density negative that produces a very contrasty print, and it sort of sucks some of the color out too. A lot of games latched onto this look. It's cool if you're the first person to do it, but when everyone does it, it all starts to look the same. So it's real easy to not do what everyone else is doing and just say,

"Alright, it's a lush adventure game, with all these different locales, let's play that up, let's make sure each location has its own color signature. Let's make sure they feel very distinct and different so the player knows that they're in a new section instead of wondering where they are." It was also a conscious choice to use color as an emotional touchstone to get the player to feel more of what was going on. When Drake is running out of luck and things are looking bad, we pull the color out, things get more desaturated, it gets foggier, or snowier. When things are good and Drake's happy, the sun's out. So we try to use the environment to enhance what's going on story-wise, and to complement the action.

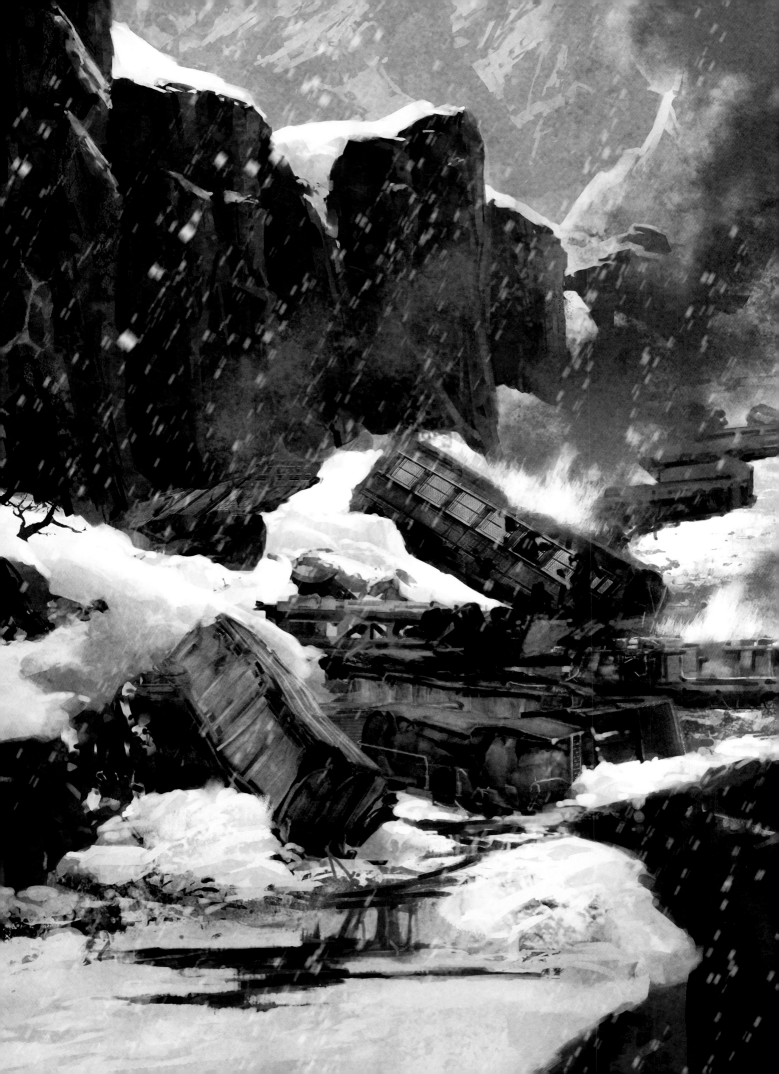

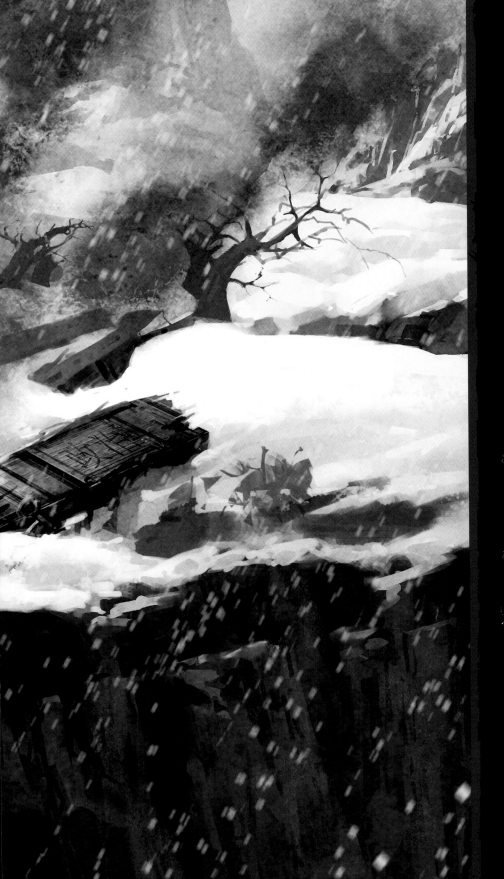

CONCEPT ART OPENING SEQUENCE

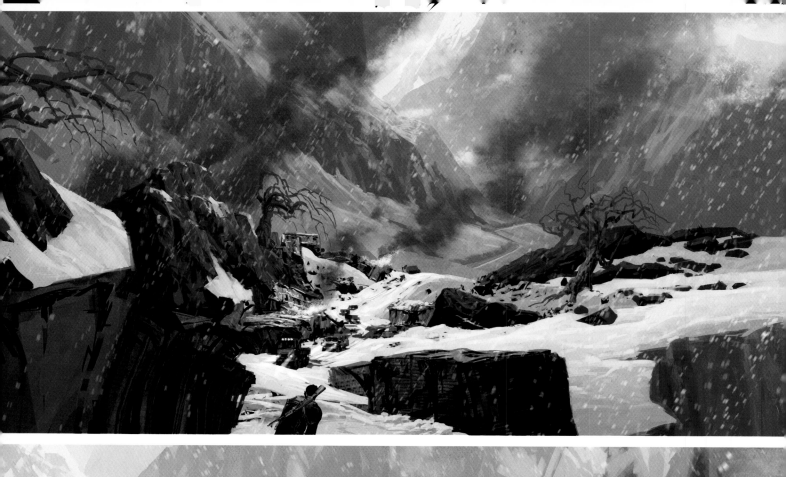
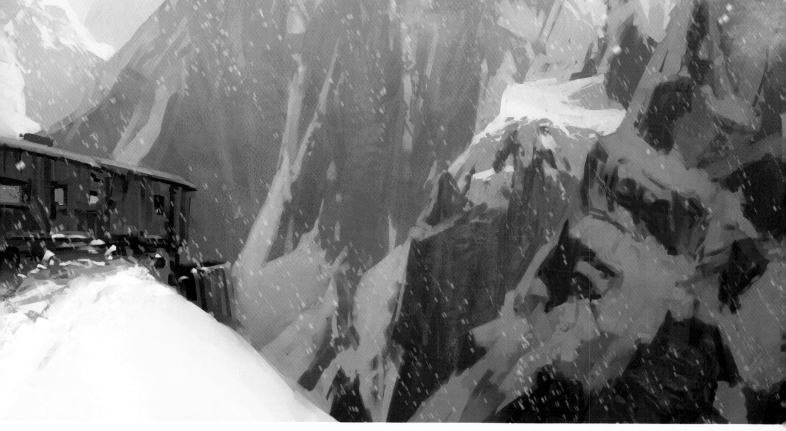

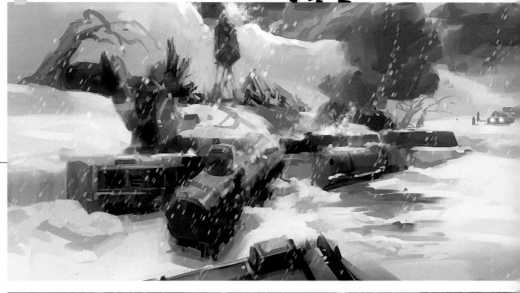

Robh Ruppel
Art Director

TRAIN WRECK

The train wreck sequence was a lot of fun to research. We have in our heads what we think a train wreck is, and then you start researching it and you start seeing how the tracks get twisted, how the train cars bunch up, how it destroys the land around it, how whatever was in the train car spills out everywhere—and all this research informs us of the possibilities. That's what makes Naughty Dog such a great studio. They're willing to invest the time to really delve into things, which makes the game world that much more interesting. They realize how important the research phase is as part of the development process, to make the experience as unique as possible. So we started with this basic question: "What would a train wreck be like?" We did tons of little paintings because at one point Drake is working his way through the wreckage and we're wondering what you would expect to see. Will there be oil on the snow? If the oil is a different temperature, is it going to sink into the snow and leave a little indent in it? What was in these train cars? You've got to have boxes and wreckage strewn everywhere— bits of train cars, bits of wheels, you know just piled up, crushed and crinkled. We have to consider all these things in the concepts, before the artists can build and texture any of it.

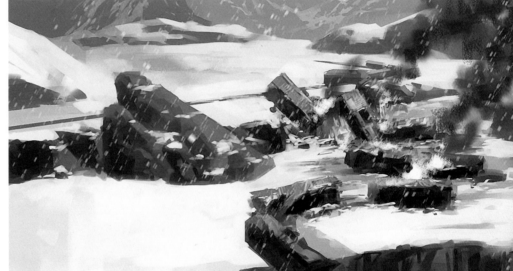

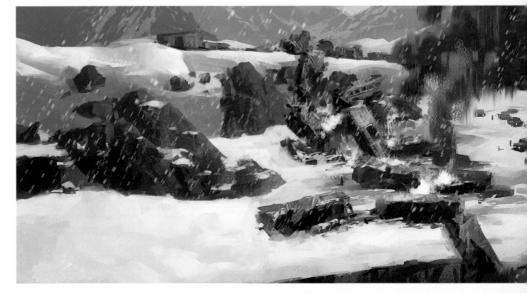

Train wreck concept [Robh Ruppel] *previous spread*
Wide view, final effects [Robh Ruppel] *opposite top*
Dangling train cars [Robh Ruppel] *opposite bottom*
Train wreckage [Robh Ruppel] *this page*

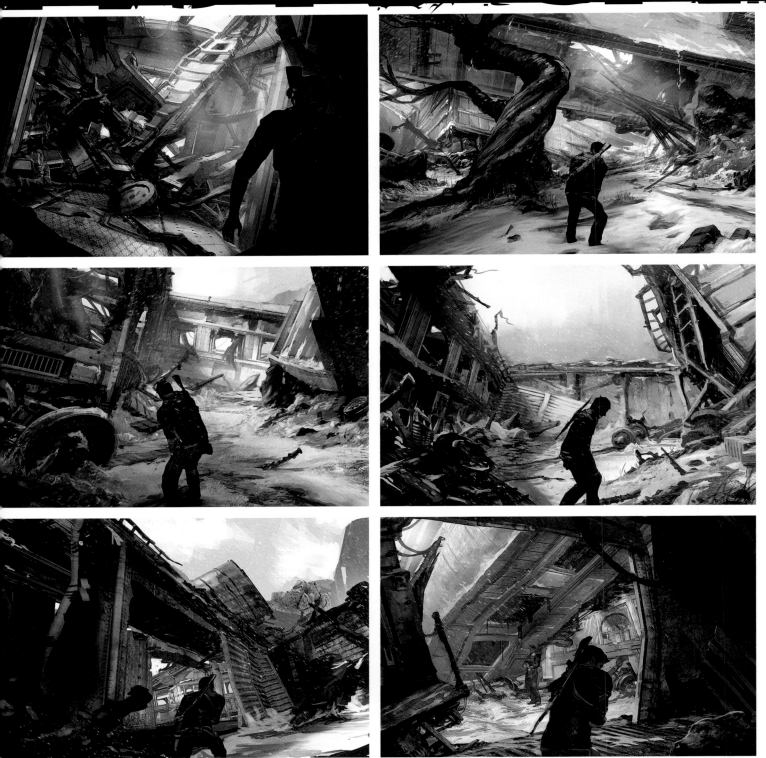

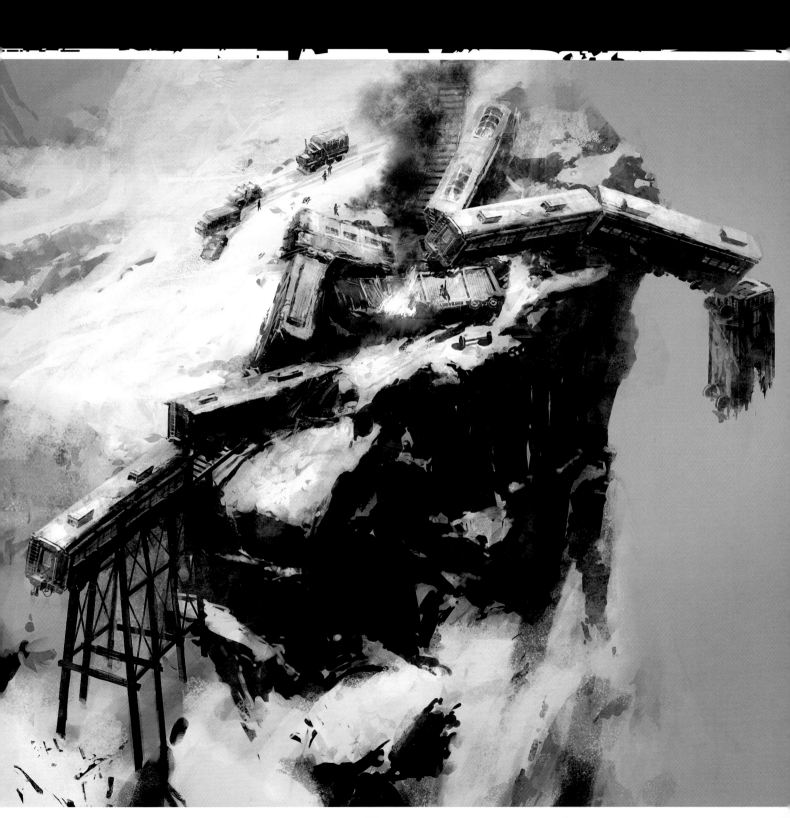

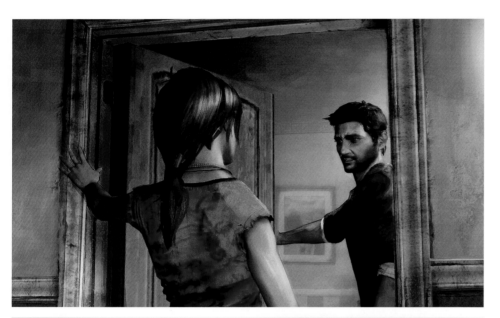

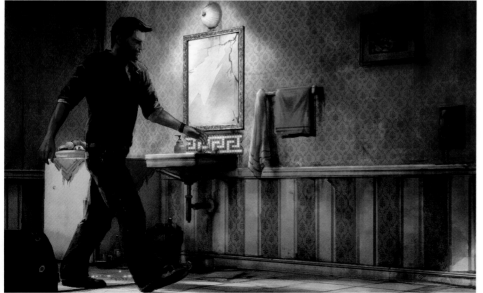

Robh Ruppel
Art Director

BEACHSIDE BAR

The fun part of designing the Greek beachside bar is that Drake is down on his luck at this point and doesn't have a whole lot of money. So he's not staying at some four-star hotel. We really wanted the place to feel like it was trying to be cheery and tropical, but it wasn't succeeding. It's not off the main drag, so it's a little away from the nicer part of town. The wallpaper in his shabby hotel room is a bit cheesy and aged, and there's some really bad artwork on the walls. That was actually fun to do. Near the end we all did these really bad paintings on purpose to put inside the hotel because you know, we've all been to hotel rooms and wondered where they get this stuff. We went with bad oceanscapes, that kind of thing. Everyone had a lot of fun coming up with that stuff. It's pretty interesting to try to work intentionally bad and come up with a composition and a color scheme for the artwork. So it's sort of trying to feel like a resort, but we want the audience to understand that he's run out of money, and he's not staying at some swank beach locale.

Hotel room meeting [James Paick] *above left*
Shabby hotel room [James Paick] *left*
Beachside bar [James Paick] *opposite top*
Beachside bar view [James Paick] *opposite bottom*

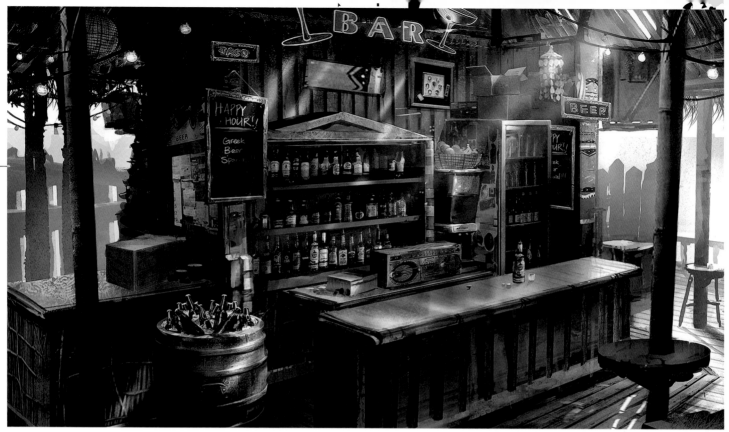

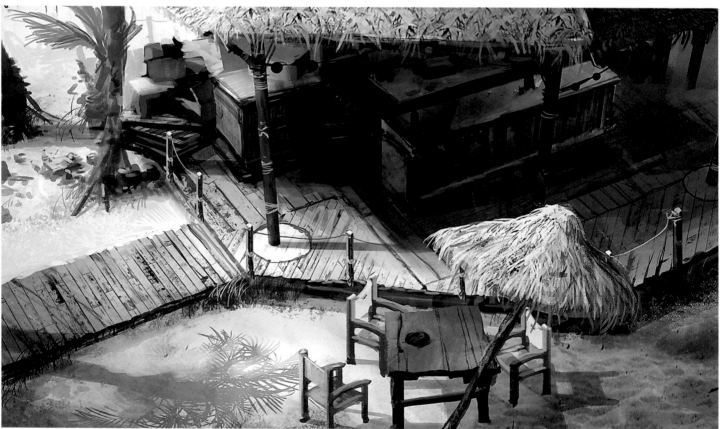

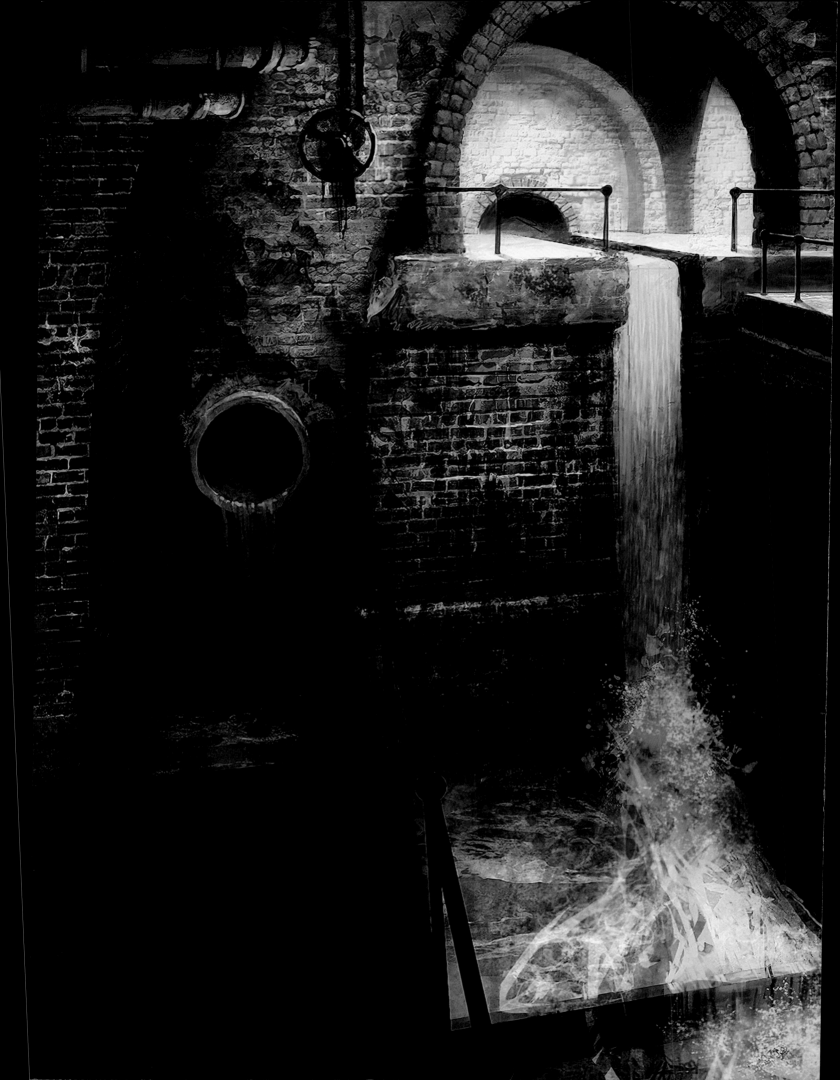

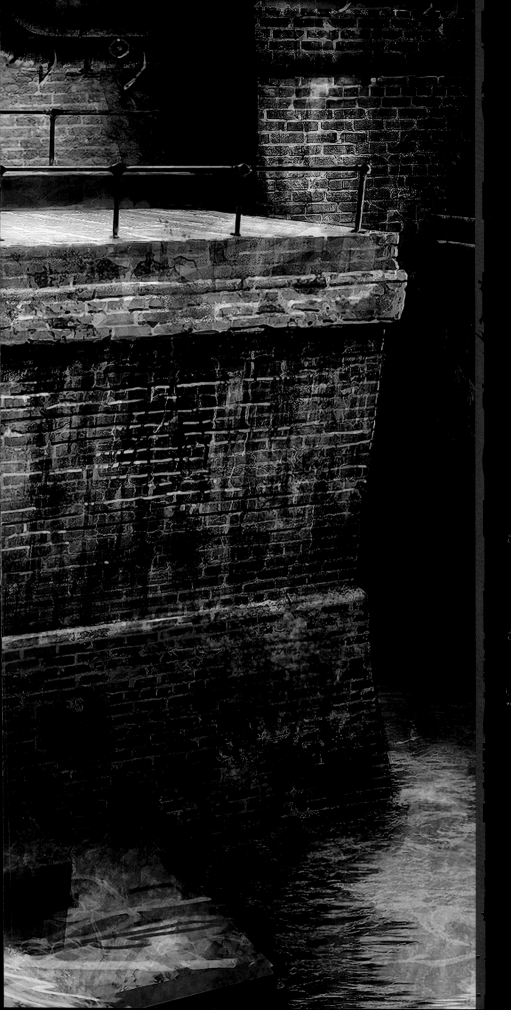

CONCEPT ART
İSTANBUL
MUSEUM

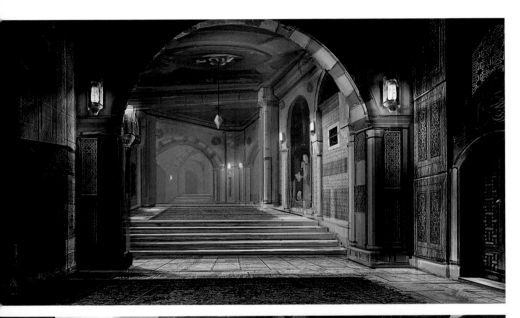

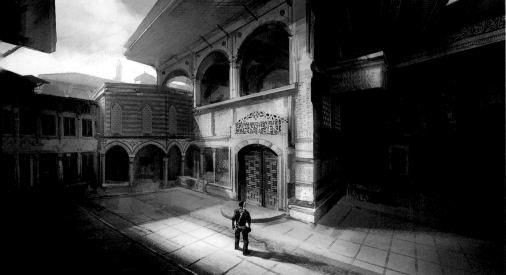

Robh Ruppel
Art Director

ISTANBUL MUSEUM

The museum was loosely based on Topkapi Palace in Istanbul, which was converted to a museum in 1924, so its look is heavily influenced by Islamic, Moorish and Ottoman architecture. There are these beautiful Moorish archways with black and white striped bands on them, along with ornate columns, and all the intricate scroll-work inside. The museum has several different levels. At the top level there's the museum proper, with all the palace architecture. Below that there's an ancient sewer system. You enter the sewer by boat, sneaking in via an outflow pipe on the cliff-side beneath the museum. The brickwork here is really old—the sewer existed centuries before the museum was built above—so the brick arches are very, very old, but the closer you get to the museum, the more signs of contemporary technology you see. Modern piping starts to appear and more conduits and offshoots are evident. This lets you know that you're heading in the right direction, as you're making your way through the sewers up into the museum.

Museum tunnels [Robh Ruppel] *previous spread*
Museum hallway [James Paick] *top left*
Museum courtyard [James Paick] *left*
Museum vista [Robh Ruppel] *opposite top*
Istanbul wide view [Robh Ruppel] *opposite bottom*

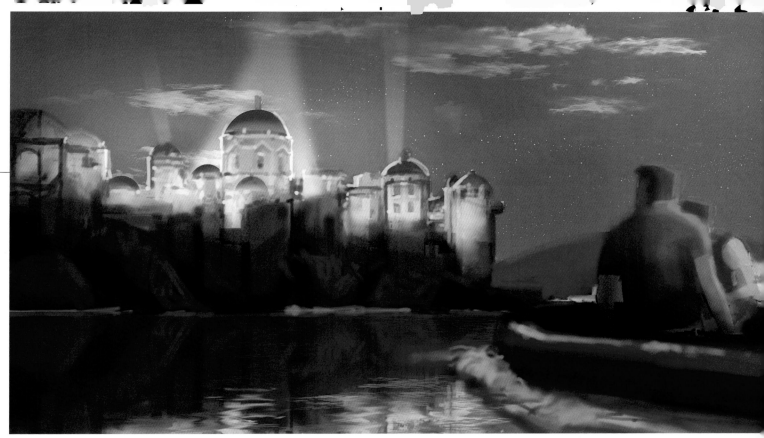

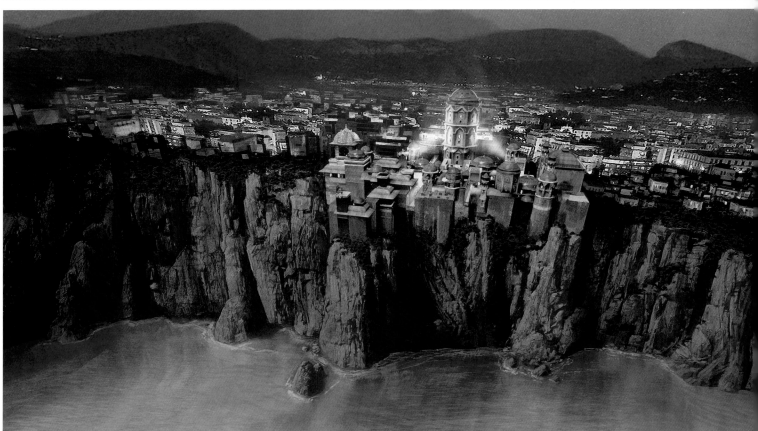

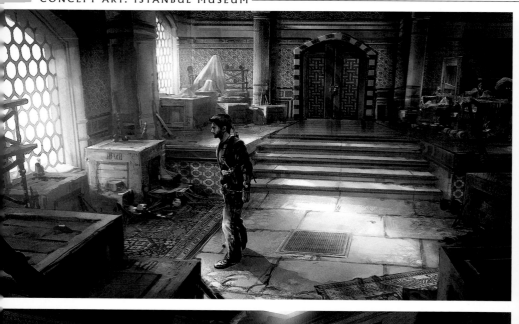

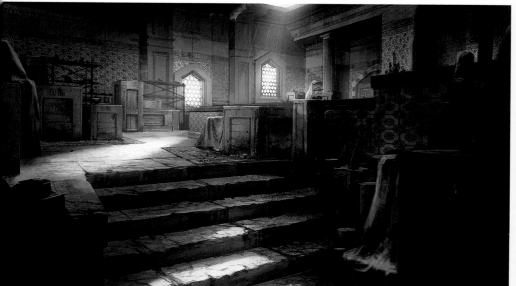

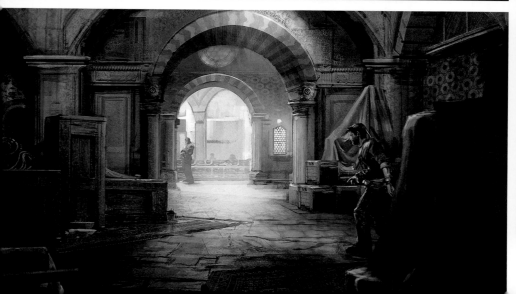

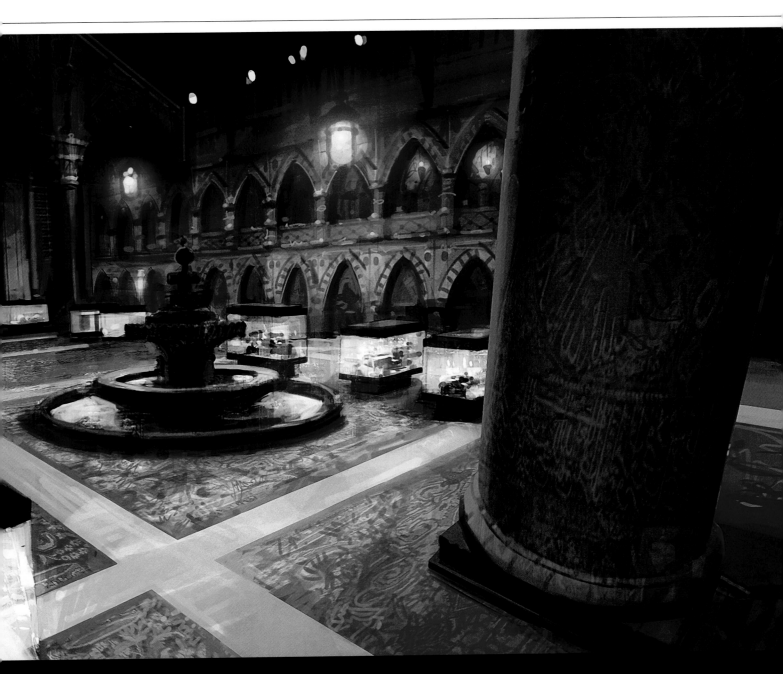

Storage area concepts [James Paick] *opposite page*
Exhibit hall concept [Robh Ruppel] *above*

INSIDE THE MUSEUM

The museum needed to have a clearly Turkish feel, inspired by Islamic architecture. A lot of this comes through the engravings and scroll-work, and the Moorish black-and-white patterning on the arches. We researched Islamic, Moorish and Ottoman architecture and layered in the appropriate details as much as possible.

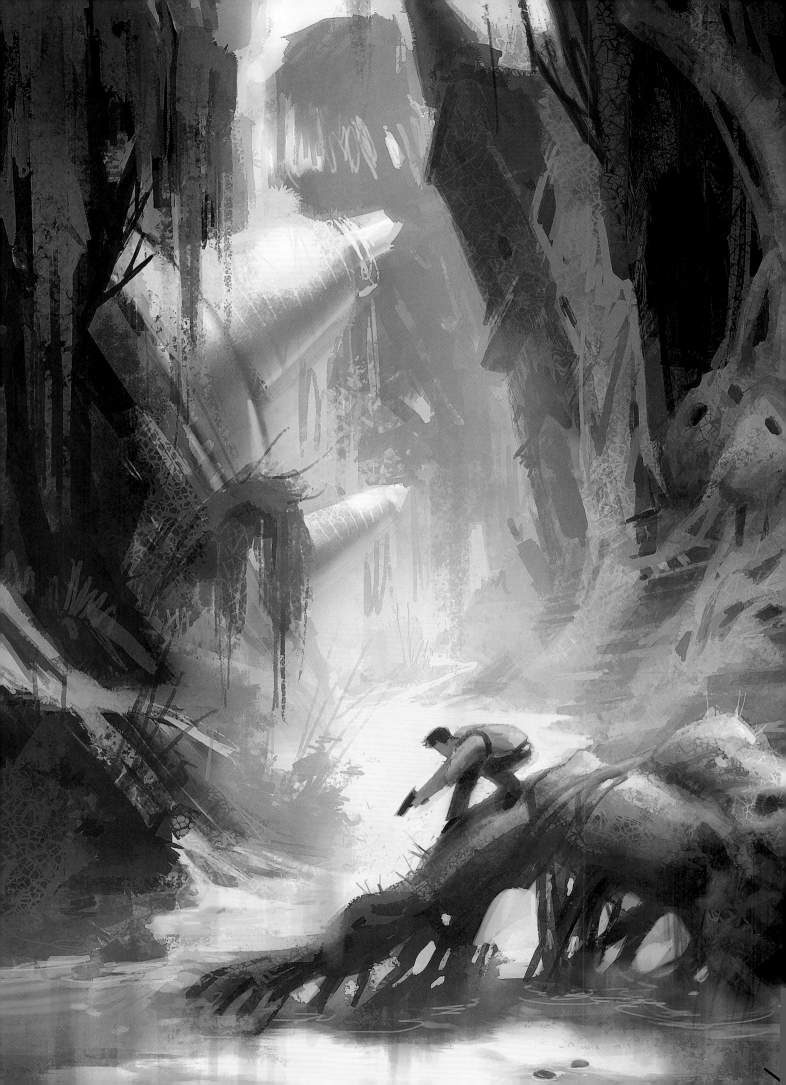

CONCEPT ART BORNEO

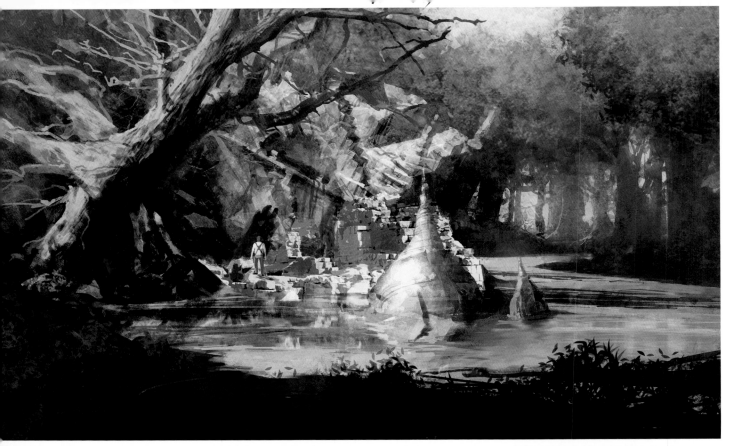
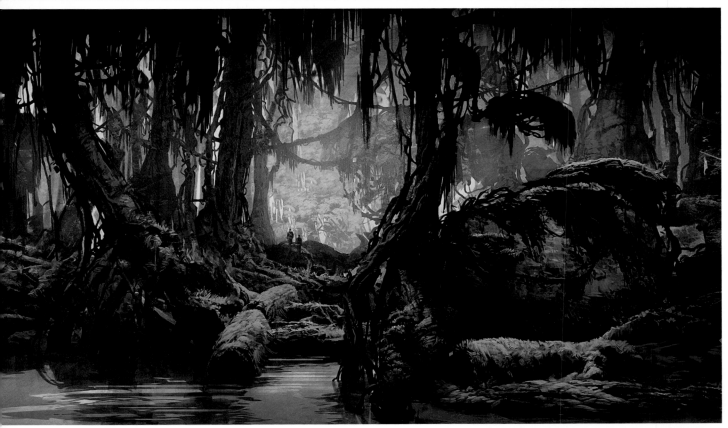

Robh Ruppel
Art Director

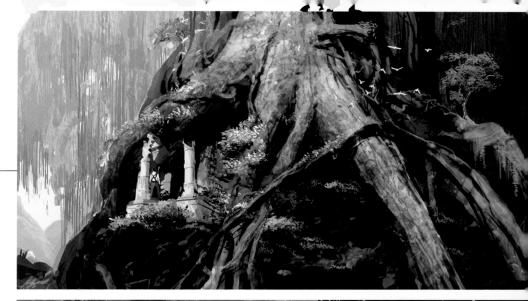

BORNEO

What we wanted to do with the jungles of Borneo was avoid repeating the look of the jungles in the first game. We started looking at Frank Frazetta, and the way he draws his jungles with the same sensuality and fluidity that he uses when he paints human figures. So for the Borneo section, we started by making it a wet, swampy jungle with thick vines and trunks and heavy moss everywhere. That's when it really evolved and became its own distinct jungle. We set the time of day for early morning, and moved away from an all-green environment. We looked for anything that would distinguish it from the first game, because we wanted to avoid Uncharted 2 being labeled another jungle game. For most of the environments we said: "Right, we've done an island, and Spanish architecture. What's the exact opposite of that?" Snow, the Himalayas, and Eastern influences. So a lot of it came about from doing the exact opposite of what we'd already done.

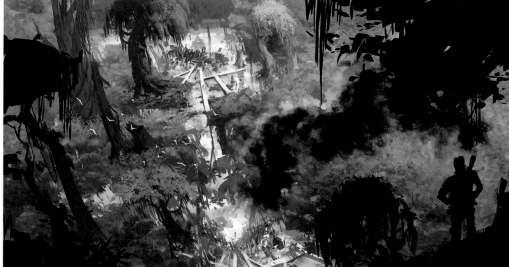

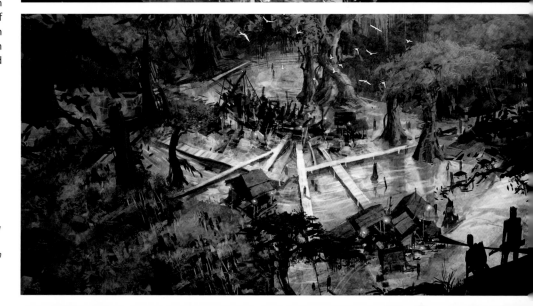

Borneo jungle ideation [Shaddy Safadi] *previous spread*
Borneo sunken temple [Robh Ruppel] *opposite top*
Borneo jungle [Robh Ruppel] *opposite bottom*
Borneo overgrown tree [Robh Ruppel] *top*
Borneo dig site [Robh Ruppel] *center*
Borneo dig site [Robh Ruppel] *bottom*

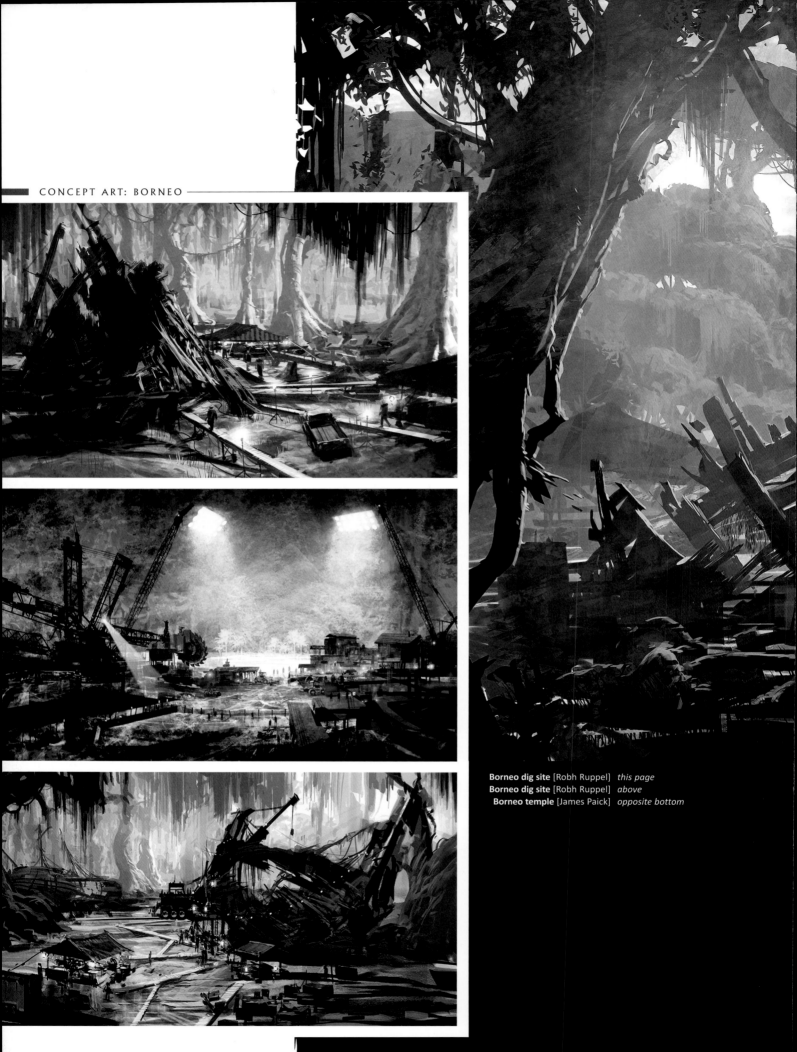

Borneo dig site [Robh Ruppel] *this page*
Borneo dig site [Robh Ruppel] *above*
 Borneo temple [James Paick] *opposite bottom*

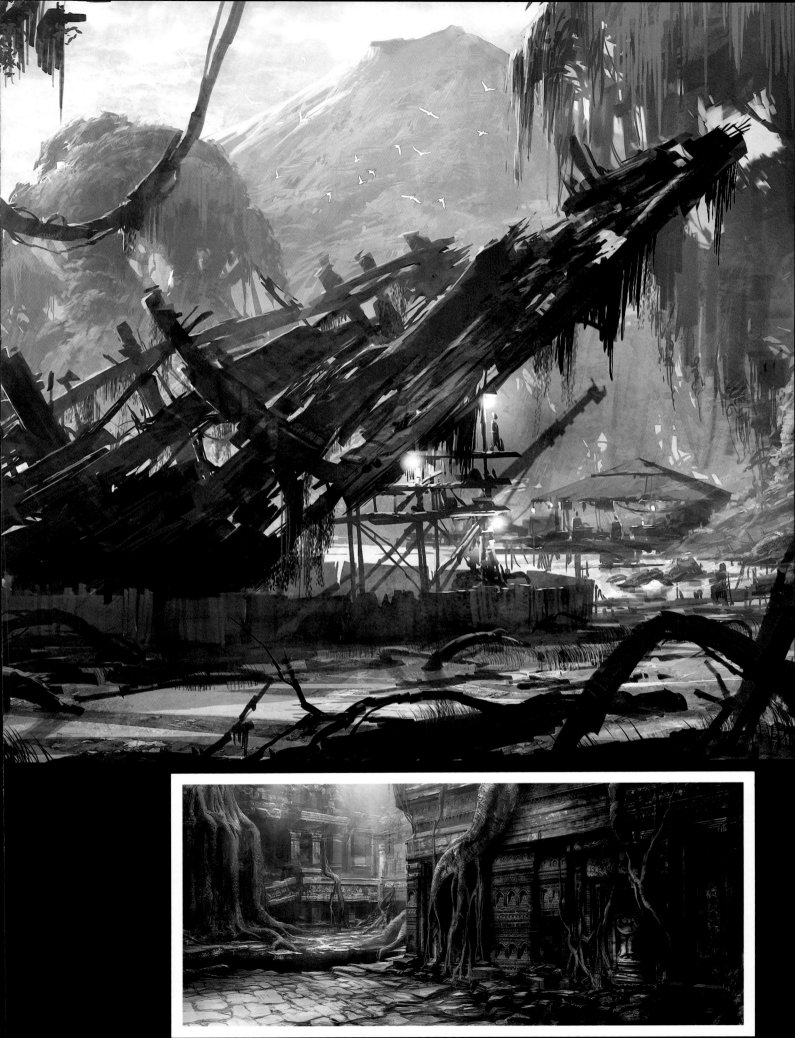

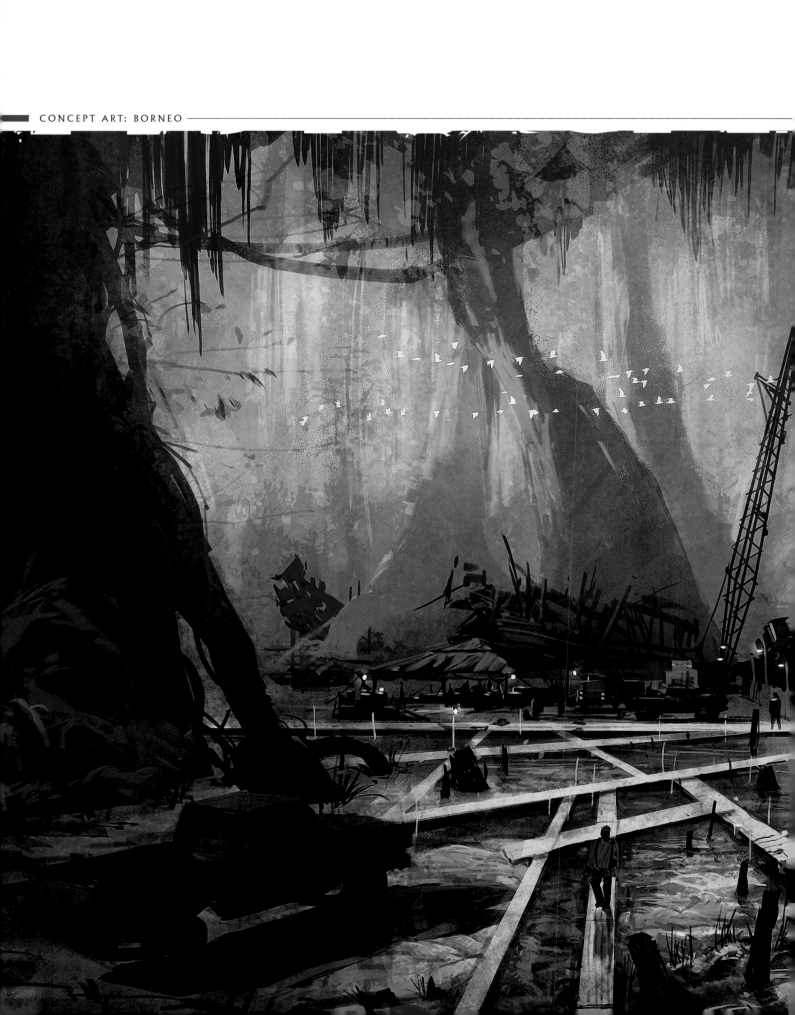

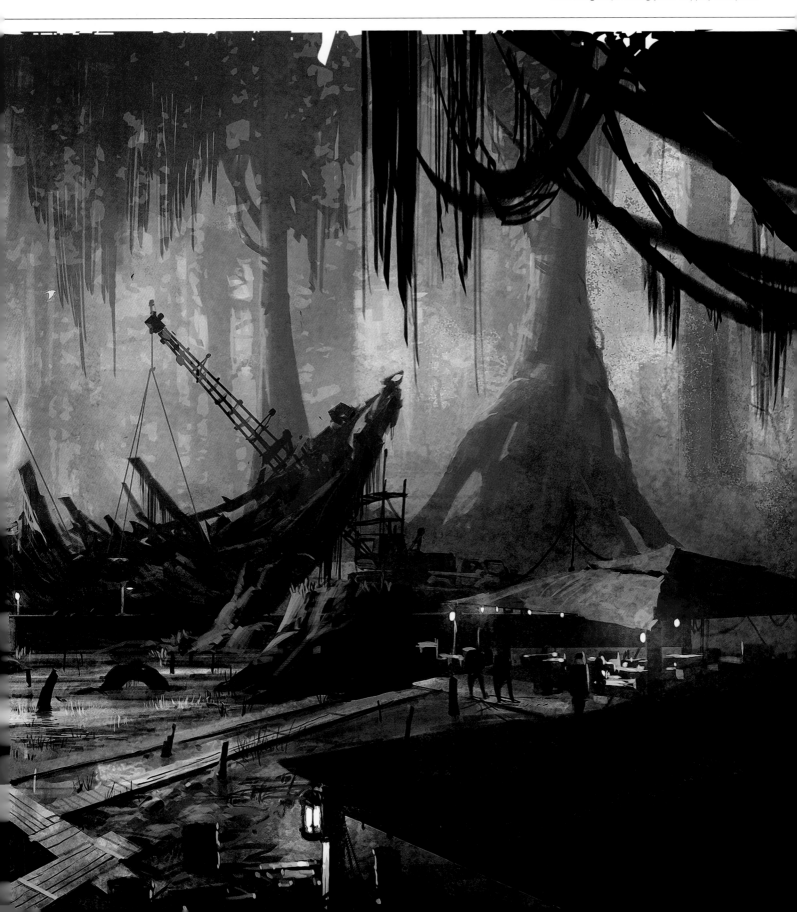

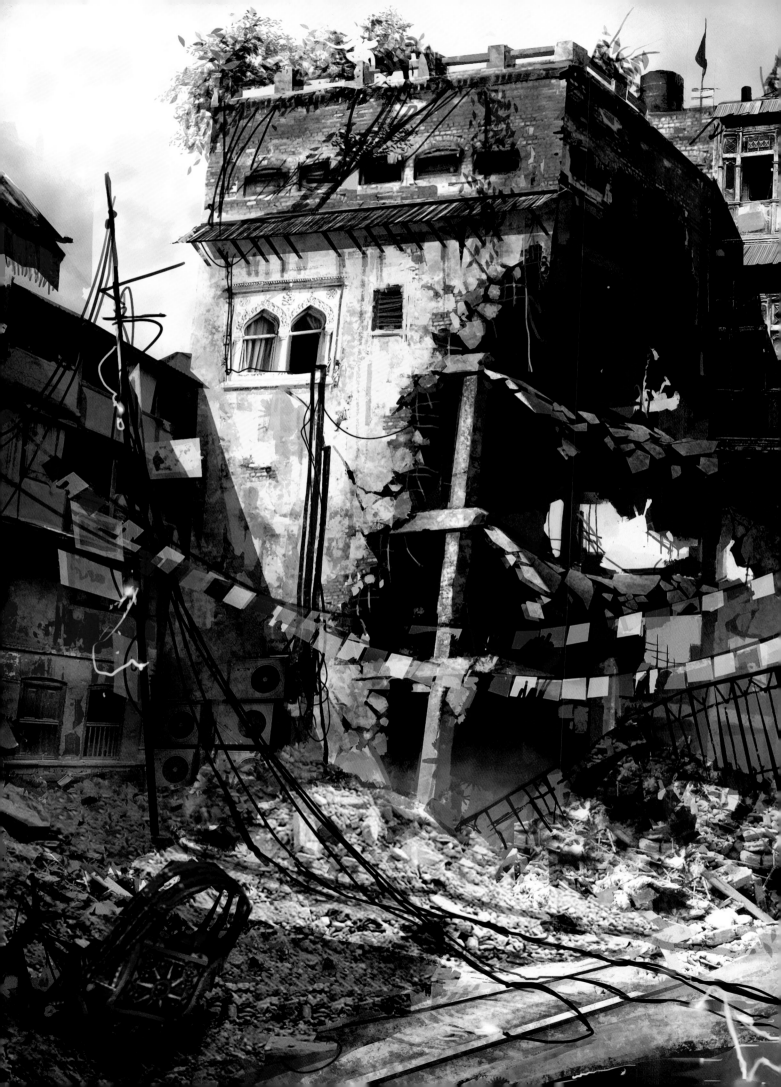

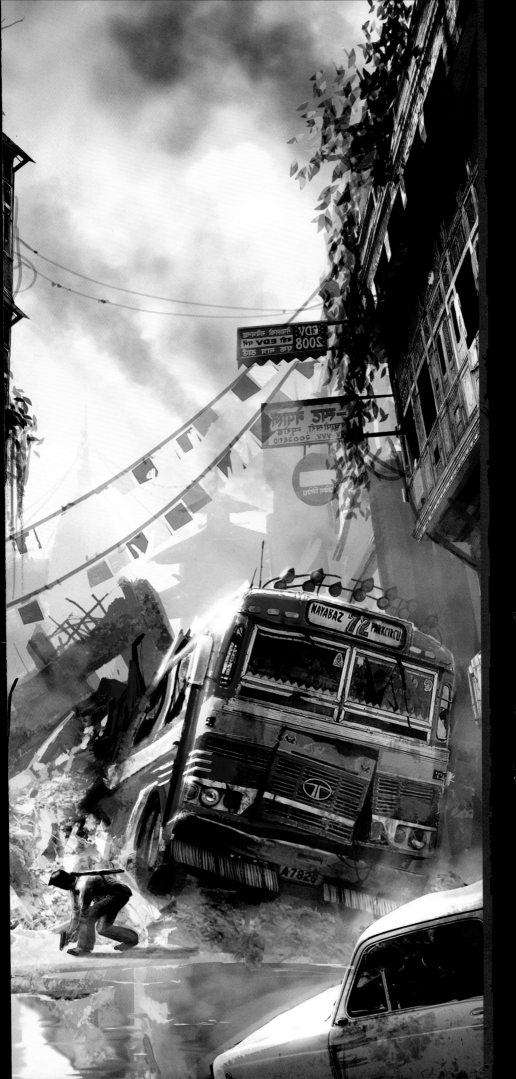

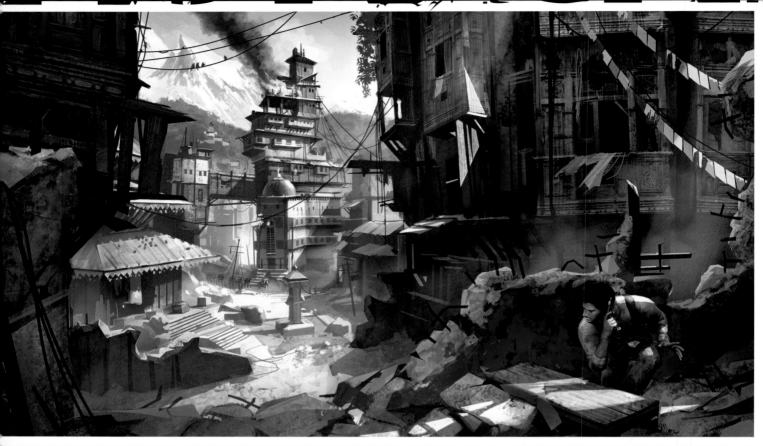

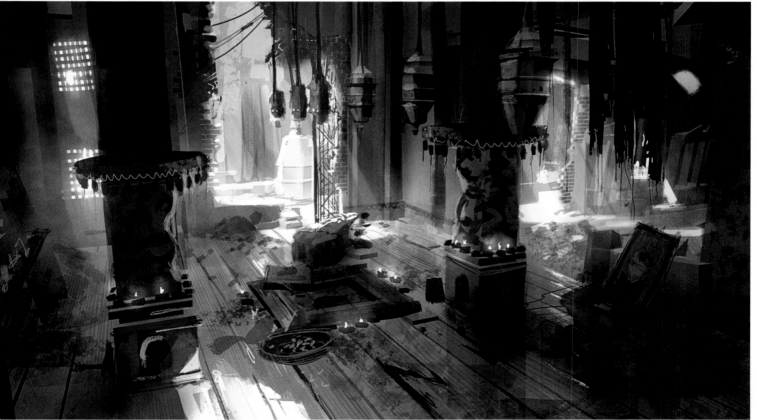

Robh Ruppel
Art Director

NEPAL WARZONE

For the Nepal warzone we used reference from Kathmandu as the starting point, in terms of having a mix of old and new architecture, but we didn't want to set our city anywhere specifically in Nepal, so (internally) we called it "Kathmandon't." We went through photo reference and picked out buildings that represented that part of the world. When telling the story with design, you've got to be specific in terms of what you pick out as reference. If you get something in there that's fairly modern, it's just going to stick out and look wrong, and we want people to feel like they're in another part of the world. So one of the first things we did was go through and pick out several buildings that looked like they could be in Nepal. We threw in a few newer buildings, but the really interesting part of the environment was the number of wires, signs and visual clutter. All of that has to be thought through, and all of it has to be researched and worked out. Since the city was under attack, everything had to be damaged or destroyed. You have to know how buildings are made in order to accurately draw, paint and model what they look like when they're destroyed. An old Sears building was being torn down nearby, so everyone went down there and shot photo reference. We also found all sorts of amazing photo reference from real warzones—apartment buildings that had been bombed, and blown up where you could identify sheet rock, two by four, and plaster.

Warzone bus crash [Shaddy Safadi] *previous spread*
Nepal warzone vista [Shaddy Safadi] *opposite top*
Ruined temple interior [Shaddy Safadi] *opposite bottom*
Nepal temple exterior [Shaddy Safadi] *right*

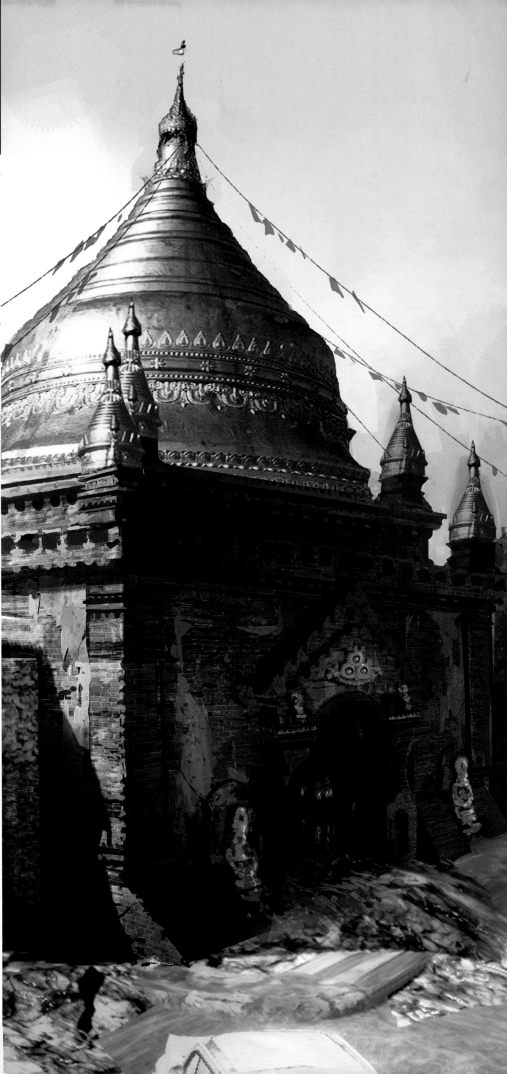

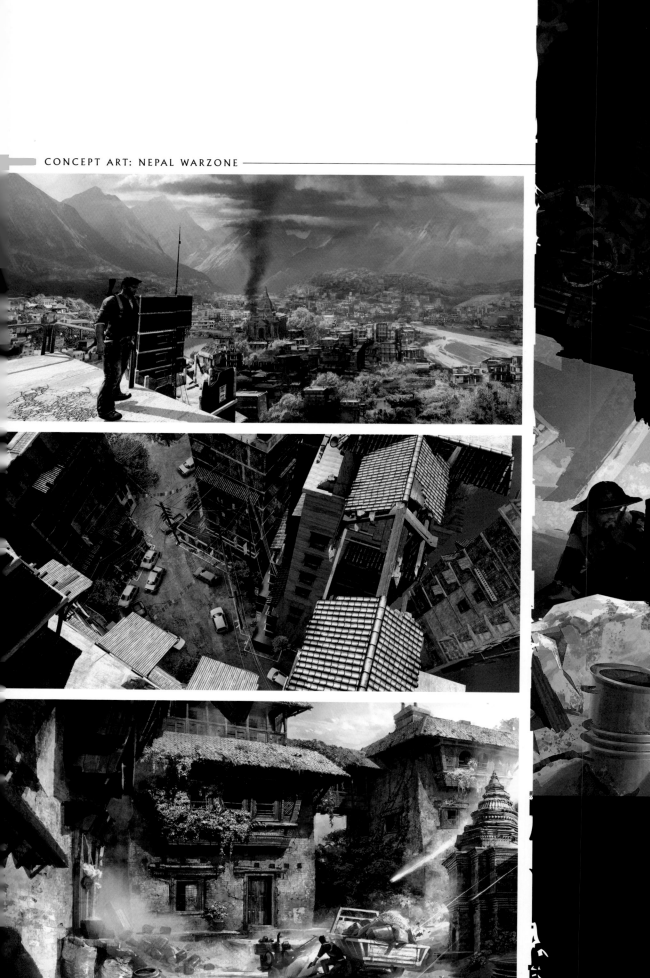

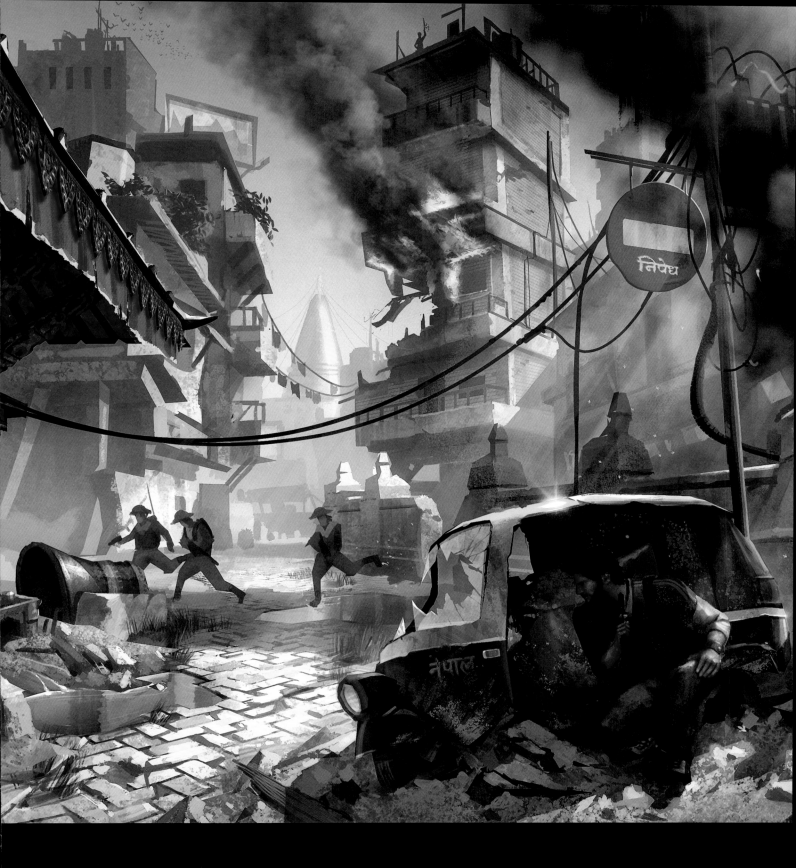

AMONG RUBBLE

First we flesh out the environment in concept, then all that detail has to be built into the models. Piles of rubble are added to the ground, more details are added to illustrate the general chaos, and all these things have to be designed, modeled and textured in a way that can be rendered at 30 frames a second.

Nepal warzone vista [Robh Ruppel] *top*
Warzone street detail [Robh Ruppel] *center*
Warzone outskirts [Shaddy Safadi] *bottom*
Warzone ideation [Shaddy Safadi] *above*

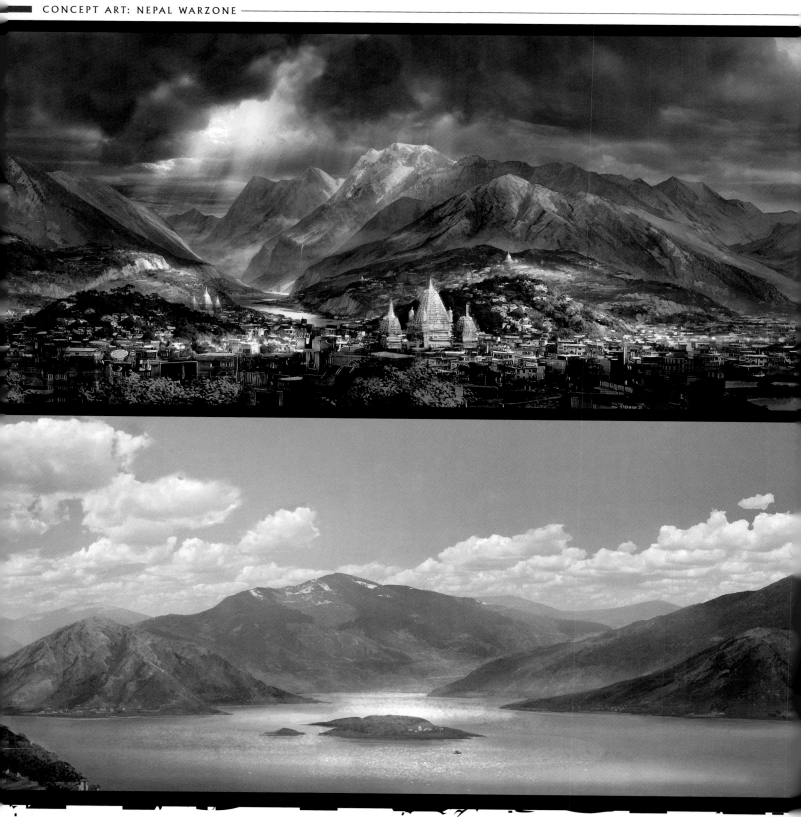

WARZONE 360° VISTA

Warzone vista Northeast [Shaddy Safadi] *top*
Warzone vista Southwest [Shaddy Safadi] *bottom*

From the top of the hotel, you can look out over the entire city. That took a lot of work. What do the hills look like? What do the mountains look like? What does the architecture look like? How can we render this? How can we get the complexity that we need? When Drake's up there, what do you see when you look down from the roof? What does the stonework look like on the street? How many cars are down there? How can we use two or three cars and repeat the shapes and change the colors to make it feel like there are dozens of different types of vehicles when in fact we're trying to be as efficient as possible and not have dozens of unique models?

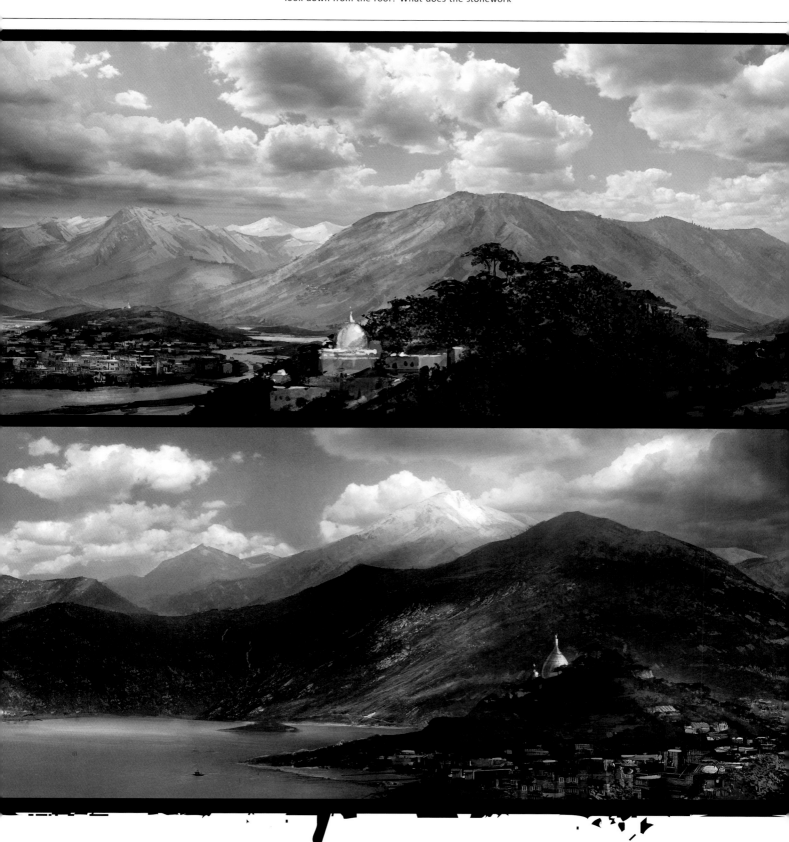

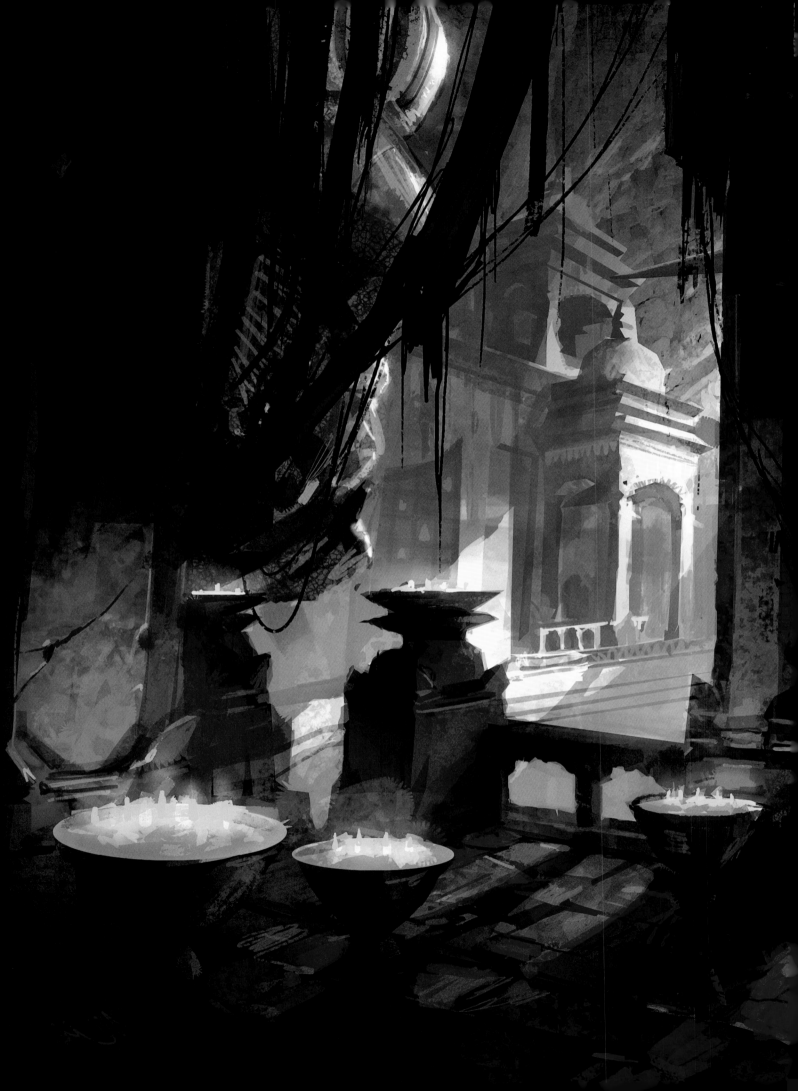

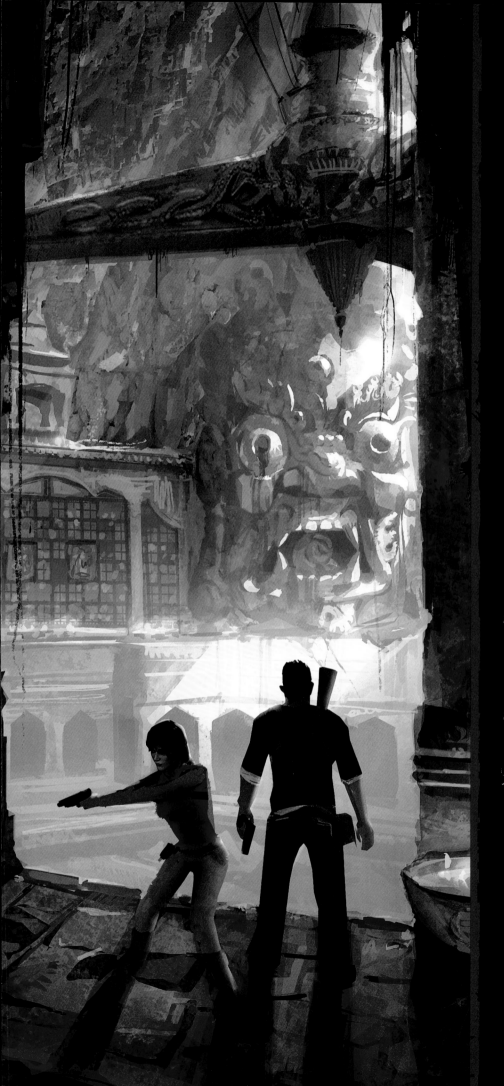

CONCEPT ART
TEMPLE

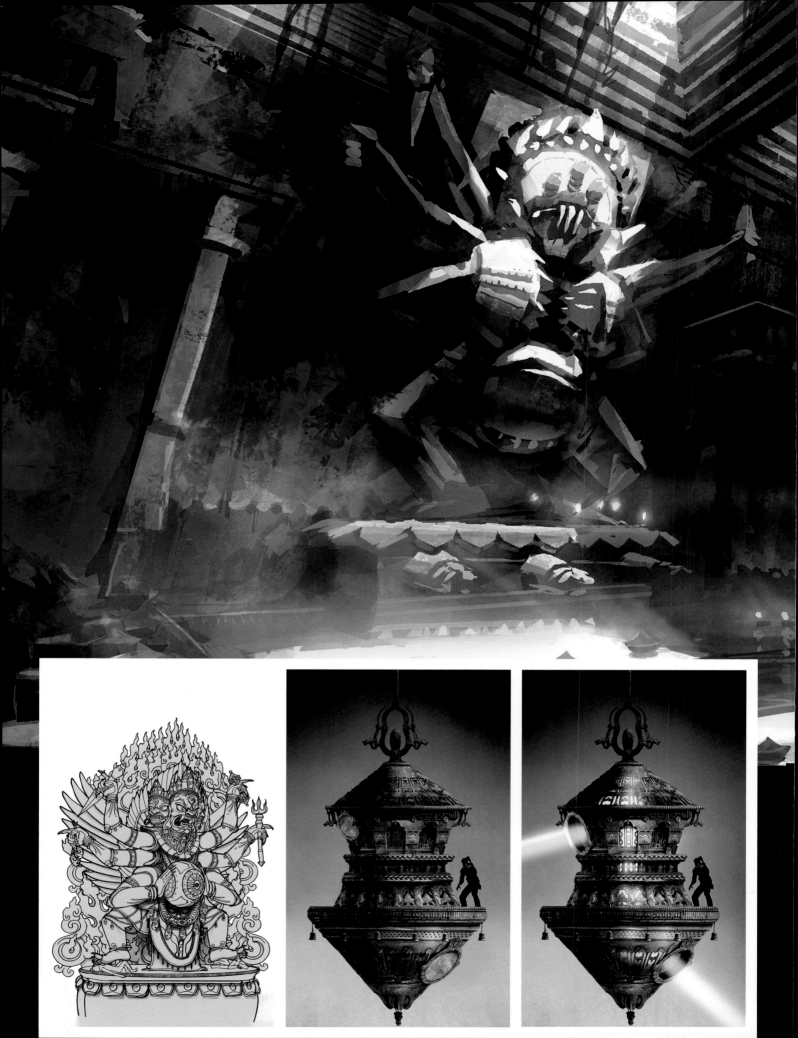

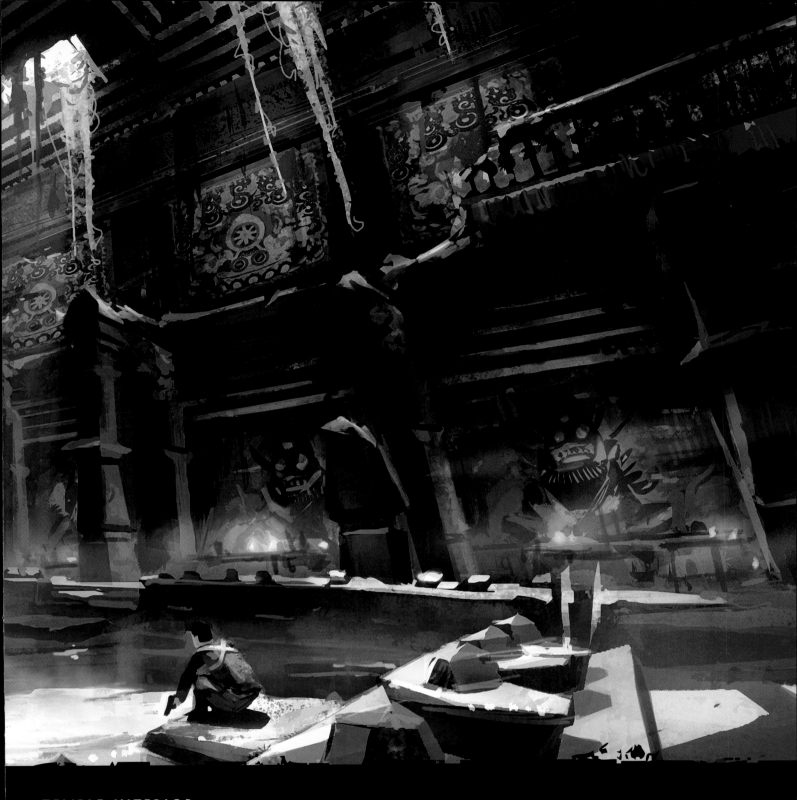

TEMPLE INTERIOR

Inside the temple, we used a lot of imagery of wrathful deities from Buddhist mythology and enhanced them. An example of this is the six-armed statue in the first room. He has a number of moveable parts as part of the puzzle mechanism, and he's holding a huge sphere—details which are combined from different inspirations. The game designers came up with the mechanics of it all, but we had to make it look authentic. We did lots of research, looking at sculptures and Buddhist iconography, and then came up with our own unique design. We elaborated on a wristband design from one statue, and found a mask that we used as inspiration for the face. We dug up lots of sculpture reference, different stone carvings and friezes, and reference for the necklace and earrings—a lot of the ideas came from Tibetan paintings of wrathful deities, with their frightening features. We took all those references and regional influences and modified them to make the statue even more menacing—like something we'd never seen before. So we researched all the details before doing design drawings for everything that we saw. The big stone faces that you find in the final temple room were based on Tibetan masks, but again, they were enhanced to look more interesting.

Temple puzzle room [Shaddy Safadi] *previous spread*
Temple statue sketch [James Paick] *opposite left*
Temple chandelier [James Paick] *opposite right*
Temple entrance room [Shaddy Safadi] *above*

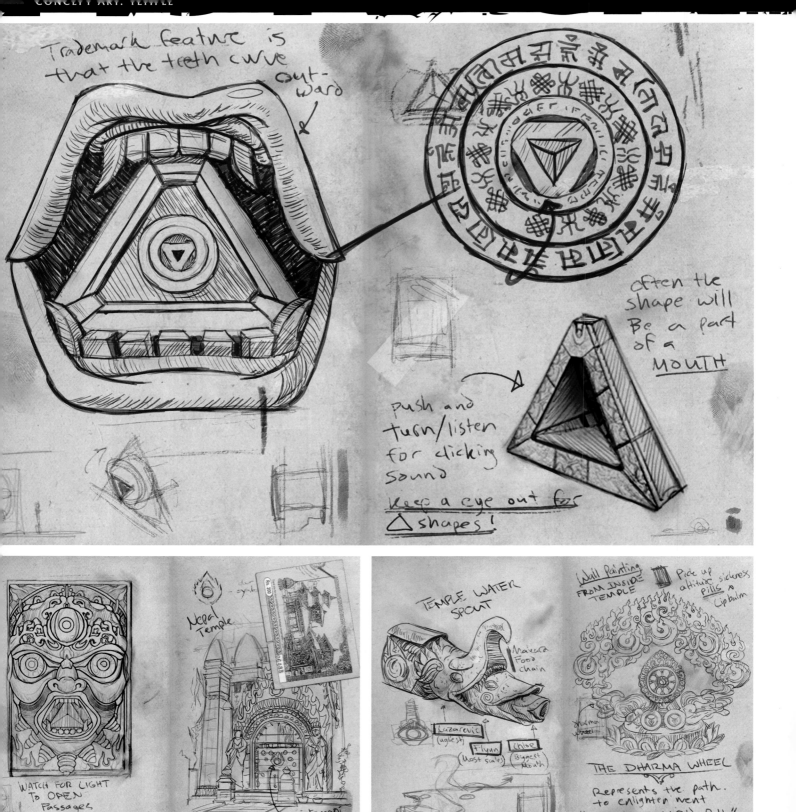

Trademark feature is that the teeth curve outward

often the shape will be a part of a MOUTH

push and turn/listen for clicking sound

Keep a eye out for △ shapes!

WATCH FOR LIGHT TO OPEN Passages

Nepal Temple

Cintamani Stone

TEMPLE WATER SPOUT

Makara Food chain

Lazarevic (ugliest)

Flynn (most scales)

Chloe (biggest Mouth)

Wall Painting FROM INSIDE TEMPLE

Pick up altitude sickness Pills & Lipbalm

THE DHARMA WHEEL

Represents the path to enlightenment "The Noble Eightfold Path"

are completely imagined? Research! I'm really proud of how authentic our statuary feels, while still being unique to the Uncharted world. These are based on a Tibetan mask, but much larger in scale. Formidable.

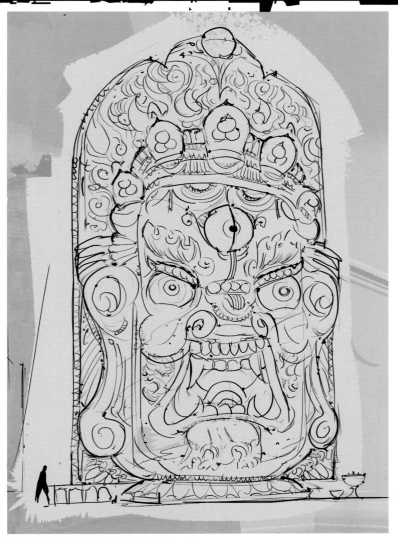

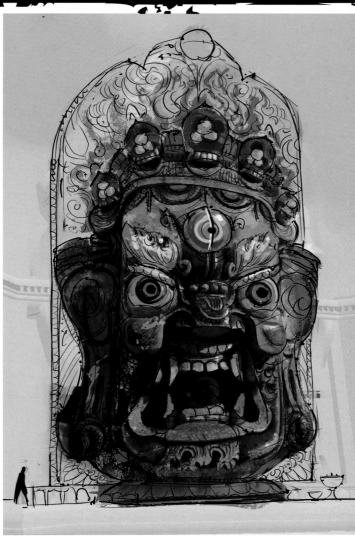

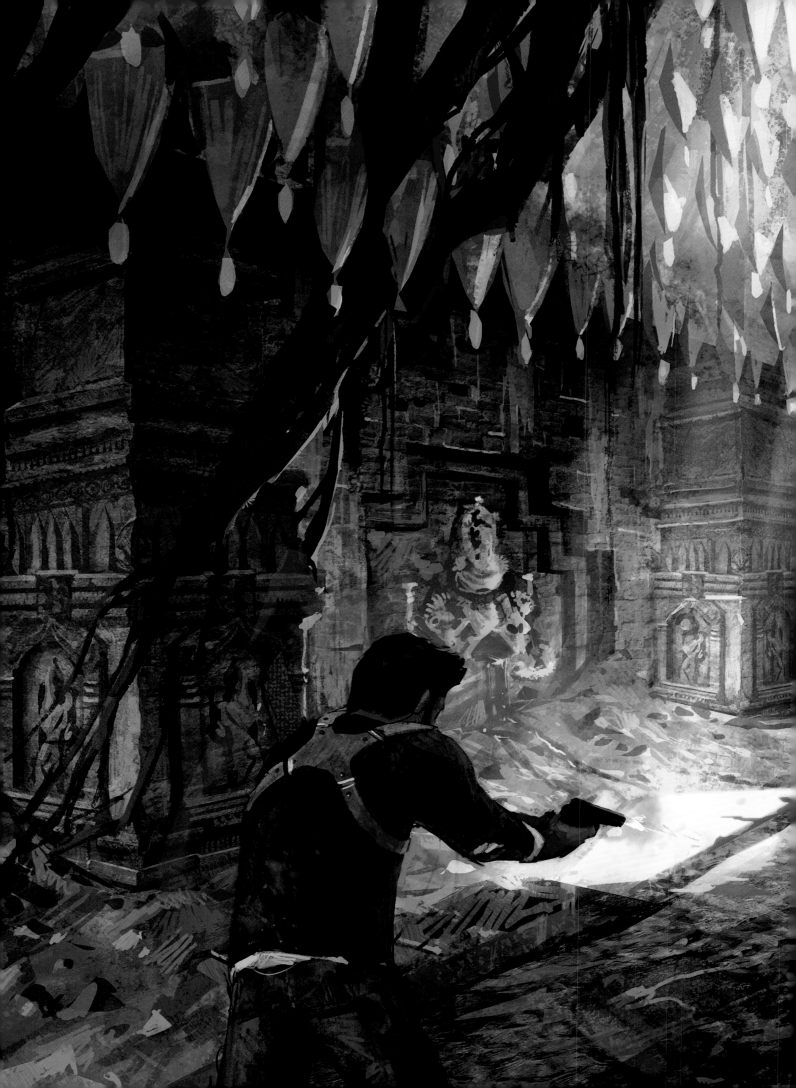

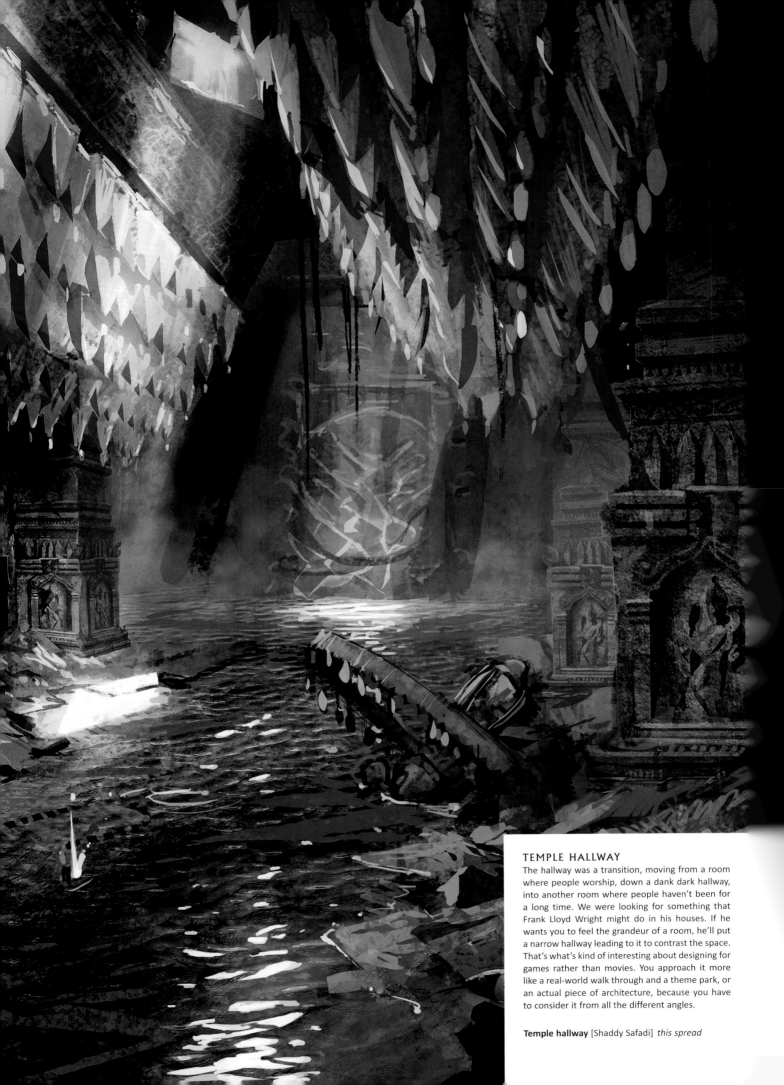

TEMPLE HALLWAY

The hallway was a transition, moving from a room where people worship, down a dank dark hallway, into another room where people haven't been for a long time. We were looking for something that Frank Lloyd Wright might do in his houses. If he wants you to feel the grandeur of a room, he'll put a narrow hallway leading to it to contrast the space. That's what's kind of interesting about designing for games rather than movies. You approach it more like a real-world walk through and a theme park, or an actual piece of architecture, because you have to consider it from all the different angles.

Temple hallway [Shaddy Safadi] *this spread*

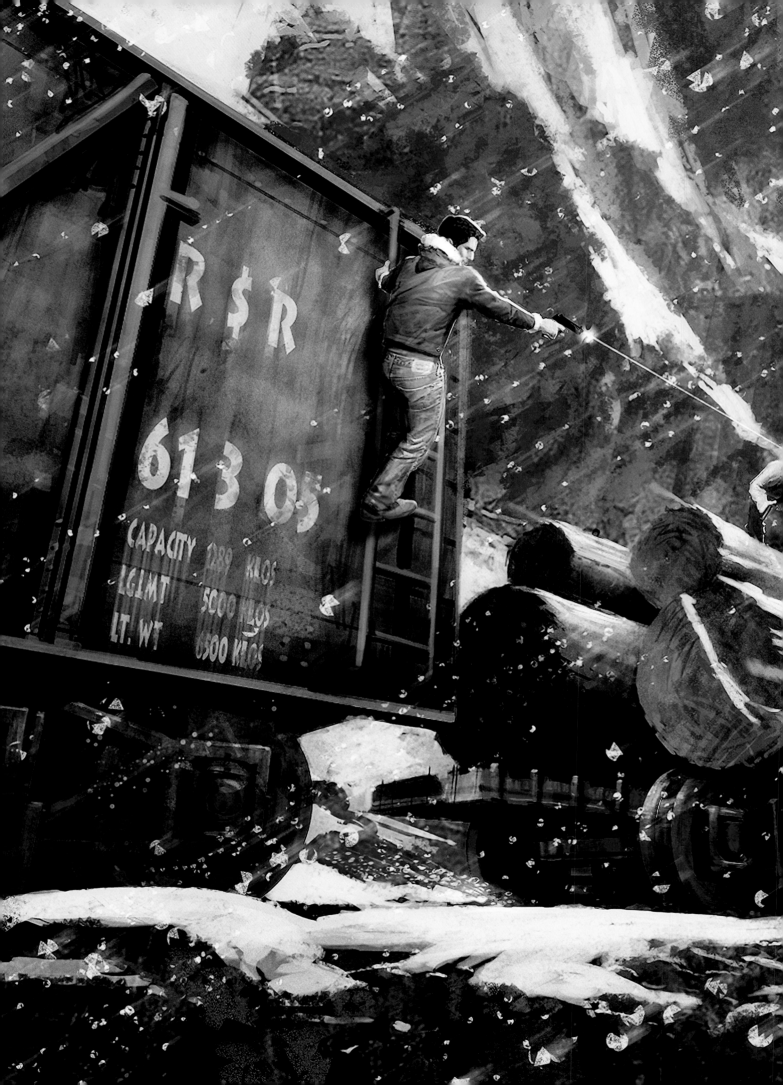

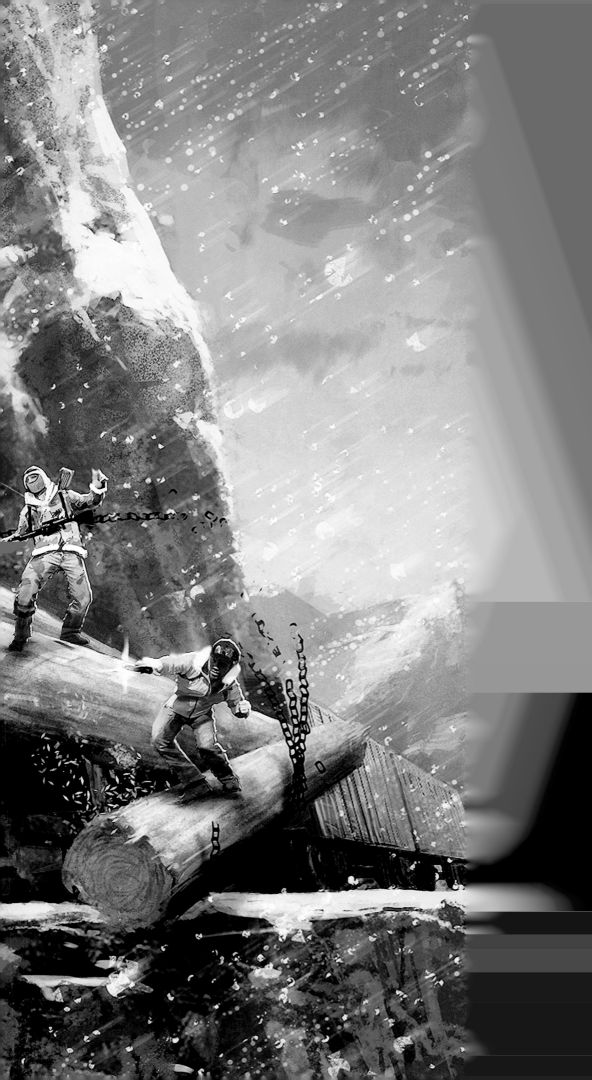

Robh Ruppel
Art Director

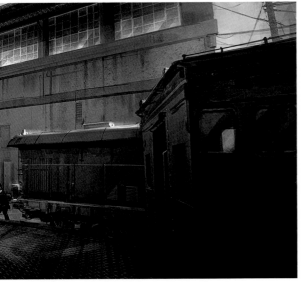

RAILROAD YARD

We started exploring the layout and the types of buildings that one would find in a rail yard environment. They're utilitarian, but there is a type and feel that railroad yards have, too. It's always interesting to find the shapes of functional water towers and coal stations as well as how the ground around the actual tracks is raised and formed. The interior had some specific layout needs, but it was the concept team's job to make it feel like a functioning train warehouse. There's a musty, oily feeling from the photos we saw that I think came through in the art. Big oil machines are stored and fixed here, and it shows.

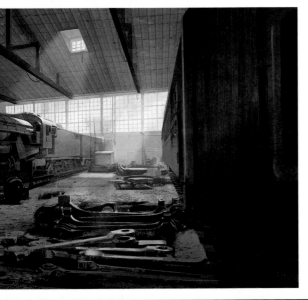

Train fight [Robh Ruppel] *previous spread*
Rail yard vista [James Paick] *top*
Rail yard warehouse [James Paick] *center*
Rail yard warehouse interior [Robh Ruppel] *bottom*
Rail yard repair [Robh Ruppel] *opposite top*
Train battle [Shaddy Safadi] *opposite bottom*

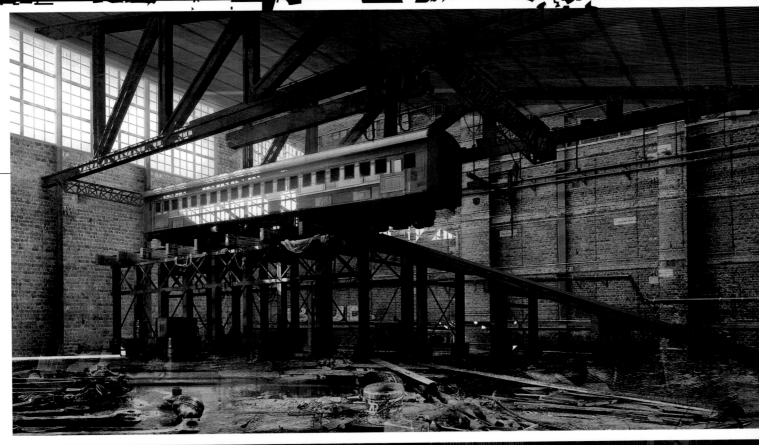

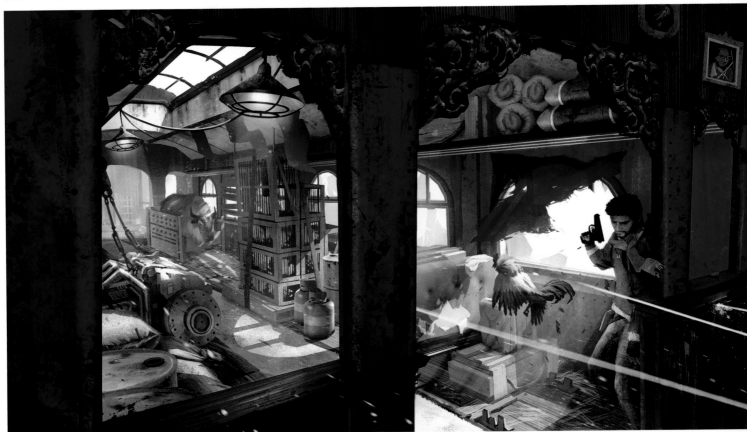

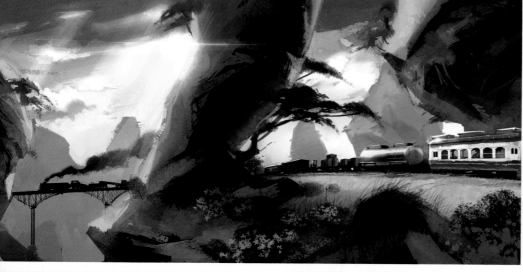

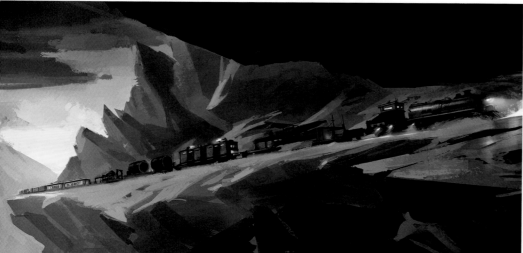

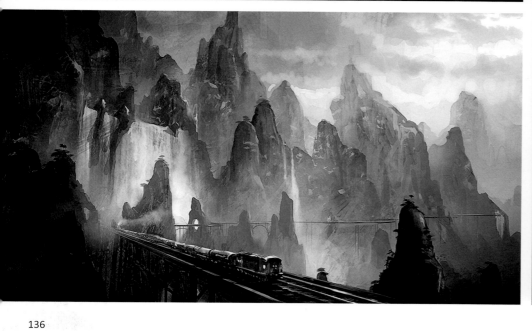

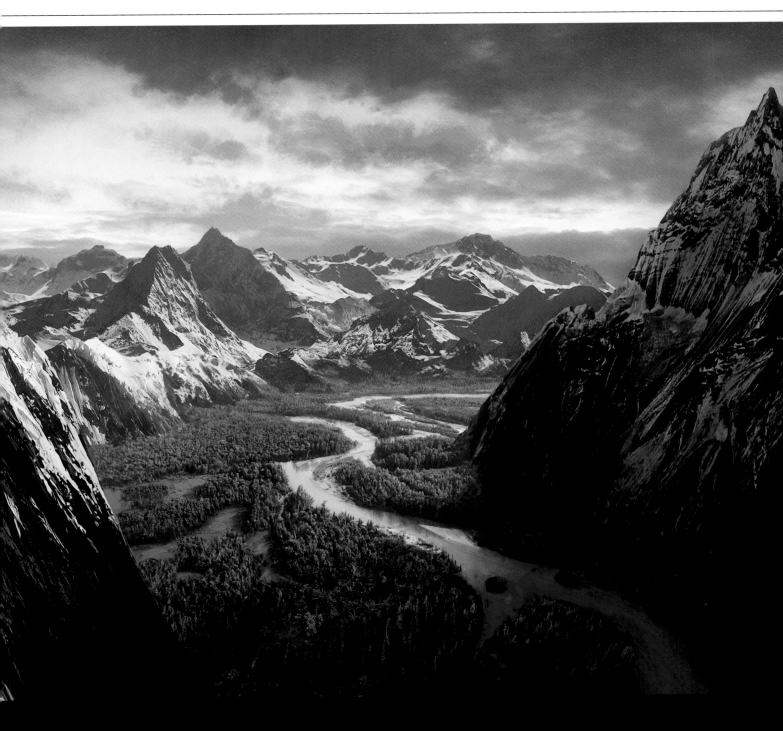

Train valley and bridge [Shaddy Safadi] *opposite top*
Train valley and cliff [Shaddy Safadi] *opposite center*
Train cliffs [James Paick] *opposite bottom*
Train cliff vista [Robh Ruppel] *above*

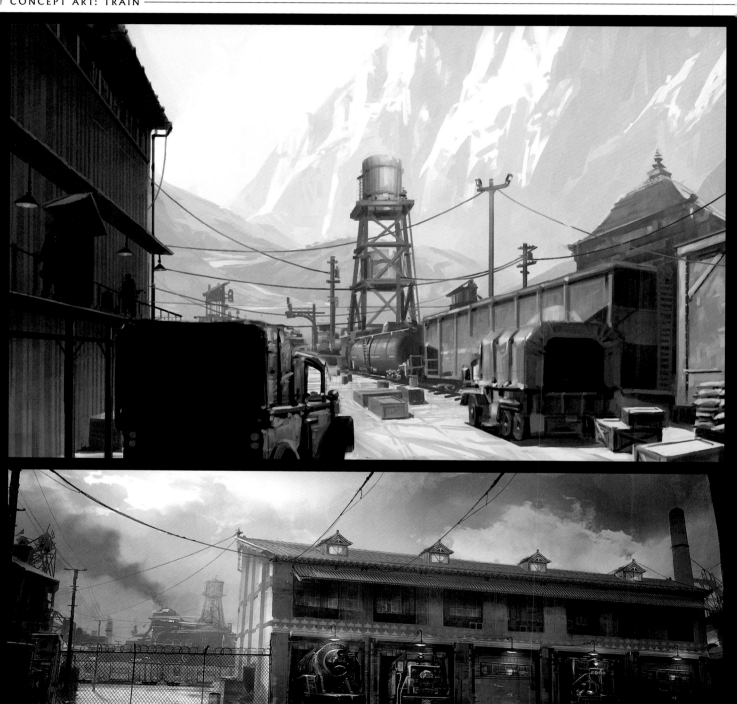

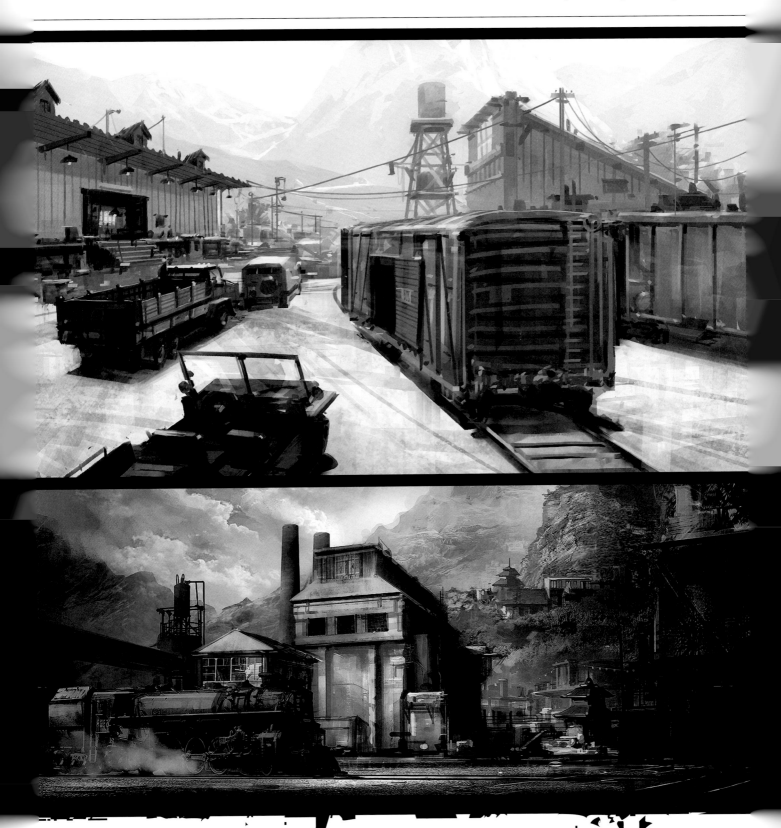

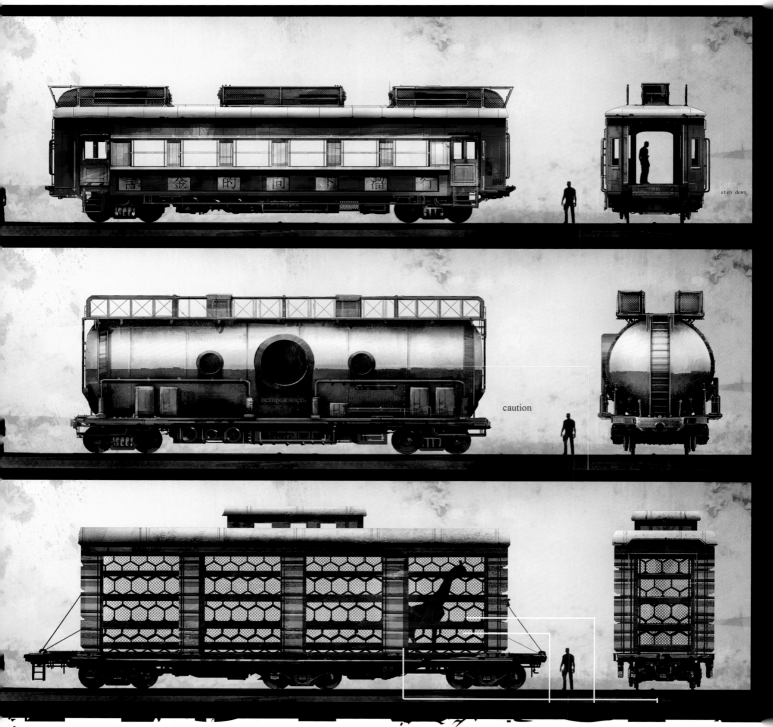

step down

caution

TRAIN CONCEPTS

Train car concepts [James Paick] *this spread*
We wanted the train cars to be unique and interesting, so we came up with a variety of concepts that felt both civilian and military, and vague in origin. Some were Indian/Nepali, some Russian, some Chinese.

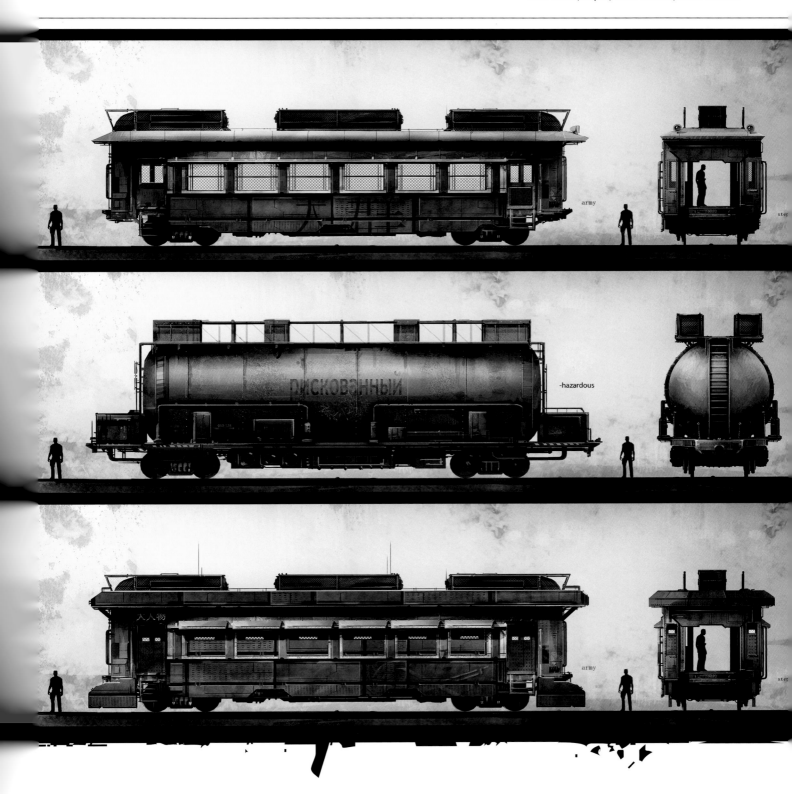

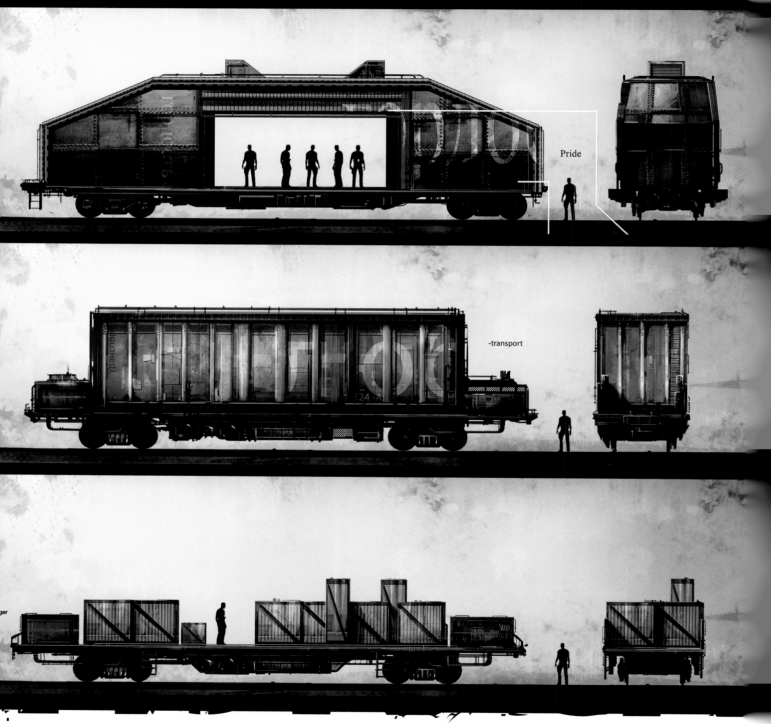

Pride

-transport

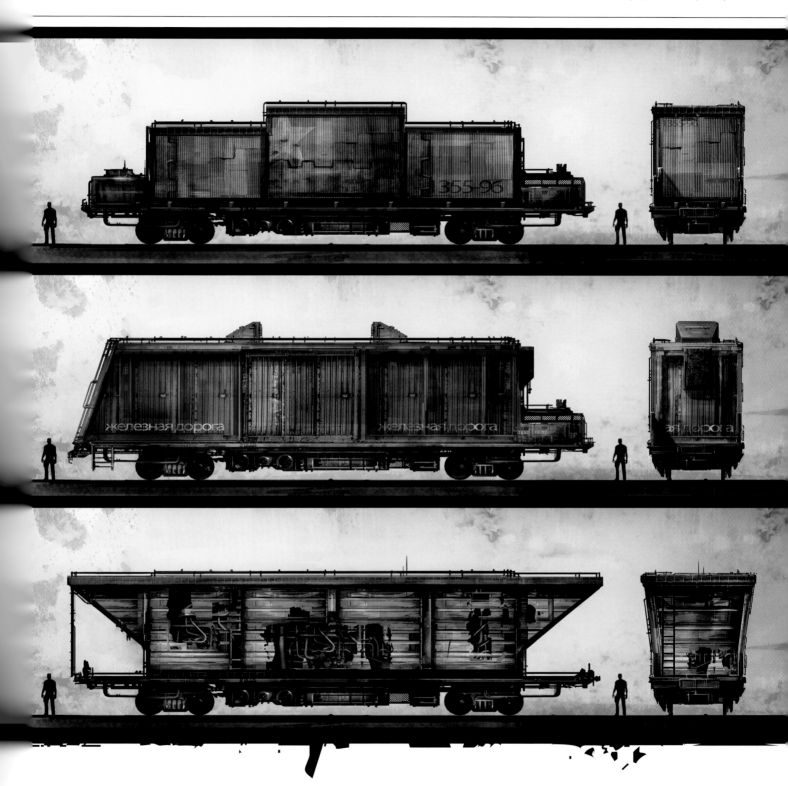

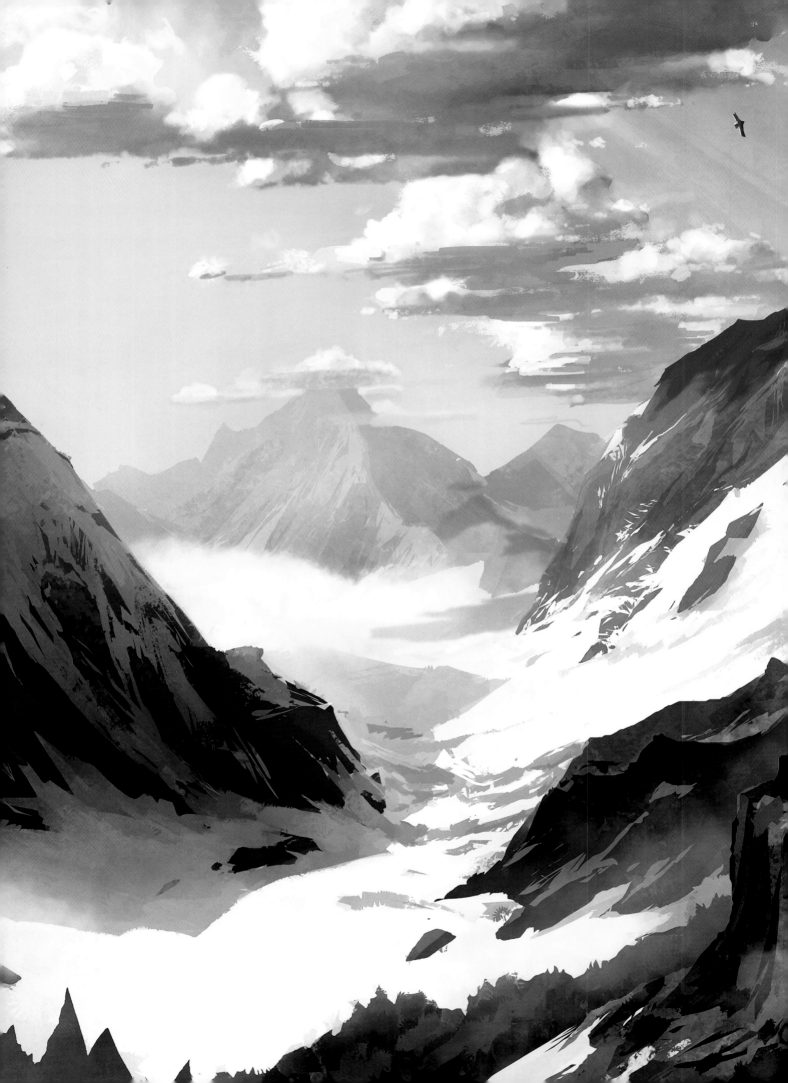

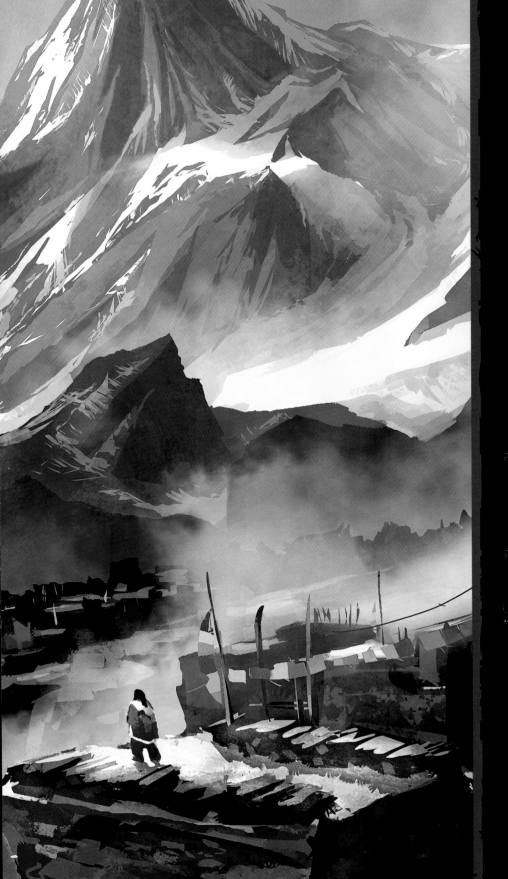

CONCEPT ART
VILLAGE

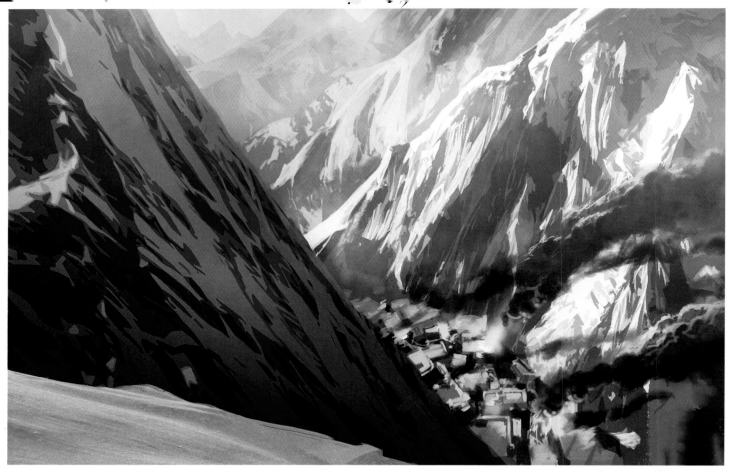

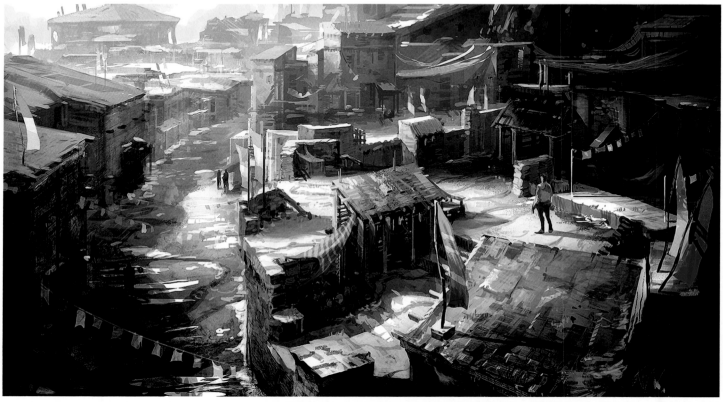

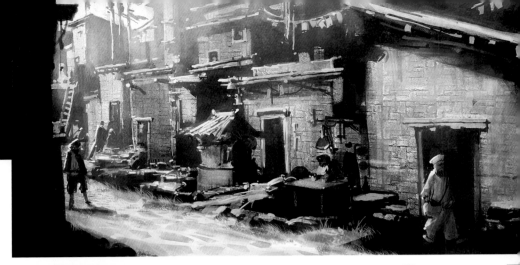

Robh Ruppel
Art Director

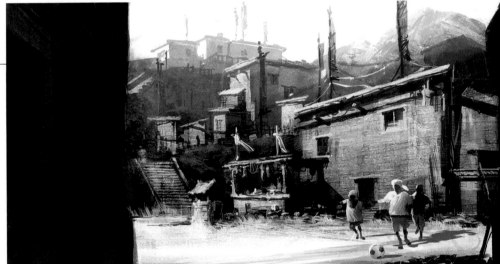

VILLAGE

The village was based on real locations in Tibet and Nepal. There's a long trek that you can take that loops around all these different sites, and one of our programmers went on it and came back and showed us all his photos. We realized he'd actually been to the village that we were studying pictures of online. It's a beautiful village with houses made from stacked stones, and the slate roofs are all flat-ish with a slight angle to them so there's already a really interesting design language established in the architecture. You look at this basic language, and then aim to enhance upon it—maybe make the buildings a little taller, change up the materials and add painted timbers just so it doesn't look so grey everywhere. So that's where the inspiration for the village came from, and then from just looking at tons of photo reference and studying every little detail. What's on the ground around this village? Oh look, they built a little fence here. This is where they stack their firewood, this is where they hang their skins. By studying all these little details you're able to decide what needs to go into your illustration in order for it to look authentic and convincing.

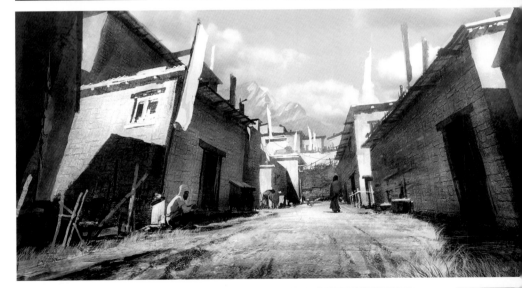

Village vista to cave [Shaddy Safadi] *previous spread*
Village overlook [Robh Ruppel] *opposite top*
Village houses [James Paick] *opposite bottom*
Village sketches [Robh Ruppel] *this page*

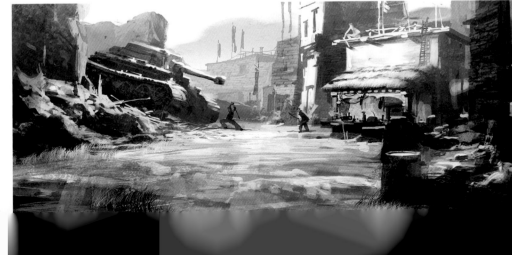

Village garden [James Paick] *top left*
Village courtyard [James Paick] *top right*
Village vista [James Paick] *center left*
Village cliff-side [James Paick] *center right*
Village street [James Paick] *bottom left*
Village steps [James Paick] *bottom right*

CONCEPT ART: VILLAGE

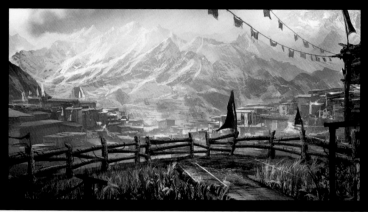 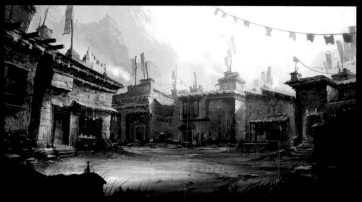

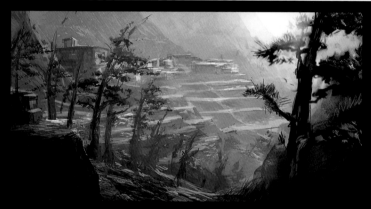 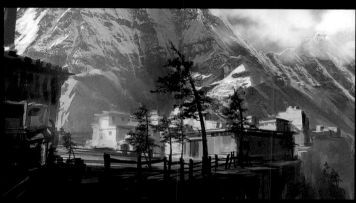

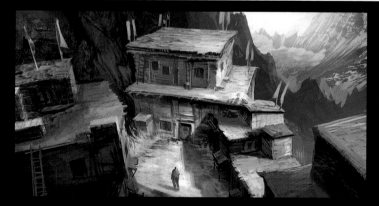 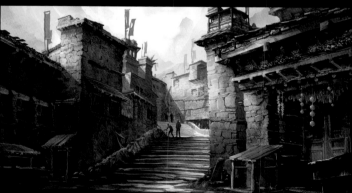

Village house [James Paick] *top left*
Village veranda [James Paick] *top right*
Village house interior [James Paick] *center left*
Village tea house [James Paick] *center right*
Village storage [James Paick] *bottom left*
Tenzin's house [James Paick] *bottom right*

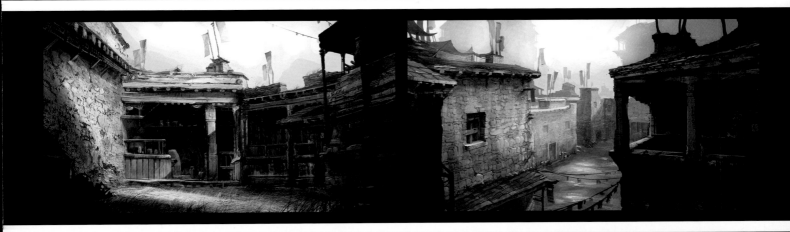

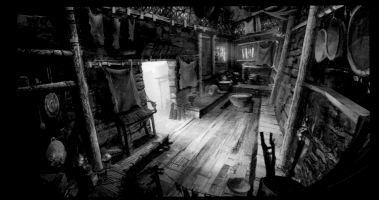

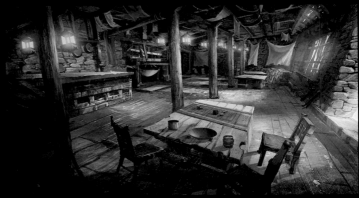

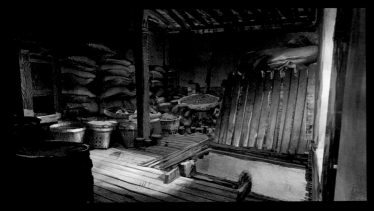

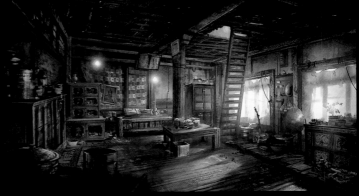

BUILDING A VILLAGE

Uncharted 2's Tibetan Village was partially inspired by real Buddhist villages along the Annapurna Circuit, which winds through the mountains of northern Nepal, near the Tibetan border.

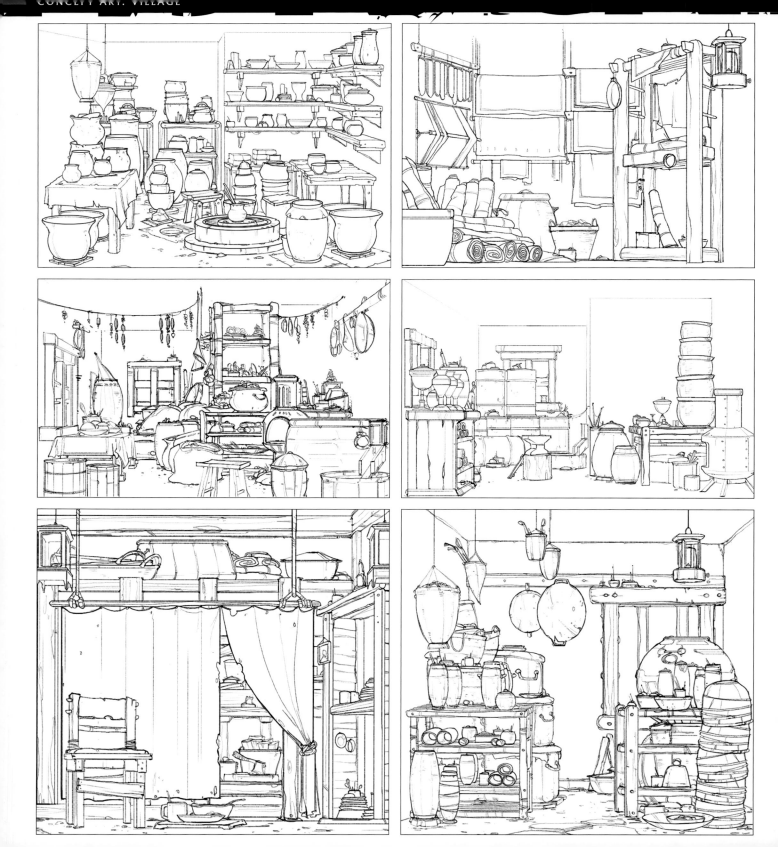

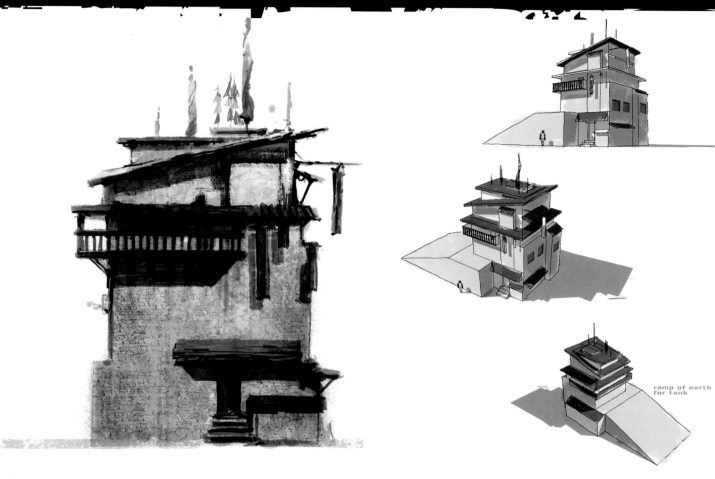

Center building of Village Level

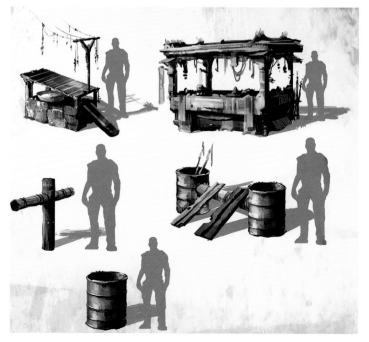

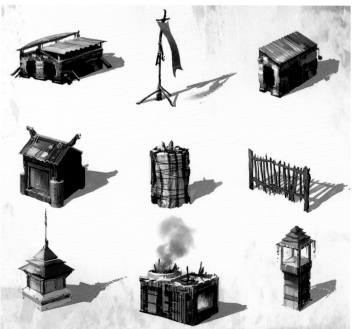

ramp of earth
for tank

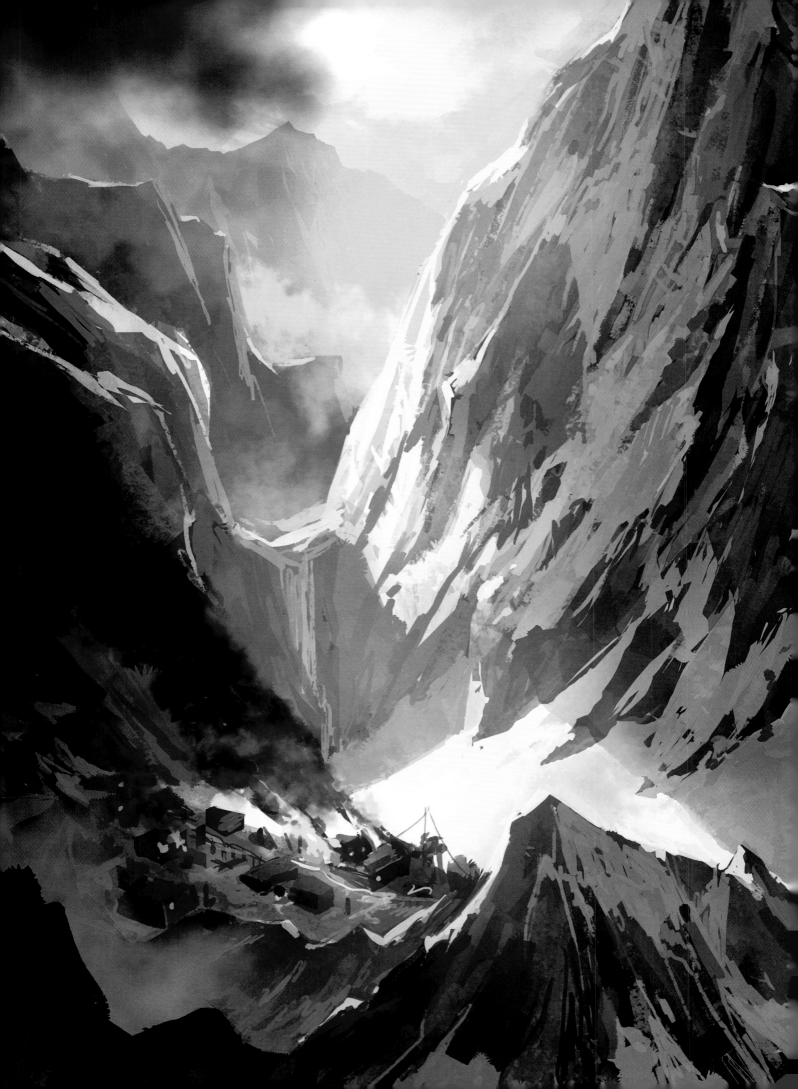

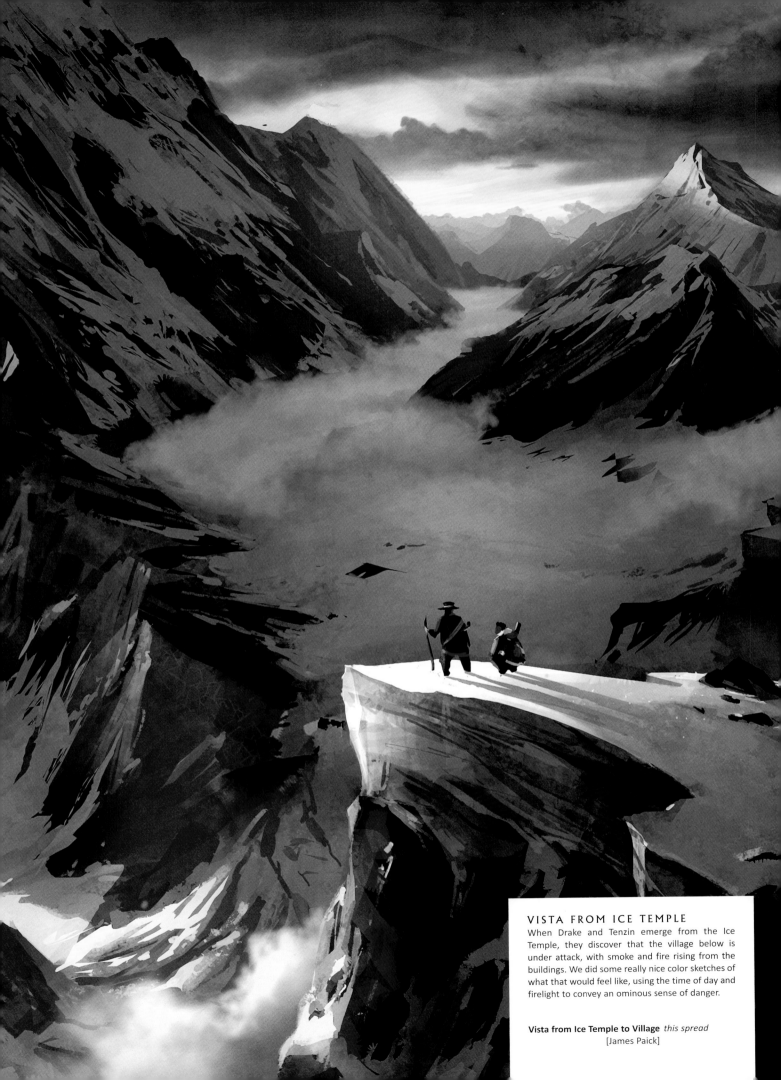

VISTA FROM ICE TEMPLE

When Drake and Tenzin emerge from the Ice Temple, they discover that the village below is under attack, with smoke and fire rising from the buildings. We did some really nice color sketches of what that would feel like, using the time of day and firelight to convey an ominous sense of danger.

Vista from Ice Temple to Village *this spread*
[James Paick]

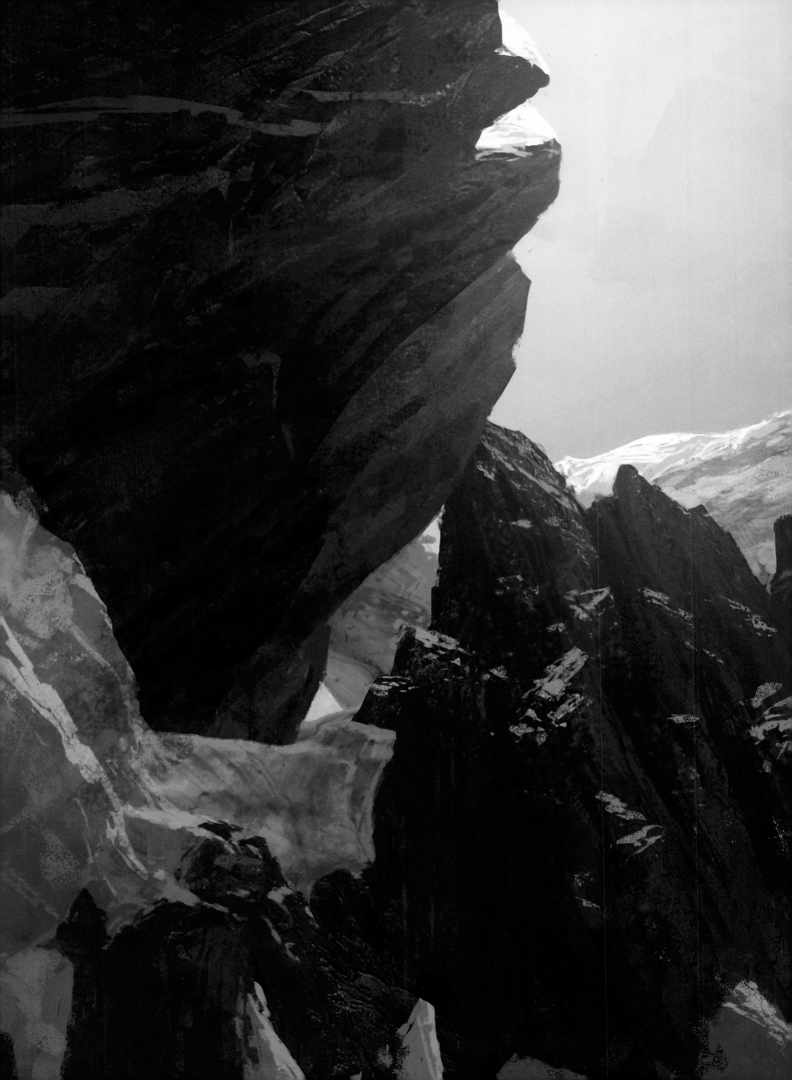

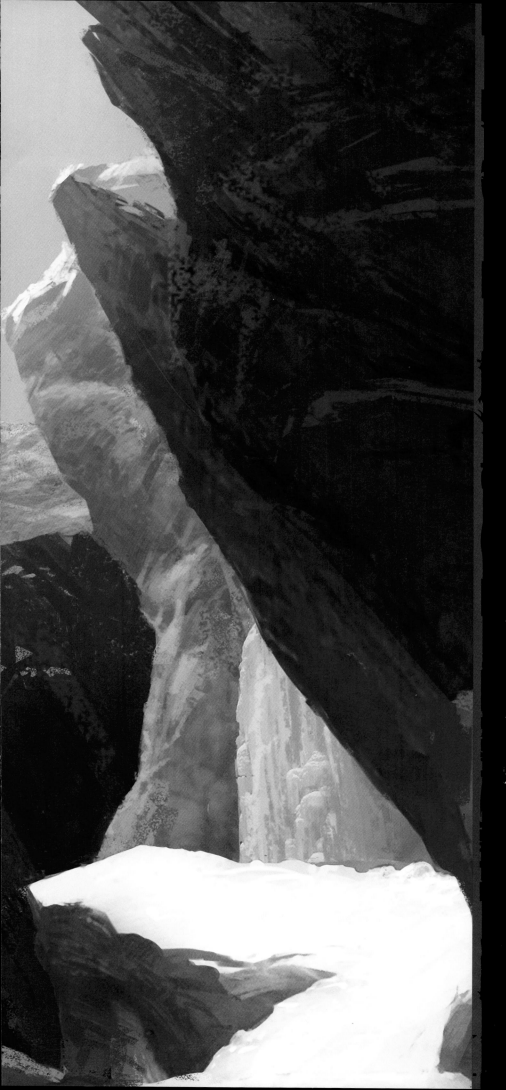

CONCEPT ART
ICE CAVE

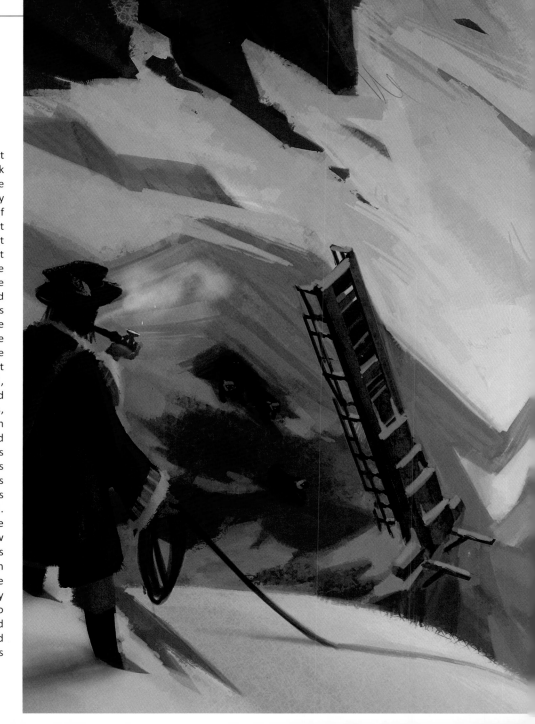

Robh Ruppel
Art Director

ICE CAVE

Creating the Ice Cave was fun but challenging. Trying to get the ice to look translucent, and trying to get a subsurface scatter effect in the snow without really doing subsurface scattering was a bit of tech that our programmers handled. But you know none of that stuff works the first time you try it. You do a pass, you look at it—it's too shiny or too blue—and decide that we need to see some iridescent sparkle on the top. How can we do that? We talked to the programmers about what snow is like, and asked them how we could make the shaders do what we wanted. For the longest time the snow and ice looked a little metallic, so it took a while to dial in the right settings. Every time the lighting changed, so too would the settings for the snow and ice. The lighters were working on the levels, and the texture designers were working on it at the same time. A lighter will go in and put some blue lights in, which then affects the snow and ice shaders. Now the snow is looking different, and the texture artist has to go back in and change the parameters to make it look completely flawless again. People playing the game have no idea the number hours we go through, saying: "How can we make this work? Why isn't this working?" It's literally hours of discussion and going back and forth, but I think more than anything that's what makes Naughty Dog really unique in that we're willing to go through all those iterations. It's an accepted part of the development culture here, and that's personally why I think the games come out to be so good.

Ice Cave concept [Robh Ruppel] *previous spread*
Ice Cave leap [Shaddy Safadi] *this spread*

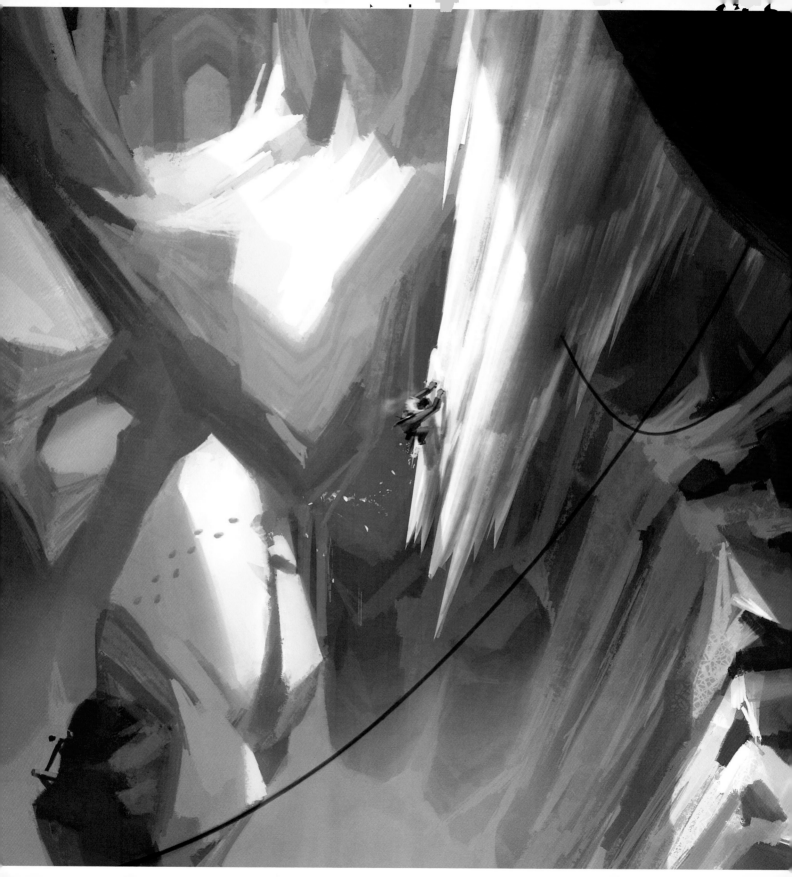

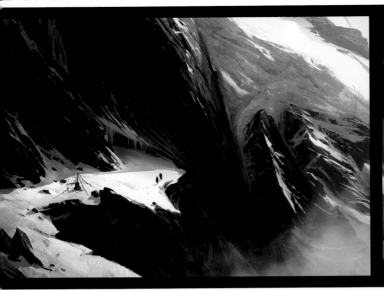

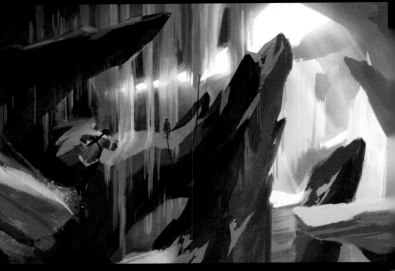

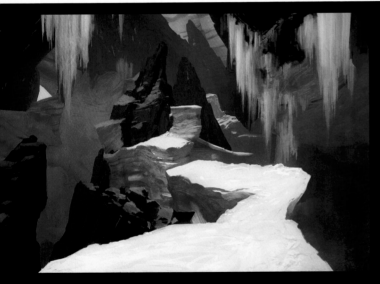

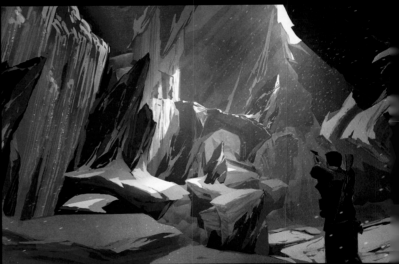

Ice cave ideation [Shaddy Safadi] *top left*
Ice cave ideation [Shaddy Safadi] *top right*
Ice cave ideation [Shaddy Safadi] *bottom left*
Ice cave bridges [Shaddy Safadi] *bottom right*

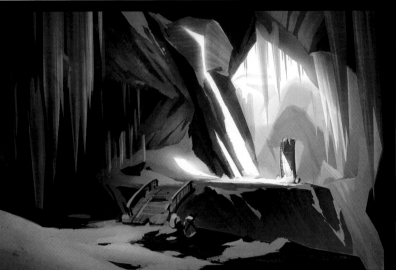
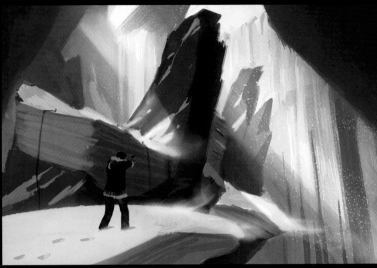
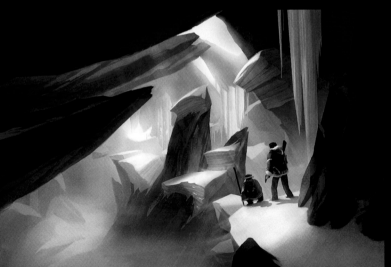
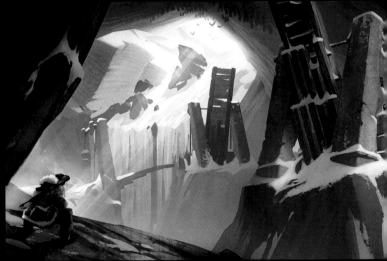

INSIDE THE ICE CAVE

This was one of the first areas we worked on, and it required a lot of work to get all the organic, natural details to work. Ice and snow are extremely complex in their patterning, shapes and surface properties, so it took a lot of tweaking before they looked believable.

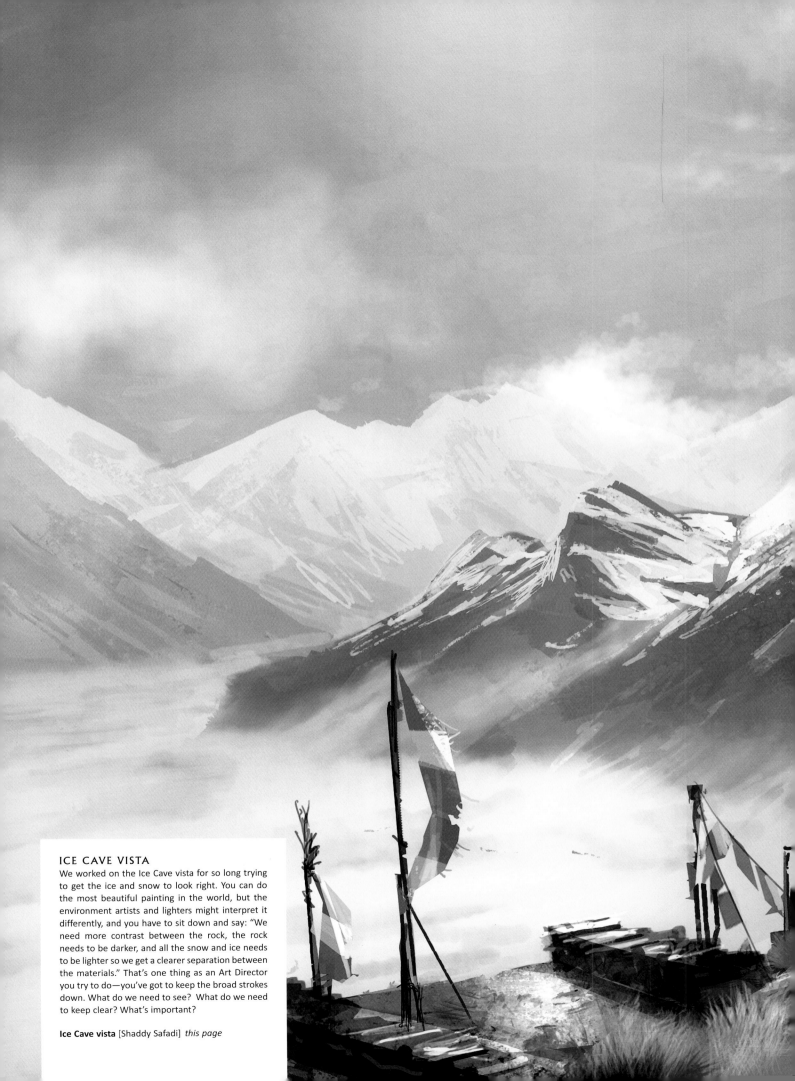

ICE CAVE VISTA
We worked on the Ice Cave vista for so long trying to get the ice and snow to look right. You can do the most beautiful painting in the world, but the environment artists and lighters might interpret it differently, and you have to sit down and say: "We need more contrast between the rock, the rock needs to be darker, and all the snow and ice needs to be lighter so we get a clearer separation between the materials." That's one thing as an Art Director you try to do—you've got to keep the broad strokes down. What do we need to see? What do we need to keep clear? What's important?

Ice Cave vista [Shaddy Safadi] *this page*

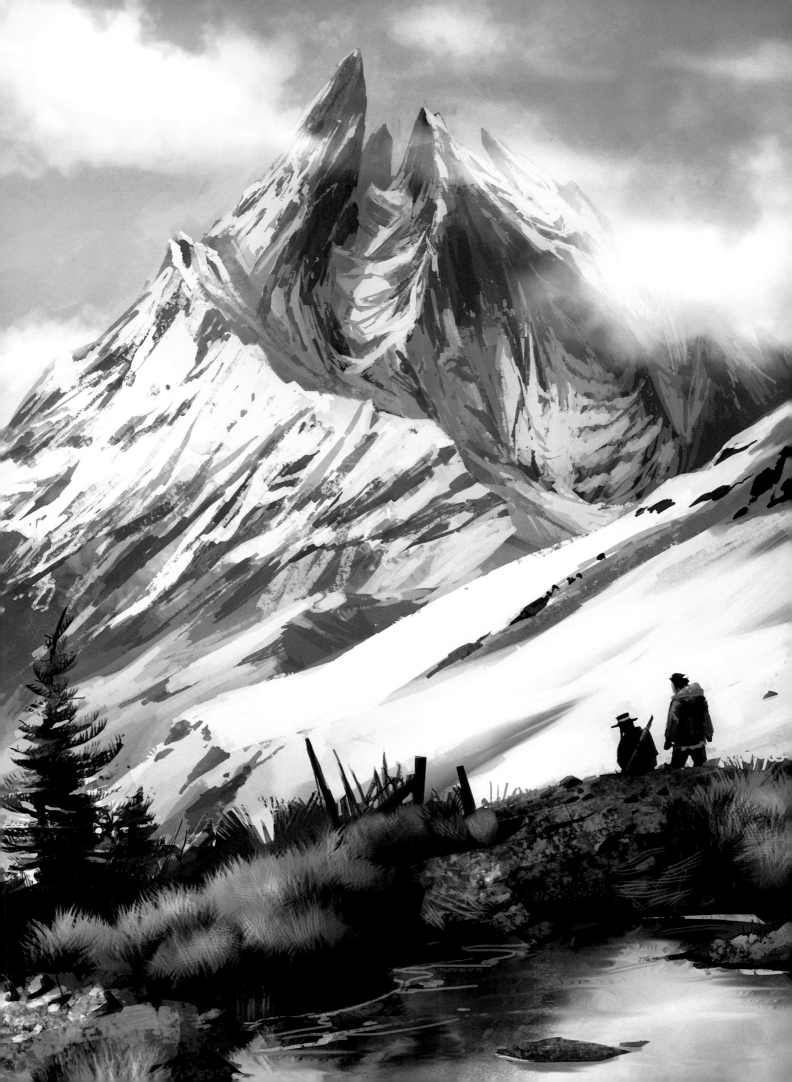

Ice Cave rocks [Shaddy Safadi] *opposite top*
Ice Cave gate [Andrew Kim] *opposite bottom*
Ice Cave stupa [Shaddy Safadi] *this page*

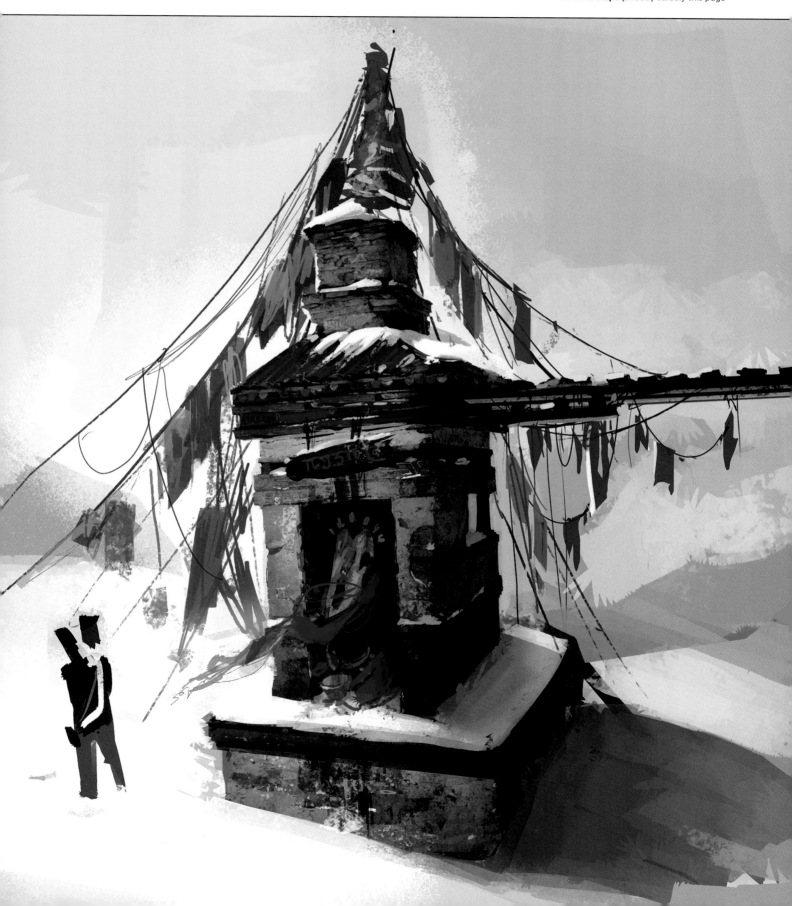

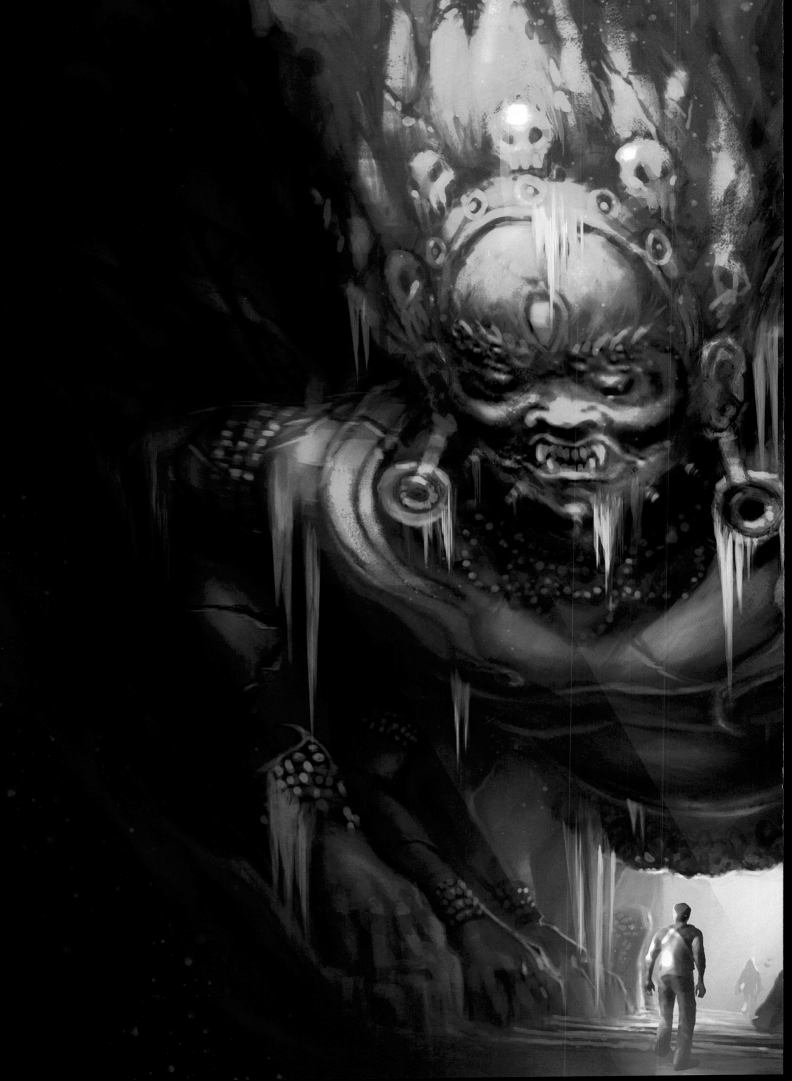

CONCEPT ART
ICE TEMPLE

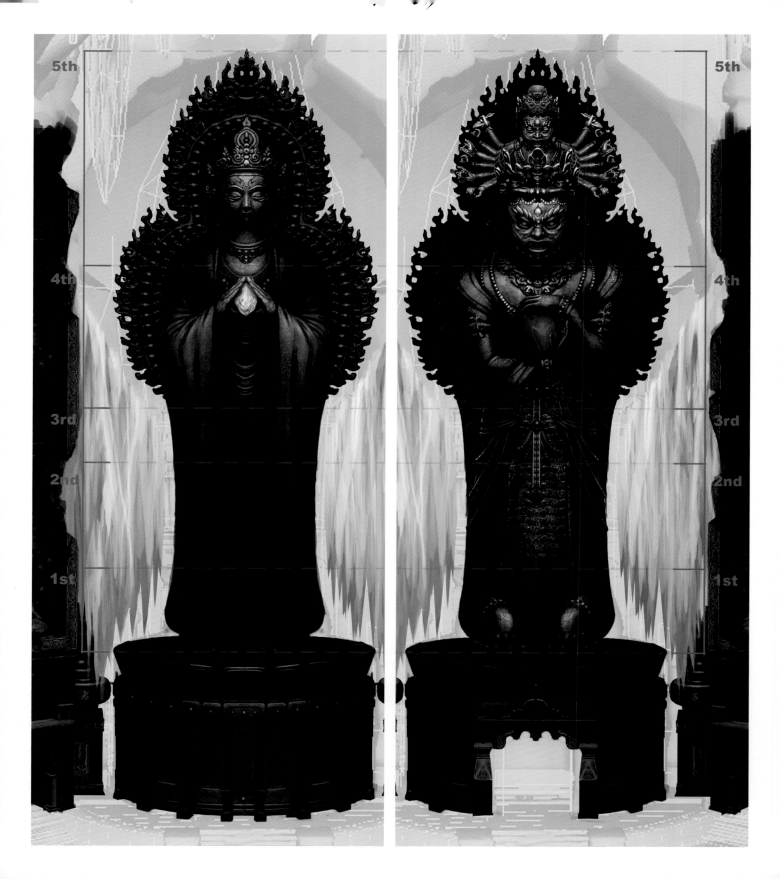

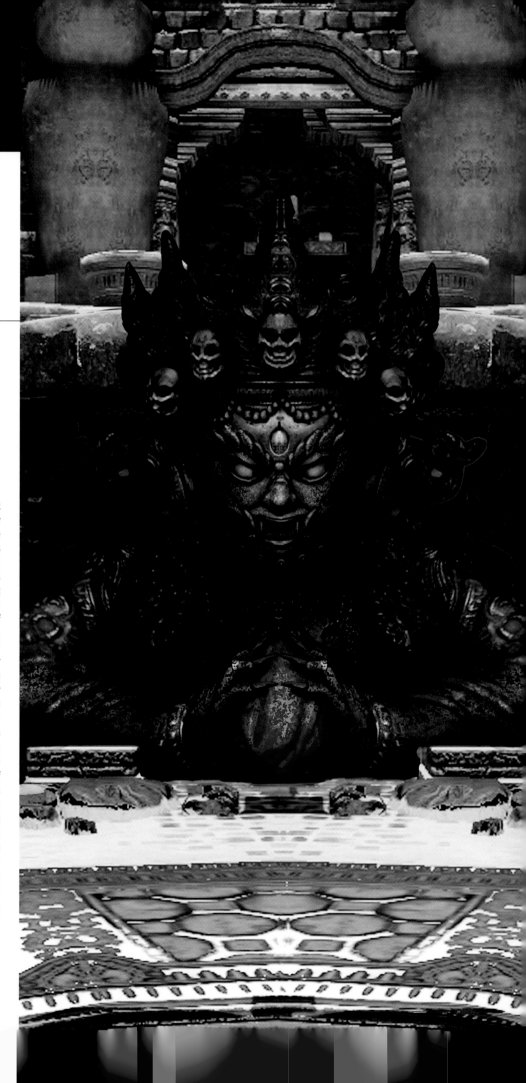

Robh Ruppel
Art Director

ICE TEMPLE

Andrew Kim produced amazing concept work for the Ice Temple. He was one of the new guys who came on, and we knew that we needed a bunch of concepts for the puzzles and statues in this area. Andrew did a ton of research into Tibetan Buddhist objects and iconography. He actually designed most of the massive statues and sculptures in the game, and he did a fantastic job of interpreting existing reference materials. He would look at Buddhist statues and carvings from all over the world, study their clothing and ornateness, and extrapolate that to create original pieces of artwork for the game that felt exactly like they came from that time period and location. This is a unique talent; that kind of skill is worth its weight in gold. Every time we had a statue to design, I always gave it to him because he did such an excellent job. At the end of the Ice Temple we had these twin statues where one is good, and one is meant to represent evil. It's the same basic pose, but they're very different in terms of all the details he worked into them. He did a great job not only with color but textural detail in the design and his renderings. His stuff was so thorough that we could send it right out to the modelers, and it would come back looking exactly like his concepts. I just love that kind of attention to detail.

Ice Temple entrance [Andrew Kim] *previous spread*
Ice Temple Guardian [Andrew Kim] *opposite page*
Ice Temple final room [Andrew Kim] *this page*

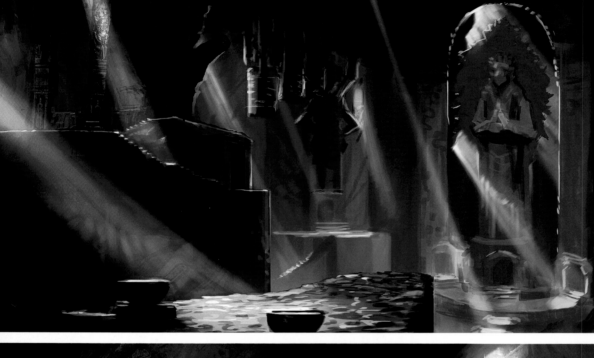

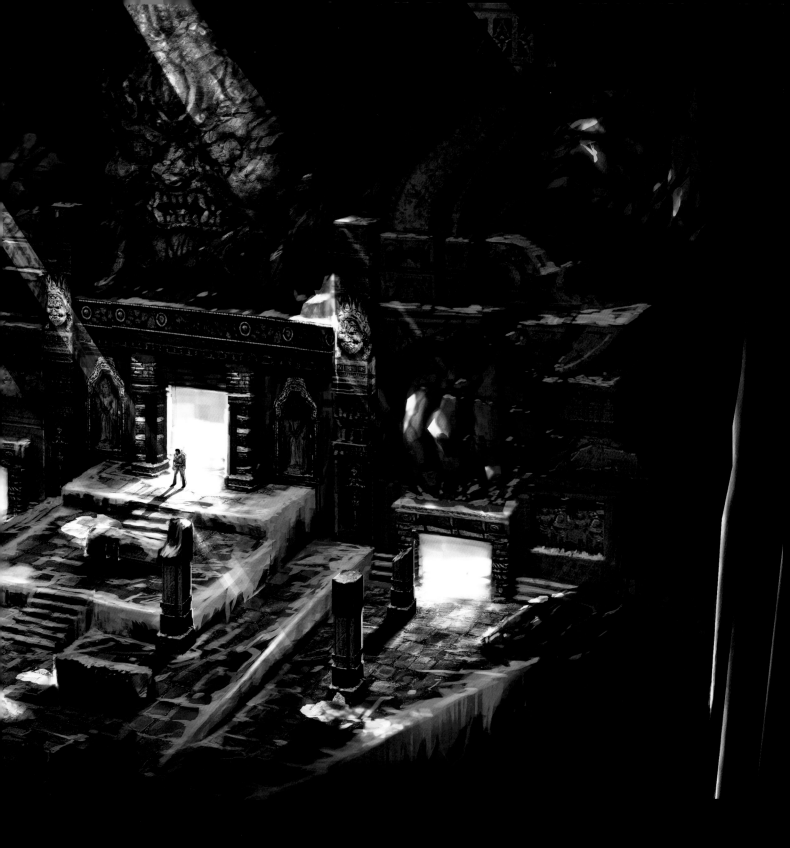

ICE TEMPLE INTERIOR

These are examples of the kinds of designs we created to work out the puzzles in this area. We needed a lot of concepts to figure out how all the individual pieces fit into the larger whole.

Ice Temple ideation [Andrew Kim] *opposite top*
Ice Temple arrival [Andrew Kim] *opposite bottom*
Ice Temple wide shot [Andrew Kim] *above*

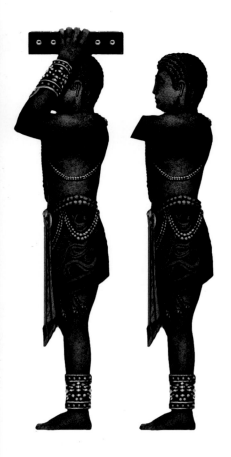

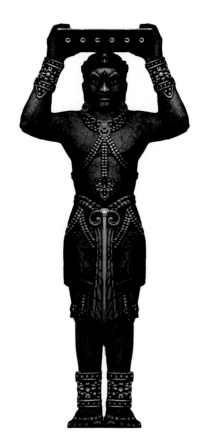

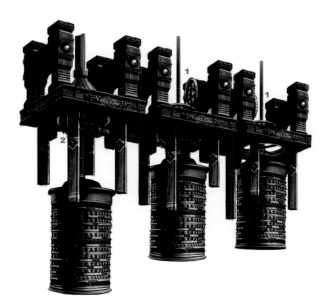

A

B

ICE TEMPLE STATUES

These are the designs working out the puzzle that went into this area. It was to work out how the individual pieces fit into the whole.

Ice Temple tablet statue [Andrew Kim] *top left*
Ice Temple prayer wheels [Andrew Kim] *top right*
Platform-support statue [Andrew Kim] *right*
Ice Temple support statues [Andrew Kim] *opposite top*
Arm-bridge statues [Andrew Kim] *opposite bottom*

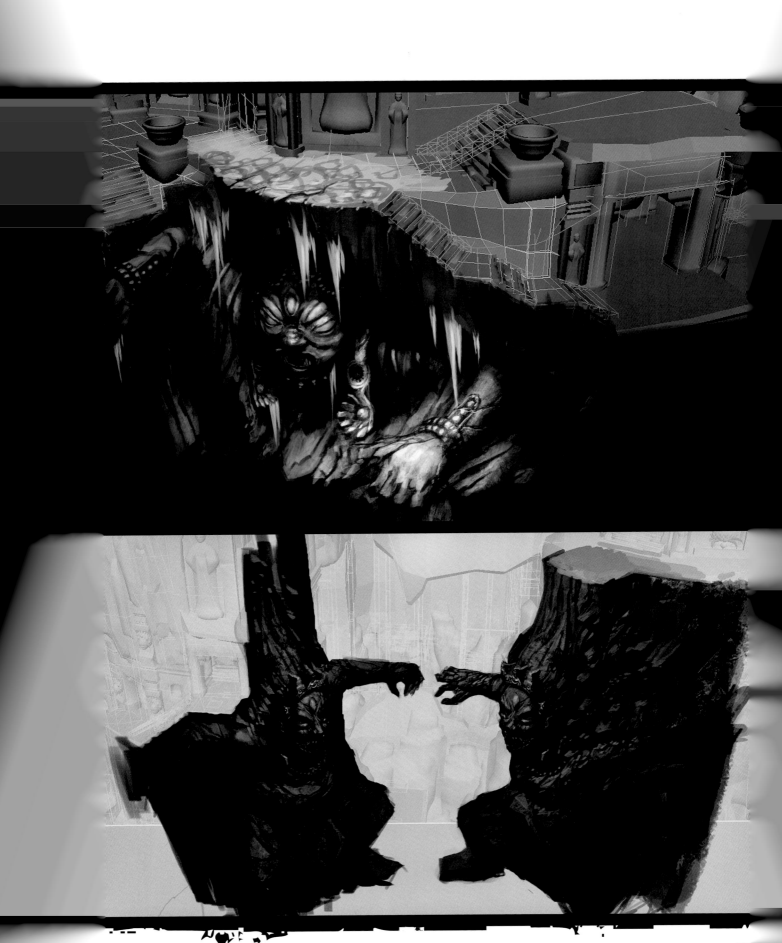

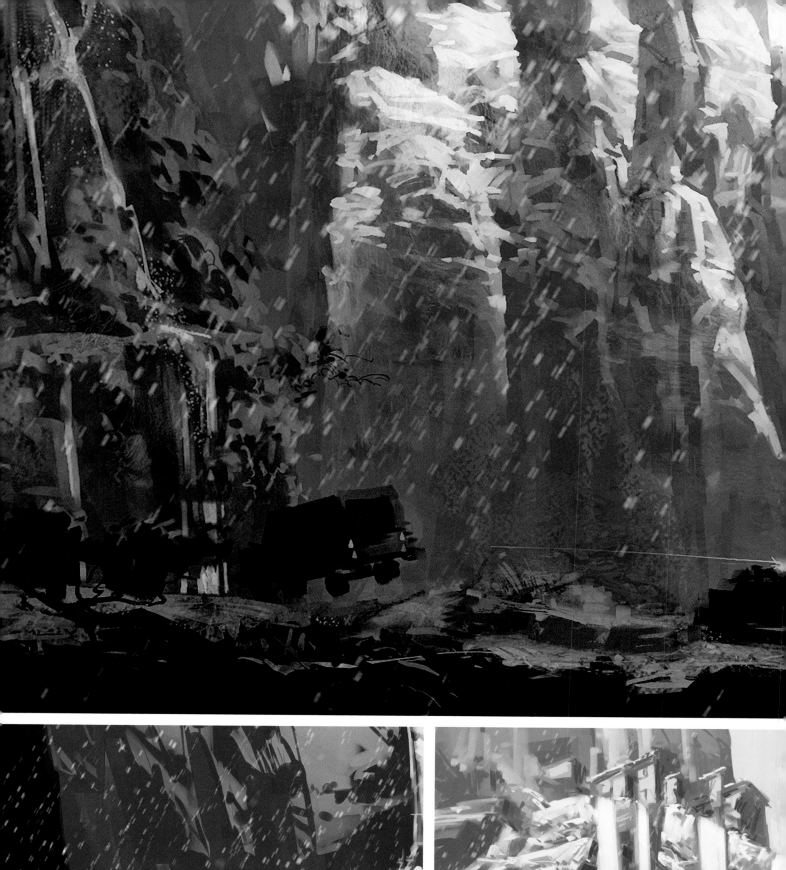
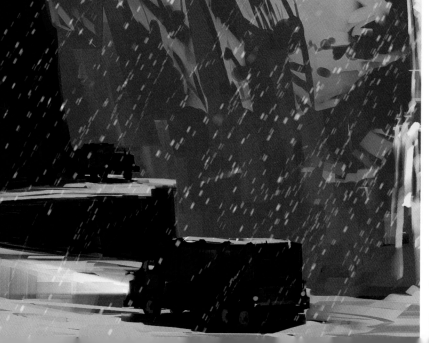
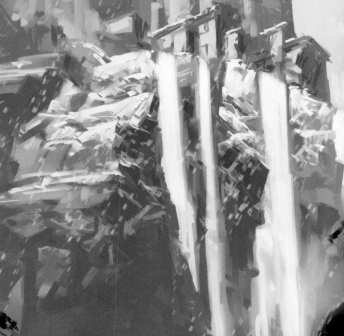

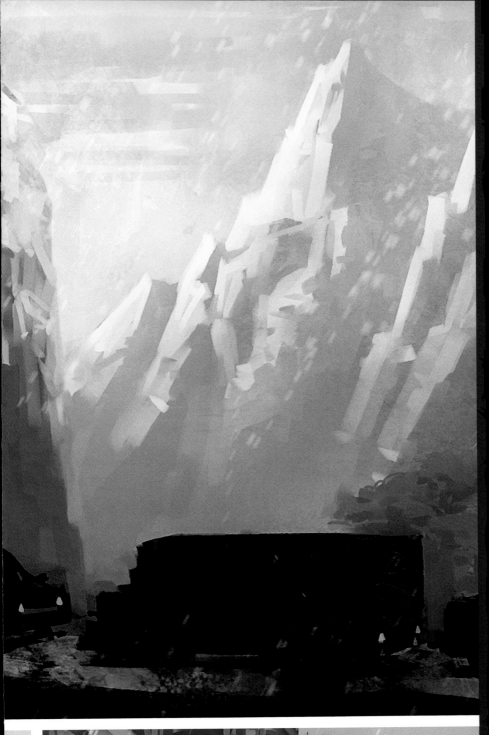

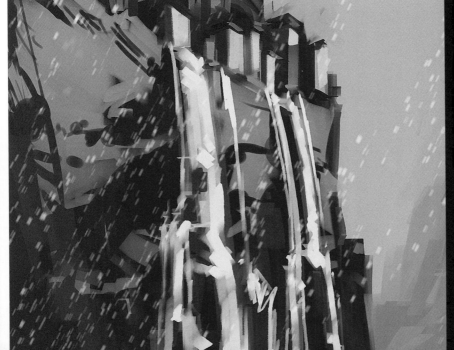

Introduction

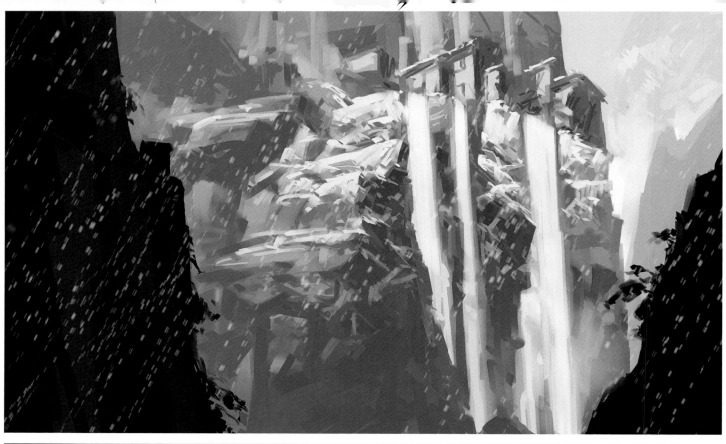
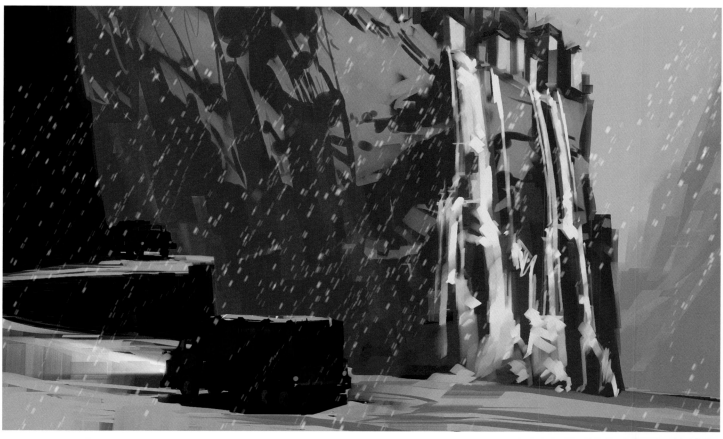

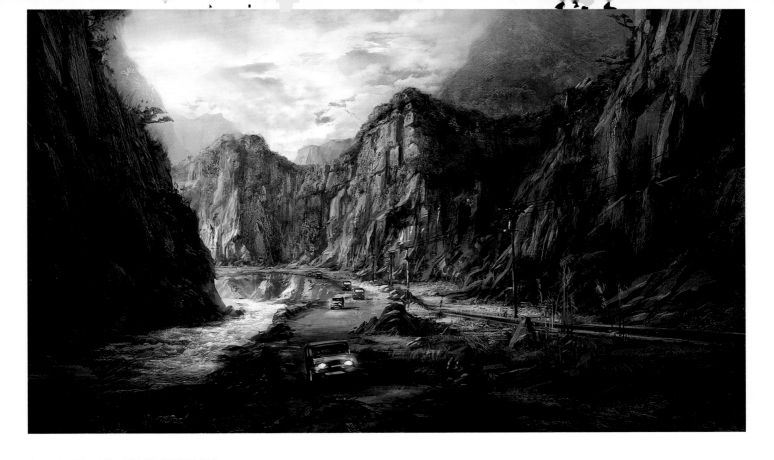

Robh Ruppel
Art Director

Convoy concepts [Robh Ruppel] *previous spread*
Convoy concepts [Robh Ruppel] *opposite page*
Convoy ideations [James Paick] *this page*

CONVOY

The Convoy is another transition level from one area to another. The challenge with this level was just keeping things looking unique and coming up with the rocks and stones that you have to drive around that are repeatable, but yet don't look too repetitious. In the distance, you always see the Monastery so every time you come around another corner you get a little bit closer. We create a sense of urgency, a need to jump to the next truck because the destination is looming, and Drake doesn't have much time to reach the head of the convoy to rescue Schäfer. Coming up with the big utilitarian trucks was also a challenge, and once again all this stuff has to be designed with gameplay in mind. You can't just say, "I'll put a truck in there." Everything has to be thought through, and you have to understand its use and its purpose. You have to come up with shapes and colors that both support the narrative and enhance the gameplay. It's also not enough to say, "It's a road." What kind of road? How long has it been there? What's it made out of? Is it eroded? What kind of erosion, how much? What's the vegetation like? Specifically! Exact plant types? Where do they grow? Are they sparse or full? So many details need to be answered by the concept art.

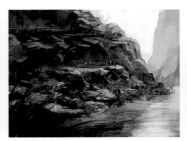
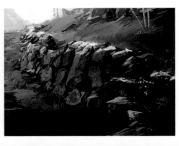

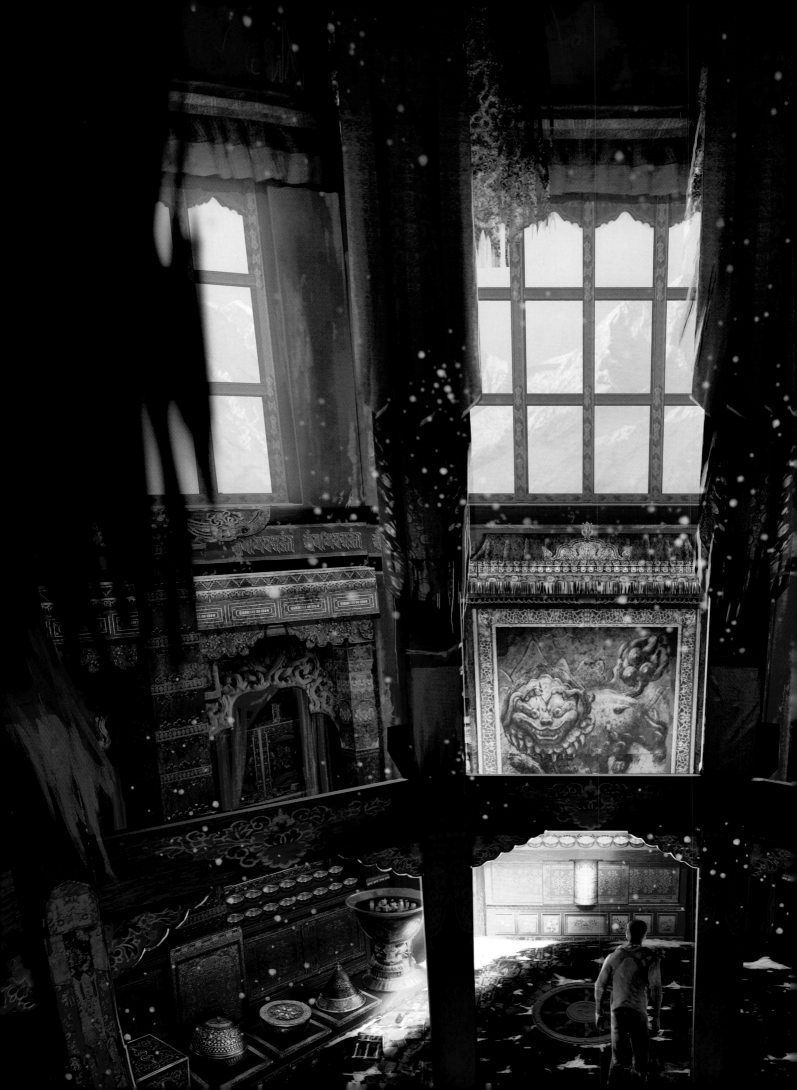

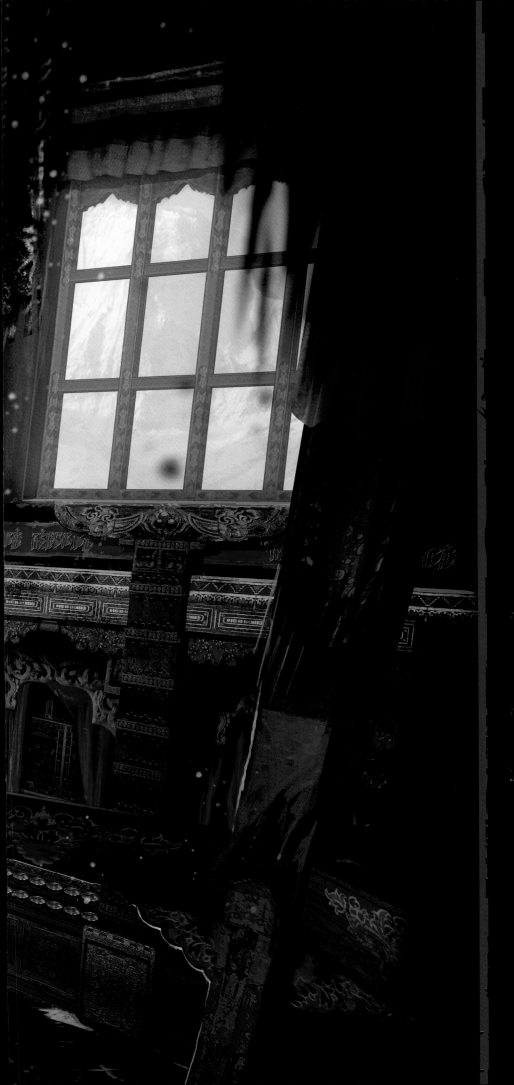

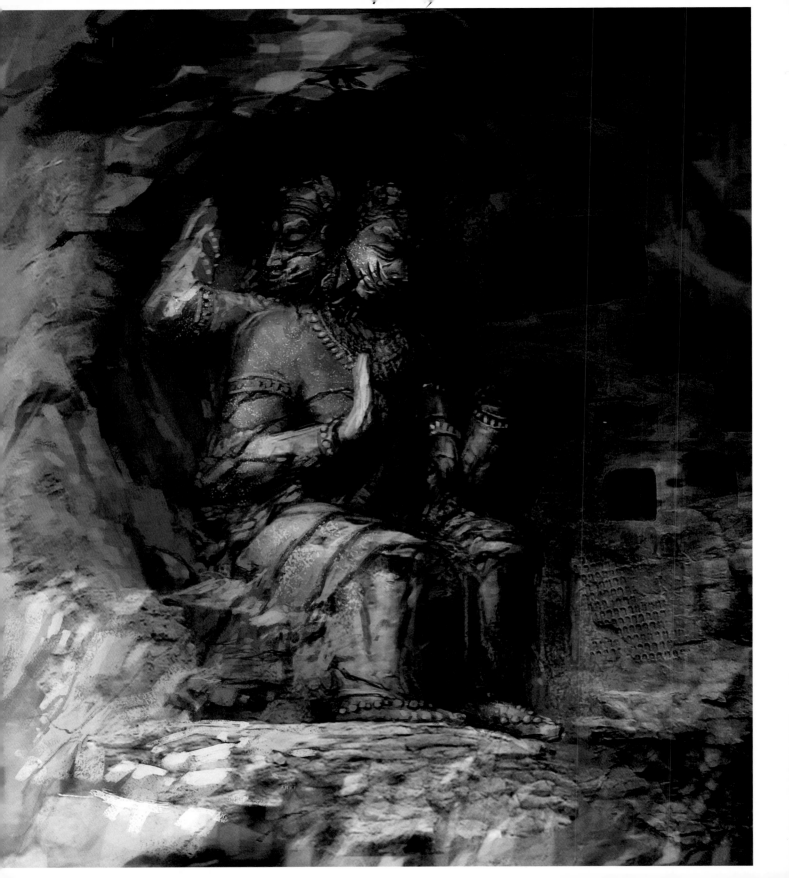

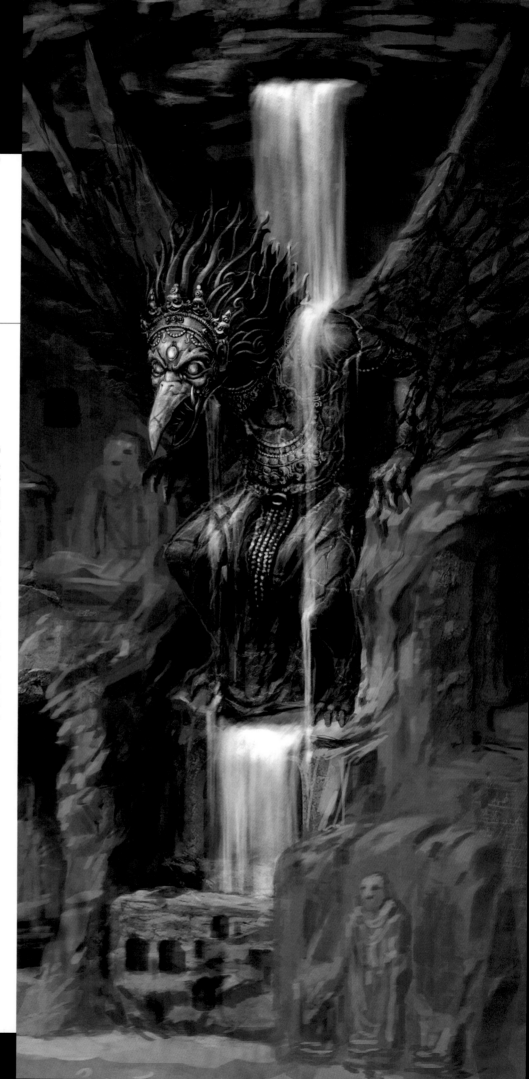

Robh Ruppel
Art Director

THE MONASTERY

The Tibetan Monastery was based loosely on the real-life Tiger's Nest monastery in Bhutan, which was our initial jumping-off point. There's a look to the roofs which are designed and constructed in a certain way—they're pitched at a slight angle. The stonework of the walls is really unique—they start off with really large stones, and then they plaster and whitewash over those. When we designed our walls we wanted a little bit of stone showing through, showing the newer coats of plaster. When they paint these walls, I don't know if they're painting with mops, but they generally cover them so it's sort of a dry brush over the stonework, which doesn't get into the deep cracks. It's not like they mask the stuff off and carefully paint it. The Monastery is a huge complex, abandoned for centuries and only recently occupied by Lazarević and his army as their base of operations. Because the Monastery was so remote, dilapidated and long-abandoned, we wanted it to have a haunted feel. It's high up on the cliff-side, and the wind is blowing all the time, so we asked, "How many prayer banners and torn pieces of cloth can we have blowing in the wind, to give it that sort of eerie, haunted feeling?" The prayer flags are faded and bleached out and there's old lanterns everywhere that are sort of swaying in the wind, along with ropes that were used to hang other things. As we go deeper into the Monastery, there are higher stairs and more ornate, ritualistic statues. Everything becomes a lot more imposing, elaborate and grand as Drake progresses deeper into the Monastery, getting closer to the secrets of Shambhala.

Monastery puzzle room [Andrew Kim] *previous spread*
Monastery cliff-side statue [Andrew Kim] *opposite page*
Cliff-side statue waterfall [Andrew Kim] *this page*

Snow lion carving [Andrew Kim] *top left*
Winged Garuda carving [Andrew Kim] *bottom left*
Monastery broken statue [Andrew Kim] *below*

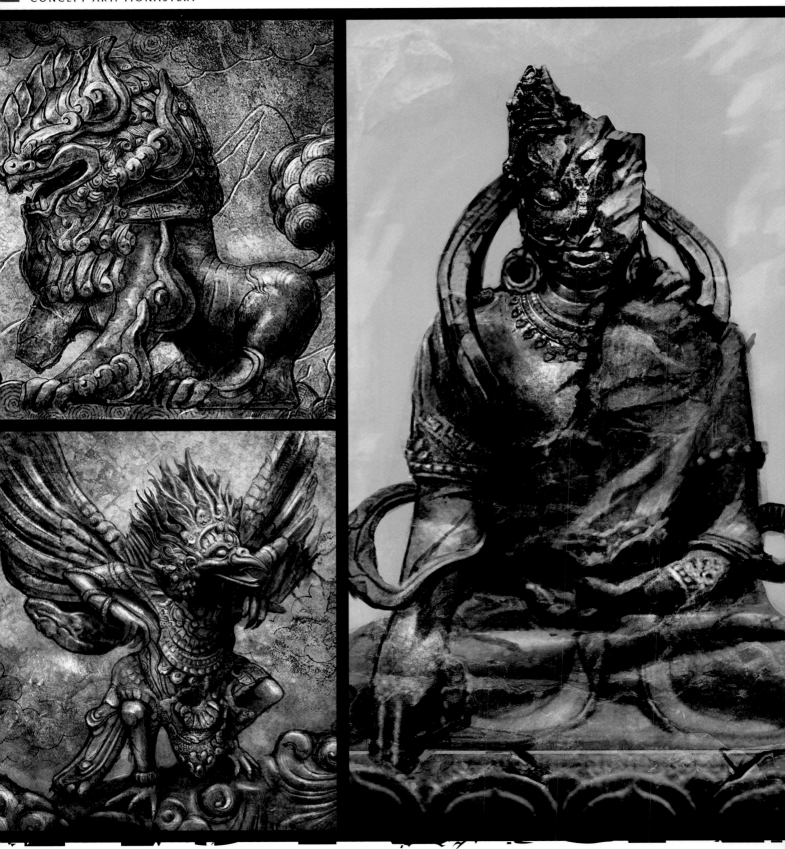

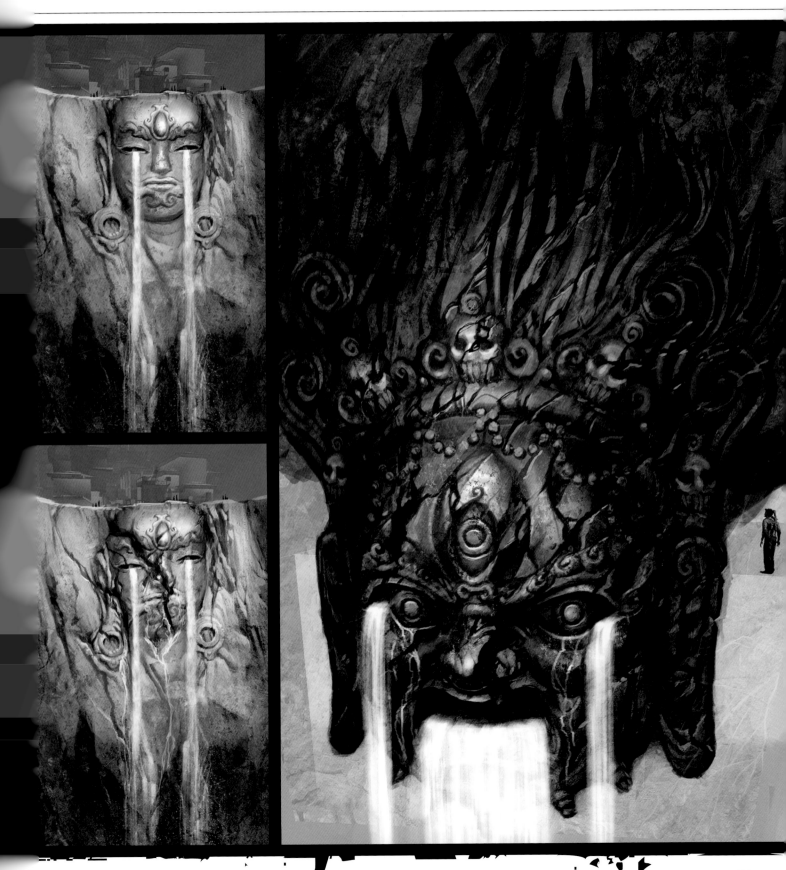

Weeping cliff-side statue [Brian Yam] *top left, bottom left*
Monastery statue falls [Andrew Kim] *below*

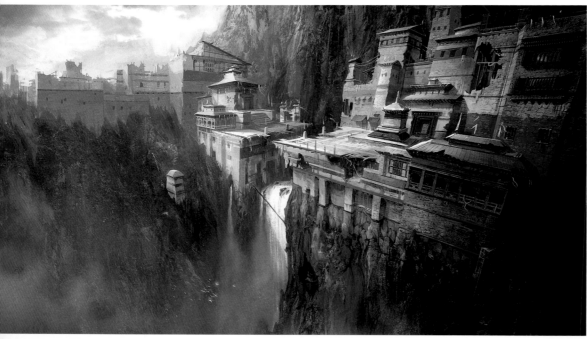

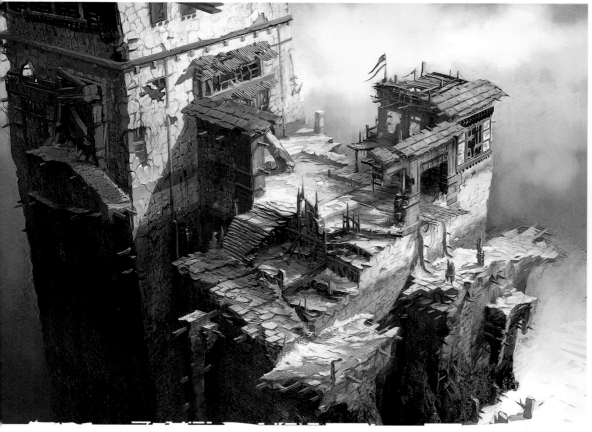

Monastery wide shot [James Paick] *opposite top*
Monastery outcropping [James Paick] *opposite bottom*
Monastery final vista [Robh Ruppel] *below*

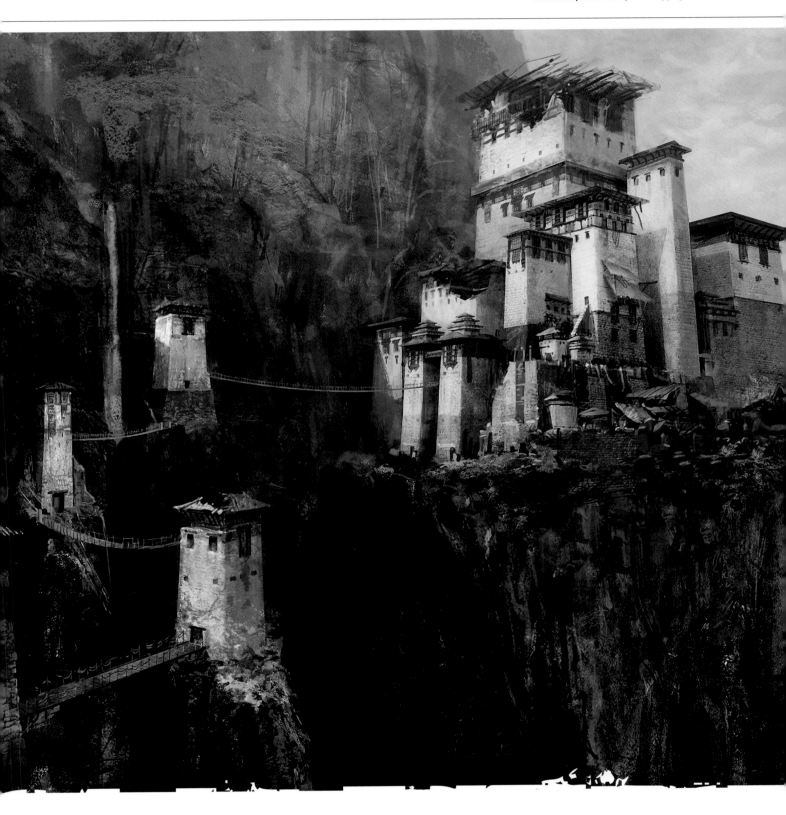

Monastery dormitory [Erwin Madrid] *opposite top*
Monastery kitchen [Erwin Madrid] *opposite bottom*
Monastery pottery [Erwin Madrid] *top*
Monastery interior [Robh Ruppel] *bottom*

TILE ROOF

UNPAINTED WOOD RAILING AND PLATFORM

STONE PATH
CONTINUES INSIDE

SMOOTHER
PLASTER
WALLS

SUPPORT BEAM
ACTUAL INSIDE
ROOF PROFILE

LOWER BEAM
EXTENDS PAST

OLDER, IRREGULAR PAVING STONES
WITH VEGETATION GROWING THROUGH

Monastery overview [Robh Ruppel] *opposite page*
Monastery study [James Paick] *top*
Monastery interior pillars [Robh Ruppel] *bottom*

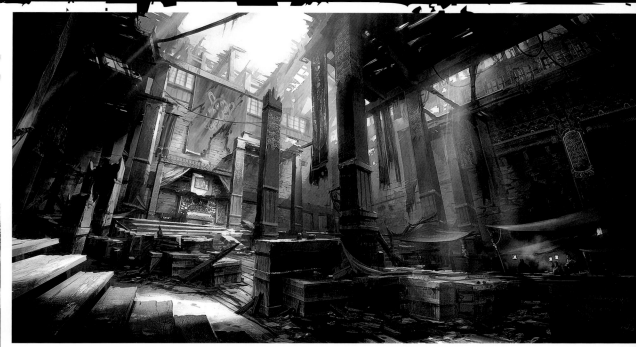

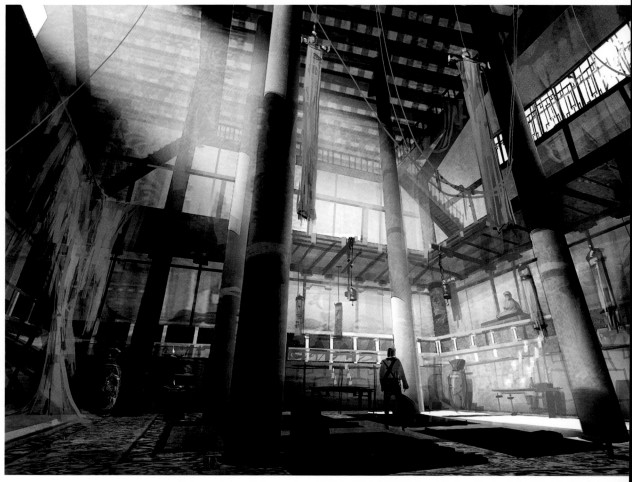

Monastery climbing wall [Andrew Kim] *below*
Monastery entrance [James Paick] *top*
Monastery steps [James Paick] *center*
Monastery main gate [James Paick] *bottom*

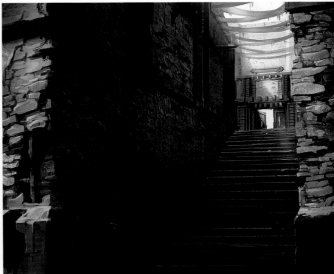

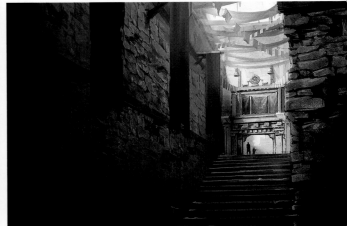

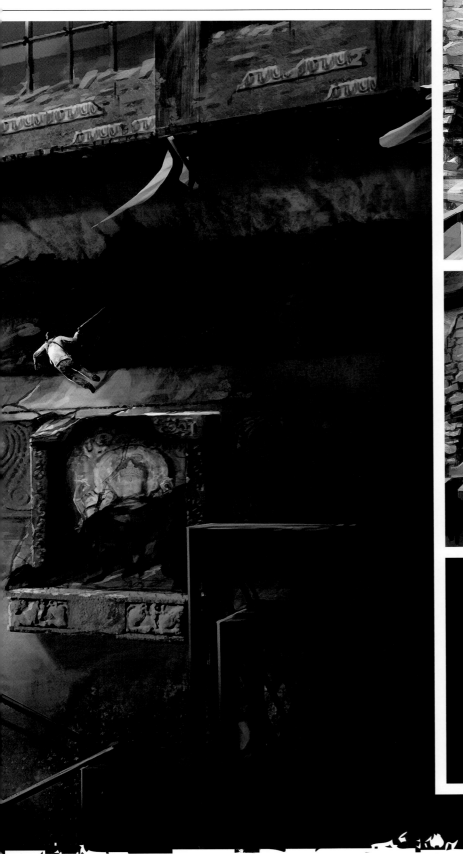

189

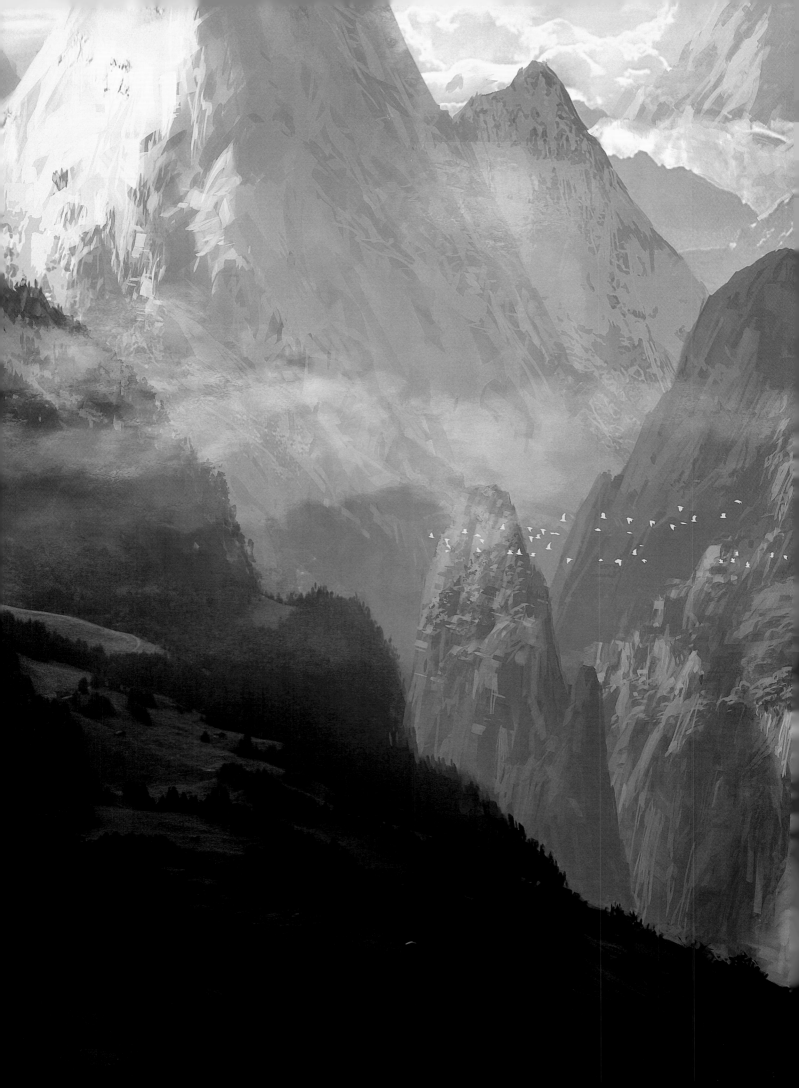

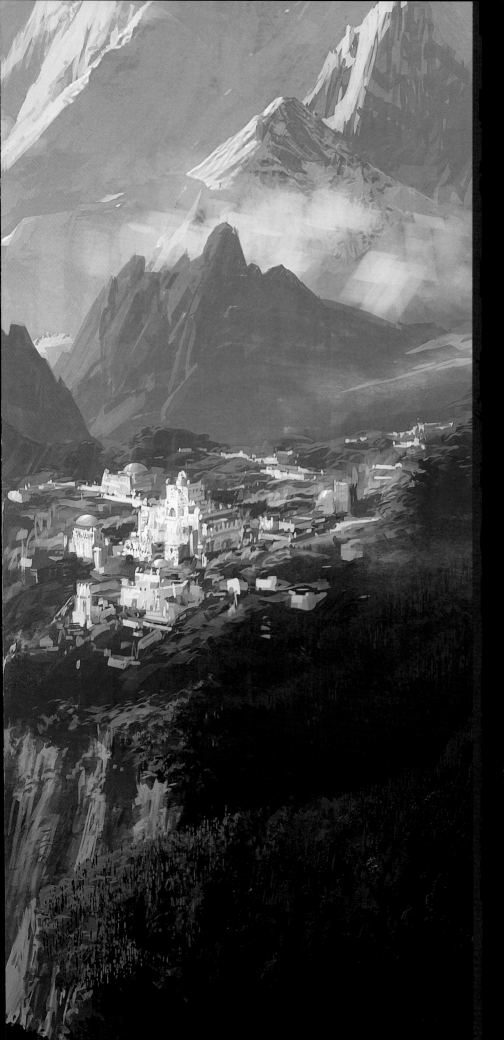

CONCEPT ART
SHAMBHALA

THE IDEA IS AN INTERSECTION OF A PYRAMID AND CUBE. THIS GIVES THE DESIGN FAMILIARITY BUT NOT A SPECIFIC STYLE WE'RE USED TO SEEING. THE DETAILS CAN INDIAN/TIBETAN INSPIRED BUT THE OVERALL SHAPE DESIGN MORE UNIQUE.

GREAT DESIGN BUT DEFINITELY "INDIAN". WE WANT OURS TO BE FAMILIAR BUT UNIQUE. WE CAN USE DETAILS FROM THIS STYLE BUT THE OVERALL DESIGN NEEDS TO BE UNIQUE

sketch

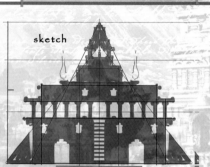

Shambhala

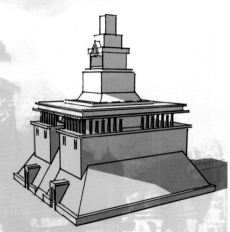

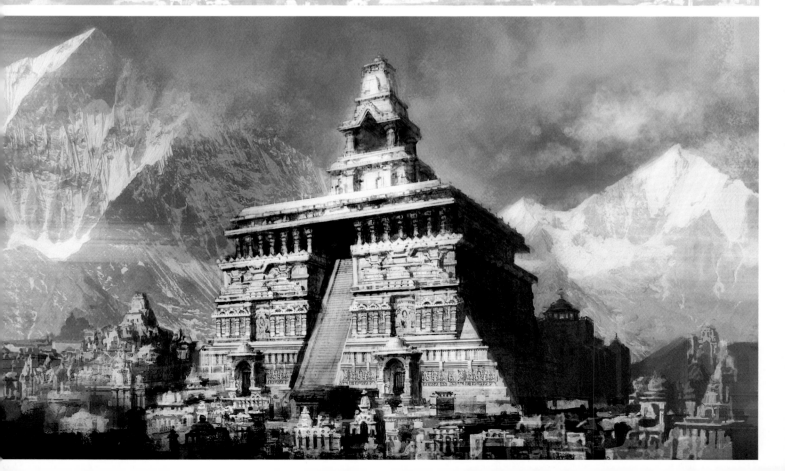

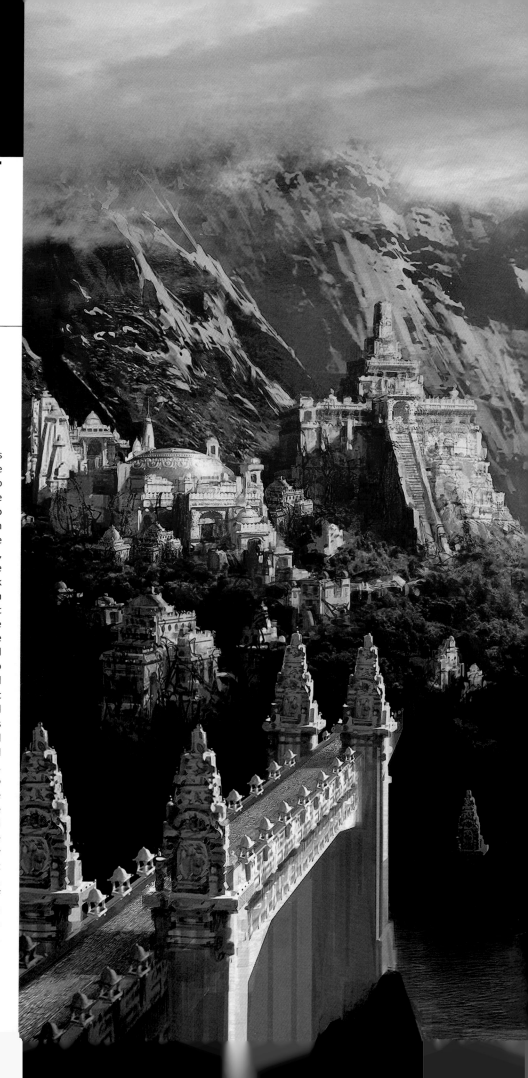

Robh Ruppel
Art Director

SHAMBHALA

Shambhala needed to look like it's of this earth—believable, but some fantastic place we've never seen. I started by trying to come up with the silhouette shape of the main temple in Shambhala. I wanted to extend it beyond just Buddhist or Tibetan architecture so I thought, let's take the base of a pyramid and wedge a square into it, and then give it an almost more Indian-style roof treatment. That gave me a nice thick pyramid base, a square top with an open plaza, and a distinctly-shaped roof piece. It combined elements in a unique way to make something that felt like it was somewhere new and undiscovered. That addressed the question of "What are we going to do to make this thing look wondrous and unique, but also believable?" I arrived at this literally just scribbling one day and looking at shapes and thinking, "That makes a really interesting silhouette. Let me build it in 3D and make sure it actually looks good from all sides." As a standalone design, Shambhala worked well. Once we got it into the game and focus-tested it though, the feedback was: "It's not tall enough. We're not seeing this main temple as the focal point that it needs to be. How can we make this thing look taller and not throw away everything that we've done?" At this point we were getting close to our release date, but we were able to use an existing roof and stretch, pull and add a couple more pieces onto it. We didn't want to change the concept much, just add some thickness, width and height to it.

Shambhala concept [Robh Ruppel] *previous spread*
Shambhala temple design [Robh Ruppel] *opposite top*
Final temple sketch [Robh Ruppel] *opposite bottom*
Shambhala climax vista [Robh Ruppel] *this page*

CONCEPT ART: SHAMBHALA

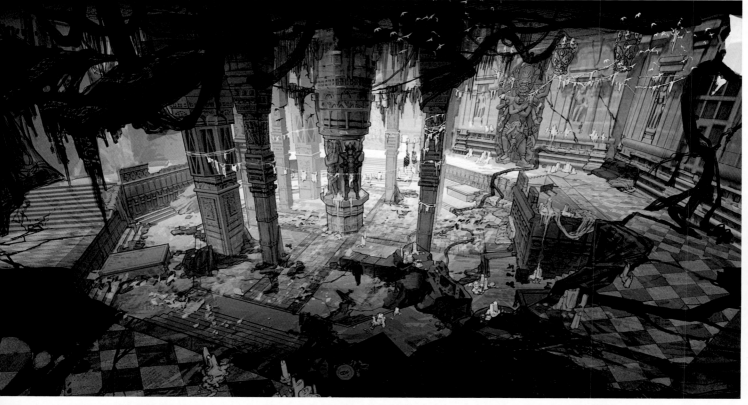

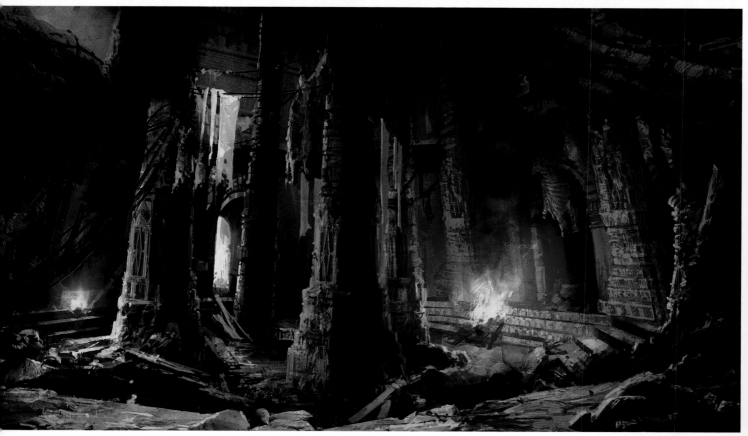

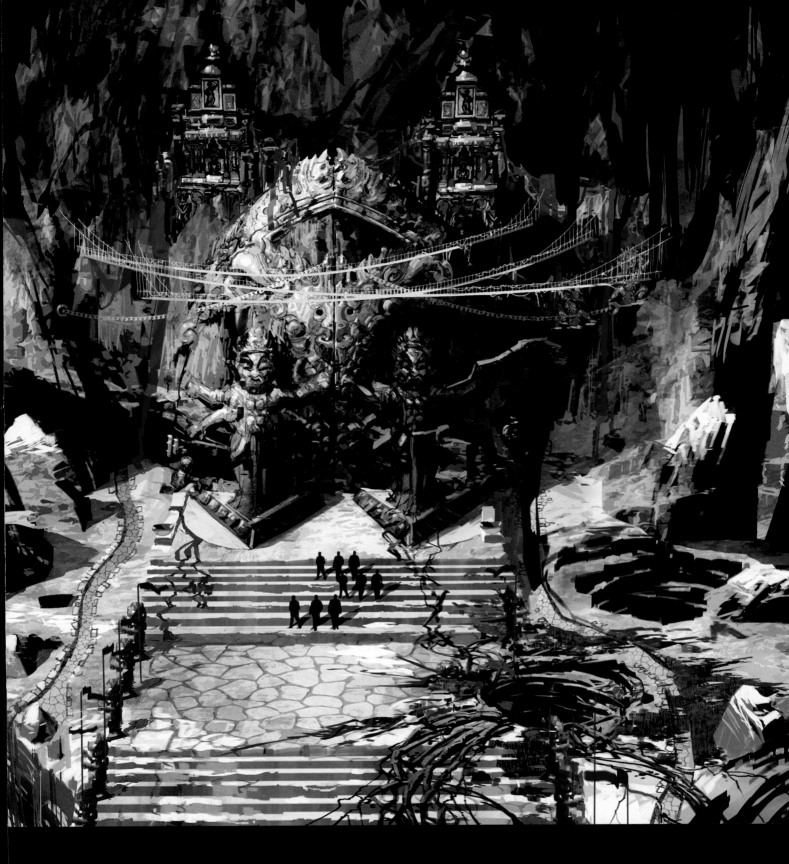

INSIDE SHAMBHALA

Shambhala guardian den, sketch [Robh Ruppel] *opposite top*
Shambhala guardian den [Robh Ruppel] *opposite bottom*
Shambhala entrance gate [Robh Ruppel] *above*

The entrance to Shambhala needed to be grand—after all, this is the gateway to paradise. Due to schedule constraints, the idea was later simplified. The Guardians' den, in contrast, needed to have more of a creepy feel to it. Once a place of reverence and worship, the bowels of the temple have since decayed into a dirty, filthy pit of communal living.

CONCEPT ART: SHAMBHALA

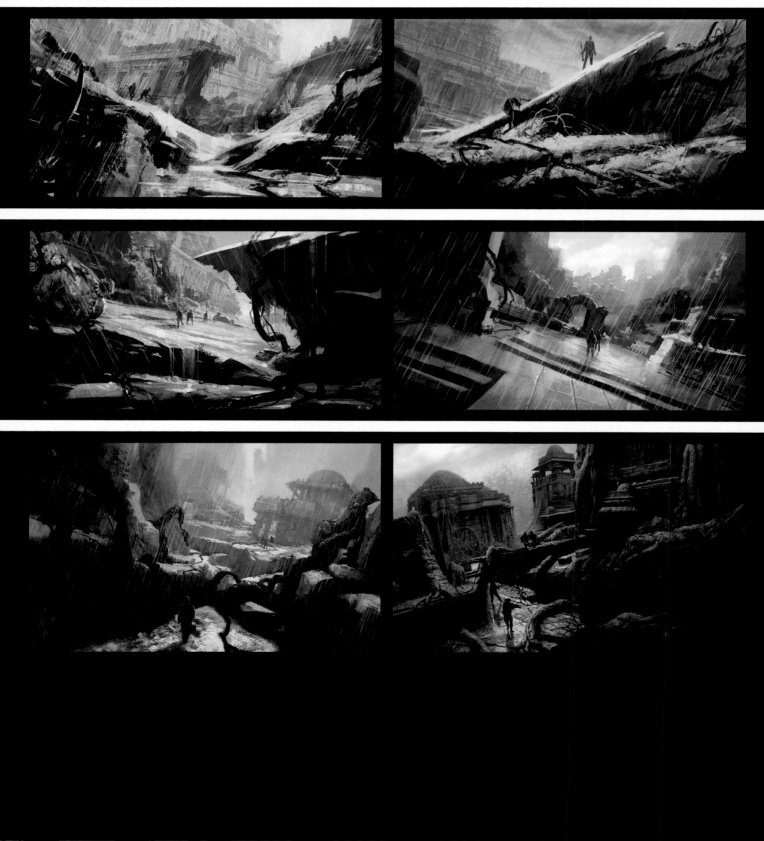

Shambhala layout [Robh Ruppel] *top left*
Shambhala layout [Robh Ruppel] *top right*
Shambhala overgrowth [Robh Ruppel] *center left*
Shambhala stairs [James Paick] *center right*
Shambhala tree trunk [Robh Ruppel] *bottom left*
Shambhala tree roots [Robh Ruppel] *bottom right*

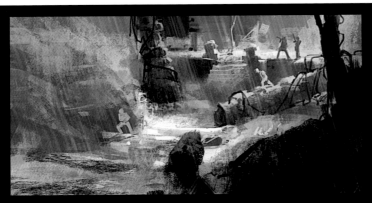 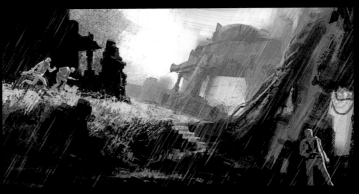

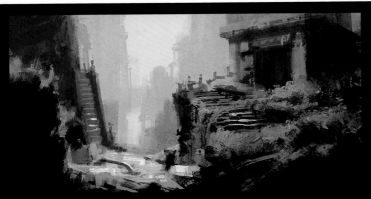 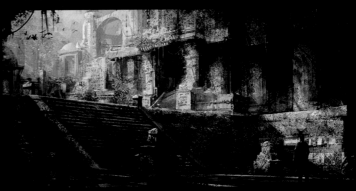

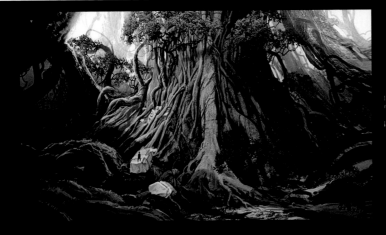 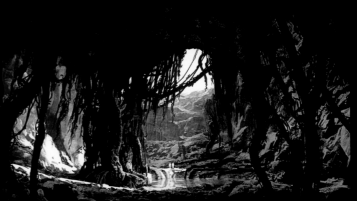

Shambhala street level *this spread*

SHAMBHALA LOCATIONS

The environment within Shambhala was thoroughly concepted, with a variety of locations. Everything at street level slants at angles toward the Tree of Life at the center of the ruined city. Above, you can see that we tried out several different ideas for how overgrown and dense the root structures were, and how collapsed the buildings should be.

197

Cintamani Temple, Tree of Life mural [Brian Yam] *opposite page*
Shambhala Guardian painting [Andrew Kim] *this page*

The mural in the Cintamani Temple reveals how the Tree of Life (and surrounding courtyard) appeared before the Tree overtook and destroyed Shambhala. In the painting below, the costumed Guardians are portrayed in the Tibetan style as wrathful deities.

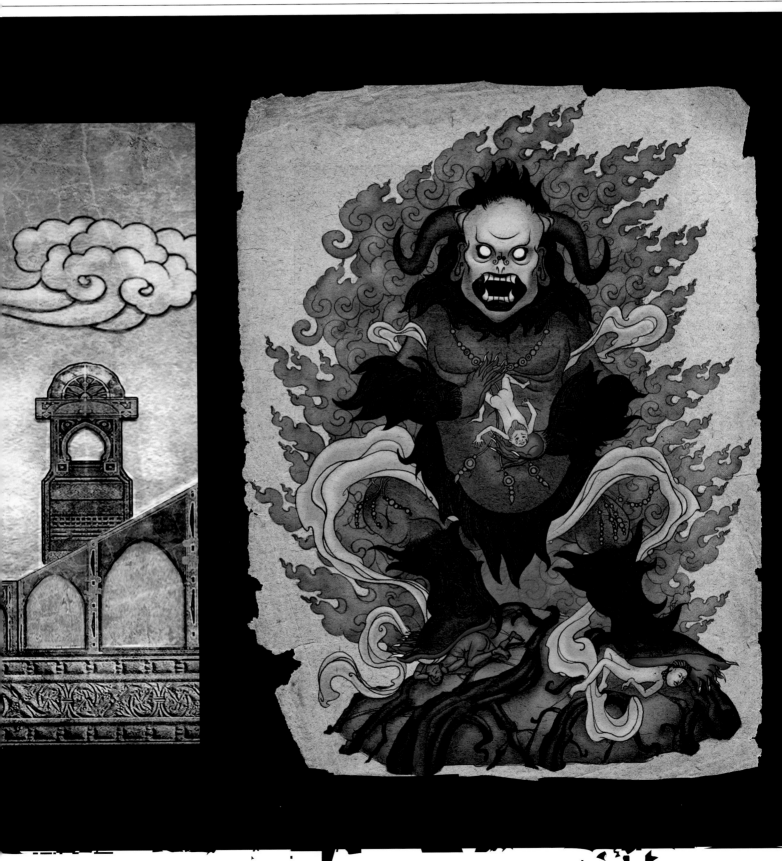

Cintamani room sketch *top left*
[Robh Ruppel]

Cintamani room platform *bottom left*
[Robh Ruppel]

Cintamani Temple room *above*
[Robh Ruppel]

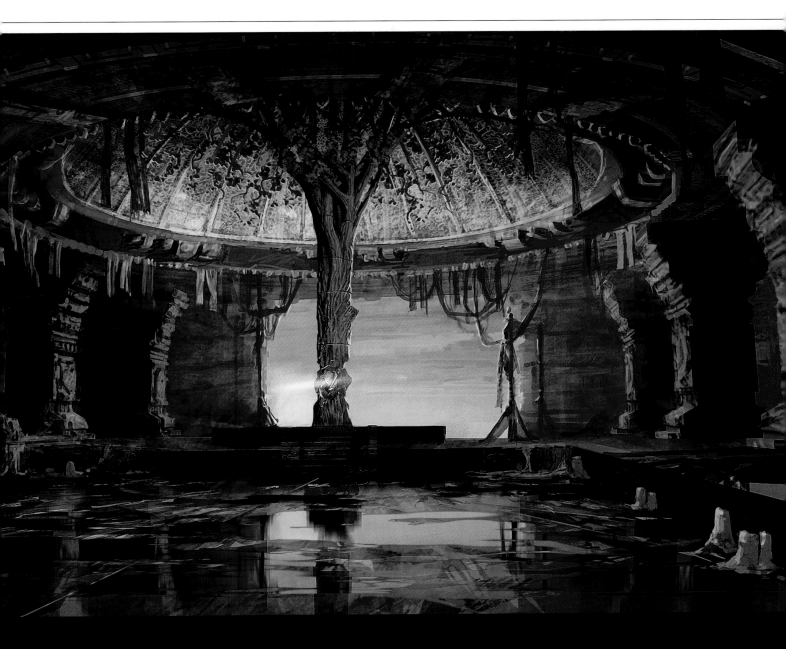

CINTAMANI ROOM

We did a lot of different concept variations for the final Cintamani Temple room. Since this was ostensibly the final goal of Drake's long journey, we knew there had to be a representation of the Tree of Life and the Cintamani Stone prominently featured here. We also needed to have a mural here that revealed that the Cintamani Stone is actually the sap from the Tree of Life, and that the Tree—once vibrant and beautiful—has since grown to overtake and destroy the entire city. From this chamber,

Drake had to be able to look down into the lower courtyard and see this enormous parasitic tree below. So the challenge was making all these elements work in a big open chamber on top of this giant temple. There's not actually any gameplay in this room—everything plays out in an elaborate cinematic cutscene, so the chamber also had to be designed to take into account the limitations of the motion-capture stage. To make it all work, we had to scale back the design for the central platform and

lower it to reduce the number of stairs, otherwise it would have been prohibitively difficult to mocap the scene. Whenever an area in the game needs to accommodate a cutscene, we have to take all these real-world measurements and limitations into consideration, as part of the design process. As it was, capturing the three-and-a-quarter minute Cintamani room scene on the mocap stage required something like eight different set changes, and took an entire day to shoot.

ROOM PERIMETER

PILLARS

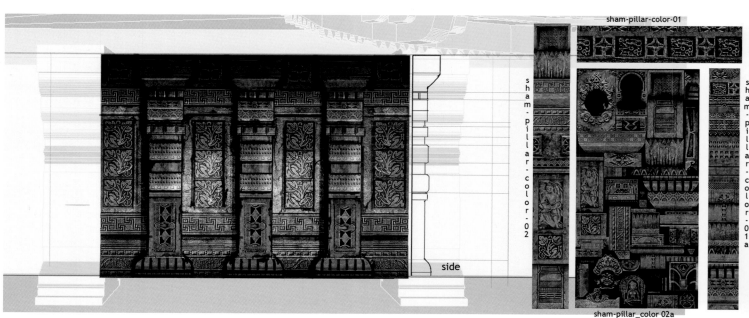

sham-pillar-color-01

sham-pillar-color-02

sham-pillar-color-01a

side

sham-pillar_color 02a

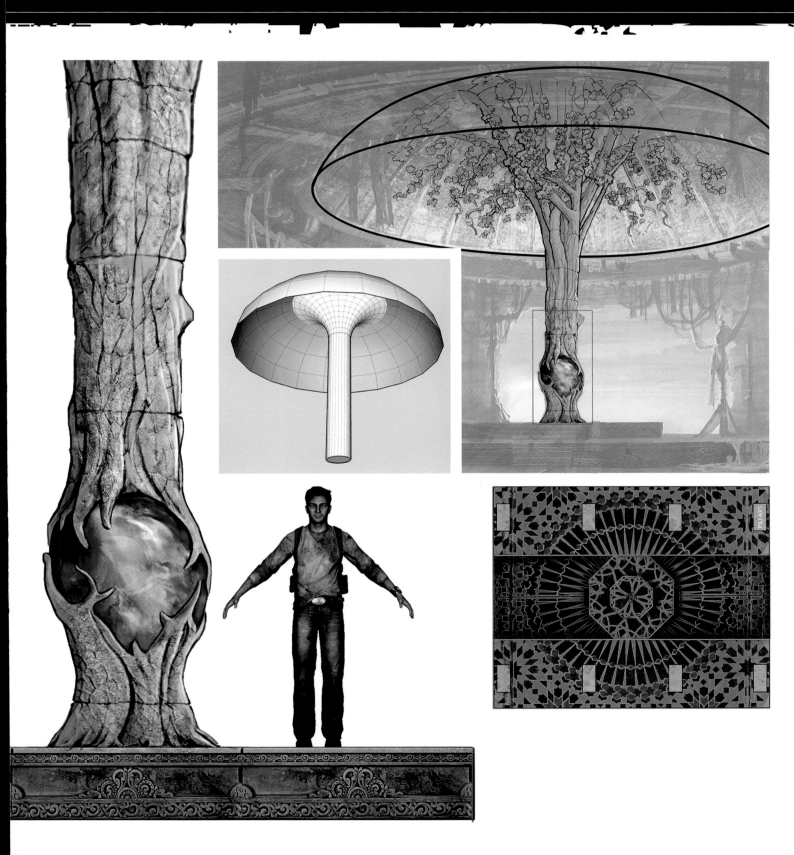

Cintamani room dome [Robh Ruppel] *opposite top left*
Cintamani room dome [Robh Ruppel] *opposite top right*
Cintamani room wall pattern [Brian Yam] *opposite bottom*
Cintamani room scale [Brian Yam] *top left*
Cintamani dome structure [Robh Ruppel] *top right*
Cintamani room dome pattern [Robh Ruppel] *bottom right*

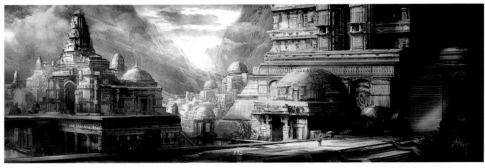

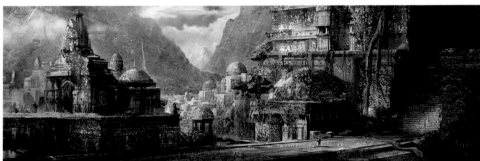

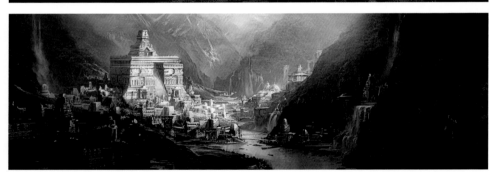

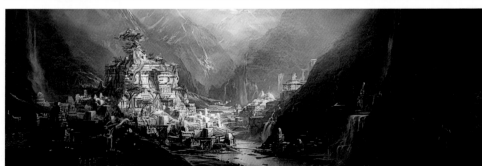

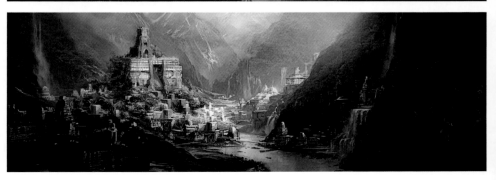

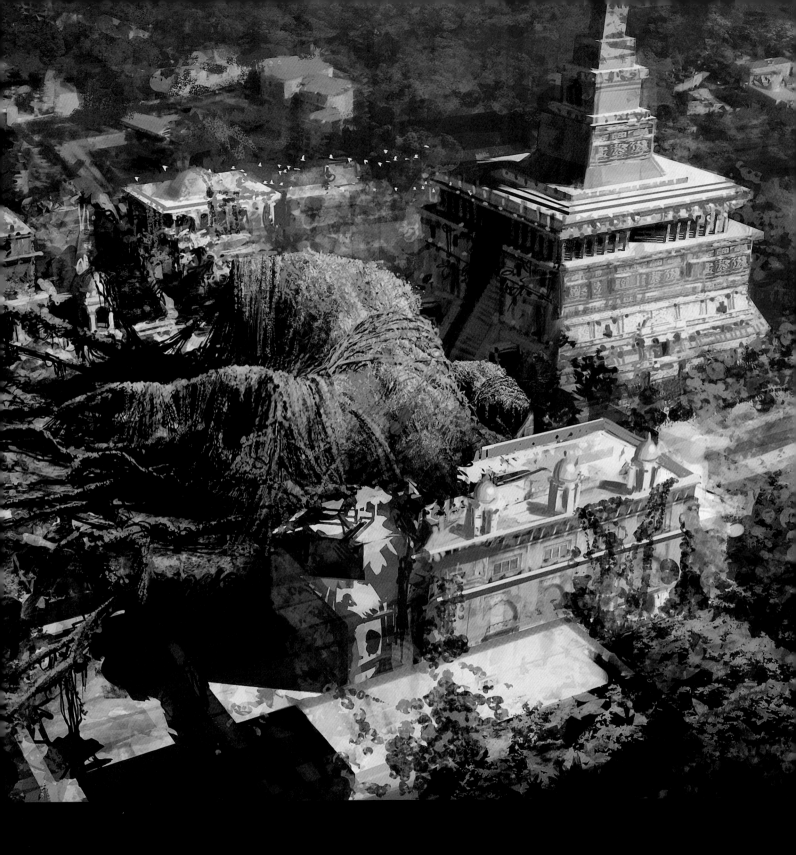

SHAMBHALA GROWTH

Shambhala overgrowth ideations *opposite page*
[James Paick]

Shambhala tree vista *above*
[Robh Ruppel]

We started off with the layout of the city in its prime, before the destruction. At the base of the Temple there's a big, multi-tiered courtyard built around the Tree of Life, with walkways leading around and up to the Temple. The inhabitants would be able to walk around this wall and look inward at the Tree featured there. We also envisioned a well tended garden and pathways around the Tree—this was how everything would have looked when the city was vibrant and healthy. But some time in the intervening centuries, the Tree overtook the city and strangled all the buildings with its roots. All the architecture is now collapsing into the ground, with the roots of the tree running rampant and pulling all the buildings down.

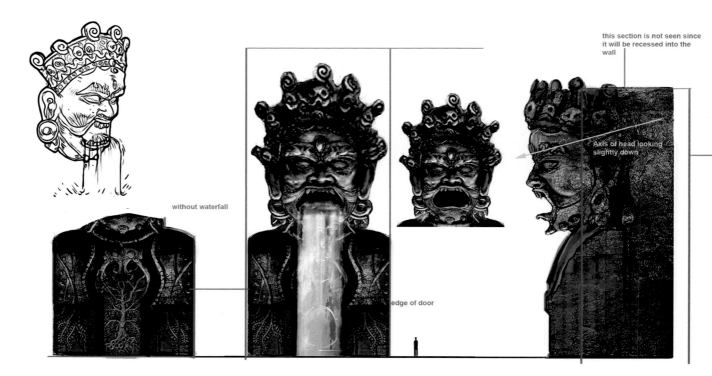

without waterfall

this section is not seen since it will be recessed into the wall

Axis of head looking slightly down

edge of door

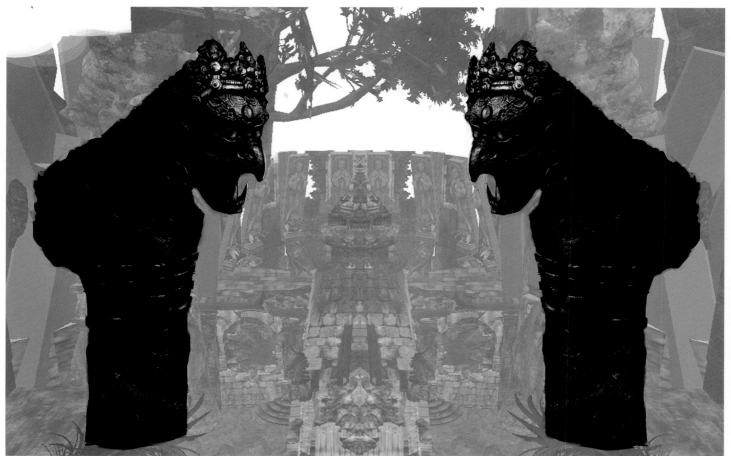

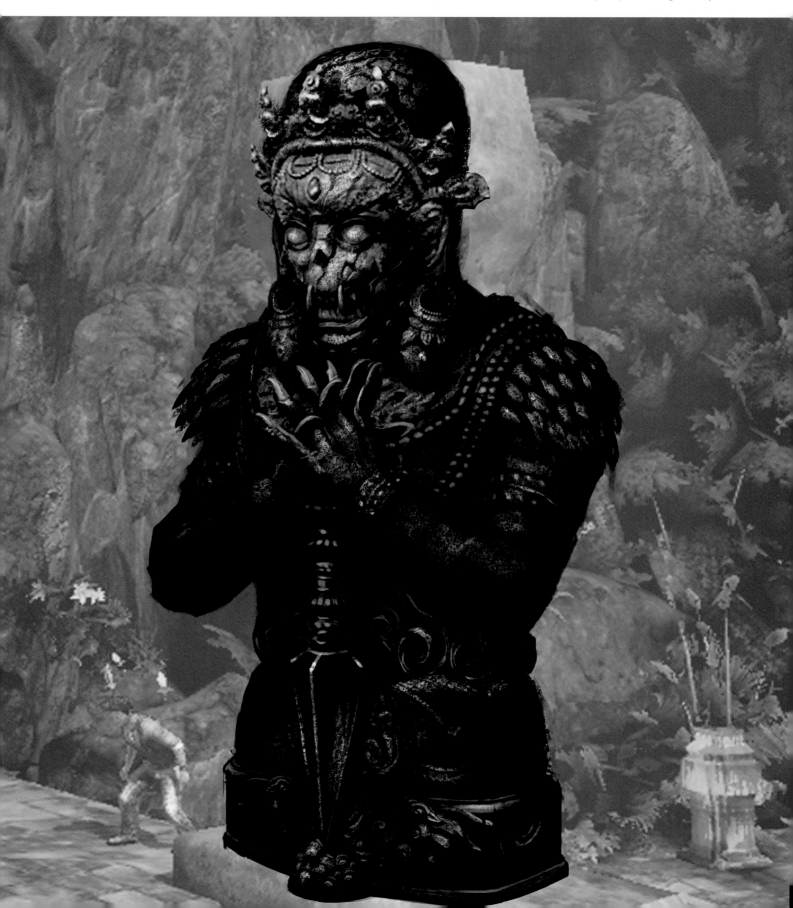

SHAMBHALA STATUES

As the player gets deeper into Shambhala, all the statuary starts to take on a sinister feel. We didn't call attention to this—it was meant to be a subtle, almost subliminal thing that would slowly add to the player's realization that perhaps all isn't right with 'paradise.'

Shambhala waterfall statues [Brian Yam] *opposite top*
Shambhala entrance statues [Andrew Kim] *opposite bottom*
Shambhala statue [Andrew Kim] *this page*

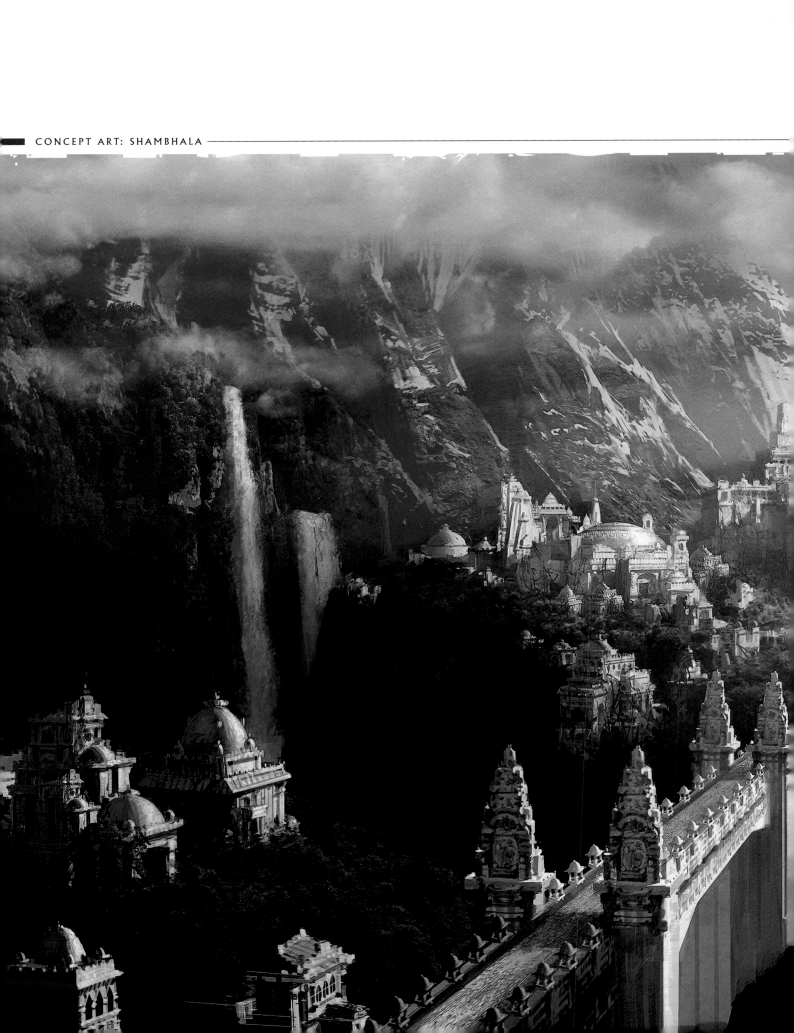

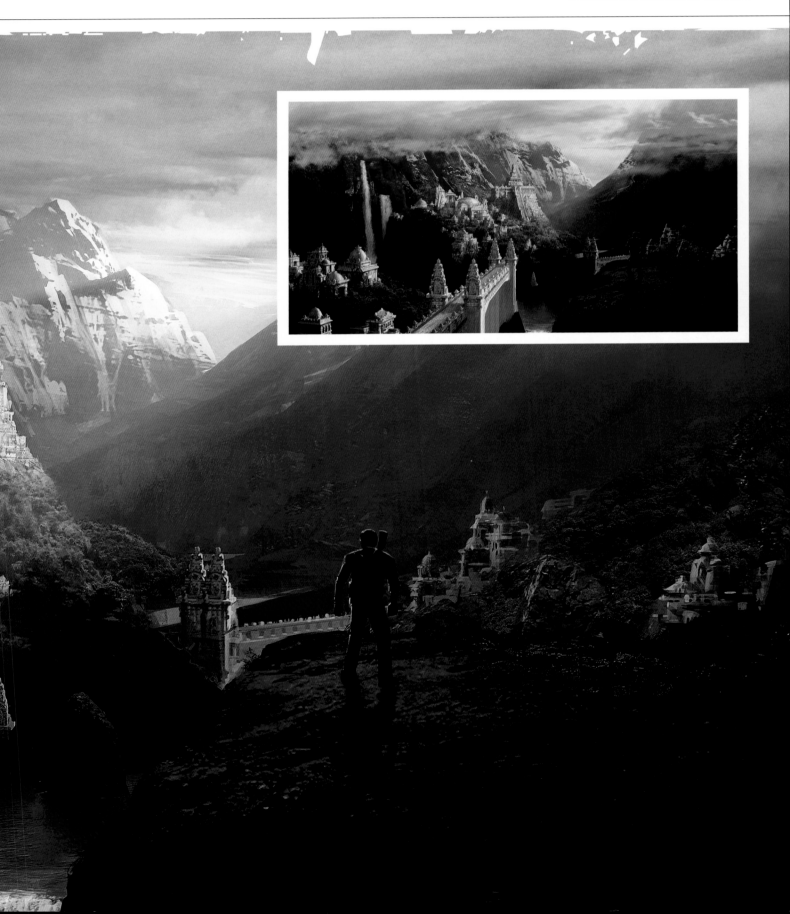

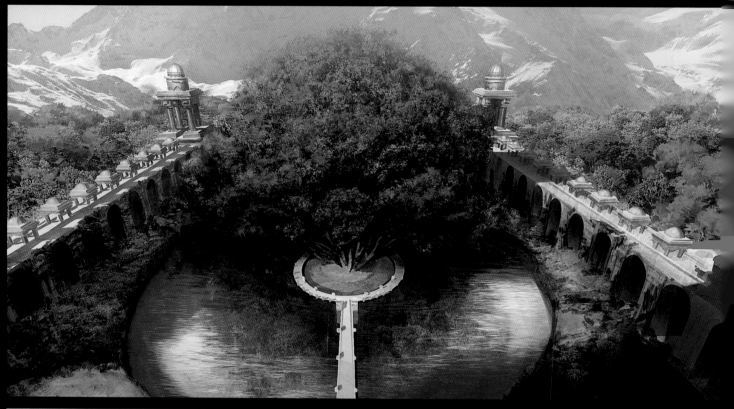

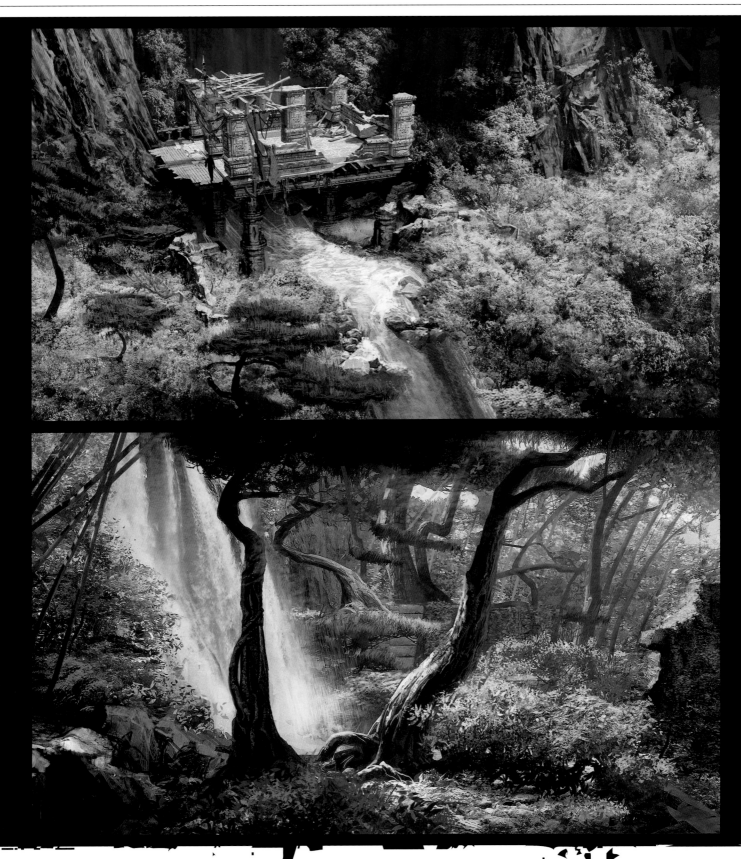

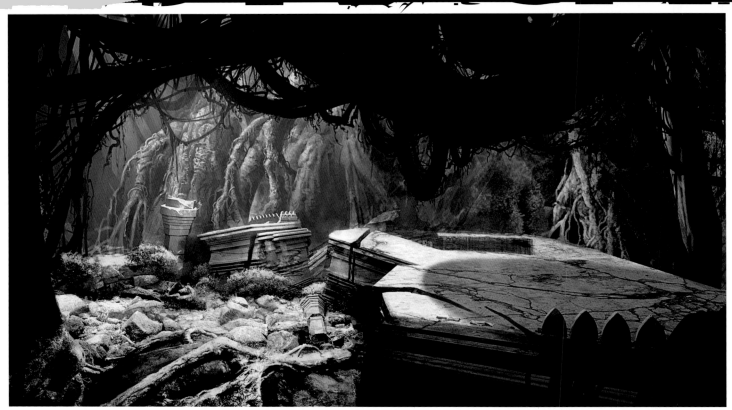
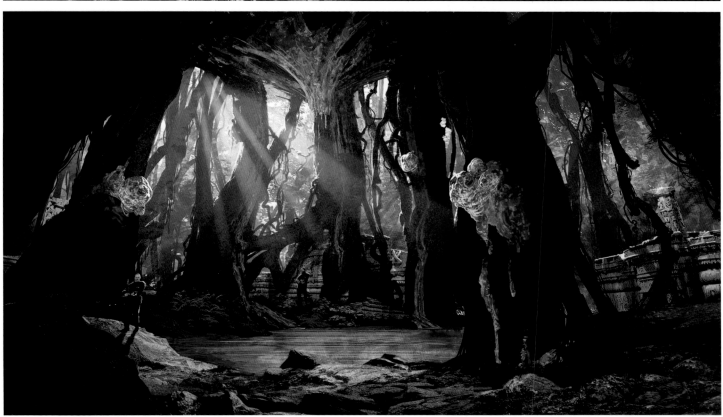

Sap chamber beneath the Tree [Robh Ruppel] *opposite bottom*
Beneath the Tree of Life [Robh Ruppel] *top*
Ruins beneath the Tree [Robh Ruppel] *bottom*

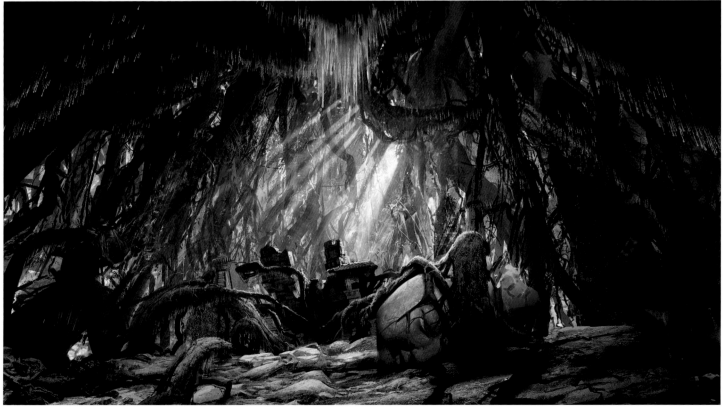

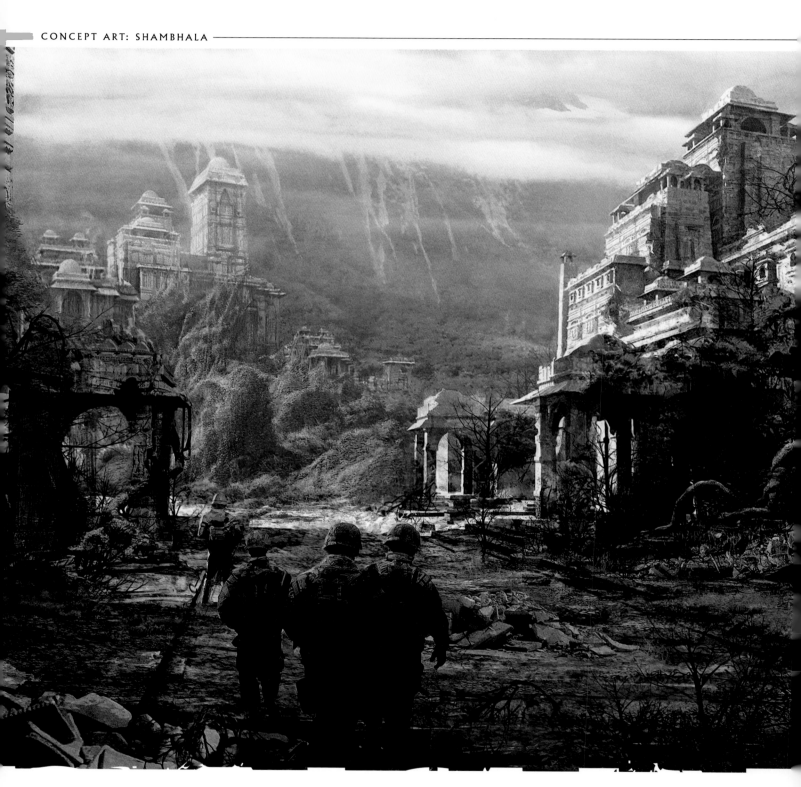

Shambhala overgrowth, street level [Robh Ruppel] *above*
Shambhala collapsed bridge [Robh Ruppel] *opposite top*
Collapsed buildings [Robh Ruppel] *opposite center*
Shambhala ruins with web of roots [James Paick] *opposite bottom*

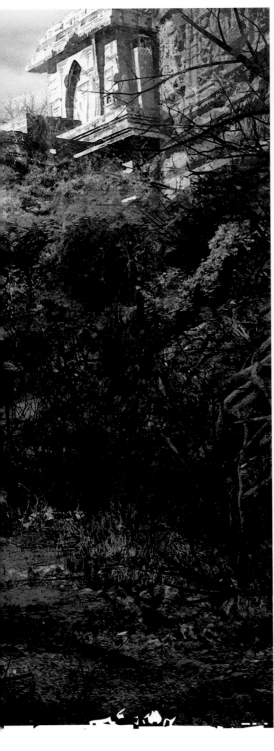

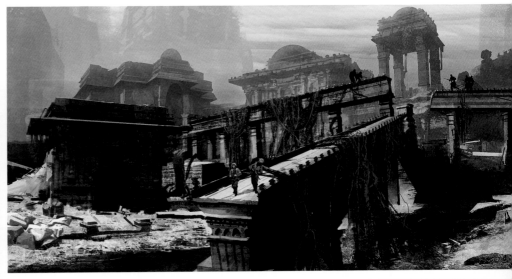

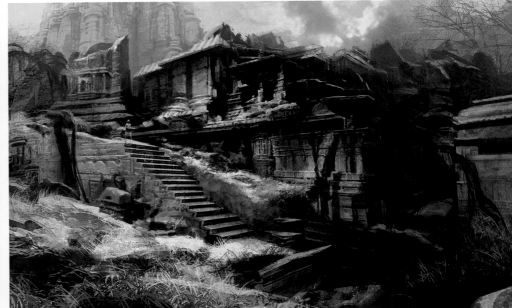

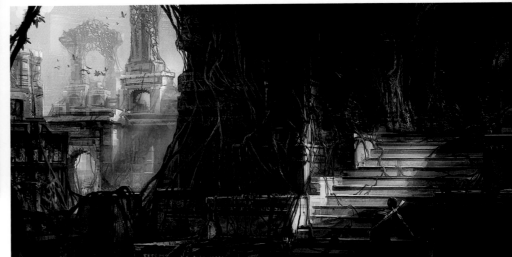

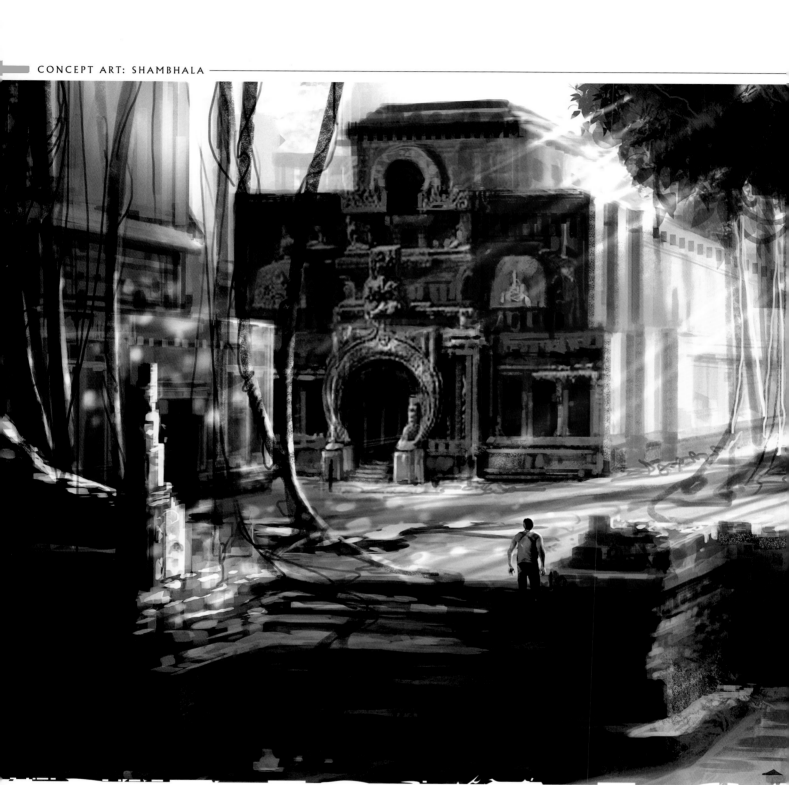

Shambhala ruined street [Andrew Kim] *above*
Shambhala collapsed buildings [Robh Ruppel] *opposite top*
Entrance to Shambhala [Brian Yam] *opposite center*
Ruins and twisted roots [James Paick] *opposite bottom*

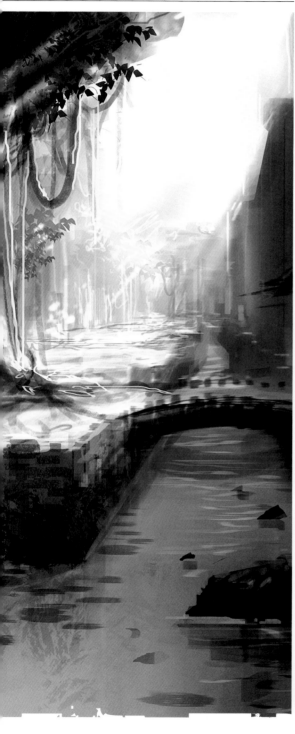

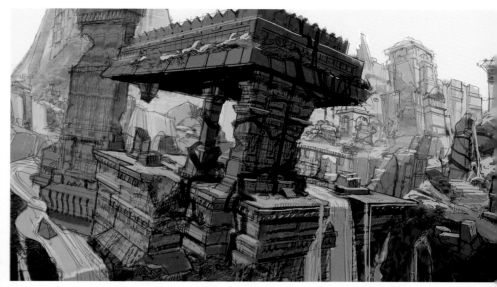

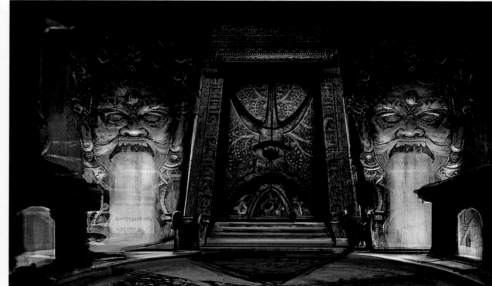

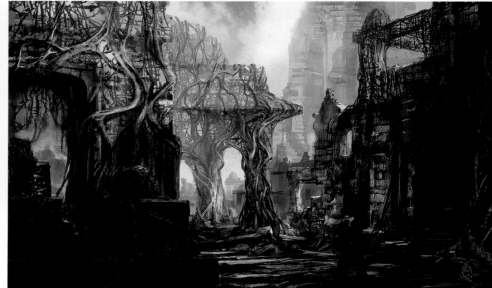

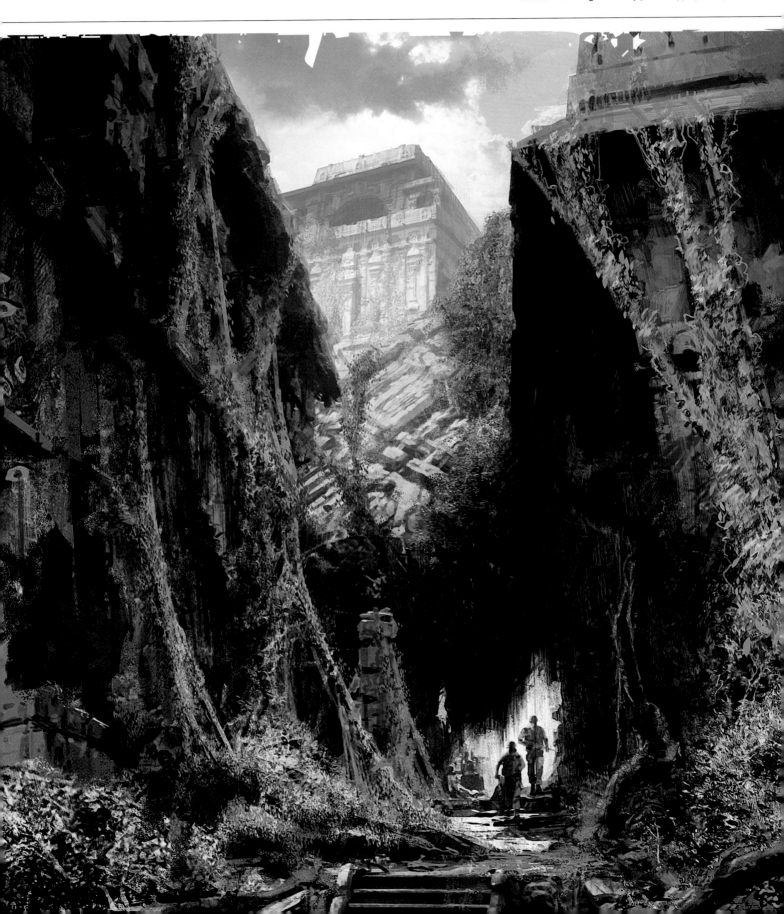

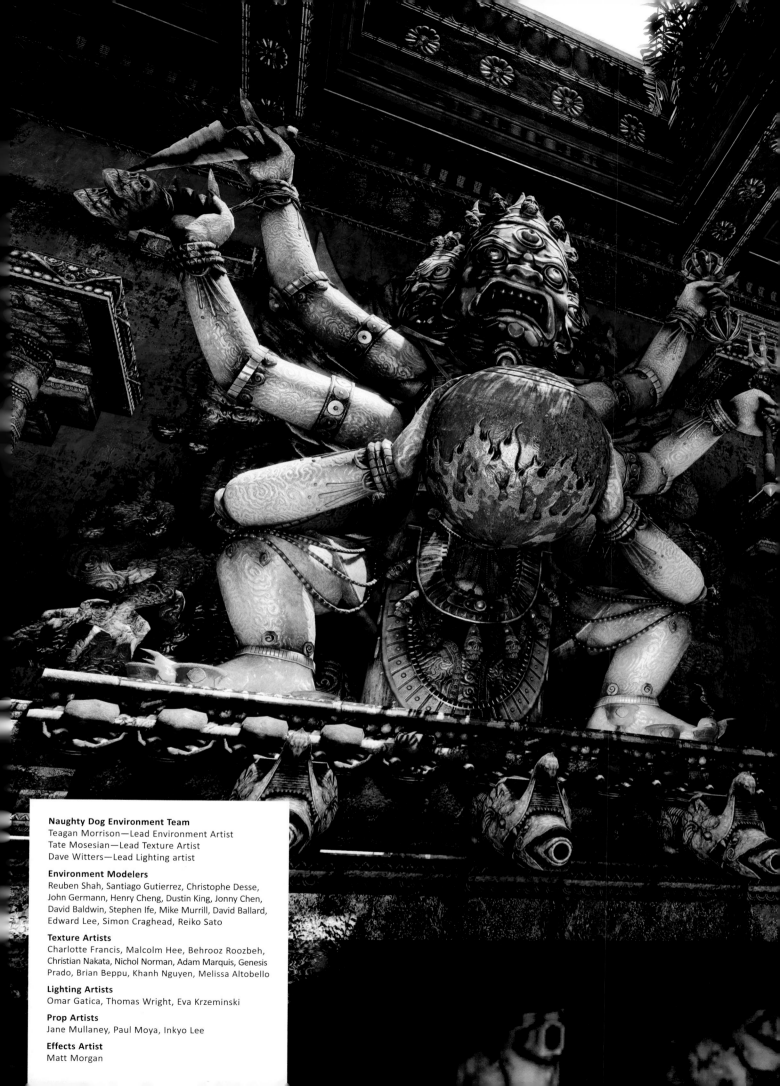

Naughty Dog Environment Team
Teagan Morrison—Lead Environment Artist
Tate Mosesian—Lead Texture Artist
Dave Witters—Lead Lighting artist

Environment Modelers
Reuben Shah, Santiago Gutierrez, Christophe Desse,
John Germann, Henry Cheng, Dustin King, Jonny Chen,
David Baldwin, Stephen Ife, Mike Murrill, David Ballard,
Edward Lee, Simon Craghead, Reiko Sato

Texture Artists
Charlotte Francis, Malcolm Hee, Behrooz Roozbeh,
Christian Nakata, Nichol Norman, Adam Marquis, Genesis
Prado, Brian Beppu, Khanh Nguyen, Melissa Altobello

Lighting Artists
Omar Gatica, Thomas Wright, Eva Krzeminski

Prop Artists
Jane Mullaney, Paul Moya, Inkyo Lee

Effects Artist
Matt Morgan

PRODUCTION ART
ENVIRONMENTS

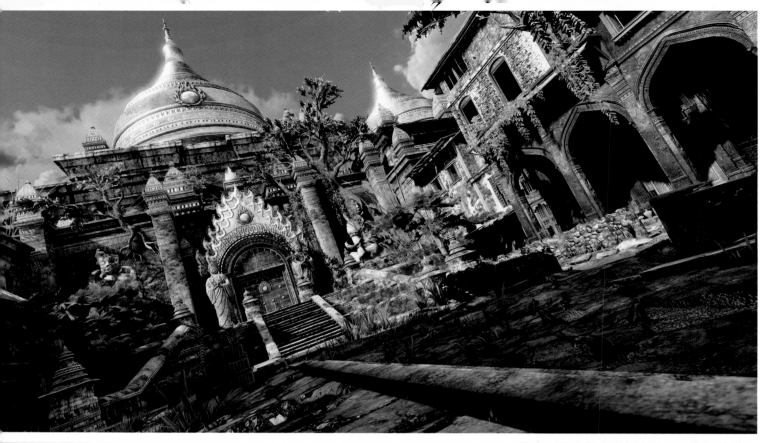
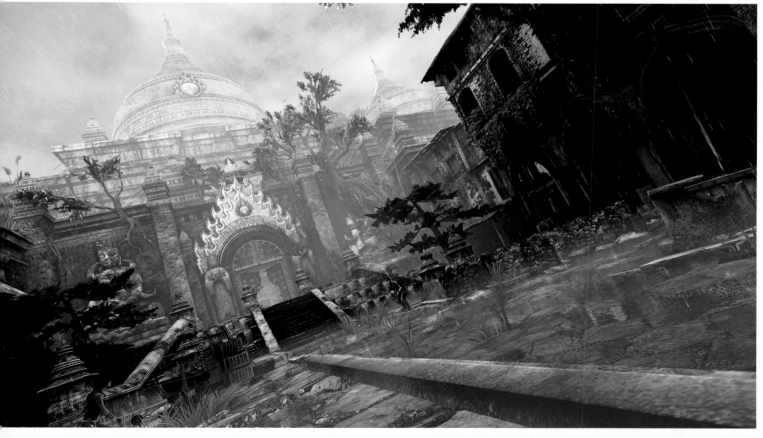

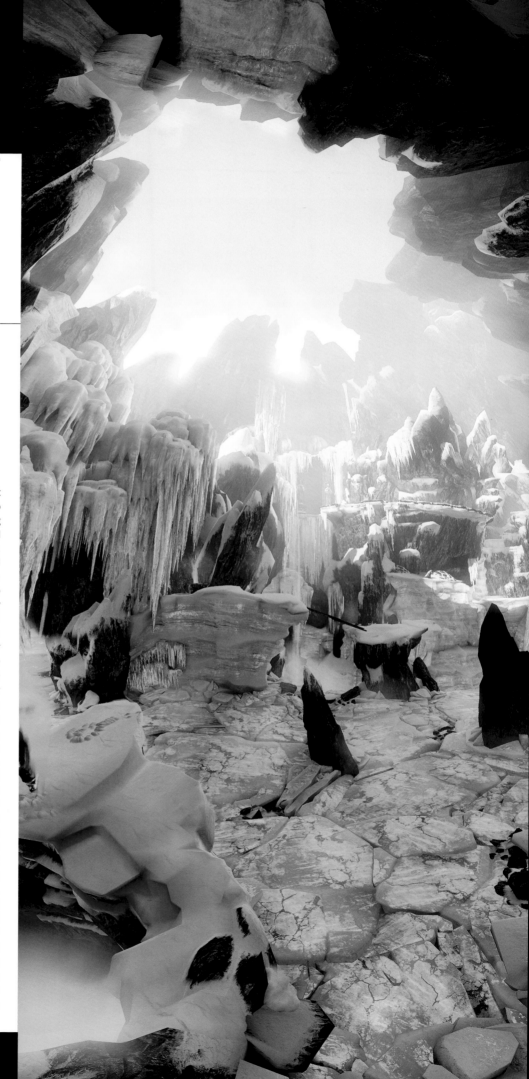

Erick Pangilinan
Art Director

PRODUCTION ART

Uncharted 2 is the most ambitious project our studio has ever attempted. Trying to surpass Uncharted 1 was already a daunting task, so pulling off this epic game called for serious logistical planning. Unfortunately, it was more of the latter which really pushed the project to the finish line. The production team at Naughty Dog has always been a group that goes the extra mile for quality. After every project, we try to improve our pipeline and implement systems to help us work smarter, rather than harder. However, every year our ambition to create a better game leads us to the same place. This time, we pushed the entire team to the limits by adding a new multiplayer mode to the game and setting the game in different cities around the world. Fortunately, we made several improvements in our tools, engine and pipeline that helped us overcome the problems we faced in this new challenge. Our improved tools gave us light maps and better lighting in dark shadowed areas, as well as a new shader interface with better debugging features. Our improved ND engine 2.0 gave us more optimized usage of the SPUs and GPU, which translated to more details in the world. All these improvements helped us elevate the look of our environments and surpass the previous Uncharted game. The production team is made up of 14 modelers, 10 texture artists, five foreground artists, three lighting artists, four particle/effects artists, one technical environment lead, one lead technical artist, one lighting lead and one shader lead. These are the talented men and woman that created the awe-inspiring environments you will see in the next few pages.

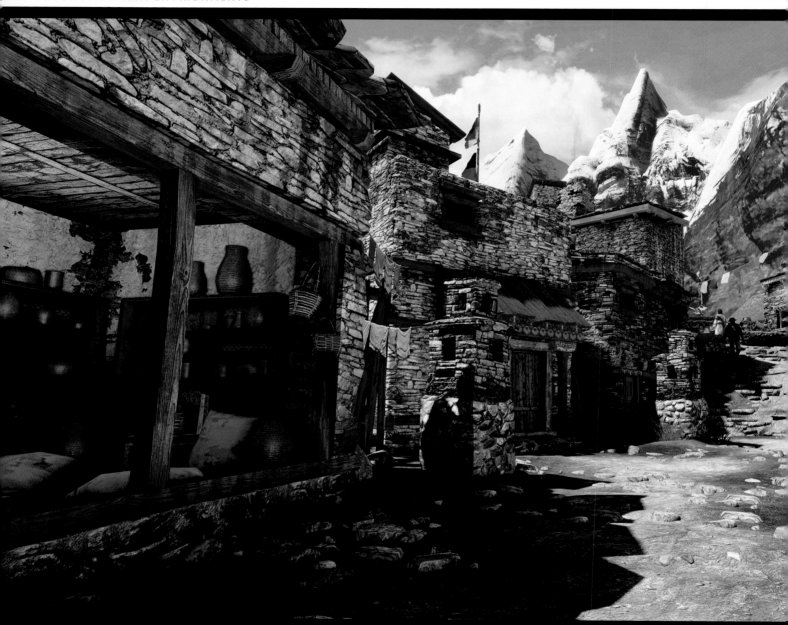

BACKGROUND ART

Creating background art is probably one of the most complicated and challenging tasks here at Naughty Dog. Drawing inspiration from 2D concept art and realizing the world in 3D raises difficult questions for the artist. How do you capture the same vibe with an interactive camera? How can you transfer all that detail with a hardware limitation and not look sparse? How will frame-rate be affected when you introduce a 15 enemy gun battle into your scene? How can you fit a vast city in memory without loading delays? All these factors will be part of the equation when you plan out your background level. Each environment starts by creating primitive shapes like boxes and cylinders in a 3D. These simple shapes describe gameplay spaces and platforms that make up the level. This layout is called a block mesh. Game designers will use this block mesh to rough out a level, test their gameplay set-ups, and plan the player path. The concept team will be working in parallel with the designers, to develop a look for this level. After the concept and layout have been tested and approved, it moves to the background modeler. The modeler will start detailing this block mesh while paying close attention to frame-rate and memory limitations. One method we use to maximize efficiency in our environments is using

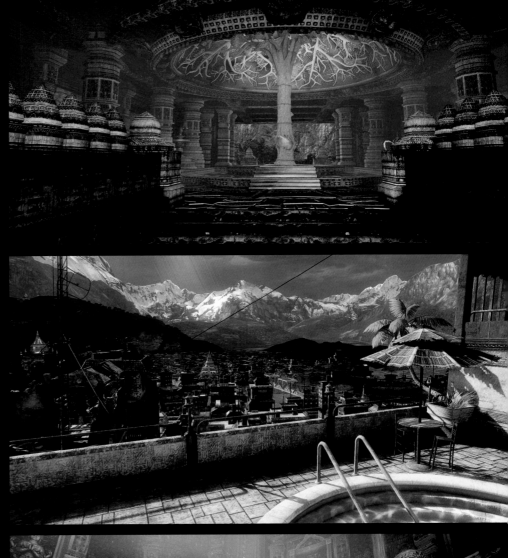

instances. This is like duplicating an object like a pot or a chair many times, but only paying a fraction of the original memory cost for each duplicated instance. This also saves us modeling time since we can standardize elements like windows, roofs, and doors without having to create unique assets for everything. Since all of these are referencing a common source file, any work done to the source is fixed on all the instances.

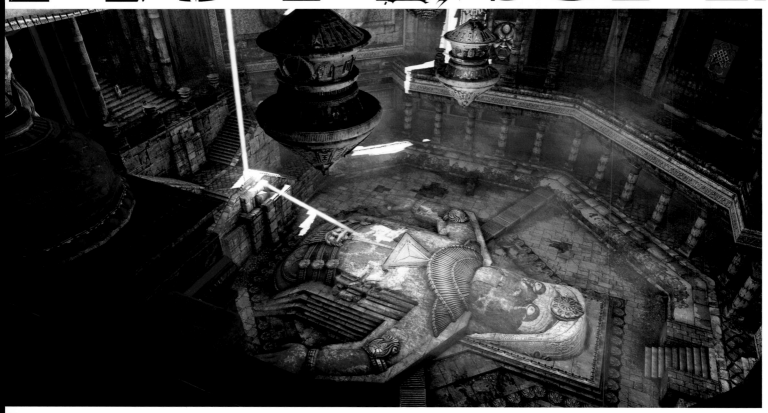

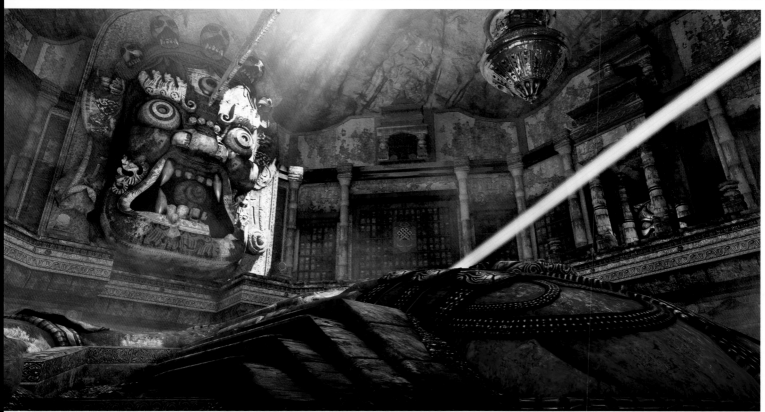

Nepal Temple Chamber *opposite page*
Nepal warzone vista *below*
Nepal railyard *bottom*

HYPER-REALISM

Uncharted 2's environments are meant to be hyper-real, where every building is taller, the mountains bigger, the cliffs steeper, the oceans more vast, and the colors brighter. Everything is stylized to some degree.

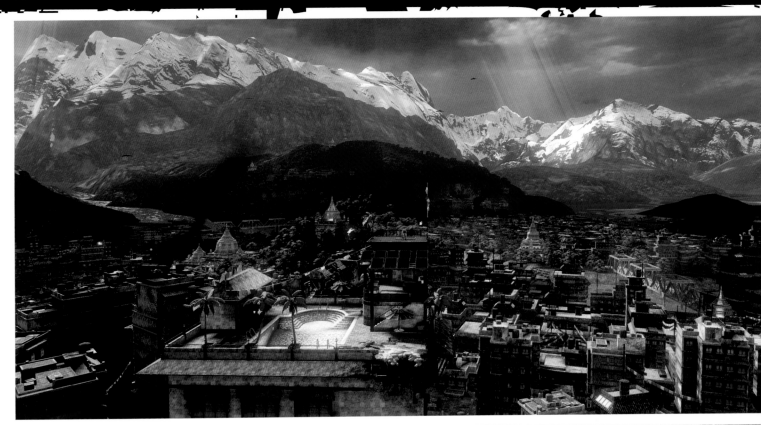

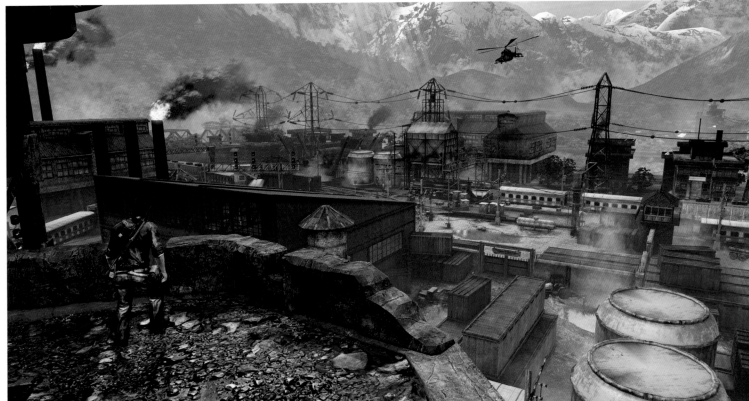

PRODUCTION ART: ENVIRONMENTS

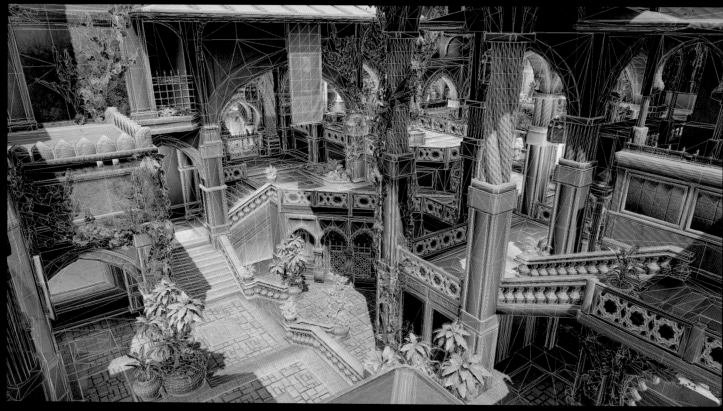

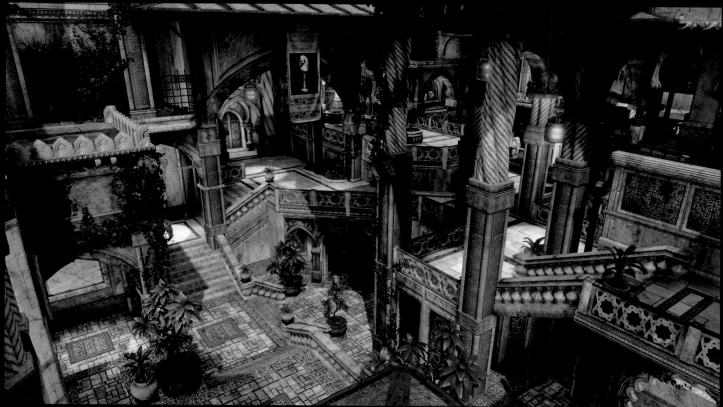

THE MUSEUM

As one of the first levels in the game, Museum is meant to teach the player some of the core gameplay mechanics. The elaborate Turkish architecture makes for a fun environment to explore from different perspectives, so we purposely made the museum level very tight and reused the same environment by allowing the player to traverse it from a variety of heights and angles. As the level progresses, we lead the player from underground sewers, through ornate courtyards and interiors, up across balconies and finally onto the museum rooftops. To help achieve the level of detail necessary in all of the Uncharted 2 environments, we use a method called "instancing" which involves creating a highly detailed model (eg. a pillar), which is then used multiple times throughout the level. Naughty Dog's sophisticated pipeline and toolset make this efficient and flexible.

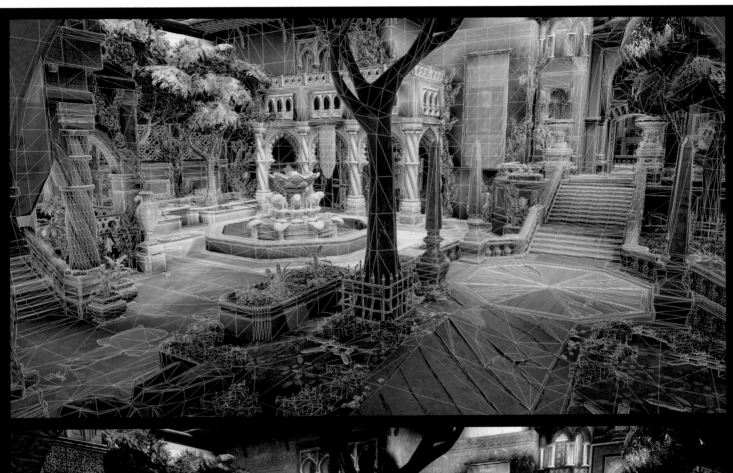

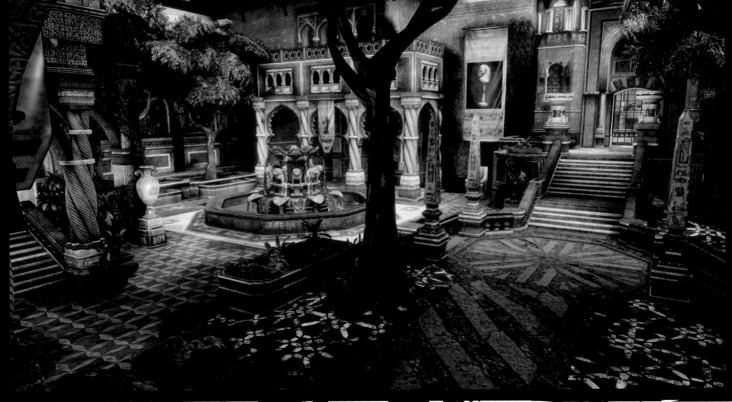

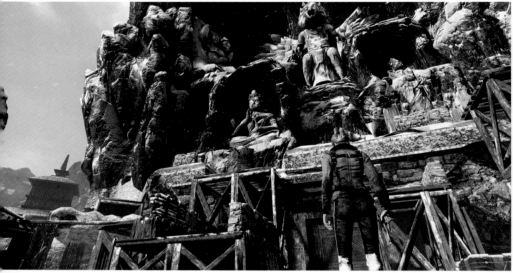

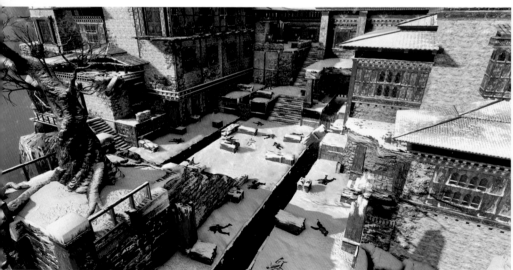

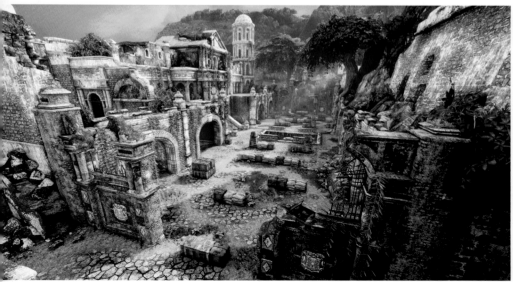

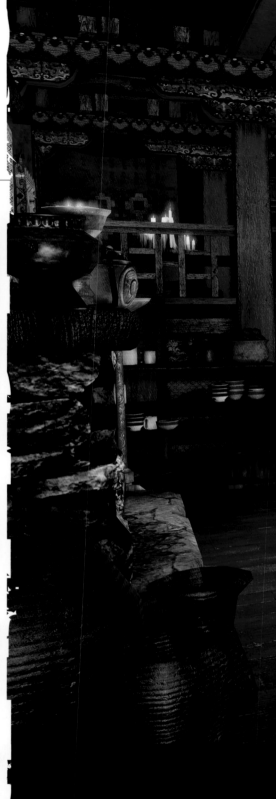

Schäfer's house *above*
The Monastery *top left, center left*
Fort multi-player *left*

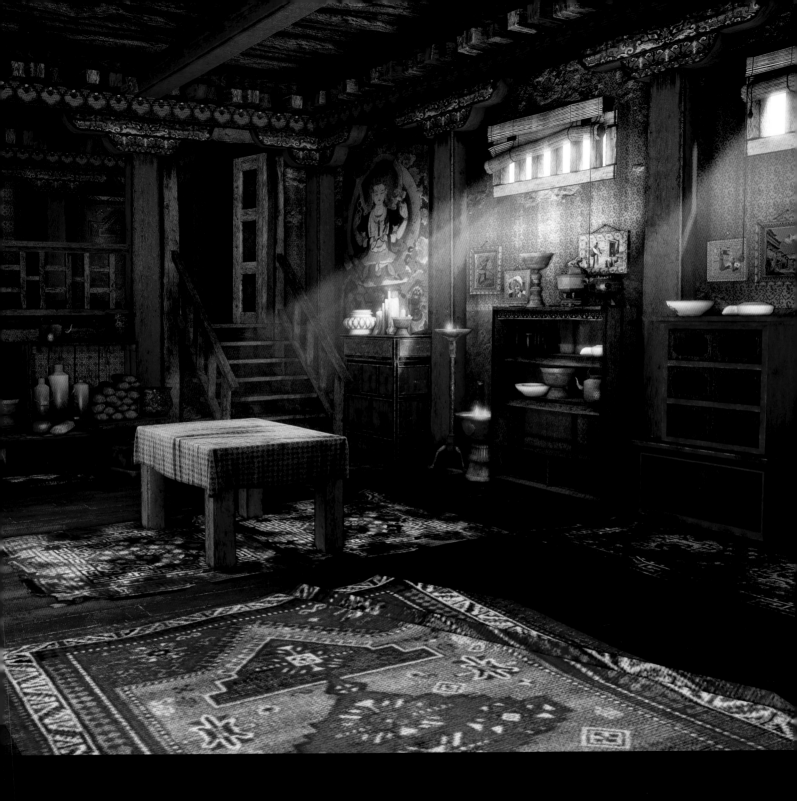

BACKGROUNDS

We usually pair a modeler with a texture artist to work together on a background scene. To create the most convincing surfaces, the texture artist hand-paints color maps in Photoshop and sculpts normal maps in ZBrush. These textures will be mapped on the modeler's mesh to increase the detail and variety that cannot be achieved efficiently with polygons alone. A powerful feature in our shader tools, called blend shaders, helps texture artists create almost endless variation by blending one set of tiled textures to another. Foreground artists get to do the fun part of the job. They get to model interesting objects, vehicles, weapons, and other machines—then blow them up! They work alongside the modelers, to determine what elements in the level need movement, destructible sequences, or have physics or dynamic properties. Basically, everything in the game that moves, aside from the characters, is modeled, textured and animated by this meticulous group of artists. The lighting artists have a critical role in adding the finishing touches to the level. Without light and shadow, all shapes and surfaces will look flat. The color that lighting brings out will help communicate emotions through the environment, while complementing the context of the story and gameplay. Special effects like snow, rain, god rays, fire, and smoke make the environment look alive, and punctuate every event. Each discipline is held together by very competent leads. The leads manage communication between departments, in addition to solving technical, artistic and production problems. Leads take on full production loads on top of being the vanguard in innovation and setting a higher standard for the team.

PROPS

Weapons *opposite page*
Attack helicopter *below*
Tank *bottom*

In the beginning of the project, we usually make a list of props and vehicles that we anticipate using. Some of them will be shelved and saved for another time, but most of them will make it into the game. These are usually handled by our foreground artist team, but if the schedule starts to slip, the overflow work will usually be outsourced. Most of these props are built using reference pictures, but if an object needs modifications to fit a special character or gameplay situation, we will have concept art draw the adjustments.

PRODUCTION ART: ENVIRONMENTS

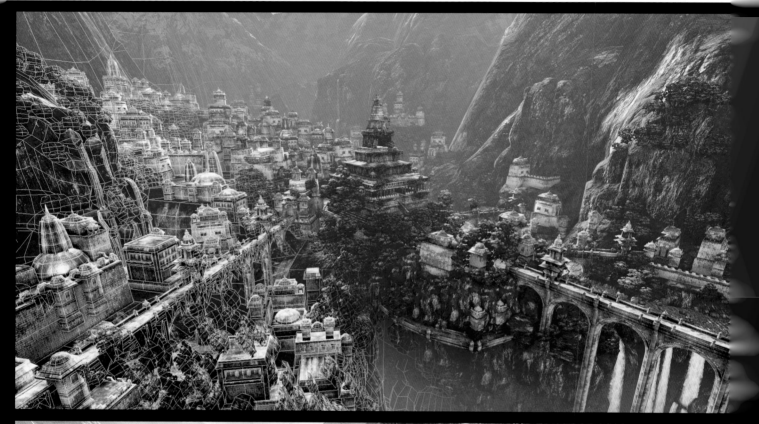

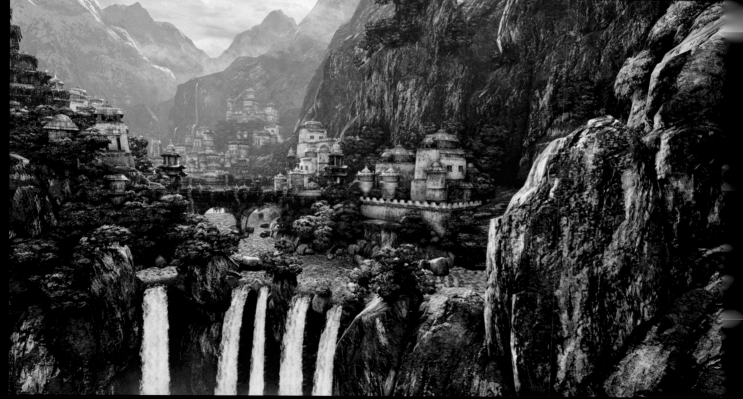

SHAMBHALA

For the final level of the game, we wanted to reward the player with an epic experience. The ancient city of Shambhala is where Drake battles his greatest enemy and narrowly escapes death to save the world. As the object of Drake's quest, this is our most fantastic environment, and one of the most technically challenging to create. The sprawling vista is composed of a small number of highly efficient, modular buildings that were instanced and put together in many different ways to create the illusion of a huge city in ruins. At the center of Shambhala is a massive stone temple which serves as a visual goal for the player. As you progress through the level, you see the temple, the city, and the surrounding mountains from many different viewpoints, which required multiple versions of many areas in the level. In the final climactic moments of the game, the city begins to collapse and Drake is forced to race across a crumbling stone bridge that spans over a deep chasm. This sequence was one of many in the game that pushed the limits of our rendering engine.

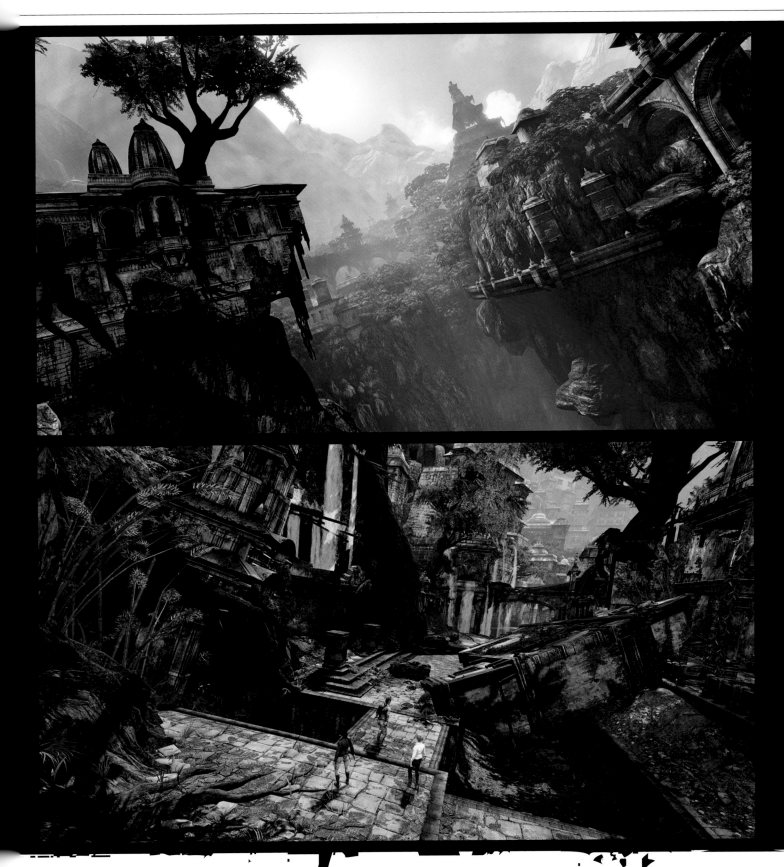

PRODUCTION ART: BORNEO

Creating the huge, sweeping vistas in the game presented some unique challenges for our artists. Using concept art and photo reference, massive areas had to be populated with optimized geometry to create the illusion of a seamless world that stretched out to the distant horizon and beyond. Various tricks were used, such as scaling distant objects to create a forced-perspective effect, but often it just came down to old-fashioned hard work, attention to detail, and stubborn persistence.

Borneo vista *this spread*

Borneo jungle approach *below*
Borneo jungle camp *bottom*
Borneo temple interior *opposite below*
Borneo temple ruins *opposite bottom*

PRODUCTION ART: ENVIRONMENTS

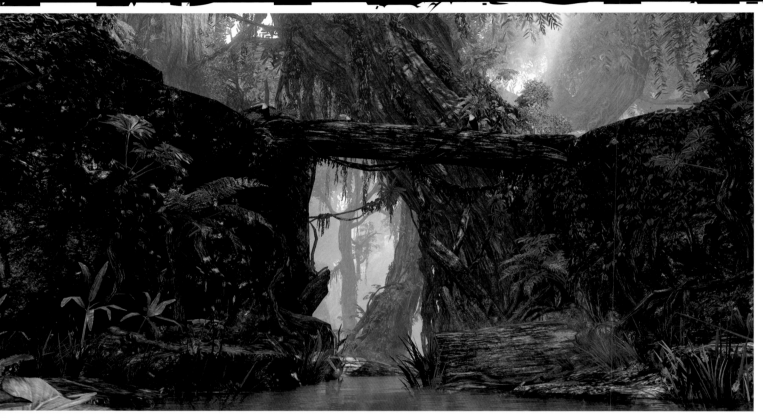

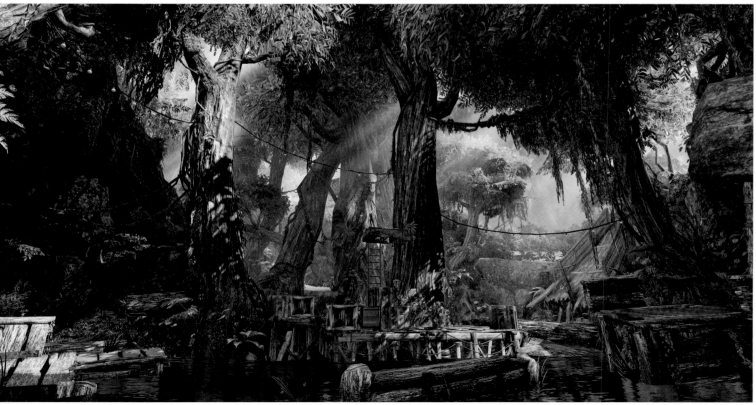

There were a lot of jungle locations in Uncharted: Drake's Fortune, so our challenge in Uncharted 2 was how to differentiate our new jungle from the last game. So, first off, we decided to make it a swamp. This added the water element to the scene which shows off the reflections of the trees and plants. We also exaggerated the scale and widened the range of sizes from tree to tree. Playing with the scale alone gave the environment a more organic and overgrown feel, with smaller roots, vines and plants growing on sequoia-like trees. We used more angle variations in the ground and tree growth, avoiding straight vertical and horizontal lines so the environment wouldn't feel stiff. Combined with our new lighting and optimization tools, we were able to pull off a more impressive jungle. The hidden temple architecture was inspired by the ruins of Angkor Wat, and the statues from Bali. We wanted to make it feel like this subterranean structure was being invaded by the jungle. Roots and vines suffocating these exotic statues helps emphasize the macabre mood. Of course, the pile of skeletons littered all over the place seals the deal.

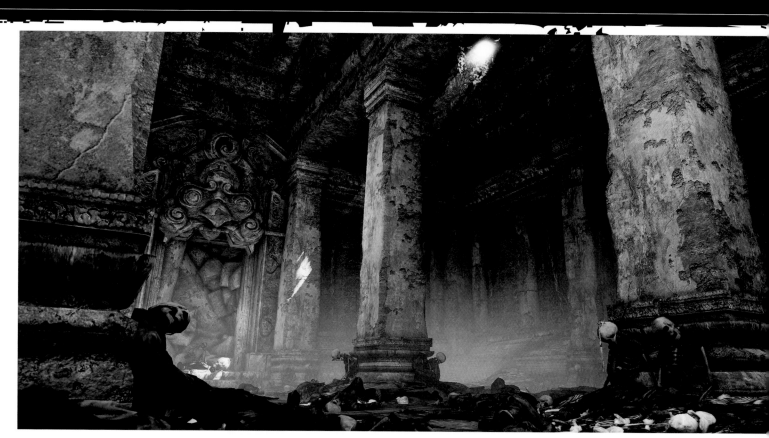

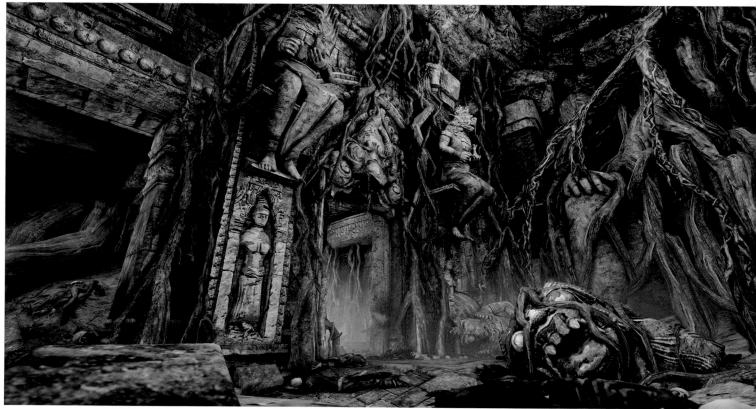

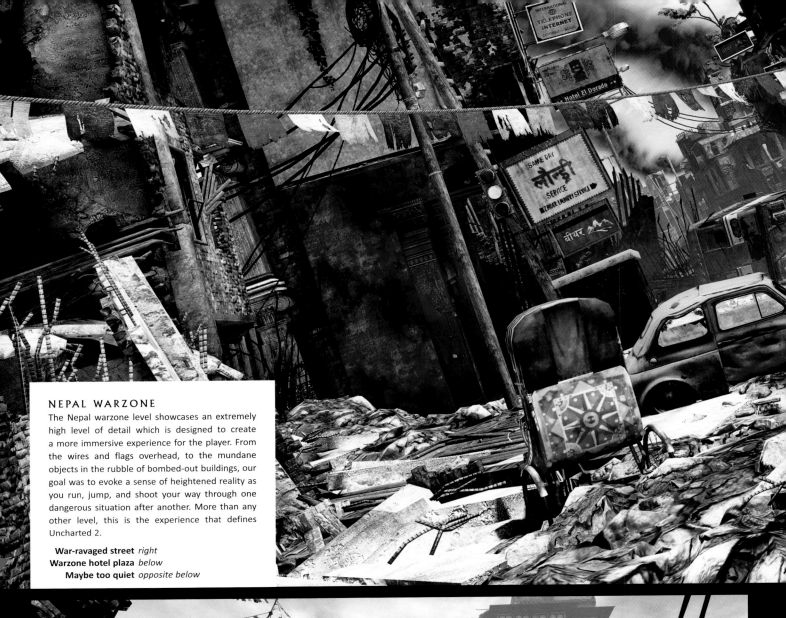

NEPAL WARZONE

The Nepal warzone level showcases an extremely high level of detail which is designed to create a more immersive experience for the player. From the wires and flags overhead, to the mundane objects in the rubble of bombed-out buildings, our goal was to evoke a sense of heightened reality as you run, jump, and shoot your way through one dangerous situation after another. More than any other level, this is the experience that defines Uncharted 2.

War-ravaged street *right*
Warzone hotel plaza *below*
Maybe too quiet *opposite below*

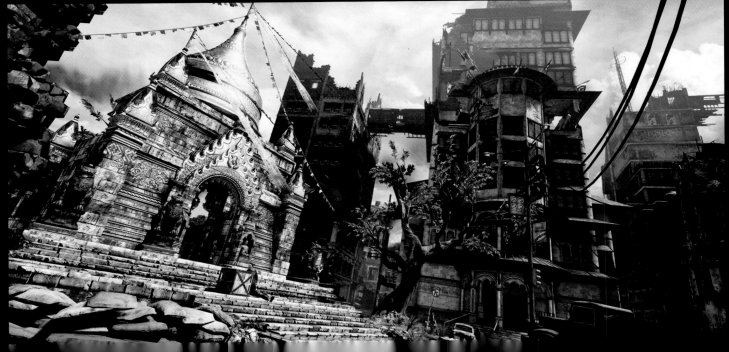

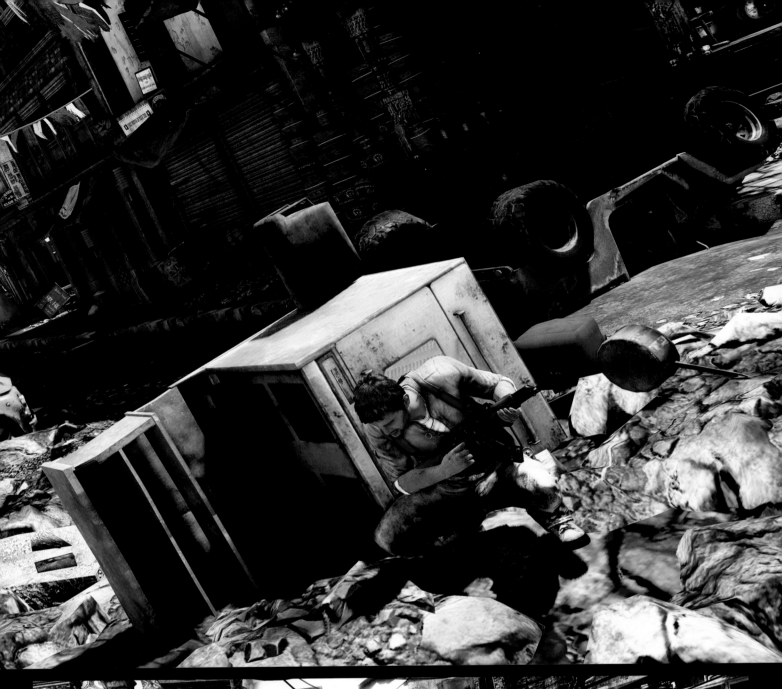

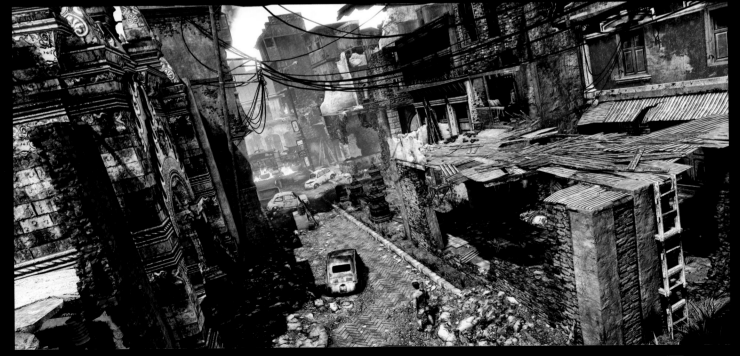

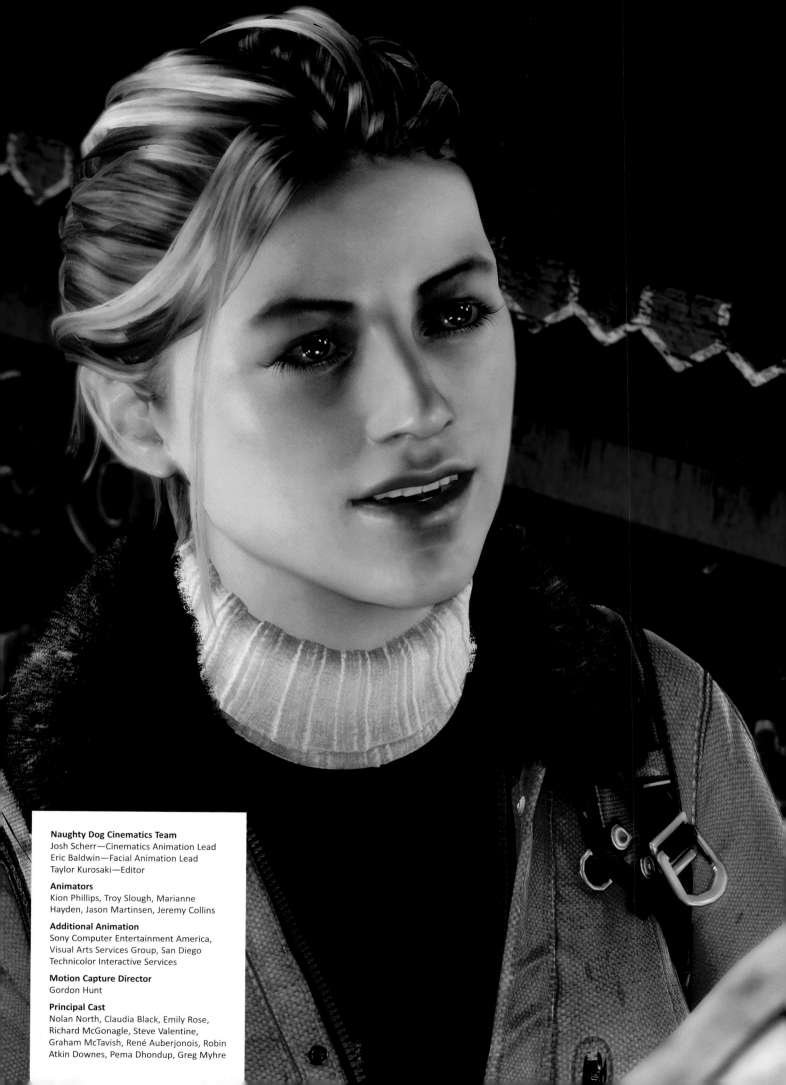

Naughty Dog Cinematics Team
Josh Scherr—Cinematics Animation Lead
Eric Baldwin—Facial Animation Lead
Taylor Kurosaki—Editor

Animators
Kion Phillips, Troy Slough, Marianne
Hayden, Jason Martinsen, Jeremy Collins

Additional Animation
Sony Computer Entertainment America,
Visual Arts Services Group, San Diego
Technicolor Interactive Services

Motion Capture Director
Gordon Hunt

Principal Cast
Nolan North, Claudia Black, Emily Rose,
Richard McGonagle, Steve Valentine,
Graham McTavish, René Auberjonois, Robin
Atkin Downes, Pema Dhondup, Greg Myhre

PRODUCTION ART
CINEMATICS

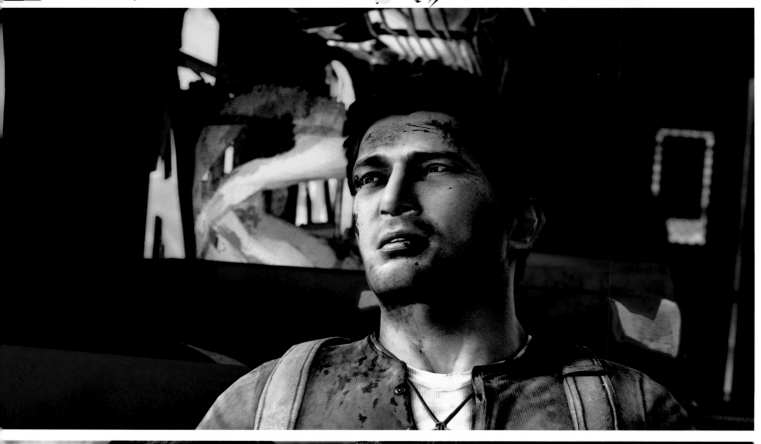
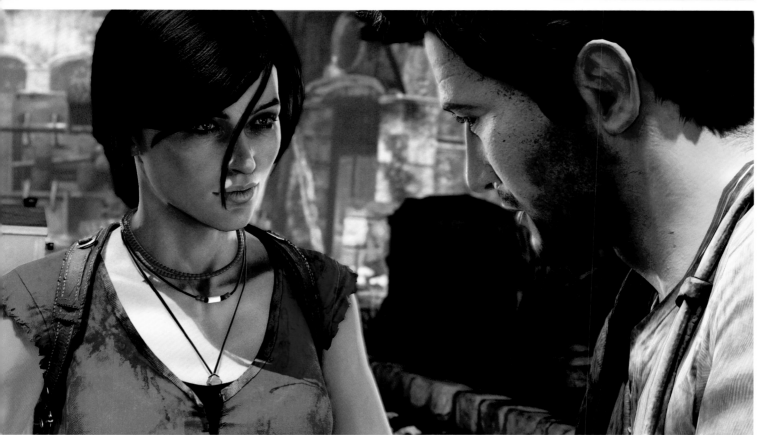

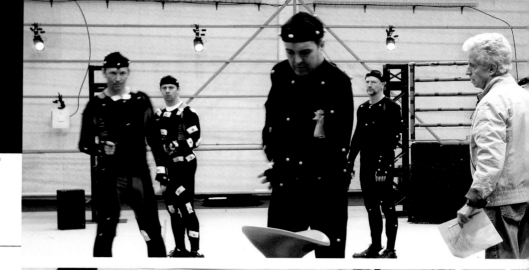

Amy Hennig
Creative Director

CINEMATICS

Because we're telling a character-driven story, capturing the emotional authenticity of the actors' performance is key. Everything we do, all the processes we've developed, are geared to this one goal. It all begins with the story and writing, of course, but after that our primary and most critical hurdle is casting. We cast Uncharted as though we were casting for film or TV—including in-person auditions, and call-backs where we have the principal characters read with Nolan North, our lead. It's important that we not only find talented actors for the roles, but the chemistry has to be right. It's also critical for us to assess the actors' physical signatures, because they provide the entire performance for their characters—including both motion-capture and dialogue recording. Unlike most other game developers, we have the actors performing together on the mocap stage, so it's really much more like a theatrical or on-camera performance in that way; it's sort of like going back to the actors' roots and doing "black box theater." We're also recording the actors' vocal performance at the same time, because we mocap the scenes on a sound stage, and we have the actors mic'ed for sound. Even when we're recording in-game audio in the voice studio, we have the actors performing together whenever possible. Any actor will tell you that acting is reacting—so it's ironic that in most game productions, the actors are performing alone in the recording studio without any real context, and without the other actors to play off of. That's why we've developed the production methods we use—having the actors on the stage together allows them to capture those "lightning in a bottle" creative moments, which give their performances such a natural quality, and so much emotional authenticity. We're able to capture every little stumble and overlap, every interruption and ad-lib that brings the characters to life. We also include the actors as long-term collaborators on the project—we work together for more than a year, we revise and table-read and rehearse the material together before we capture it, and we allow for a lot of collaborative improvisation on shoot days.

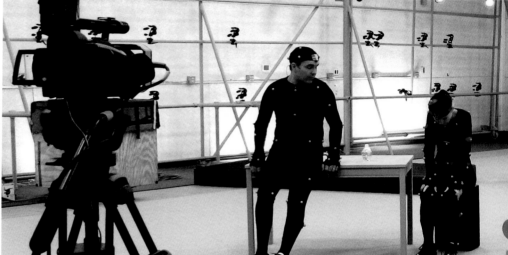

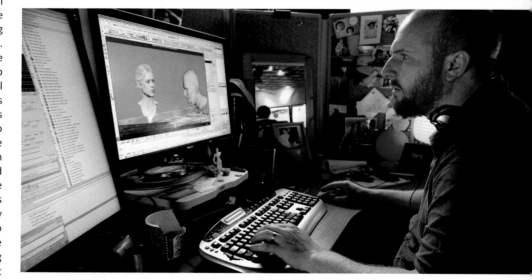

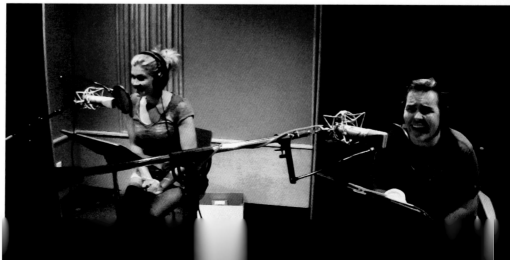

Capturing the cinematics for Uncharted is more like shooting an on-camera production than a video game. It's like shooting a multi-camera TV show, or performing a stage play, because the actors perform entire scenes in a single take—we don't have to break the scenes down into shots because the mocap cameras record the entire performance from all angles simultaneously. All the camera staging and editing happens later, in Maya, when we get the mocap data back and the animators get to work. We'll only break a scene into multiple shots if the size of the mocap stage can't accommodate the entire scene, or if we need to break down the set for some reason. Otherwise, we just let the actors run the scene all the way through. We'll usually do several takes, just to make sure have enough choices

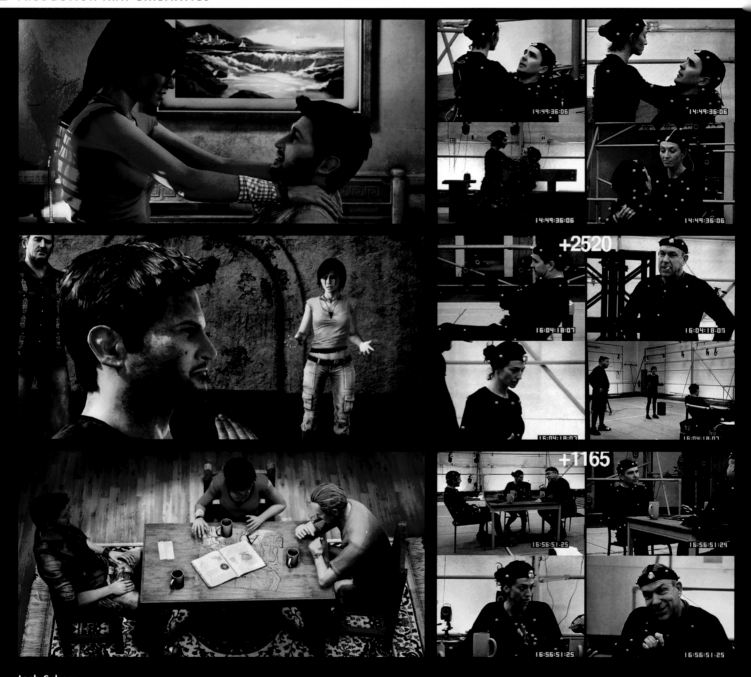

Josh Scherr
Cinematic Animation Lead

MOTION CAPTURE

We approach motion capture quite differently than most studios. While we do extensive planning prior to the shoot, we don't do storyboards. We discovered early on that planning out all the shots ahead of time was not only unnecessary, but didn't allow for all the spontaneous discoveries (and inevitable changes) that happen during rehearsal and shooting. We'll sometimes do rough camera blocking for scenes with elaborate setups or a lot of characters. We spend most of our prep time measuring our game environments to make simple physical sets, coming up with rough staging, and making props. On the day of the shoot, my job is to make sure the animators get everything they need to create the best possible performance. Getting video footage is absolutely vital. Not only does it

when we get to the editing process, and to allow for some alternate readings and improvisations. The actors really enjoy the process, because it takes them back to the roots of their craft. We also like to work fast and keep things moving, so there's not a lot of waiting-around time. And it's a pretty forgiving medium, since we can easily cut together different audio and mocap takes to fix any problems,

more so than we'd be able to do if we were shooting for film or TV. Ultimately, we carry the Naughty Dog philosophy into the mocap studio—which is a check-your-ego-at-the-door, no BS, collaborative working environment which the actors enjoy. There's a lot of camaraderie, and it's a very relaxed set, not a lot of tension—all of which shows, I think, in the end result.

'Mostly professional' motion capture *opposite top*
'Payback time' motion capture *opposite center*
'Payback time' motion capture *opposite bottom*
'Last year's model' motion capture *top*
'Cornered' motion capture *center*
'Schäfer's story' motion capture *bottom*

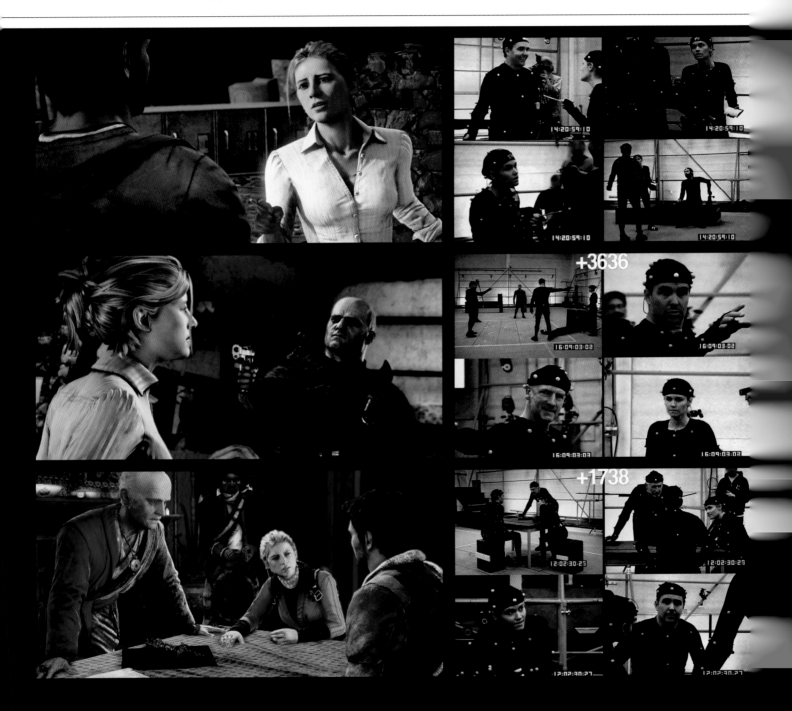

help me pick the best performances from each actor, it provides the animators with essential reference. We don't do any facial mocap—all of the faces are animated via keyframing—so three of our four cameras focus on the actor's faces, and the fourth camera acts as a master

overview of the scene. I also try to make sure the actors don't make any performance choices that won't read well once applied to their characters. After the shoot, I review the best takes and choose what mocap I want to use. Since there's rarely a completely perfect

take, I usually mix and match the best takes from each actor to make the final scene. Once we receive the data, the real work begins. We don't just take the raw mocap, drop it into the game, and call it done. Everything is carefully edited, modified, and polished.

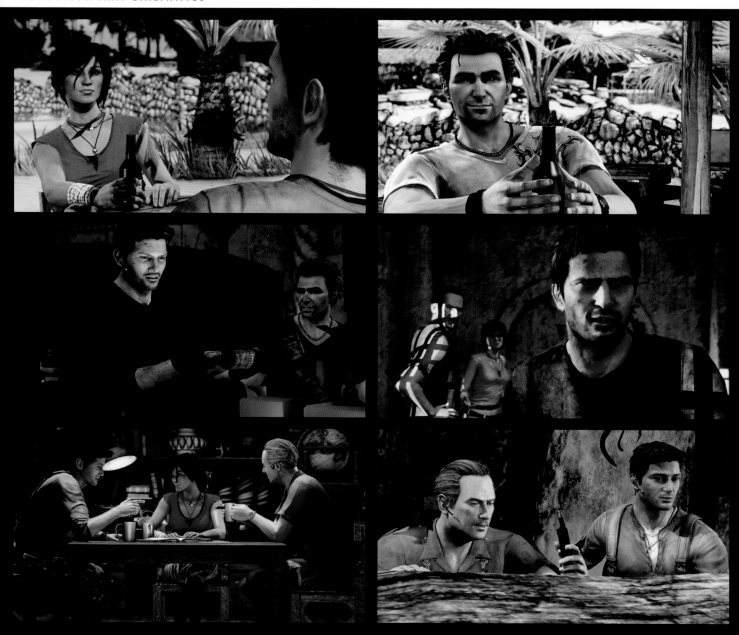

Josh Scherr
Cinematic Animation Lead

ANIMATION

Our animation process begins with scene layout and camera animation. Seeing the data in Maya is like watching the actors from a god's eye perspective, so we'll just go in and start exploring the possibilities. For the simple scenes, we'll often just animate a single camera or use free software called zooShots that lets you place multiple cameras and create an edit decision list. For the more complex scenes,

we'll work with our video/audio editor Taylor Kurosaki and provide him with a series of cameras that provide coverage of a given scene, then let him turn it into a cohesive whole. Once the animators receive their scenes, they first do a general clean-up pass on the mocap data to get rid of any unwanted pops or weirdness. Feet and hands are locked down, fingers are animated, props are constrained to

the characters, and animated where necessary. Since mocap can often look floaty or stiff in the broader gestures, the animators will loosen up the arms in a walk, punch up arm gestures so they have more snap, and tone down excessive bouncing or fidgeting. We make sure any physical contact between characters looks good and has the proper weight. Lastly, if we don't get the performance we're looking for,

"Last Year's Model," where Drake and Chloe meet Elena and Jeff, was not only one of my favorite scenes in the game, but one of the hardest to produce. The first challenge was choosing the mocap data, which was culled from many different takes for each actor. The camerawork also proved tricky, as the actors were often walking around and crossing the camera plane. The animators had their work cut out for them as well. There was lots of physical contact between the characters, lots of prop animation, and some of the most demanding facial animation in the whole game. Chloe in particular was a challenge in this regard, as she had to cycle through a wide range of emotions.

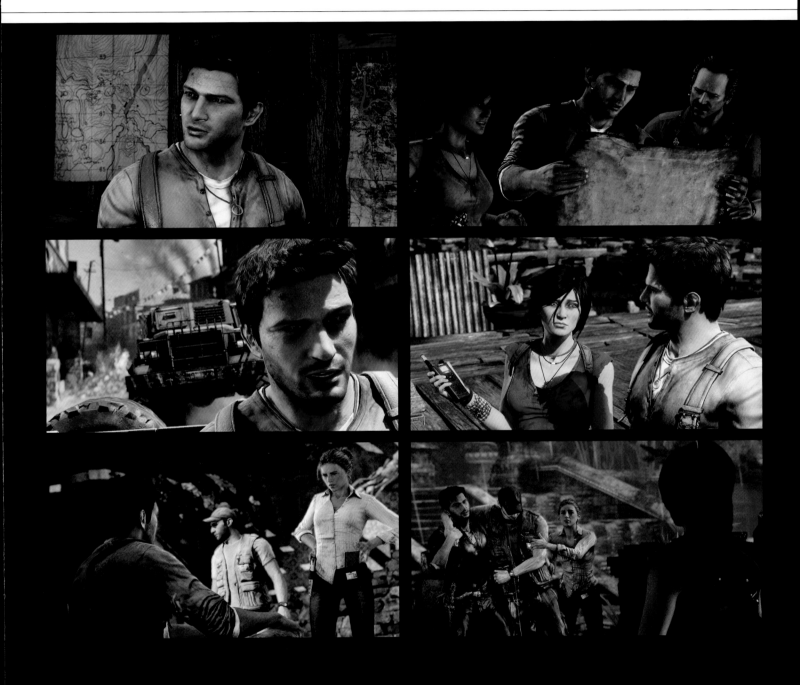

animators will use the mocap as a base and then go in and do some keyframe animation. Given our time constraints, we only do this when absolutely necessary. Having said that, all of the dangerous stunts are always keyframe-animated. Keyframing the facial animation from scratch requires a lot of time and care to get right. While we can let little issues in the body animation slip by, you'll know right away if something's wrong with the face, so it becomes the priority when time is short. Rather than absolute realism, we strive for a "stylized realism." We push the character's facial expressions just enough so their faces don't seem stiff or dead, but not so far that they look cartoony or grotesque. The video reference is not used to rotoscope the faces, but rather reinterpret the performances. Eric Baldwin, our lead facial animator, ensures that the faces look consistent between each scene and each animator. At its peak, the cinematics team had 32 animators who produced 90 minutes of highly polished animation in less than a year. Each animator was responsible for 12-15 seconds of finished animation per week, including the body, face, eyes, props, vehicles, and whatever other elements might be in a scene.

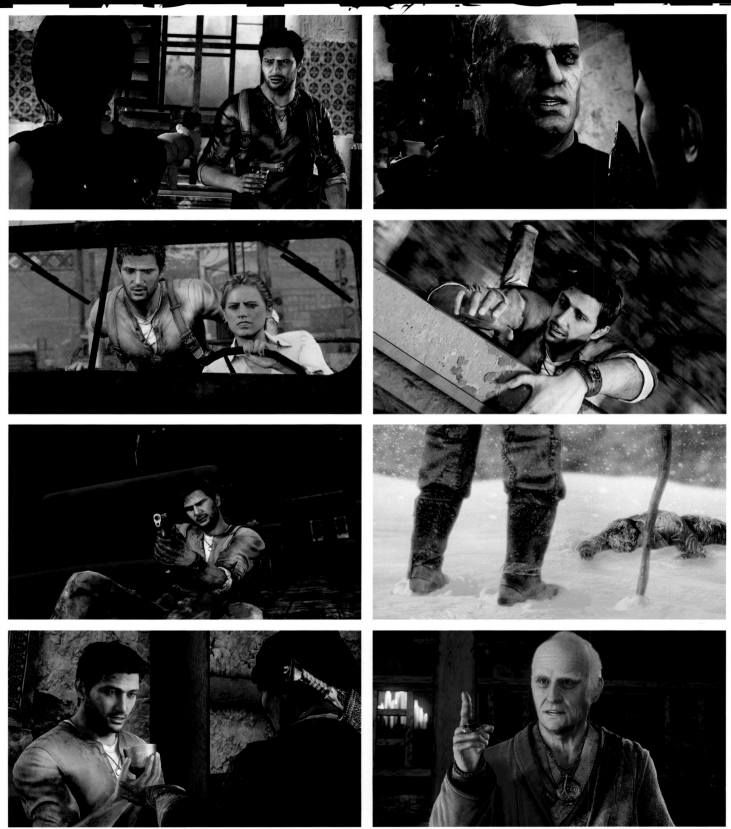

Naughty Dog's goal with Uncharted 2 was to create an "active cinematic experience," which partially meant taking control away from the player as little as possible. The collapsing building in Nepal, the convoy chase, and helping Jeff get to safety are all moments that might've been cinematics in other games. However, we made them fully interactive and they were all the more immersive and awesome for it. So when we do take control away, it had better be for a good reason. Cinematics in Uncharted 2 are used not only to tell the story and showcase our characters, but also to create moments that are difficult (if not downright impossible) to provide when the player is jumping off cliffs or trying to shoot bad guys. Globe-hopping transitions, intimate character moments, and subtle emotions are much easier to convey—and more effective—when the player isn't in control of Drake.

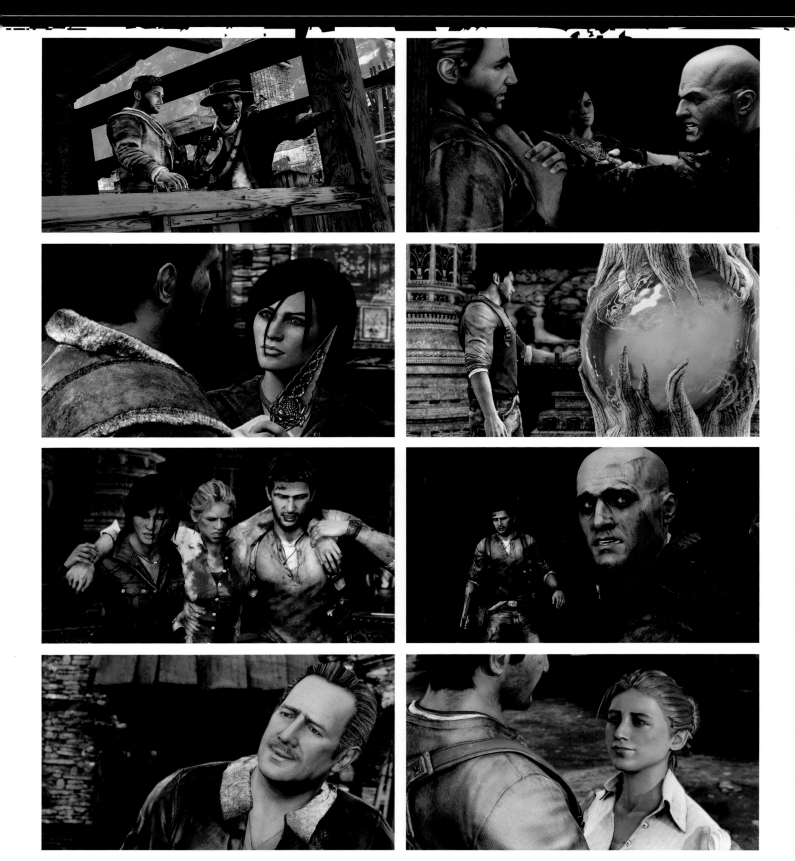

Naughty Dog Effects Team

Dynamics Artists
Michael Fadollone
Eben Cook

Particle Artists
Keith Guerrette
Mike Dudley
Michael Gevorkian

PRODUCTION ART
EFFECTS

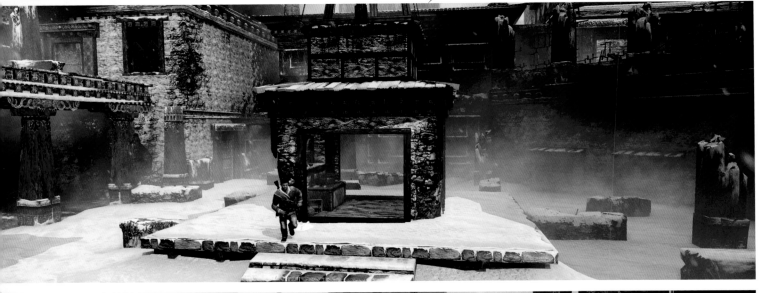
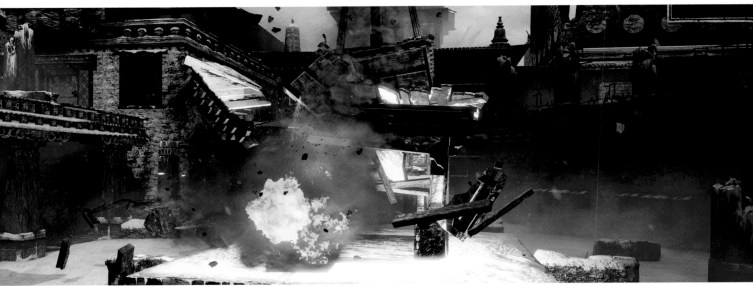
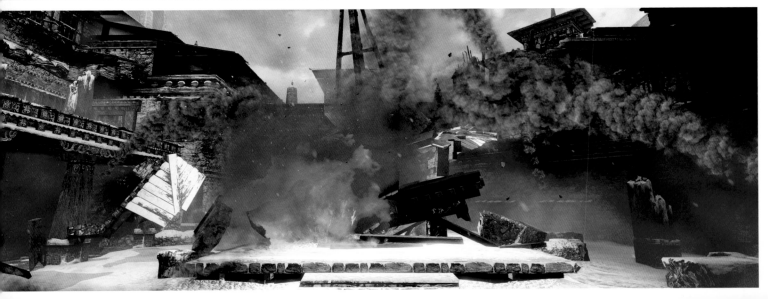

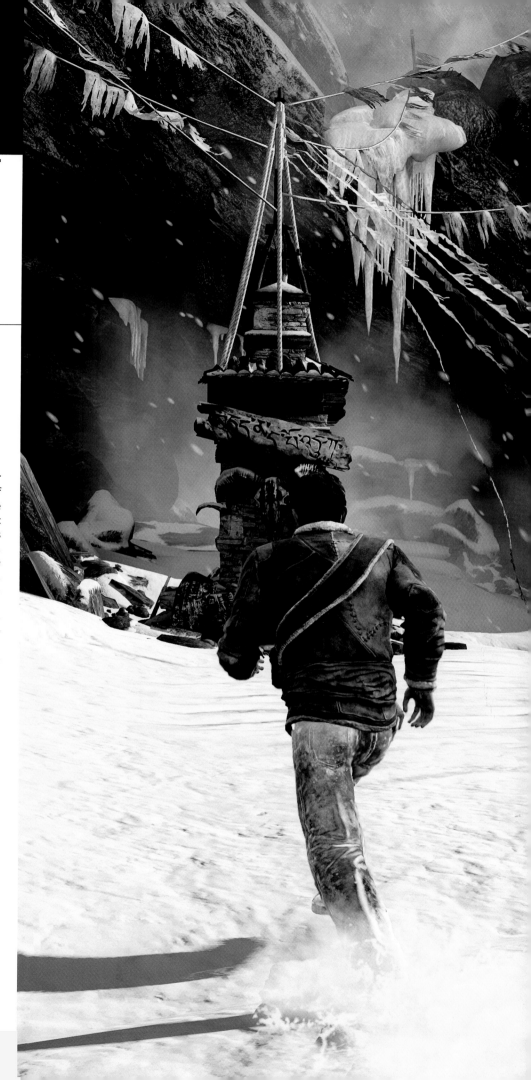

Mike Hatfield
Lead Technical Artist

EFFECTS

One of the things we wanted to improve over Uncharted: Drake's Fortune was our use of real-time physics-driven events. Situations like a character moving through an environment where he's knocking things over, or he's destroying cover with the machine guns. We really wanted to bring more life to the environments with things that are dangling, or hanging off of the ceiling, that you can bump into and shoot and see them react in real-time. We also wanted to increase our use of pre-simulated physics so if we had a major destruction effect like a building collapsing, we'd pre-simulate all that in Maya, bake all that animation down, and then run that through the game engine. So you'd have real-time control of the player, but the building collapsing is a pre-simulated event. To push things further we also wanted to layer our real-time physics objects over the pre-simulated events. So in the collapsing building sequence we've also got computer monitors and plants that are rolling around in real-time reacting to the environment. To add a third layer on top of that, we also added physics-driven particles, so we have sparks that are coming off the light fixtures, that are particles hitting the ground and bouncing. It's pretty amazing that it actually works. To complete the effect you've got enemies that you're shooting while the building is collapsing, and when they're killed they turn into rag-dolls flopping around the environment. The overall result of all these effects is to overwhelm the player so that they don't really have time to pick it apart and figure out: "Hey, that's pre-simulated, and that's real-time." We just want them to get caught up and pulled into the whole experience. All they know is they're controlling Drake and trying to survive.

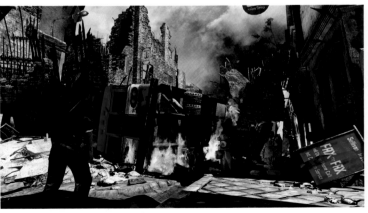

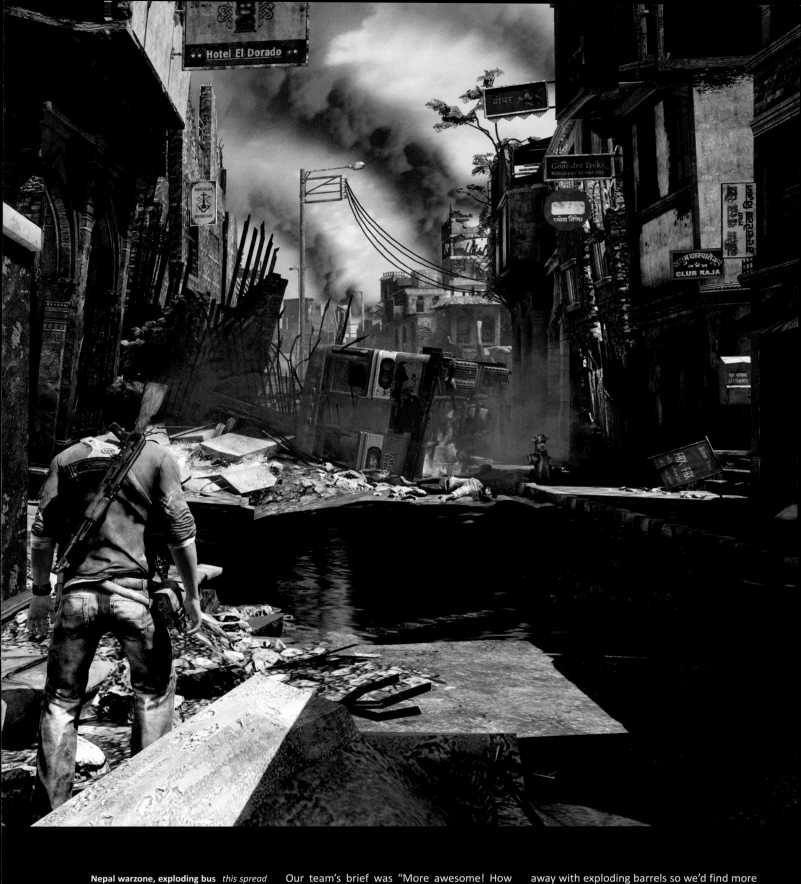

Nepal warzone, exploding bus *this spread*

Our team's brief was "More awesome! How do we make this more awesome than the first game?" From an effects viewpoint, "More awesome!" equals bigger effects, and pacing them out so those big effects have more dramatic impact. It also means having more interactive stuff in the environment. The first game had very few physics-driven items so we definitely wanted to have a lot more this time around. Part of our goals from the very beginning was to have more interactive items, more real-time physics-driven items, and to do

away with exploding barrels so we'd find more creative solutions to our gameplay problems. We had to find more creative ways to do the same tricks that we've always been doing. We "gate" the player off from area, but that's packaged up in an awesome explosion, and a great dramatic moment finalised by a funny remark from Drake commenting on what he just experienced. All those things are sleight-of-hand distractions for the mechanics of what we're trying to accomplish while moving the player from start to finish.

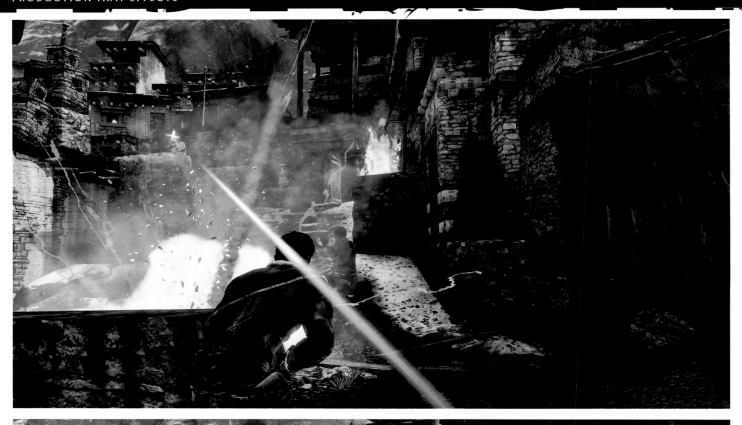

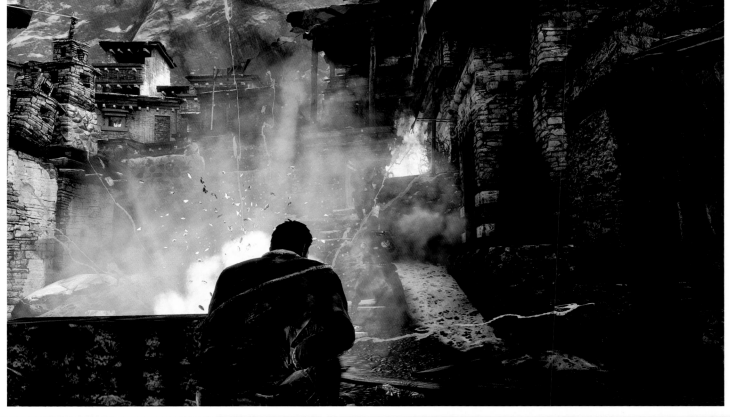

USING HAVOK

We brought in the Havok physics engine for Uncharted 2. Before we had Havok we had our own in-house physics system, developed by one of our programmers, which we used for the first game. It was great, and it worked well, but we were limited in how much we could do with it and how many different features it had, because it was the work of one programmer. Havok is supported by a huge company, and has been through several revisions, so it made things easier for our artists to use. The Havok system gave us the tools to do things like having a light fixture that's hanging from the ceiling that swings around in real-time, and can react to the player or even gunfire. Havok also gave us some performance improvements so we were able to push more physics objects around in any given frame.

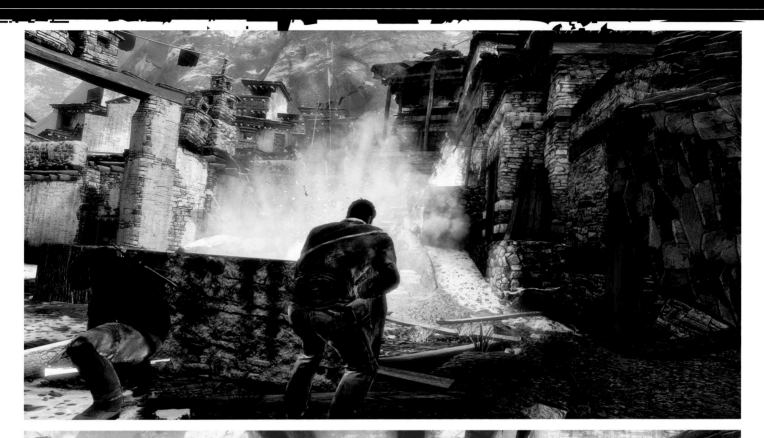

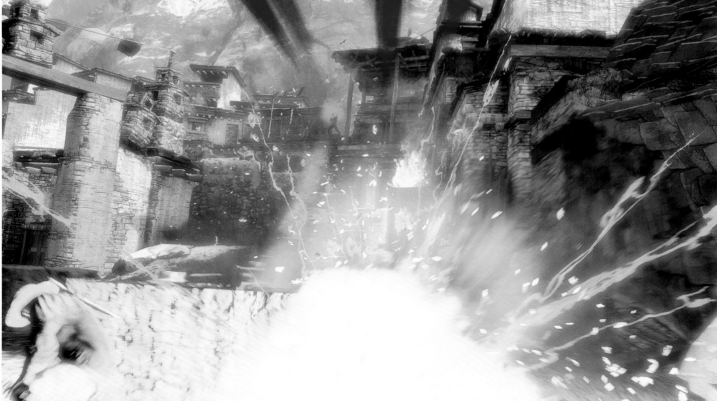

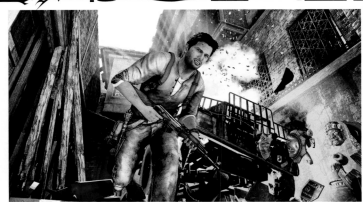

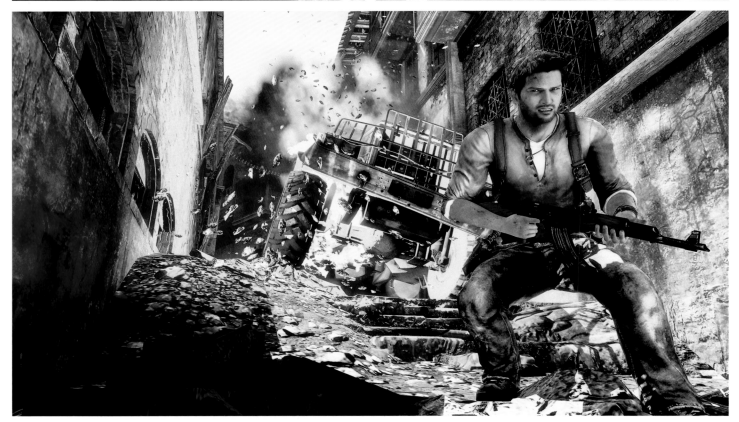

Hind helicopter attack *this page*

In the Nepal warzone, Drake is chased by a Hind attack helicopter. The Hind destroys the bridge Drake is hanging from with machine gun fire, dropping him onto a series of awnings. He then starts running and jumping to avoid the incoming rounds spraying the windows. We got all those windows blowing out with some convincing particle effects. Drake and Chloe make it to a rooftop garden, so we had a lot of plants in pots and the great thing was that the plants were set up with real-time Havok physics. Not only would they be interactive if the player shot or walked through them, but we could also generate wind that was coming from the helicopter. As the helicopter moves from point to point you can see the direction that the wind is coming from by how it affects the plants. The plants also blow violently when the helicopter hovers.

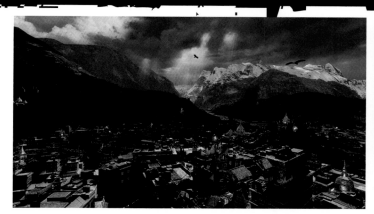

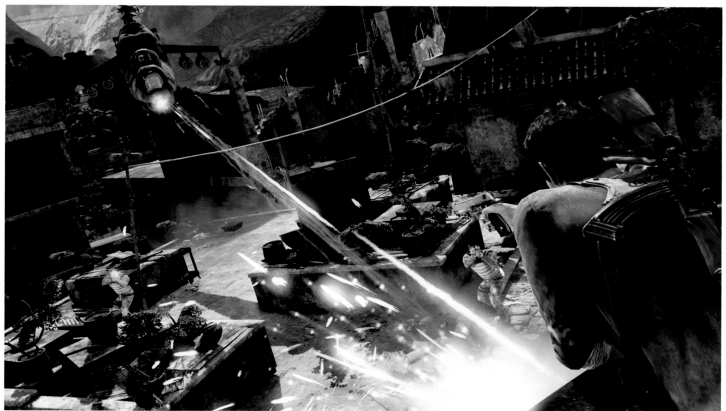

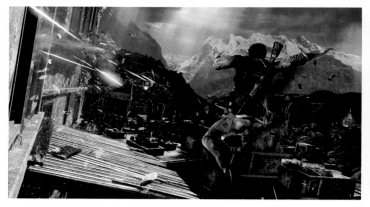

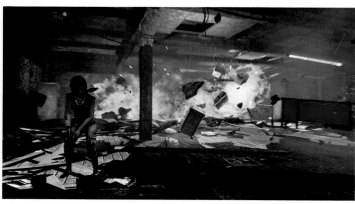

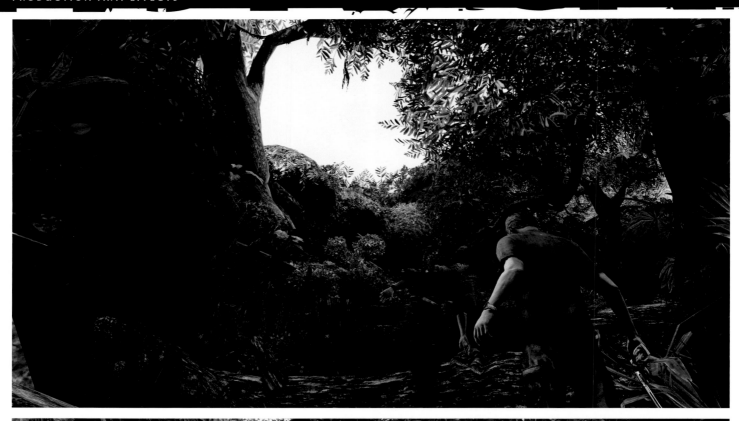

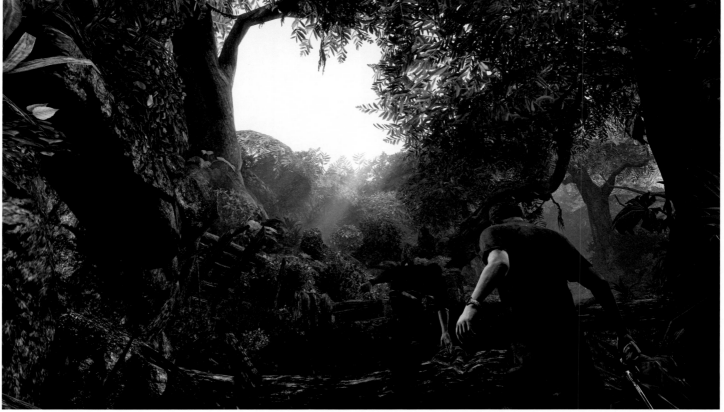

COLLABORATION

The game designer will have an idea of what they'd like to see in a level, but they need the co-operation of the background artist and the effects artist to make it happen. The designer has overall responsibility for establishing the pacing and making sure that the level as a whole is the experience that they want to deliver. Within that there's a lot of room for conversation and compromise and that is how we end up with well-paced games. When those moments come, they're fantastic. It's the culmination of a lot of people's great ideas all mixed together. The most satisfying thing about working at Naughty Dog is the collaborative effort. It's not just among artists and designers, but also the programmers. Programmers are more in touch with our technical limitations than anybody else in the team. Artists are pie-in-the-sky people. We want to see everything. We want high-res textures, and unlimited polygons. The programmers are tethered to reality, but we try to inspire them to find ways to make the technology facilitate these amazing things that we want to do. It's all collaborative, it's all compromise, and then hopefully in the end we come up with something that feels like a win for everybody involved, including the player.

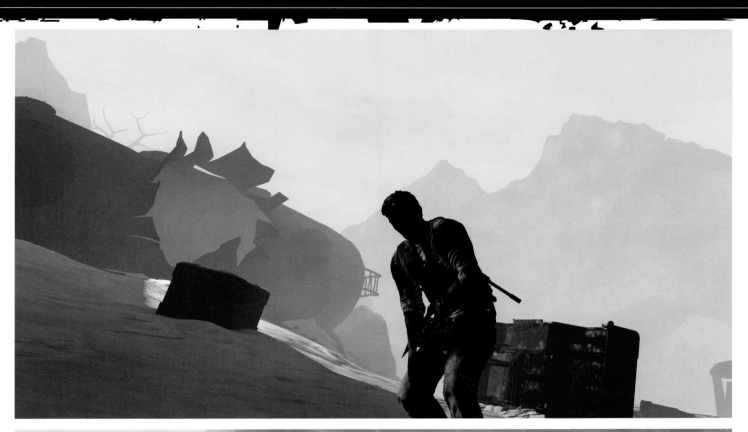

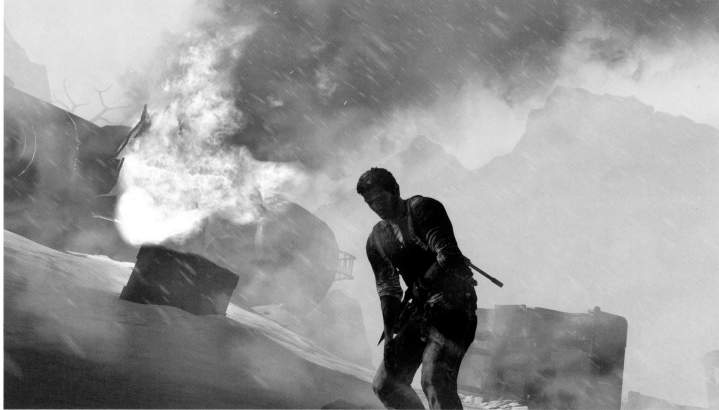

PRODUCTION ART: EFFECTS

BLOWING THINGS UP

We didn't have as many player-initiated large destruction events in Uncharted 2, but we did have a lot of destructible cover. When hiding behind a low cover wall while the enemy is shooting, you'll see your cover chipped away bit by bit—eventually taking enough damage to collapse. That gave our designers a tool to push the player in the direction they wanted them to go, and to create time-constraints for different combat situations. We looked at the story beats to decide when we needed to blow something up, or have a big event like a wall being blown out. Often, they'd be triggered when Drake gets close, and the blast knocks him off his feet. This takes away control for a second and forces the player to be passive for a moment while Drake collects himself. This gives you chance to evaluate your environment, and decide on your next move.

Drake's train journey ends when he blows up some gas cylinders and derails the whole train, causing a massive train wreck. There's a blizzard that's rising in intensity over the course of the level. When you start there's just a gentle snow falling, but over the course of the level we're able to dynamically ramp up the intensity of the blizzard so that by the end you're fighting your way

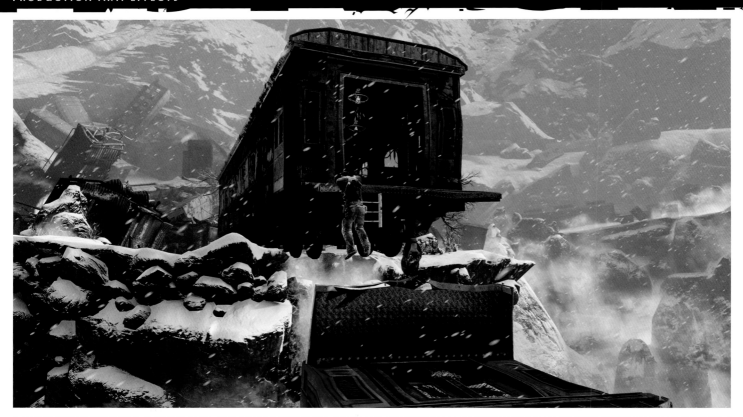

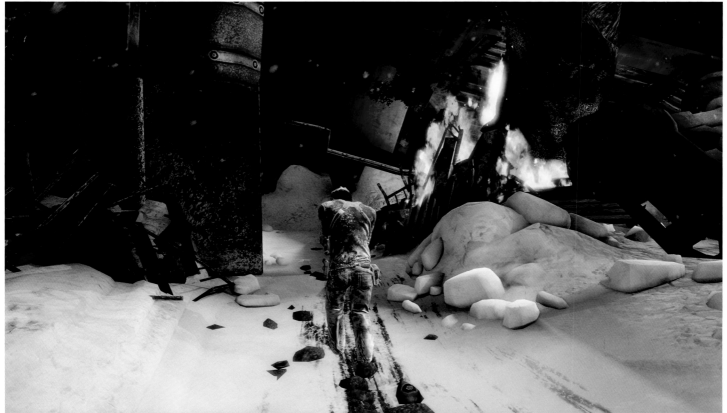

through a pretty heavy blizzard with limited visibility. At one point when you're climbing through these battered train cars, you get up on top of one of them just as another car explodes on the hillside next to you. We call this sequence the 'washing machine' because the explosion sends another car sliding down the hillside which t-bones the car that Drake is standing on top of,

knocking him back inside the car, which then tumbles like a washing machine towards the edge of a cliff. The camera's actually inside the car in this sequence, so you get to see just when the impact happens, and we shatter all the glass. The camera is stationary as the car tumbles around. The camera's inside the car going with it but the car is tumbling and you see Drake

flopping around inside the car. Drake gets knocked out for a little while at the end of that. That's just a cool sequence. You're walking, you're looking around, exploring, trying to figure your way out and then all of a sudden 'bam' there's a big explosion and a huge amount of noise and this incredibly violent scene that happens.

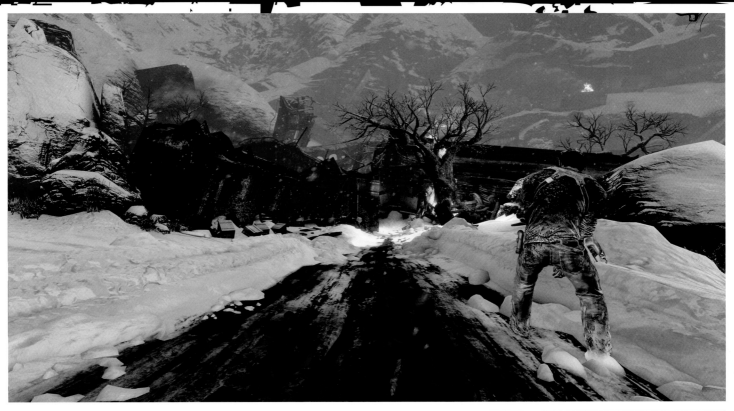

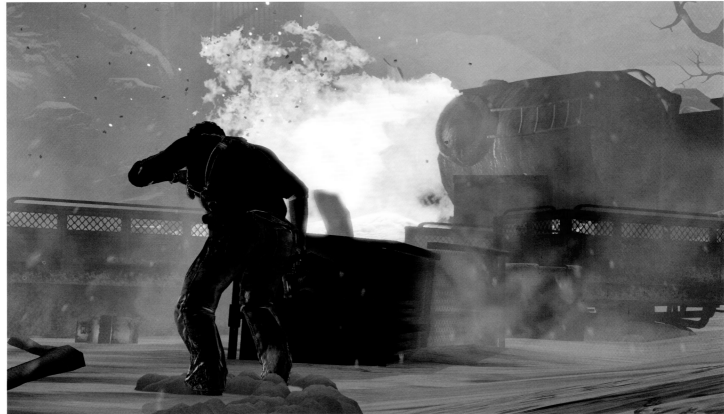

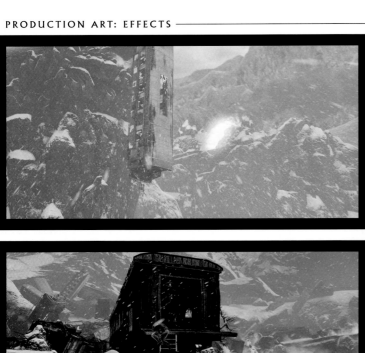
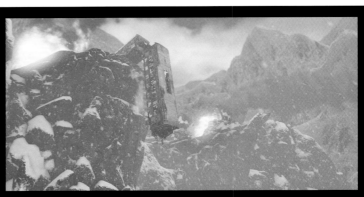
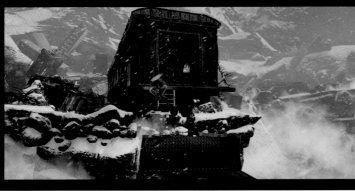
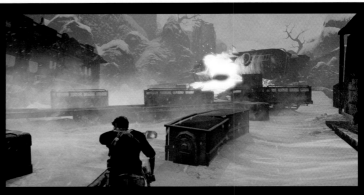
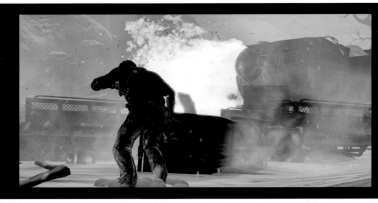
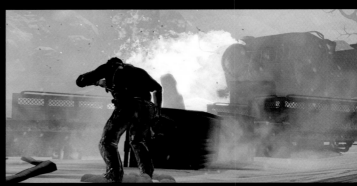
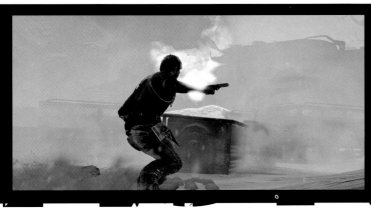
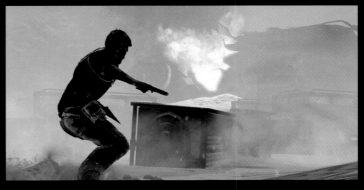

HEAD TO THE LIGHT

Train wreck sequence *this spread*

In the Train Wreck level there's a burning tanker car that you can use as a visual beacon through the blizzard to keep your bearings. As a rule, we keep people headed towards the light. The tanker eventually explodes during the battle and sends a big piece of debris flying through the environment. The explosion blows a cap off the tanker and if that cap happens to hit an enemy, it will kill them. It'll happen every once in a while, and it's really cool to see.

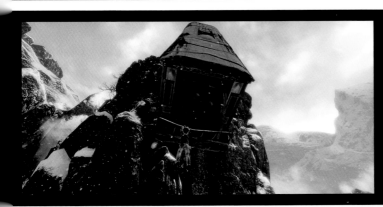

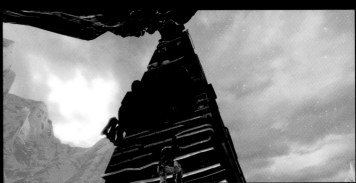

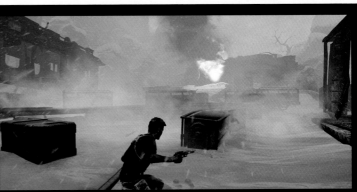

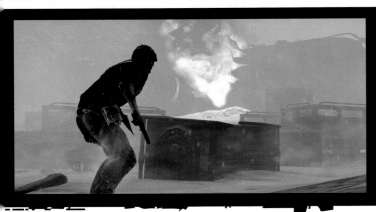

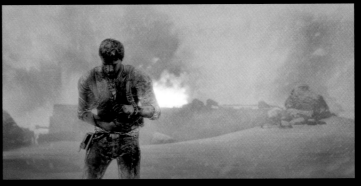

Nepal warzone, explosive effects *this page*

RUBBLE

Anything that gets destroyed requires pretty extensive testing because we have to make sure that any real-time events happen randomly enough to be satisfying. We also have to make sure that it happens in a controlled way that prevents the player from getting stuck. We blow up a lot of stuff in the game, and then we have to put all that rubble somewhere. If we're going to create a big pile of rubble from something we destroy, we have the testers climb all over that thing and give us all kinds of bugs about wherever they see any collision problems. If any combat has to happen in the vicinity of the debris then it's especially important that we have smooth traversal over that geometry. So we do a lot of testing on the piles of rubble that we create, basically to make sure that we don't break the game and ruin the experience.

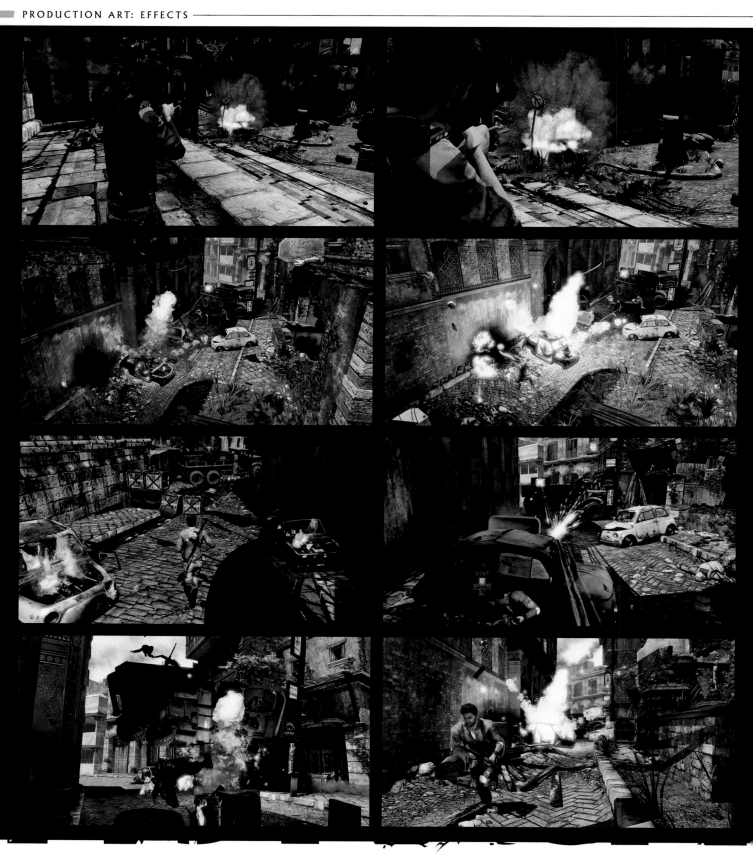

CONVOY

Convoy battle *this page*

In the Convoy level, we had large rock outcroppings that the vehicles were driving between, so if you hit one of those outcroppings they would collapse. If it collapsed in front of a vehicle, the vehicle would smash into it, so you could take guys out that way. The vehicles themselves turn into physics-driven objects once they get blown up, because we never know exactly where they'll be when they get destroyed. We have to be ready at any time to switch from their predefined animation path to physics-driven behavior to let them fly into the air and see where they land. That's part of the fun of real-time physics. It's never the same result twice, and you never know when you're going to see something really amusing, like sending a jeep full of guys flying off the side of a cliff and seeing them tumble through the air.

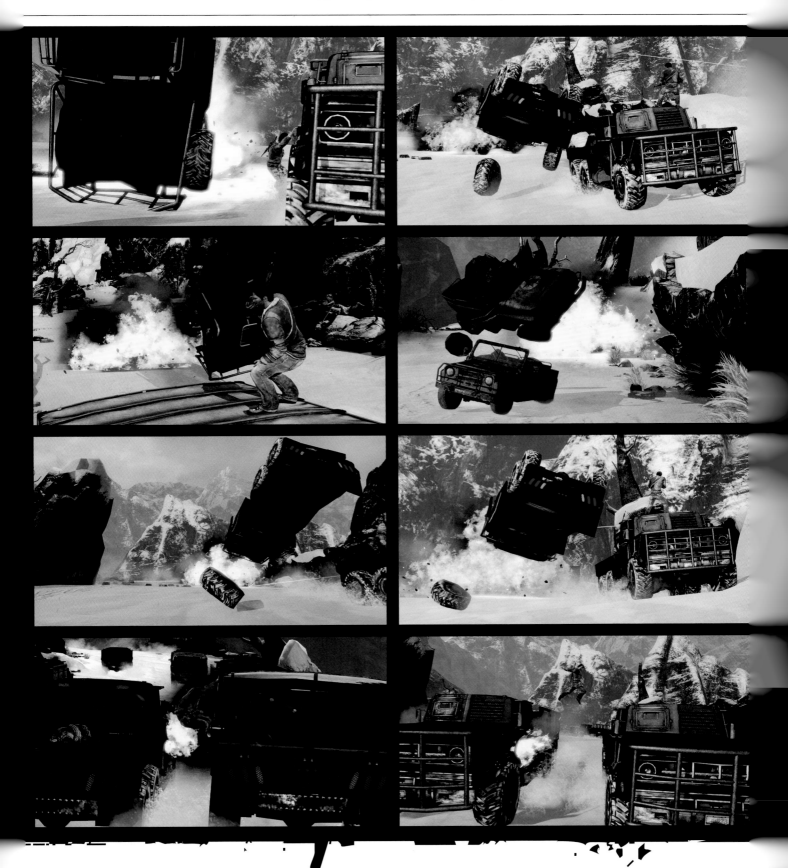

THE ART OF

GOD OF WAR III

FLIP THROUGH EVERY PAGE OF
The Art of GOD OF WAR™III AT OUR WEBSITE!